PRANKS 2
by V. Vale

LETTERS, ORDERS & CATALOG REQUESTS TO:
RE/SEARCH PUBLICATIONS
20 ROMOLO #B
SAN FRANCISCO, CA 94133
PH (415) 362-1465 FAX (415) 362-0742
email: *info@researchpubs.com*
www.researchpubs.com

Production Manager: Marian Wallace
Staff: Margo Beebe, John Sulak, Leslie Hodgkins, Kiowa Hammons,
 Mari Naomi, Justin Hager
Consultants: Seth Robson, James McNamara, Phil Glatz, Eddie Codel
Correspondents: Gary Chong (L.A.), Chris Trela (NYC)
Friends: Scott Beale, Chris Cobb, Alan Coe, Valerie & Jim Kunz, Ted McCalla
Interns: Sandra D, Doug Currie, Dillon, Richard Young
Photographers: SM Gray, Yoshi Yubai (NYC)
Legal: David S. Kahn, Lizbeth Hasse, Gail Takamine

©2006 RE/Search Publications
ISBN 1-889307-08-4

10 9 8 7 6 5 4 3 2 1

Front Cover Design: Marian Wallace, Doug Currie
Cover Design Consultant: Robert Collison
Bookstore Distribution U.S.A.: Publishers Group West (PGW)

CONTENTS

P RANKS 2

I magine we are fish swimming in the sea, and no matter where we look we see advertising, branding, marketing, and corporate/governmental coercive messages everywhere. What we once thought of as news, knowledge, politics, culture, art, music, and wisdom has all become one with this ocean of marketing and mind-control. What to do? How to keep one's sanity, sense of freedom, and unique identity? What can we do to resist?

Resistance is ultimately dispiriting unless we can also *have fun*. "The society that has abolished adventure makes its own abolishing the only adventure." [Situationist slogan] The last remaining quasi-legal territory of imaginative, humorous, creative, dissenting expression is signposted by pranks.

What are pranks? For us, pranks are any *humorous* deeds, propaganda, sound bites, visual bites, performances and creative projects which pierce the veil of illusion and tell "the truth." Pranks *unseriously* challenge accepted reality and rigid behavioral codes and speech. Pranks deftly undermine phoniness and hypocrisy. Pranks lampoon sanctimoniousness, self-glorification, self-mythologizing and self-aggrandizement. Pranks force the laziest muscle in the body, the imagination, to be exercised, stretched, and thus transcend its former self. The imagination is what creates the future; that which will be.

Why prank our world? When we look around and can see nothing but corporate propaganda as far as the eye can see, our only "communication freedom" lies in creatively talking back, any way we can. Who gave corporations the monolithic ownership of our total environment to force their one-way coercive messages upon us? So if we replace their messages and symbols with our own, we must wear big hats and sunglasses and mufflers to hide our chins, so their ubiquitous surveillance cameras can be pranked. (Or, preserve our Internet anonymity behind layers of evasive tactics.) Imagine if everybody became artists and pranksters and poets and freely changed any noxious corporate message in sight? (It is too much to hope for our so-called legislators to come up with a bill outlawing all corporate advertising in public space, even though the majority of voters might endorse this.)

If we are not slaves and robots, it also behooves us to systematically start thinking about reclaiming all the freedoms that have, inch by inch, been taken from us over the years to serve the interests of corporations and wealthy landholders. Freedom is never willingly given; it must be *taken*. And Americans have definitely become less free since 1776, hundreds of thousands of laws later. In fact, how have so many humans worldwide been bamboozled into being content with their paltry, miserable lot in life?

Pranks may be our last remaining freedom of expression in post-Constitutional, post-Bill of Rights, post G.W. Bush America. This book is a mere introduction to the enormous body of unheralded, uncelebrated, undocumented pranking that has occurred just within the past hundred years. And this book may be imperfectly organized, because pranks often elude facile categorization, and the same goes for the persons interviewed, who may sprawl ungainly over several categories. However, if a mere low-tech *book* can offer provocation, inspiration and laughter to a small but enlightened, freedom-loving readership all over the planet, then our mission has succeeded. If you've read this far, we say: Thanks for your support, and Happy Reading!

—V. Vale, founder of *RE/Search/Search & Destroy* in 1977, San Francisco

CULTURE HACKING

Time is running out. Talented musical and political firebrands like Jello Biafra and Al Jourgensen know this, and are criss-crossing the planet attempting to rally those who have not yet succumbed to despair and Prozac. There are now many public provocateurs who are lampooning the George W. Bush presidency and its war-mongering, while making audiences laugh. Out of the sea of information-overload they extract and present ideas and information that can change our lives. Artists like these are vital in letting people in other countries know that not everyone in America is a rightwing, brain-washed, Christian SUV-lover.

Long ago, the visionary U.K. writer J.G. Ballard predicted that "the past will disappear and the future will be next." As America's education system gets dismantled and firsthand exposure to the Constitution, Bill of Rights, and the history of the Founding Fathers disappears, a new United States of Amnesia is emerging, blinking its eyes and grasping at any shiny new toy offered on TV or the Internet, oblivious to America's uniquely democratic past. The driven individuals touring and attempting to give wake-up calls deserve our support not only for their perseverance, but for their unfettered imaginations, as they reprise the eternal role of the mythological Trickster, reinvented for our hyper-media-sedated society.

LET JIHAD SPEAK

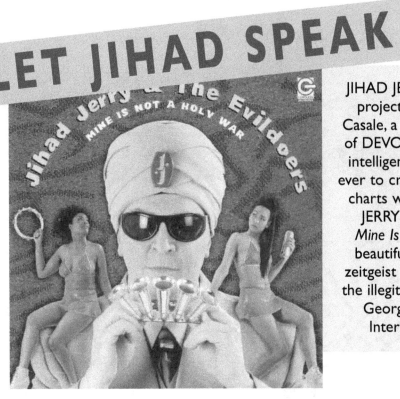

JIHAD JERRY is the latest project from Gerald V. Casale, a founding member of DEVO, one of the most intelligent musical groups ever to crack the best-seller charts worldwide. JIHAD JERRY's debut album, *Mine Is Not a Holy War*, beautifully captures the zeitgeist of America under the illegitimate authority of George W. Bush, Inc. Interview by V. Vale

♦ **JIHAD JERRY:** In a way, there's nothing better than a prank. Pranks should never be thought of as menial, or *light,* or pejorative, even. If you think about all the best things in history, they qualify as pranks, including DADA. So I never mind being associated with pranks—pranks need to be *elevated.*

Why? Because pranks are confrontational; pranks are creative; pranks are in that realm of transgressive art; a creative response to ludicrous situations that people find themselves in, in society, faced with illegitimate authority, illogical explanations, and mind-sets that are very, very unhealthy. A good prankster, basically through a creative act, breaks through all of that, and questions that and makes other people participate in that questioning. So, I would like to think that any good art is a prank on some level that is for the audience's own good. The intention isn't evil.

♦ **VALE:** *I like the idea of the prank as a cultural Trojan Horse, and I'd like to think that Devo's songs, at best, gave people little conceptual "barbs" that were like time bombs. People think they're getting something funny or light or amusing, but then it turns out you've given them something that keeps rising up out of their subconscious, provoking them to think about things.*

♦ **JJ:** A good prank definitely scrambles the assumption field, and as a result you're forced to re-think all your assumptions—which is fantastic. The latest example of that, which was great,

and I hope it's still available on-line, was the comic Stephen Colbert, from Comedy Central. Somehow—and this is a very important part of the concept of pranks, by the way—because of his fame within his little area, and because of his ability to have a voice in the marketplace due to Comedy Central, he was able to more or less sneak into the foreign correspondents' dinner in Washington, D.C., attended by no other than George W. Bush, his wife, Tony Snow, and assorted other nefarious characters from the *junta* that runs our country.

Stephen Colbert got up at this traditional *ha-ha* roast situation and proceeded to pretend to take on a persona of being this conservative comic who's on Bush's side, and using that as a platform to ridicule and mock Bush, twelve feet away from him, for a complete 25 minutes. Non-stop, no falterings, as the laughter and titters turned to deathly silence; as it got really, really personal and really mean. And he nailed Bush in a way that nobody from the straight press could ever come close to doing, and said things that nobody else could get away with, 'cuz he was a "comic" at a roast. And it was incredible.

It was on *YouTube* for awhile in three parts. It was brilliant, and I would recommend it to everyone, to watch this guy. Rarely does one get the opportunity in life to actually, in reality, get a position like that where your big fantasy would be, "God, if I ever got to talk to Bush, I tell you, I'd

give him a piece of my mind," and of course, that's just like bravado and front-porch posturing that never could happen. But this guy—not only did he get the opportunity; he didn't squander it; he didn't blow it; he didn't get nervous; he wasn't afraid—he *did* it. And it was stealth, and it was perfect.

♦ **V:** *That's fantastic—*

♦ **JJ:** It *is* fantastic. You should watch it. [Google "Stephen Colbert"] It starts with a knife to the gut and then just keeps twisting. It doesn't even mess around. He gets up and goes, "Wow, I am just so lucky to be here tonight. I can't believe this. Ohmigod, whoa, lookit, here I am, ten feet away from one of my all-time heroes: George W. Bush. I can't believe it; here I really am. Somebody pinch me—I must be dreaming." Then he goes, "No no no—no, I'm such a deep sleeper . . . somebody shoot me in the face! Oh . . . that guy isn't here tonight. Gee, just when you need him for something he can do!" [he was referring to Dick Cheney, right after he shot his friend in the face.] And you watch Bush quit smiling at that point, and you never see him smile again. His lips are pursed; his brows are furled, his wife is losing it and wants this guy killed, and Bush looks ahead straight-faced—can't look at him, and starts turning red! And the camera keeps going to him because it's C-Span, and the coverage was just standard C-Span coverage, so they're cutting to him a lot. So what you see is just the actual C-Span coverage of the foreign press corps dinner. And it's devastating. That's enough on that; I just want to tell you that he is a prankster and he did a great job—I salute him; it's his finest moment.

♦ **V:** *Well, putting this in a pranks history book helps preserve it—*

♦ **JJ:** This could never now be suppressed effectively; it's out there. And of course, due to White House pressure, the very next day C-Span used a never-used tactic, because they're always on these Internet services, and the Internet services show everything from C-Span. They cited "copyright infringement" to make all these sites take it off—obviously, because they were being threatened!

♦ **V:** *That's a whole legal arena whereby truth can be suppressed: invoking "copyright infringement." Now it's used punitively, too—*

♦ **JJ:** All the time. None of these kind of corporate whores and corporate criminals have an ounce of humor . . . certainly no ability for introspection! And so they hide behind litigators just using pure, raw, brute power and money to just subjugate and threaten everyone so they're too afraid to make fun. It's so typical. And they're getting bet-

ter and better at it.

Pranks used to be much easier. Today, it requires a lot more sophistication. In the case of Stephen Colbert, who booked him for the foreign press correspondents' dinner? Who got who to agree that Stephen Colbert would be the last speaker of the night? Obviously, somebody had to see the script beforehand—see his monologue. And somehow, he was able to do this. That's what's interesting there.

What's important about the prank is the energy that goes into organizing it . . . into getting yourself into a position to *do* the prank. The prank itself is actually just the *coup de grace;* the icing on the cake. The foundation is actually more interesting to me: the planning; the energy it takes to realize the idea.

♦ **V:** *Right. Often, there's a direct relationship between the thought and preparation, in regard to how much the final prank is truly satisfying.*

♦ **JJ:** A lot of people have great, funny ideas, and nobody *does* anything about 'em. The prankster sticks his ass on the line. He actually sets about, with the time and energy, to do the deed and reap the consequences of his action.

♦ **V:** *Somebody sent us an email that it was kind of amazing that DEVO was able to plant subversive thoughts in people by the millions, under the guise of humor—*

♦ **JJ:** Well, we lucked out. They looked at us, and felt superior to us, so that was a good start! Like with JIHAD JERRY, it's always good to leave being "cool" to everybody else, and let people think you're an asshole and a clown and a pathetic person . . . which is what "they" all thought DEVO was. They came to laugh at us; then they felt very superior and condescending, and then that made 'em like us! [laughs] But then they've subjected themselves to *you,* so now you have an audience; now you have a platform.

♦ **V:** *A pop song can implant one-liners that you can't get out of your head—*

♦ **JJ:** When you think of the fact that Bob Dylan, in 1965, had an AM hit called "Like a Rolling Stone," which was a scathing, incisive samurai sword to the mainstream culture and the people that were backing the Vietnam war, it was amazing.

♦ **V:** *We should have a history of subversive songs that became popular—*

♦ **JJ:** "Like a Rolling Stone" and "Sympathy for the Devil" are right up there, in all time.

♦ **V:** *Did that Stephen Colbert video reach millions?*

♦ **JJ:** Yeah.

♦ **V:** *I don't have anything against the goal of trying to get a large audience, especially if you're trying to plant subversive ideas or thoughts or memes or*

soundbites—whatever you call them—

♦ **JJ:** In a way it used to be easier, because there wasn't as much narrow-casting in media available to whoever, whatever subgroup wants to keep preaching to the choir, so that there's, like, skinheads who like Samoans, skinheads who hate Chinese people, and they all stay in their little groups. It used to be that there was a mass media and there was radio, and either you were on it or you were off it. So if you actually survived and ascended into having a voice, you were reaching millions, because there weren't any of these little sub-markets—*everybody* participated in this; it was a mass experience.

It's very strange, but it'd be like: if the Beatles were around today—if there were somebody *like* the Beatles for now, that the Beatles were to their time then, it's possible that they would have, like, a little fan base, an Internet following, and that's how it could *stay.* [laughs] And the people who ride Vespas would be into them, and they could sustain a nice life—they're making enough money off their "merch" and their shows and their web-site, but that's *it.*

Today it's almost like there's niche markets for everything, and nobody's participating in some mass experience . . . because all the content is meaningless. There's just no meaningful content. So, everything has just been homogenized and stripped of any force, so that it's not threatening. So, you have the freedom to be as weird as you want—as long as your weirdness means nothing.

♦ **V:** *It does seem that almost anything goes now, as far as your physical appearance and what you're saying. But it doesn't reach anybody except for a tiny niche.*

♦ **JJ:** That's right: in other words, it doesn't mean anything; it doesn't have any force. If it did—if it threatened anybody, then those people would be dealt with head-on, and they would disappear.

Marx's analysis was always correct about the effects of centralized power, means of production and distribution. What happened next in its application was obviously quite flawed, but only because it fell far short of the ideal. In other words, communism was doomed to die a quick death because it actually aspired to some kind of ideal about human nature—to try to *elevate* the human condition.

Whereas capitalism was very smart. It was more like an insect that just "read" the human condition and created a means, an economy, around the human condition *without* trying to elevate it. So it just *exploited* the animal/insect side of human nature. And that's why it can thrive today.

Unfortunately, there are many kinds of humans, and very few of them, any more, have any kind of *noblesse oblige* idea, or understand history or philosophy, or even read a book. So, the dumbing-down is now complete. And centralized corporate control of messages and media is also complete.

So you have Fox News network and Rupert Murdoch; you have Clear Channel. And what they've done is just take everything and just make it absolutely pablum.

♦ **V:** *But they always have shock value titillating you with sex and violence—*

♦ **JJ:** Oh, sure—that's why they love gangster rappers. In a way, that's kind of like the Black Panthers' worst nightmare come true, where these guys are actually acting like what you would think black people would think are racist parodies. And they are acting like racist parodies *willingly* for the corporation. And selling nihilistic, materialistic, thug messages—which is perfect, because it doesn't help anybody. It keeps everything going just the way it "should." In other words, they're actually acting in concert with their huge corporate record distributors. It's not rebellion at all; it's not threatening at all.

♦ **V:** *I was arguing with somebody who said hip-hop was the next counterculture after punk. I said, "No, a counterculture is just that—it's against the prevailing capitalist culture because it has different values."*

♦ **JJ:** Now, early hip-hop may have been; I don't know, but of course it was quickly co-opted. What I'm talking about actually has nothing to do with what hip-hop started as. Now what we have is just *filth!*

♦ **V:** *The values of hip-hop/rap are the same as the dominant culture's values: bling, blow [i.e. drugs/alcohol], and bitches.*

♦ **JJ:** That's it. That fits me: bling, blow, and bitches. That's right. In other words, it's spiritless and materialistic, as in Fifty Cent's movie, *Get Rich or Die Tryin'.* He don't beat around the bush . . . now *there's* a message! And I guess Ken Lay did both! He got rich and then died before he had to give his money away.

♦ **V:** *On the Internet there were all these blogs saying, "I bet he just faked his death and is alive in some tropical paradise, living it up!"*

♦ **JJ:** No, he died.

♦ **V:** *Everyone's mad because he didn't really get punished for ruining thousands of people's lives.*

♦ **JJ:** Well, in his own way he probably got punished. I mean, the reason he was in Aspen was: he couldn't even walk around his Texas community anymore because so many people were yelling at him and throwing eggs at him and spit-

ting at him, and he couldn't be left alone in a restaurant. Even though he may have actually been so self-deluded that he thinks he did nothing wrong, he destroyed so many lives through "willful incompetence" or "turning the other way" (or whatever) . . .

I think he died because he was so disgraced, that he was stressed out to the point where it created a heart attack. Maybe he didn't personally think he did anything wrong, but he certainly felt the heat. So really, he received a death sentence.

It's kinda so Dickensian. The whole thing reminds me of something you'd see in England in the eighteenth century. when people would stone somebody in the town square—some nefarious asshole who got caught dipping his hands into the till. It's so primitive. To all these people, it was a one-company town. He and Skilling basically robbed the bank and left all these people screwed. It was pretty horrible; pretty horrible. Anyway— quite a prank! He played it rough!

♦ **V:** *Paul Krassner was saying how the whole Bush administration has pulled one prank after another on the American people.*

♦ **JJ:** They certainly have. They've given a bad name to pranks, because there, it *is* evil. In other words, there's no good intentions there, like lying to everybody about WMDs when you had really planned to go into Iraq before 9/11. All of that stuff: loading up the courts, whittling away the Bill of Rights, secret wiretapping programs and torture chambers and flying people to countries—

♦ **V:** *Preparing hundreds of concentration camps . .*

. It's almost in the realm of some diabolical comic book fantasy that it's happening—

♦ **JJ:** And it keeps happening. And Bush keeps getting away with it, because everyone's so asleep at the wheel. Even the ones that know better, and know that there's merit and basis for these charges, they can't even let themselves feel rage because they just want to keep their jobs and they don't want trouble.

And the rest of the morons actually have *bought* the soundbites and the propaganda, because after 30 years of having an education system being decimated by Republican right-wingers and Christian fundamentalists, the resulting kids today don't have the ability to analyze information . . . don't have the ability to see through the lie. They just accept the soundbite, and the more you repeat it, the more they're like the sheep in *Animal Farm* that don't remember that the rule was different last week. It's perfect.

There is no outrage anymore because there is no informed public willing to take action.

♦ **V:** *And it really does seem impossible to ever have a mass protest movement again, which is what punk rock was—*

♦ **JJ:** It won't happen.

♦ **V:** *So when Marx predicted the rise of globalizing, monopoly capitalism, and concentrated ownership of the means of production and distribution, did he also include the media? The media is so important—*

♦ **JJ:** More important than anything.

♦ **V:** *It's so important that media be independent*

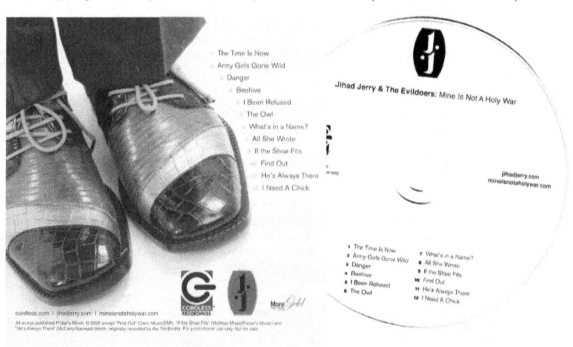

Jihad Jerry & The Evildoers: Mine Is Not A Holy War

The Time Is Now
Army Girls Gone Wild
Danger
Beehive
I Been Refused
The Owl
What's in a Name?
All She Wrote
If the Shoe Fits
Find Out
He's Always There
I Need A Chick

jihadjerry.com
mineisnotaholywar.com

1 The Time Is Now
2 Army Girls Gone Wild
3 Danger
4 Beehive
5 I Been Refused
6 The Owl
7 What's in a Name?
8 All She Wrote
9 If the Shoe Fits
10 Find Out
11 He's Always There
12 I Need A Chick

cordless.com | jihadjerry.com | mineisnotaholywar.com

and have the balls to tell the truth. Did Marx predict the rise of media monopolies?

♦ **JJ:** It is amazing. The question remains: Why did the media pick Bush? Certainly they are in a position now to pick the President. And why did they pick Bush? I wish I knew the answer. I guess they thought it would make for more interesting news.

♦ *V: I look at Bush now as "Bush, Inc."—a corporation whose business plan is—*

♦ **JJ:** —all war, all the time. It's the cost of freedom, which of course *is* your freedom! It's a tautological argument. It's fantastic that these evil-doers, these horrible terrorists [Bush and Co.] are threatening our way of life. So that they won't be able to take away our way of life, what we're gonna do is: we're gonna take away that way of life *ourselves!* All in the interests of "national security" and "safety." [laughs]

♦ *V: That's a good phrase: "The cost of freedom is your freedom!"*

♦ **JJ:** That's the cost of freedom, pal.

♦ *V: At least we still have the "freedom" to express our little niche analyses and put out books and CDs, which brings me to Jihad Jerry. You funded it yourself, and came up with the concept, the songs, with collaborators—*

♦ **JJ:** Yes. There are some collaborations on there, but mostly, it's me. I really thought, "What's more ridiculous than taking the bogeyman terminology and the whole 'jihad'-infested world we live in, where we're being bombarded by our own media, with these bogeymen in turbans and words like 'jihad.' " In a way, we (that is, the Western press) are doing a great job of *publicizing* these guys, right?

I thought, "Let me appropriate these psychotic fundamentalists and their ways of talking and their terminology and use it, parody it." Like Jihad Jerry's "Mine is not a Holy War." That's the whole point: "jihad" means holy war, and you listen to their "logic" and it's just like the Christian fundamentalists—*they're* engaged in a holy war, y'know. The fundamentalist Jews are engaged in a holy war and they're going at it right now. The tails wag the dog.

All the reasonable, rational people left on the planet are sitting here hijacked by psychotic, powerful people—ideologues—with insane agendas. Because they're believers, "men of faith." How ridiculous! Somebody tells me, "Your pilot is a man of faith," well, I'm going to get off the plane, then. I want a man of science. Jihad Jerry—his war is against ALL idiotic, illegitimate authority spawned by fundamentalist beliefs.

♦ *V: I've been trying to attack the very notion of "belief"—that believing* anything *is "okay."*

♦ **JJ:** Exactly. You shouldn't believe anything. Although, you can believe that people are always up to something, and that they don't mean what they say. [laughs] *That* you can believe!

♦ *V: Well, all knowledge (including "scientific" knowledge) is a work-in-progress. The original Greek skeptics (which we aren't taught about in our "history of philosophy" classes) had compartmentalized the world into "skeptics" and "dogmatists"—*

♦ **JJ:** There you go.

♦ *V: Well, you have a great line in your song, "You look through your glasses/But the rest of the world looks* at *them"—*

♦ **JJ:** That gets back to Devo's smart-ass prank which was the Philosophy of Devolution. And we realized it was completely quack, but we thought it was as good as what people *did* believe in—certainly more believable than the Bible. And so we were making fun, once again, of what people believe . . . what they think is "true" and "real."

The idea that we descended from psychotic, brain-eating apes kind of explained more clearly the position we're in today, than evolution *or* the Bible. [laughs]

♦ *V: In a certain tribe it was customary to eat your father when he died. But, it was considered complete sacrilege to burn/cremate your father when he died—that was taboo!*

♦ **JJ:** Yeah! Because then you're not getting the hormones in your body, like cows that eat your own. We're all "mad cows" now!

And that's another thing: we found that people *a priori* thought that "evolution" meant "progress." Somehow evolution got associated with progress in that kind of Western sense of progress, like "things are getting better, and we're all moving towards some great future." When, really, evolution didn't ever *mean* that. It just meant that things *change.* [laughs] And that can be bad!

In other words, I don't like the new model "human"; I think it's dumber and meaner than the old human.

♦ *V: But it's more self-confident!*

♦ **JJ:** Absolutely. That's right. It is nice to be dumb enough to—what's that cliche? "Have the strength of your own convictions." Anyway, that's the problem with cliches.

♦ *V: And unfortunately, a lot of them reflect so-called "truths."*

♦ **JJ:** Well, that's how they get started: they're based on something that is *kind of* "true"—half-true.

♦ *V: J.G. Ballard said that "nothing is true and*

nothing is untrue." Everything requires careful vetting and analysis—

♦ **JJ:** Absolutely. I think that creative people enjoy ambiguity; they're comfortable with it. And other people—they don't want to make peace with that idea; they want *answers.* [laughs] They want to be told what's what. Like, even when it comes to "freedom"—it's just a brand! It's a sales slogan. It's like, "Well, how do I be free?" "Well, you do *this.* And you put *those* pants on, and you get *that* haircut, and you're free!" "Thank you." And they go do it. And it proves they're unique

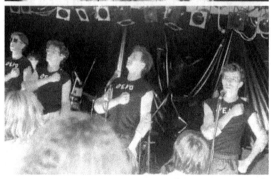

individuals and they're free!

That's about all freedom has become, like Pepsi and Coke, where people will fight over which one's better. That's what it comes down to.

♦ *V: One of the themes of punk rock was trying to understand what William Burroughs called "the control process"—how we may be controlled, and not even know it—*

♦ **JJ:** Absolutely.

♦ *V: Camus and others wrote that to be a man means to be a rebel. If you're not a rebel, your balls have been cut off; you've been lobotomized. We make progress in life by rebelling against clichéd ideas and so-called received wisdom. And I thought, "If I were a corporation wanting to put a lid on social rebellion, I couldn't think of a better way to market products in the name of 'rebellion' than hip-hop." The hip-hop legends inspire awe for the people they may have killed and the drugs they may have sold and all the women they've bedded. And in their MTV videos they're driving the biggest SUVs—*

♦ **JJ:** Escalades, Navigators. On "MTV Cribs" you walk through their house and it's just this compendium of expensive bad taste and kitsch—

♦ *V: And they're wearing impossibly heavy gold chains, Rolex watches, and serving Cristal champagne which costs $400 a bottle—*

♦ **JJ:** It's very expensive; yeah. It's just moronic; completely moronic.

♦ *V: The thing is, this has siphoned off a lot of rebellious impulses in young people who maybe should have been aspiring to be scientists and Tom Swift-like inventors—*

♦ **JJ:** Yep—you got it. Couldn't agree more.

♦ *V: Back to Jihad Jerry: at least you've* done *something, rather than nothing. And the songs are incredibly catchy. These two ten-year-olds I look after are always asking, "Can you play Jihad Jerry?"*

♦ **JJ:** Well, I hope I can get my head above the world and hit the radar screen and get played at least on some college radio and specialty radio, because certainly Jihad Jerry and the Evildoers face one huge uphill battle onto Clear Channel. [laughs] I'm going to make a new video to the first song, "Time Is Now," and I'll try to play live later on.

♦ *V: Whatever the concept is, it's not just Devo—it incorporates the blues. I think the blues are some of the only music that can express the way a lot of us are feeling now—*

♦ **JJ:** The blues are true roots American music. It's music that now is only historic, because the practitioners are all mostly dead now. They were alive in the Sixties when our own country, of course, shit on black people and black music—the *real* black music, not this stamped-out machine plastic rap stuff. And it took the English groups like the Yardbirds, the Rolling Stones and others to re-introduce American kids to their own music! So kids were loving these songs, and on the first records by these English groups, most of the songs weren't written by the groups—they were written by people like Howlin' Wolf, Muddy

Waters, Sonny Boy Williamson, and Robert Johnson. And it was fantastic that they kept that alive. And in the nineties, I think it was destroyed; it went away. So I'm just reminding people of the roots of good American music.

♦ **V:** *It must have taken you thousands of hours to learn how to play the blues harp so well—*

♦ **JJ:** I've been playing the harmonica since I was in college.

♦ **V:** *I just don't remember you playing it in Devo—*

♦ **JJ:** [laughs] No, I can't imagine Devo and a harmonica! That's very funny.

♦ **V:** *Well, I thought that maybe I'd missed it—*

♦ **JJ:** No, that's too real. That's too real for Devo: harmonica.

♦ **V:** *Well, I like the idea of Jihad Jerry as an anti-racist/political statement, reclaiming the right of all freedom-loving Americans to wear a turban if they choose to—*

♦ **JJ:** I'll be glad if they just get that little brooch I made that's my "J/J" emblem, I'm trying to approach a cheap lighter company to manufacture lights that look just like that!

♦ **V:** *What a pun . . . an incendiary device, indeed. The "J/J" pin could be nice, too—you could wear it on a suit or a coat. I wish somebody would start manufacturing that incredible harmonica you're holding on the cover of the CD—was that real?*

♦ **JJ:** That's real. [laughs] But on the recording, I used Hohner blues harmonicas with wooden reeds. The harmonicas have been soaked in water, so you can "bend" the reeds; bend the notes.

♦ **V:** *There are a lot of little musical details in the recording that you don't even notice until the tenth or fifteenth time you hear it—*

♦ **JJ:** Well, I tried to put good production in, and work with good people. Because when you listen to a recording, you want it to have some "layering," some kind of richness, that makes you listen again. I spent so many years in the studio doing that. Just make sure whatever you *do* put in there, you like the sound of it! You can go back to an early recording like Elvis Presley's "Don't Be Cruel," and there's probably no more than eight tracks, but they're beautifully recorded and they gel together in this kind of "sound envelope" that becomes *more* than the sum of its parts.

♦ **V:** *Like, everything seems "right," somehow. It's your own instinct or intuition guiding you there; it's not purely intellectual. Music isn't just "intellectual"; some people think it's pure emotion. But I disagree; I think there's logic and rationality involved—*

♦ **JJ:** Lots of it! Lots of it, really. The better the music, the more it's logical. You can't say that Jimi Hendrix isn't thoughtful and almost like a mathematician. I mean, it only *seems* crazy . . . and it's not at all. The end result makes you *feel* something, but if you look at the *craft* of it, it was thought out and hard work.

♦ **V:** *We're talking about the possibility of orchestrating emotion, using logic—*

♦ **JJ:** Of course!

♦ **V:** *But what I really like about music are those moments that seem to capture a sudden spontaneous inspiration. Who knows where those inspirations come from?*

♦ **JJ:** Exactly. You gotta start with something great.

♦ **V:** *Music is such a blending together of logic and emotion; it's like, thinking and emotionality get blended. Well, what are we: professional music critics?*

♦ **JJ:** [laughs] Well, I'm just a guy who makes music.

♦ **V:** *But you're also capable of analysis. I realize that to be able to "come up" with music, that's a whole different state of mind—maybe you go into some kind of trance state, or something, to let the music "come out." Well, it must come out of your subconscious. Do you wake up humming a tune, or do tunes come to you in the shower? Here we are talking about the creative "process"—*

♦ **JJ:** Well, it is true that I have to, on purpose now, put myself into a certain type of "mental space," whereas when I was younger, we just *lived* it every day and that was all we did—we were always in that space. And then "life" takes over; you start recording, and you become a business entity, and all the politics involved and all the years of knowledge and cynicism [laughs] and bad experiences that you're trying to forget about . . . you can't play music like you used to! You can't even want to, in a way; you have to go, "Well, how do I feel *now?*" [laughs] "Let's do something based on that."

In Jihad Jerry, I wasn't trying to recapture the Jerry that was founder of Devo. Jihad Jerry wears that turban not to hide from justice, but to perform it!

♦ **V:** *I just got it! You* had *to invent a new, parallel persona—whatever you want to call it—so you could renew creatively—*

♦ **JJ:** That's right; that's what I was trying to say.

♦ **V:** *And it's a complex persona, too. Just like when punk rock began, why did I start publishing? Because I was angry about all the lies being told about Punk in the newspapers and everywhere, and that's why I did what I did. Same with you: you created the Jihad Jerry music because you were angry. All of us now are angry about this Bush corporation taking over and wrecking our lives and wrecking the*

whole world, really—

♦ **JJ:** Absolutely: the end of democracy and the pervading feeling of just malaise and dread and bad energy.

♦ *V: We hate that, because we were lucky enough to live through Punk when people actually did something about it—*

♦ **JJ:** And had a good time!

♦ *V: Well, I think your new Jihad Jerry album—which, again, you didn't have to do—truly reflects the zeitgeist, the spirit of the time now.*

♦ **JJ:** Well, I hope it gets played somewhere. It's like everything: if they don't promote it, no one will hear it, and then it won't matter if any of the songs are good, cuz nobody knows it. I need people to hear it, and then if they don't like it, I can accept that, of course. But I think a lot of people *would* like it if they heard it.

♦ *V: Well, I certainly hope it can take off on the Internet or however, although I'm still a bit cynical about the hype that the Internet offers you the quickest way to reach millions of people—*

♦ **JJ:** I think it is completely hype. It's kinda sad. In a way, nothing has changed—only the formatting; only this specific thing. It's like: okay, there were 78rpm records. Then there were 33-1/3 and 45 records. Then there were 8-track tapes and audio cassettes; then there were CDs. And in a way, if I look at it, the plight of the artist is even *worse* now than this "Old School" record model that everybody is busy trashing and making fun of. I don't see anybody better off because of this "new paradigm."

♦ *V: There's a book out called* The Long Tail *that claims, "Now, you can make money just selling a few items off a million-item inventory!"*

♦ **JJ:** It all sounds like a Ponzi scheme!

♦ *V: The corporate media monopoly likes to publicize anything that offers a kind of "lip-service rebellion"—*

♦ **JJ:** That's exactly what it is: packaged rebellion. I know.

♦ *V: And if something really is way deeper, "Well, we don't have time for that!"*

♦ **JJ:** That's right. It's like, "Okay, smart-ass, we don't need that. That's negative, man. That's a bummer. Who do you think you are? You think your shit don't stink, Mister? I mean, it's so sad that a creative guy like you would *choose* to do this. To see you destroy yourself this way just makes me sad . . . " [laughs]

♦ *V: Tell us how you conceived the Jihad Jerry project—*

♦ **JJ:** Well, I imagined the persona of Jihad Jerry to be this almost self-effacing, masochistic guy, because he's using the language and stance of jihad to debunk fundamentalism—radical fundamentalism, not just Islamic but Christian and Jewish as well—because all of that stuff is what I think is the biggest threat to the future of humans on the planet today. And then I thought, "What would he *wear*? This isn't a rich guy. He's kinda misunderstood. He's a guy without a home, in a way—even when he's home, he doesn't feel comfortable. So he goes down into a ghetto store and he buys the really cheap pimp suits because they're the cheapest suits you can buy. Cuz you get, like, three suits, three shirts, three vests and three ties for $300, y'know. You've got your whole wardrobe! So I just did that, and made matching turbans. There's a retro element; I almost look like some Fifties or early Sixties—

♦ *V: Ohmigod! Back then, Korla Pandit won over so many millions of housewives with his morning TV show. He never spoke and he wore a turban—*

♦ **JJ:** And there was Sam the Sham after that. But that guy you're talking about: he was incredible, because he was very alien-looking, like light-skinned; maybe he was a mulatto from New Orleans. Yeah, he was great! [laughs]

And so, there's a retro element in Jihad Jerry, and a funny element in it, you know, sort of like: "Who's this ridiculous guy? It's almost like Kreskin from the Ed Wood days, wearing this ridiculous get-up—clothing—that everybody can laugh at and feel like, "Gawd, I wouldn't wear that!" And that's the point: Jihad *will*.

♦ *V: And I like those sunglasses; what are they?*

♦ **JJ:** They're seventies-style glasses from England.

♦ *V: Well, if you're going to do an art project, you may as well get all the details down—*

♦ **JJ:** Yeah!

♦ *V: And I thought it was totally brilliant to bring in some "women of color" singers—*

♦ **JJ:** There's a Thai girl and a black girl. And they're *good*; they're good singers.

♦ *V: And where did you get those great shoes, by the way?*

♦ **JJ:** Same store. [laughs] Those shoes are ridiculous.

♦ *V: Yes, but they're kind of charismatic too, in a weird way. Things can be kitsch and also be beautiful—*

♦ **JJ:** Absolutely .♦♦♦

JELLO BIAFRA

was the founder and primary spokesman of the Dead Kennedys, a Bay Area Punk band that began in 1978. Having recorded with Lard, the Melvins, and other musicians, Biafra regularly gives Spoken Word tours around the world, and his provocative utterances are condensed to provide answers on the subject of pranks.

♦ **VALE:** *What's the worst "prank" the Bush government is pulling on us, besides the war on Iraq?*

♦ **JELLO BIAFRA:** Voter fraud. I never thought that in this day and age we'd be having to fight to reclaim our right to vote. The main weapon of Ku Klux Bush is electronic voting, where: one click of a mouse and we've kissed democracy goodbye!

We're the only major democracy in the world to allow private corporations to secretly tabulate our votes. And one of the main culprits is a corporation called Diebold. No other country outside the United States will buy their machines. And the head of Diebold, Wally O'Dell, said, "I will deliver Ohio for George Bush." And boy, did he ever.

Robert Kennedy, Jr. (a *real* Dead Kennedy!), in *Rolling Stone* of all places, just laid it out, fact by fact, state by state, that thanks in large part to hacked digital voting machines, Bush didn't just steal the 2000 election, he stole the 2004 election as well!

It wasn't just Ohio that was stolen, but Nevada: 10,000 people, in districts known to lean kinda liberal, mysteriously didn't vote for anybody for President. And in New Mexico, 20,000 people mysteriously didn't vote for anybody for President, which could have tipped the electoral vote. Gee, I wonder why?

Florida: estimated another 50,000 people either had their vote stolen, or they weren't even allowed to vote in the first place, when they were qualified to do so. The U.S. Civil Rights Commission even suggested *indicting* Jeb Bush for monkeying with elections when he mysteriously beat Janet Reno, but they can only *recommend*. It's the Attorney General who has to prosecute. And of course the Attorney General is Alberto Gonzalez, the one who said it's okay to

torture people, and that human rights treaties are "quaint" things, and that mentally-incapacitated people and developmentally-disabled—we can execute them, too! He just loves killing people, I guess. But he doesn't like pornography! Of course, a lot of Democrats voted to confirm him.

According to Kennedy's article, as many as 350,000 people in Ohio were denied either their right to vote or have their vote counted. And the whole time, one thing he barely touched on, though: "Okay, we knew this was going to happen in advance. The Republicans even bragged about it; they were going to try and block black people from voting, and challenge their addresses!"

But where was John Kerry? I mean, he would have made a great actor for those low-budget vampire movies, now that we don't have Christopher Lee and Peter Cushing to do 'em anymore. At least if he'd gotten in, they would play the *Munsters* theme instead of "Hail to the Chief" whenever the President entered the room. But when push came to shove, Count Kerry the toothless vampire couldn't even climb out of his coffin to challenge what was going on in Ohio.

And then Greg Palast in his book, *The Best Democracy Money Can Buy,* goes after Diebold and ChoicePoint and some of the others and pointed out that one of the electronic machines, in a liberal-ish district in Florida, came back with *negative* 16,000 votes for Al Gore. And this was put in the hopper. How did that happen? For that matter, where was Al Gore when that did happen? Was he that allergic to being photographed with civil rights leaders who weren't white? I don't get it.

But, it gets creepier. 2002, in Georgia, everybody in the state was forced to use electronic machines with no paper trail, which Diebold

claims is technologically impossible, even though their main bread-and-butter business is bank machines that dispense the cash and come up with a receipt! Yeah.

So in 2002 in Georgia, there were a couple of Democrats who were supposed to win by pretty large margins: 12 to 16 percent for governor and senator. Election day happens, and they *lose* by 12 to 16 percent! So this clown named Saxby Chambliss is now in the senate. He was so low and dirty he bashed his opponent, Max Cleland, as being "soft on terror, soft on national security, soft on war, and an all-around wimp and a pussy." Max Cleland is a triple amputee from the Vietnam war, while Saxby Chambliss is a chicken-hawk who didn't even bother to serve in the military at all—one of those.

Same suspicions with electronic machines giving Jeb Bush another term in Florida. And this goes even back before that: in 1996 in Nebraska, stunning upset: conservative Republican Chuck Hagel gets "elected" to the senate. Nobody expected him to win, and migosh, he even won all these black districts in Omaha which no Republican had ever done. How did this happen? Well, the electronic machines were run by a company called Electronic Systems and Software (ES&S for short, who's still one of Diebold's competitors) and guess who was in charge of ES&S at the time? Chuck Hagel! [laughs]

It's that blatant. It's so blatant that people in Ohio took out a referendum on the state ballot for the 2005 election to reform the voting process, and ban these electronic machines that don't have a paper trail and don't allow a recount. It was predicted to pass by a 2/3 majority; day of the election, it *loses* by a 2/3 majority. *How much longer is this going to go on? Voting should not be privatized.* No!

So, there's got to be some conscientious, patriotic, hackers who will do their patriotic duty, protect our constitutional right to vote, and monkey with those machines just like the Republicans do. So that all of a sudden at the next election you see the pundi-toids on television freaking out: "Ohmigod, this is the twelfth state where Homer Simpson has been elected governor!" That'll expose electronic vote fraud! Moral of the story: Since no other major democracy in the world allows private companies to run their elections, why should we?

♦ *V: Is "Homeland Security" a Bush Administration prank on the American people, too?*

♦ **JB:** Well, does anybody feel even remotely safer since the Patriot and Homeland Security Acts were passed? Now we have the dog-and-pony show of getting groped and searched at the airports as never before, so I know nobody will hijack a plane with tweezers while I'm trying to fly back from Chicago. I feel *so* secure.

And they haven't even checked the background of a lot of those TSA employees who search you. They might be ex-cons; they might even be, *ohmigosh, illegal immigrants!* What if they're illegal Al Qaeda immigrants? They haven't even checked *that.* But what really galls me about our fake homeland security cash-in scam is, meanwhile, while they're groping everybody at the airport, boy does it get tempting to show up with something they red-flag: they open up the suitcase and there's another one inside. Open up that and there's a smaller one inside. Then another smaller one; then another smaller

one. Finally they open they open the little one and *boom!* . . . out comes a jack-in-the-box that looks just like Osama bin Laden!

Then they check my backpack and out comes another jack-in-the-box with a cowboy hat on: "Don't mess with Texas! Don't mess with Texas!" [laughs]

Meanwhile, though, 90 percent of our shipping cargo is not inspected at all. You bring it in by boat in one of those great big near-semi-truck-size shipping containers . . . you can put surface-to-air missiles in there to shoot down a plane, that were bought on the black market in Pakistan because they didn't collect them for the *mujahadeen* after we armed *them* in Afghanistan. You know, they could bring in stuff for a dirty bomb.

You could even smuggle Osama bin Laden himself in one of those containers, and have a 90 percent chance of success. Osama could be driving a cab in New York right now! Or is he the *ice cream man?* Or is he the new tech support guy that you're forced to train so he can replace you at your own job? You never know with these things.

♦ **V:** *What are some other pranks that Bush has pulled on the American people?*

♦ **JB:** Do you remember when Bush flew into Iraq for a nice photo-op on Thanksgiving, giving the soldiers a turkey? How many of you knew that the turkey was made out of rubber? It wasn't a real turkey at all!

How many of you know that when Bush appeared on that aircraft carrier declaring, "Mission Accomplished," he wasn't in the Persian Gulf? No, he was off the coast of San Diego! And they wasted a million dollars of fuel sailing that boat around and around in circles until Bush's media handlers decided the *lighting* was just right . . . as the sun went down.

♦ **V:** *Tell us some "funny" things about George W. Bush—*

♦ **JB:** A man with so curious a thirst for knowledge, he'd never even been to Europe before he was awarded the White House. Said he has no memory of the Vietnam War ever being *discussed* while he was going to Yale. Was he really *that* drunk? Maybe so. And now *brags* that he doesn't even read the newspapers anymore: "I just glance at the headlines, just to kind of get a flavor for what's moving. I rarely read the stories, and get briefed by people who probably read the news themselves." [laughs]

Asked what the greatest mistake he'd made in his first term was, he said he couldn't think of a single one. But then he recently told a German tabloid called *Der Bild* that the best moment of his Presidency was, "When I caught a seven-and-

a-half-pound largemouth bass on my lake."

Now, if you think Bush got any smarter after September 10, '01, think again. This quote is only from last spring: "Border relations between Canada and Mexico have never been better." And he seriously believes that "we've had an enduring friendship with Japan for the past 150 years!" [laughs] Bush thinks his lack of intelligence is funny: "Nobody should tell me what I believe. But I do need somebody to tell me where Kosovo is."

And then there are these frat-boy nicknames he gives people. He calls Vladimir Putin "Pooty Pooch." Condo-sleaze-a Rice is called "Guru." Cheney, for no obvious reasons, is called "Big Time." Karl Rove he addresses as "Turd Blossom." [laughs] And then he turns around and dismisses environmentalists as "Green, green, lima beans."

Here are more quotes from Bush: "The illiteracy level of our children are appalling." Threatening Saddam Hussein in the fall of '02: "You disarm, or we will." "I'm honored to shake the hand of a brave Iraqi citizen who had his hand cut off by Saddam Hussein." [laughs] "A vampire is a cell deal you can plug in the wall to charge your cell phone." "Will the highways on the Internet become more few?" "I know how hard it is for you to put food on your family."

More Bush quotes: "I understand small business growth. I was one." "Africa is a nation that suffers from incredible disease." Talkin' tough: "When I was comin' up, it was a dangerous world. You knew exactly who *they* were. It was us versus them, and it was clear who *them* was. Today, we are not so sure who the `they' are, but we know they're there." [laughs] "It's clearly a budget: it's got a lot of numbers in it."

How did *this* guy get buttered and squirted through Yale, and Harvard, which are pretty tough schools to get into, let alone get a degree from, but he just sails right through.

♦ **V:** *Tell us about Bush's religious views—*

♦ **JB:** Bush, in July of '04, told a group of Amish people, "I trust God speaks through me." *What?* That, coupled with a report that he told a reporter in Austin years ago that "Jews can't get into heaven." And there's a religious-right DVD put out before the '04 election, a pro-Bush one called *Faith in the White House,* that claimed that one of Bush's favorite things to do is to go up to this little hill on his little toy ranch in Crawford, Texas, all alone, and talk to God. Yeah! "That's why I'm never wrong! Because, I am God's vessel. God speaks through me. Therefore, questioning anything I do—you're questioning the Almighty Himself!" Where have we heard *that one* before?

Pat Robertson? Osama bin Laden? *That's* where we've heard that before.

♦ **V:** *What's your take on the Internet?*

♦ **JB:** Maynard from Tool told me that after Rupert Murdoch bought MySpace, his anti-Bush statements all got stripped off of his MySpace site! Interesting.

There's a bill in Congress now designed to stamp out neutrality and a level playing field on the Internet. And now they want to keep putting up tollbooths on the Internet (which Al Gore proposed when he was Vice-President) just to keep people from communicating, especially if they're Patriotically Incorrect.

But, sometimes we aren't helping matters, either. Somebody says, "I talked to so-and-so yesterday." "Oh, really? What did he say?" "Oh, I don't know; I just emailed 'em." Sending an email is not communicating; it's just sending an email. And then if you don't get a reply back, you send another one: "Didn't you get my email?" [laughs] . . . when you could just pick up the phone and actually talk to a human being on the other end of the line. And talk about "Instant Messaging"—you ask 'em a question and they *answer* it! Instantly! And then you can even ask them another question! I can't believe that we've gotten so sophisticatedly stupid that we can't figure that out, anymore.

Text-messaging is so popular with the kids and their fancy phone-toys: "Ooh, I'm sending a little text message to you. I can see you fifty yards away at the mall, but I'm not going to talk to you. I'm only going to 'text' you." An ex-girlfriend of mine was in an L.A. club and a woman came up to her. They introduced themselves, and the other person said, "Oh, you're my MySpace friend!" . . . and then walked away and didn't talk to her anymore. [laughs]

It's like: here we are, emailing, MySpacing Out, and creating all these imaginary friends, and not wanting to communicate with real people. It used to be that living in a world of imaginary friends was classified as a mental illness! But now, it's used as an exciting new fashionable way to live in your own little walled-off digital cocoon so you're *that* much more easily manipulated.

Granted, phones are becoming very fascinating toys, and the sooner they can be used to hack Diebold voting machines, the better! But, I keep wondering when people are finally going to realize they've been *had*. When they finally get tired of things like, "Wow, I just got to see a whole live BonJovi concert for Verizon customers only, on my phone, and BonJovi was the size of an ant the whole time. It was so awesome!" [laughs]

I like *more*. I like live bands. I like to listen to things without some video showing me what the song's supposed to mean, so I can decide that for myself. We ignore everything going down all around us; it's so obvious: the rich get richer, the poor get poorer, democracy fades away, people get tortured/shot by the cops. No! You should stay home and stay on the edge of your seat worried sick about which one of those ho's after ho's after ho's groveling before those snippy judges on *American Idol* gets crowned *the* one, who gets to tour the world singing the worst music I have ever heard!

It's interesting how times have changed, where nowadays, instead of keeping our private diaries and our thoughts all to ourselves, we put every last detail of ourselves up on MySpace, hoping somebody wants to be our friend. [laughs] Preferably a *virtual* friend, that you never have to *talk* to.

♦ **V:** *What can we do?*

♦ **JB:** Doing something is better than doing noth-

ing, every time. Starting with: if you want to, just make a little vow to yourself: "I'm not cooperating with Bushism, or the corporate agenda, anymore. They can't have me." Starting with: Don't give them your money anymore!

No more money to chain stores! No more money to chain restaurants! Patronize the businesses who are locally owned, and keep the money in the community. Don't go to Clear Channel venues. Support the local market instead of the corporate supermarket—you're more likely to get hopefully locally-grown and hopefully *organic* food, instead of genetically-modified/genetically-mutilated frankenfood. Support the local music store. Support the local bookstore, instead of the big mega-chain. The clerk may even know how to *read,* and be more interested in literature than fixing lattes in the little corner cafe in the bookstore. [end]

An excerpt from Jello Biafra's track, "Hacking the Planet" (from *Become The Media,* CD#2, track #1), edited by V. Vale.

Online communication/"Becoming the Media" is so damn important. Part of the reason so many people who were so pissed off at run-amok corporate rule showed up in Seattle (and in D.C. for April 16) was: online networking that wasn't possible before the Internet came into being.

As a kid, what I wanted to be when I grew up was the villain on Batman: the Penguin, or the Riddler. And now we all have the chance to be the Joker—the one who jammed the radio and the airwaves to broadcast his own "news" *Captain Midnight*-style, instead. And this Joker tradition does go back a ways—at least in Britain, people figured out a way during protests to intercept the police radio frequencies and misdirect the cops to other parts of town, away from the demonstrations.

And as usual, the British and Europeans are a little ahead of us in the modern Jokesterism as well. There's a U.K. group called the Electro-Hippies who have never even met each other except online. They claim they got half a million people to swamp the W.T.O.'s website around the time of their meeting in Seattle, thus interfering with the W.T.O.'s ability to get anything done, or tell people how wonderful they are as they loot the world. The Electro-Hippies "model" was: "In cyberspace, everyone can hear you scream . . . if you want them to!"

And there's the Electronic Disturbance Theater, who monkey-wrenched the web-page of Mexican dictator—excuse me, President—Ernesto Zedillo, and nailed him for human rights

violations: "Human rights not found on this server." They listed the names of people murdered by the Mexican Army! This isn't mere *hacking;* this is "Hacktivism."

Not your frat-boy, Animal House school of hacking of monkey-wrenching a tiny little community web server to show you can do it, while ignoring the Nike website in the meantime. Or, "Ha ha ha, I just ran up $20,000 on somebody's credit card and I don't even know who they are." That's not hacktivism—maybe it's just *greed.*

Another entity called "Bronc-Buster" was able to remove some of the filtering from firewalls that separated China from the rest of the Net, allowing the Chinese unfiltered browsing for information their government didn't want them to know. I have to wonder if Al Gore's dream of a privatized Net will also mean that kind of filtering over here: "What if little kids in the library find out that people have sex, or find out how to prevent the spread of AIDS? We can't have that; we must totally have abstinence! Heh, heh."

In other words, Hactivism may now be as important as Becoming the Media . . . becoming the *new* fourth branch of government to police the other three. Some people claim, "Well, you're so into "freedom of speech that that's *censorship,* because when you monkey-wrench a Nike site, you're 'censoring' what Nike has to say." Well, that's kind of like saying, "White people are discriminated against" in the United States of America. It doesn't fly when the deck is stacked so far on the other side.

The *new* fourth branch is a way to keep people like that "clean." If it wasn't for Global Exchange going after Nike's sweatshop practices so hard, even the incremental progress Nike *had* to do, to try and save their public image, never would have happened. So now, the buzzword in the papers (including those *New York Times* articles on Kevin Mitnick, etc): "This isn't mere monkey-wrenching or vandalism, it's *terrorism.*" Terrorism? On a par with blowing up all those people in Oklahoma City, or Palestine, or Israel, or Northern Ireland or whatever—this is the same thing as 'terrorism'? I don't think so. The little arms of our corporate government hack into our personal lives and terrorize innocent people every day.

The World Bank and the International Monetary Fund (IMF) loan money to little countries to build giant dams and oil pipelines so that Bechtel (among others) can get rich, in the meantime just totally screwing up the people in the area and taking away their meager welfare system—now *that's* terrorism! Our embargo against

the Iraqi people didn't hurt Saddam Hussein at all, but is now estimated to have killed two million—many of them children—*that* is certainly terrorism! The way we treat Cuba is certainly terrorism! Gentrification and bulldozing out low income people and people who've rented their places for thirty years so some slime-mold Yuppie can move in—*that's* terrorism!

The drug war is certainly *terrorism!* There are many instances the corporate media are never gonna tell you about: when SWAT teams crash into the wrong house and then kill somebody, on suspicion of growing marijuana: "Well, he sat up in bed, so we just had to blow him to pieces in front of his family!" This happened in New Hampshire; it happened to a blind rancher outside of Malibu, California.

How many of you know about what the D.E.A. just got caught doing? People trying to get information, positive or negative, about certain illegal drugs like marijuana, will have an anti-drug ad appear at the top of the search engine, leading people to government anti-drug websites. A "cookie" gets planted on your hard drive so they can keep track of every single person curious about drugs, and lay their little fascist Orwellian claws on 'em. With this level of corporate dictatorship slowly being eased in so we don't even realize that a *coup* has been going on, fighting back and resisting isn't just a helluva lot of fun, it's our *patriotic duty!*

Our hijacked, unconstitutional government of the people, by corporations, for corporations, must be overthrown!

I've always had a soft spot in my heart for "creative crime." In a way, crime is the last unspoiled art form left on earth. You don't go to art school or the fashion institute to learn how to do creative crime, people just crawl out of the woodwork and do it. And the cyber-revolution has ushered in new frontiers of sabotage on the job! My personal dream of dreams would be that some patriotic citizen could find a way to go into the Defense Department, D.E.A. and F.B.I. etc's computers and erase everything they know!

I heard about a prank at a factory in Savannah Georgia, with 1,500 employees. First thing in the morning, this came up on everybody's computer screen: "Half the work force will be laid off at the end of today." And people stopped working all day just to talk about this!

Some of this is as easy to do as putting little post-its on key pieces of equipment saying "Out of Order." I've heard of calling "emergency" supervisors meetings so they all show up and meet and nobody can figure out why they're there! A friend named Johnny Risk, who played in a band called Angst, came up with the concept of "Johnny Potseed," where you fight the drug war by planting marijuana seeds in city parks and lawns so there's so much weed growing they can never get rid of it all, let alone throw everybody in a privately-owned prison on drug charges.

What if *everybody* floods their email with words Tipper Gore doesn't like, so that government surveillance programs looking for "key words" are rendered useless? Of course, the corporate world order is fighting back, labeling actions like this not vandalism but "terrorism." If cyber-sabotage is truly "terrorism," on a par with blowing up innocent people, then maybe our government has finally admitted that they define terrorism not as threatening or injuring someone's *life,* but someone's *wealth or property.*

And we're already going through a rather extreme expansion of the definition of "property rights." The so-called "Wise Use" movement led by logging companies and mining companies say, "Well, you passed a new environmental law where we can't pollute or strip-mine as much, so you automatically have to pay us for the money we're gonna lose, or it's a 'property-taking'!" The *air,* less polluted, is a 'property-taking'?!

But the beauty of the dawn of the computer age is, for every obstacle put in place to thwart free speech, and squash non-corporate commerce and Hacktivism on the Net, everything they come up with, some bored teenager somewhere, of whatever age, is gonna find a way to thwart them, every time! As R.U. Sirius put it, "It is impossible to control non-physical property, when it can be easily and nearly infinitely, copied."

Back to Hacktivism: there's an online entity called "Buster" who defines it this way: *using the Net to blend activism and technology in a positive way.* Is flooding the W.T.O. or Nike or Ernesto Zedillo's website an act of terrorism, or a show of growing solidarity and unrest among the people against *their* terrorism? This is a time filled with efforts to impose greater and greater restrictions on freedom, and not just freedom of speech. It's so simple and so important just to participate resisting this: *Doing something is better than doing nothing.* Wouldn't you rather help *make* history than watch it on TV, or, excuse me, gossip about it on the Net? Thanks for listening! ♦♦♦

AL JOURGENSEN

made his name originally in dance music and helped to define the Chicago Wax Trax sound. When Sire signed him, they gave him any producer he wanted, so he chose Adrian Sherwood to learn his studio skills. Then he put big guitars back into dance music and slowly evolved it into a Wall of Sound dance floor production, but with metal, hypnotic rock and funk. Ministry is Al's main band; Revolting Cocks is his party band. He has recorded Palehead with Ian MacKaye, Lard with Jello Biafra, and Acid Horse with Cabaret Voltaire. Interview by V. Vale and Jello Biafra, partly at the Fillmore Auditorium.

♦ **VALE:** *This project is called* Pranks, *and it has to do with resisting authority and authoritarianism. Sometimes you have to do a put-on or an impersonation or a bit of theater—*

♦ **AL JOURGENSEN:** I've definitely had my share of run-ins with major labels over the years—

♦ **V:** *That's what we want to hear: a story about how you did a creative or imaginative response—*

♦ **AJ:** Well, let's hope that's how it's viewed! One can only hope. Some of the stuff has been pretty well documented, like blowing up a tour bus—that was a $63,000 prank right there.

♦ **V:** *Ohmigod—you blew up a tour bus?*

♦ **AJ:** Well, it was accidental, but afterwards we just thought it looked so cool that we actually took credit for it.

♦ **V:** *Give us some context. First of all, you're in a band and apparently you have a major label contract and a tour, I assume—*

♦ **AJ:** Right. This was on the second Lollapalooza tour. The Red Hot Chili Peppers were the first band and we were the second—

♦ **V:** *This was in 1992?*

♦ **AJ:** '93. And so, along our travels, in some truck stop somewhere in Tennessee where all the buses and trucks were refueling, this toothless old man sees me in the parking lot of the Petra gas station—I won't forget this place anytime soon—but anyway, it was near the Fourth of July, so he was like, "Hey boy, you want to buy some fireworks?" And I'm like, "Yeah, sure, it sounds interesting. What do you have?" I'm figuring he had Black Cats or M-80s or something which we had on the bus anyway, because we used to wake up Trent Reznor in the bunk every morning by throwing Black Cats and M-80s in there . . . so we were already well-versed in the "Art of Pyro" on the tour bus.

This guy took me behind the truck stop, and came out with what looked like a fuckin'

bazooka! I mean this thing was six feet long. It had a long tube with some kind of "pack" on the top—it looked like a bazooka, with a long string and a coil on the end of it. He wanted a hundred bucks for it. I asked, "Well, what does it do?" And he said, "Well, it's supposed to make a galleon in the sky." Apparently this is one of those fireworks that creates a pirate ship in the night sky! You know, you're a mile offshore in a boat when you shoot off these things. And I was like, "Cool! Yeah, I'll take it." I figured we'd shoot it offstage or something.

We got on the bus, and I put it in one of the junk bunks that nobody was using, and just kind of forgot about it. After the Houston show, we hooked up with an old friend of ours, Gibby Haynes from the Butthole Surfers, and he decided he'd come along for a few shows just to hang out—me and Gibby are good friends.

So he came on the Ministry bus, and discovered our M-80s and Black Cats, and says, "Man, let's light some of these off!" And for some reason—because I hadn't seen Gibby in while, it became a kind of a "male testosterone pissing party." I went, "Ah—that's *nothing!* I got something else that'll . . . let me *show* you!" I remembered I had this thing in the bunk, so I thought maybe I'd light the fuse in the back lounge of the bus, point it at someone or other, and then put it out. I thought it would freak everyone out.

Well, I lit the fuse, and I didn't know it was an underwater fuse—you can't put the thing out. Once it's lit, it's *lit*—you have to cut it in front of it, and nobody had scissors! This thing was going off in a very closed environment, no matter what we did. So basically I did what any other brave soul would do: I immediately handed it to someone else, "YOU TAKE IT!" "NO—YOU TAKE IT!" "NO, YOU TAKE IT!" And it went around the room about four times while the wick got

shorter and shorter . . .

Finally, this guy from Alternative Tentacles Records, Greg Werckman, got stuck with it, while everyone else bailed and jumped into either a bunk, hid under something or covered themselves with pillows and blankets. Poor Greg squatted down and literally shot it toward the front of the bus. He was on one knee holding it like a bazooka, and this huge explosion goes off, which knocks him back about three or four feet—and this is while we are going down the road. So we are on the highway, the music's blaring pretty loud and you can't really hear what the hell's going on; you can't hear all of the screaming—but you *did* hear the explosion, and believe me—that was *loud!*

Here's the way the bus is set up: there's the driver in front, then a front lounge, then the entire bunk area, then there's a back lounge. We were in the back lounge, and there's a door that goes between the bunk area and the front lounge. Well, after the explosion, all you heard was this *ping ping ping ping ping ping ping ping* . . . it was the pellets that were supposed to make the mast and sail and everything else in different colors just pinging off doors and landing on bunks, and catching the entire bus on colored fire! It was like the scene in *Apocalypse Now* with the character "tripping" with the smoke—it was multi-colored smoke that filled the entire bus.

So the bus driver screeches on the brakes and pulls over, and immediately orders us off the bus: "I'm calling the po-lice on all of you! I can't believe what you did to my bus!" And the whole bus is on fire—we're trying to put out the bunk fires, but there's all this beautiful colored smoke—purple, green, orange, red—just *pouring* out of the vents and windows on the bus, as it's pulled over on the side of the road. The driver yells, "Get everything off of the bus! Get everything off! You guys are off the bus!" So we did what any respectable rock band would do: we took the keg of beer off the bus and that was it! We left everything else inside.

So there we sat on the side of the road, drinking beer out of the keg, waiting for the police to come—figuring we'd get one little last drunk on before we would have to sit in jail. Finally the police show up, and it's like something out of *Smokey and the Bandit* or "The Dukes of Hazzard." This little portly guy—a Texas state trooper chewing tobacco—I mean, he was such a cartoonish, caricaturish stereotype that it was almost unbelievable . . . he and his partner, who was a younger guy. So the portly fat guy comes up, spits his chaw, looks up at the bus pouring out orange, green and purple smoke, and looks at the driver, who is literally jumping up and down screaming, "I want these boys in jail! They ruined my bus! I want these boys in jail!" And the *Smokey and the Bandit*-looking cop looks at the bus driver and says, "Man, get these boys back on your bus after the smoke clears, and get 'em offa *my* highway!" Then he adds, "This here's rock-'n'roll! What didja think it was—*Mozart?*" And he left the bus driver there and took off! We had to wait three hours for all the colored smoke to clear out of the bus. It was quite an amazing scene—and the cop let us finish the keg on the side of the highway while we were waiting.

♦ **V:** *That's an amazingly down-to-earth policeman you encountered.*

♦ **AJ:** Yeah, to me it was almost like an apparition—especially in the state of Texas!

♦ **V:** *That toothless old man behind the gas station also seems like an apparition—*

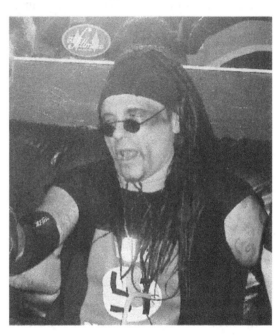

♦ **AJ:** Yes, that was very surreal as well. I mean, it was a scene out of *Pumpkinhead* or *Hellraiser*—like, "Hey boy, come here—you wanna buy something cool?" The whole situation was surreal!

♦ **V:** *That's great that you can have an adventure like that on the road in America—*

♦ **AJ:** I just can't believe nobody died during that. Outside of possibly the birth of my daughter—being in the room and seeing her come out—this was the second coolest thing I'd seen in my life!

♦ **V:** *You know, if you ever come to San Francisco, please be on our TV show. It's called the "CounterCulture Hour"—*

♦ **AJ:** Oh, we'll be there in the summer. Jello Biafra and I have worked with each other for

twenty years, and he's on both of my new albums that are coming out—I have a Revolting Cocks album and a Ministry coming out at the same time, and actually one band is opening for the other, so I'm doing double shifts!

♦ **V:** *Oh, that's smart. I hope that saves a little money on the tour.*

♦ **AJ:** Well, yes and no. Jello's doing the whole West Coast tour with us. He does this every pilgrimage we go out on. Jello does about ten shows with us—we have a band together called Lard as well. I've known him for going on twenty-one years. We do Christmases together—we're about as close of "rock" friends as you can get!

♦ **V:** *Great. I was talking to someone just today about how there aren't enough role models for "keeping your edge until you die at age eighty"*—

♦ **AJ:** Oh—I have to send the new Ministry album to you immediately! It's probably the most political and anti-war statement of any band at any time since the '60s, and it's really angry industrial thrash metal, very intelligently put together and very political—every single song. So there's fifty-one minutes of absolute rebelliousness. If that's what you want, then this is the perfect band for you!

♦ **V:** *Great . . . I'm sure there's a kind of conspiracy to make all so-called "counterculture types" out to be sort of crazy and taking drugs and being unstable and dying young—like James Dean.*

♦ **AJ:** Of course—shit, they even do that with mainstream Democrats!

♦ **V:** *Yes, but there's got to be more: you can be counterculture* and *you can actually raise a child—that sort of thing.*

♦ **AJ:** Raise a child—and have a consciousness!

♦ **V:** *Yeah, and sometimes the two go hand-in-hand! I've learned so much from having my kid, and I never planned on having a kid—it was just sort of a miracle that it happened.*

♦ **AJ:** When I was raising my kid, I probably learned a helluva lot more from her than she learned from me . . . The cover art on our new album will definitely get us audited by the IRS—Ministry has a habit of railing about Bush—

♦ **V:** *Well, at least someone has the guts to*—

♦ **AJ:** —and his father too. I mean, we've been doing anti-Bush songs for twenty years, and one of them went platinum! So that says something.

♦ **V:** *Which one was that?*

♦ **AJ:** That was called "Psalm 69," and that was during the first Gulf War while we were railing about his dad. We also had a song called "New World Order" that did quite well. And this new album is called "Rio Grande Blood."

♦ **V:** *John Wayne was in the Howard Hawks film,* Rio Grande. *You know, someone should make a movie of the story you just told me.*

♦ **AJ:** Let me give you one more story about my dealings with Warner Brothers, which I was on for twelve or thirteen years—

♦ **V:** *That's a major label*—

♦ **AJ:** Yeah, we had a couple gold albums and a platinum album with them and this and that. It was great when we were selling a lot of records—they pretty much put up with a lot of my shit. The second we stopped selling, it was *Revenge of the Nerds* time! I mean, they couldn't *wait* for me to stop selling, so they could finally get back at me for some of the stunts I pulled there.

Now, this story took place on another Lollapalooza tour where we were going to cancel at the last minute. We're not a "picnic/daytime" kind of band. We weren't as big as some of the other bands like the Chili Peppers or Ice Cube or Soundgarden or Pearl Jam—the bands that went on at night-time. But we have a lot of political visuals behind us on three big screens—things like that—and the audience wouldn't be able to see them during the daytime, so we were "respectfully declining."

The record company said, "Okay, we'll tell you what: all the rest of the bands want you on this tour, basically for credibility or something. So we'll let you have the next-to-headliner slot, when the lights first come on. That's the best slot to have at a festival. But you'll have to remain at the same pay as if you were a daytime opener." That was fine about the money, but there's also a point when you need some help from the label—it's the general practice of a label to give tour support.

At this point I'd already done about twenty-five other things to piss them off, to the point where at the last minute—after we had confirmed everything, hired our crew, put retainers down, got the sound and visual projection system that we needed, all the equipment, the buses (which eventually we blew up) . . . so at the last minute they decided to pull their tour support.

♦ **V:** *They probably promised that orally, but not in writing*—

♦ **AJ:** Exactly! Normally *nobody* pulls tour support; if you say you're going to do it, you do it. It's such a common practice. But I'm sure they had a little agenda in mind on "sticking it back to me," because I'd done a lot of things to Warner Brothers and they were none too pleased with me. At any rate, they pulled the tour support, and we really couldn't cancel—we were between a rock and a hard place.

I decided I had to take drastic action. The plan I came up with was to basically masturbate into a

Ziplock bag and Federal Express it to the Vice President of Sire Records (which we were on) with a ransom letter cut out from newspapers and magazines, stating that, "If you don't reinstate our tour support, you will receive a different bodily function from either myself or a member of the band or crew every day for the rest of this tour, as we're losing money. So expect a lot of bodily functions!"

I ejaculated into the bag and sent it to Howie Klein, Vice President of Sire Records, and waited for a response. Well, the next day I get this kind of really confused call: "What the hell is *this?*" I was like, "Well, what do you *think* it is, Howie?" He said, "Well, I don't know, but it smells really bad." I started laughing: "Howie, that's a bag of cum I just sent you! I'm pretty pissed off! And you're going to get a lot more than cum in the next few weeks!" As soon as I told him it was cum, I hear this coughing and gagging on the phone, and he gets back on the phone about fifteen seconds later and goes, "You asshole, I *tasted* that, too!" Needless to say, we got our tour support back the next day, so that worked.

♦ *V: Well, you didn't just come up with words; you came up with a powerful surrealist image—*

♦ **AJ:** Yeah, if we're going to be out there sweating blood and losing money so "The Man" can make money, then *he's* going to get some of our bodily fluids too, along with it!

♦ *V: It's so funny that he tasted it. Well, those definitely qualify as pranks! Do you want to tell me about anything else?*

♦ **AJ:** You know, if you see Jello, ask him about me as well—he knows a few stories. I'll give you one more. And this was again with Warner Brothers—and all of these are well documented; there's no tomfoolery or Oprah Book Club *Million Little Pieces* B.S. about this—this really happened. This all is the real deal!

At any rate, when it came time to make a video, we always had a habit of taking on first-time video-makers. Whether the band be Revolting Cocks or Ministry or whatever, we would always get someone who was young and hungry and had good ideas, and who wasn't part of the Old Boy Network that's out there—

♦ *V: Good idea—*

♦ **AJ:** —so every one of our videos has been done by a first-timer. For the Revolting Cocks, we did a cover of "Do You Think I'm Sexy?" by Rod

Stewart, and we made it as sordid and prurient as we could.

We had this idea for a video, and I found this lunatic in Hollywood who did all the special effects for the Clive Barker movies—you know, the "Horror King"? This guy's name was Tom, and he sent me this beautiful script about how the video should be shot. It was literally a week-long shoot.

Now usually with a music video, the band shows up for two hours and then leaves, and the video-maker does all the rest. But this guy had a week's worth of activities planned, with all these different shots. And his brother is another lunatic who lives down the road from Waco by the Branch Davidian-David Koresh Ranch. He has his own survivalist camp, and is certain that the end of the world is coming, and has collected all this old military gear—everything from P-15 Mustangs to half-tracks with fifty-caliber machine guns, and you name it—Huey Helicopters from Vietnam—

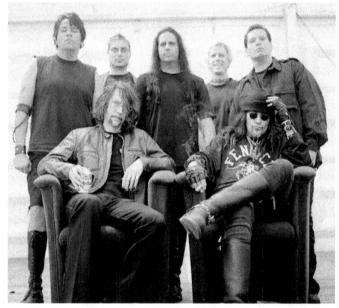

he's got it *all* in this giant airplane hangar that we were going to film at.

So I'm liking this idea more and more, the more I hear about it—and by the way, when we filmed it, the Waco siege was going on a mile away; we would get done with filming and go down there and hang out with the FBI agents and watch all the shit go down! So that was amazingly good timing on our part. At any rate, I bring this concept to Warner Brothers—and if we're going to do a week's worth of shooting, it was going to cost about thirty-five thousand dollars. Now, thirty-five thousand dollars to do a video is

like Madonna's catering budget!

♦ **V:** *To an outsider it seems like a lot of money—*

♦ **AJ:** Not for a week's worth of shooting, counting all film costs and everything included—Madonna spends that much on Krispy Kremes on the set for her dancers! So we didn't think we were asking for a lot, but this guy drew a line in the sand and wanted to make a point. His name was John B—, he was the President of Warner Video, and he was giving me of these, "Now look, kid; you don't know what you're doing" looks, cigar in his hand. He's telling me, "*Nobody* gets to choose their own directors! We've let you do that twice, but that's it; no more. Not even *Paul McCartney* gets away with that! Now I've got this great guy I want you to talk to . . ." And we're like, "Fuck you, man! This is the concept, this is the video—take it or leave it."

He goes, "I don't know what other kind of shit this guy's done!" And I'm like, "Well, he's done this, and that." He goes, "Well, I don't know . . . Just have him send me something showing me the shit he's done!" So I went back to Tom with the *exact quote:* "Tom, he needs to see the shit you've done." Well, Tom's a lunatic. So Tom immediately takes a picture of himself taking a shit, with his seventy-year-old black family maid that helped raise him handing him the toilet paper, and made it into a T-shirt saying, "This is the shit I've done." Then he proceeded to take about fifteen pictures of the actual turds in the toilet themselves—blew one picture of a turd up into a poster that said, "Revolting Cocks: Do You Think I'm Sexy?" and sent it in as his resume to the Warner video department.

By the way, they kicked us off the label about two years after all of these shenanigans, but we got our way because I think it just reached the critical-mass point of, like, "I know this is just the tip of the iceberg . . . and what *else* are these fuckers going to do to me if I don't?!" So the word spread around the corporation, and it was pretty much, "Basically, if anyone from the Ministry camp calls, be out to lunch or be on vacation, but if they do get hold of you, just give in to their demands because it's not worth the fallout!"

♦ **V:** *That shows/proves the power of imagery—much stronger than words alone. Very smart.*

♦ **AJ:** Thank you; turds in the toilet says it all! And there's nothing like a bag of cum on Valentine's Day! [end] I've gotta go now, but get Biafra to tell you more of the pranks I've done . . .

[joined by Jello Biafra backstage at The Fillmore Auditorium, May 26, 2006]

♦ **JELLO BIAFRA:** You must tell us about the Steven Spielberg prank—

♦ **AL JOURGENSEN:** Ministry was in Spielberg's *Artificial Intelligence* movie. He had never worked with a rock band before and he was really freaked out. We were there for two days and he wouldn't even come near us.

♦ **VALE:** *I think it was because of the way the band looks—*

♦ **AJ:** Finally, Spielberg's handlers set up a meeting. We had to line up, all of us in a row single-file, like we were meeting the fuckin' Queen! Spielberg came down greeting everyone and shaking hands, "Good to have you here . . ." They put me down at the end of the line, like they were hoping I might give up and walk away or something. Finally he gets down to me and I snarl [nasal voice], "*Hey!* Steven, David, *look!* The band's gotta quit. We can't *do* this film. All of us are walkin' out right now!" He's like [gasps], "*What?!* Why?" And all his handlers are scribbling down notes an' shit ...

I said, "We were told *A.I.* was a porno film that stood for "Anal Intruder," and what is all *this* shit? We were told it was a *porno* film, and *fuck you!*" (In the film, there were a bunch of teddy bears runnin' around; like, what is this crap?) And they all went *running* . . . Spielberg immediately grabbed his heart and *ran,* with all his other people—

♦ **JB:** He was looking for somebody to yell at and fire, right?

♦ **AJ:** So when he ran off, I had to go after him and I was in my full dress costume where I had on all my metal; I couldn't even run. I yelled, "Hey, I was *just kidding!*" [laughs] So every day after that, at the beginning of the day Spielberg would come up to me with a new "porno" title for *A.I.,* like: "Ass Intruder," "Animal Instinct" . . . And then he started wearing my hat and jamming with us onstage. So we ended up getting along great!

♦ **JB:** You gotta tell the Seymour Stein prank; it's one of my favorites—

♦ **AJ:** Seymour Stein was the head of Sire Records. He gave Ministry a lot of money to make a recording, and then we didn't do anything for awhile. Finally he wanted to hear something—

♦ **JB:** Al was working with Adrian Sherwood at Southern Studios, trying to absorb Adrian's studio skills and applying them—

♦ **AJ:** Somebody called and said, "Seymour's on his way. He wants to hear something." He had just gone to rural English rehab for cocaine addiction, and had gotten out and headed straight to our studio. We were like, *"Fuck!"* Adrian and I

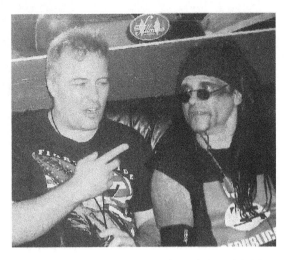

turned to each other and said, "Are you thinking what I'm thinking?"

So we put up a big Nazi flag outside the studio, just hanging there—like hanging an American flag in your front yard. So when Seymour got out of his car, he knew he was in hostile territory. He walks through that and comes in.

Now me and Adrian and had been up for three days snorting straight speed—Wilko Johnson used to make us our speed, and that's why they call him "Dr Feelgood." We knew that Seymour *might* show up, so we had recorded a special tape for him of us thumping the microphone with our thumbs, me yelling into it and mixing in all this metal machine feedback—the whole deal—and twelve minutes of that. The whole thing had been sampled into a Fairlight synthesizer—that's what saved us—and we had quickly made a crude mix recording.

Seymour had been expecting a commercial dance music recording. So we turned on the amp and went, "Here, Seymour—*bam bam bam bam!*" [while Al does a series of hoarse screeches]. Adrian went [British accent], "This is a major trend in the clubs, y'know!" Adrian was so high that for some reason he thought Seymour's name was "Marshall." So when Seymour went into the "speed bathroom," Adrian was following him, shouting [U.K. accent], "Marshall. Marshall. I need to get paid in cash, now. This is the new single!" Seymour went right back to rehab and didn't come out for three months. He never spoke to me again . . . That became Howie's job.

♦ **JB:** Didn't you once aim a bazooka at a Warners executive's car in the parking lot while he was standing at the window, watching? What prompted you to do this? What was his name?

♦ **AJ:** [laughs] John Bugue.

Nakano, a big video director from Japan, wanted to do our "Cracking Up" video. He had turned down Madonna, he had turned down a bunch of people; he said, "No. I only want to work with Ministry." The day we were supposed to start filming, Warner Video cut off our funding (this was after Nakano had flown all the way over here). They were mad because he wouldn't do Madonna. So I bought a bazooka off a friend of mine, aimed it at the head of Warner Video's car in the parking lot, and then security suddenly appeared and took away my bazooka. I was mad, so I went up and took a shit on John Bugue's desk—the head of Warner Video. Well, the next day we got our budget back!

♦ **JB:** The reason "rock star" behavior has turned into what it is, is because major labels deserve it. Their attitude is, "Once you sign on the dotted line with them, you cease to be an 'artist' and from that point on, you are their *employee.* You are employed for them to strip-mine your talent so they can sell it to mall kids (and others) and forget to pay you when the time comes—

♦ **AJ:** And they forget that we can make their life a living hell! I know I have.

♦ **JB:** Didn't you once go up to Barry Manilow and ask him if it was true that he had a latex butt?

♦ **AJ:** Hmm . . . Well, beating off into a Ziplock bag got us our tour support back. The bazooka and shitting on the desk got us our video budget restored the next day. So terrorist tactics rule! You just have to make sure that you can shit on cue, you can buy explosives, and you can beat off whenever you want . . .

♦ **V:** *Tonight you mentioned something about Olivia Newton-John—*

♦ **JB:** She sued Al because he did a cover version of "Let's Get Physical" and sampled her voice—

♦ **AJ:** She sued me, so I bought a "Map of the Stars," went out to her house in Malibu to try and talk to her about it, and she wouldn't come to the door. So I said, "Fuck you!" and peed all over her mail in her mailbox, pissed over everything, and tried to get in a fight with her butler that she sent out. The people I was with all got together and dragged me back into the car: *"We gotta go!"*

♦ **JB:** Well, that's one way to settle a lawsuit!

♦ **AJ:** We never heard a word from her again.

♦ **JB:** I just wish I could have locked you and my ex-band members into a room and settled it that way . . . Do you have any good Il Duce [Mentors' 250-pound lead singer] pranks?

♦ **AJ:** I don't know about his phone pranks, but I know what we did to him. [The Mentors and Revolting Cocks did a tour together.] Il Duce opened for us. Afterward, back in the hotel, we were partying, snorting coke, and suddenly he passes out mid-sentence [demonstrates]. So I got some women to donate some clothes and make-

up and we stripped him down, put fishnet hose on him, a bra, smeared a bunch of lipstick on his mouth, and then rolled him out and dumped him by the Pepsi machine next to the elevator—all dolled up.

We went back to partying. About two hours later we hear this *commotion,* like all hell's breaking loose! We go, "Oh shit," open the door, and there's two Filipino maids—one of 'em's hitting him with a broom while the other is spraying him with a can of aerosol spray! He's wearing fishnets and a bra and yelling at them, trying to get up off the floor. We're laughing like mad. But the best line I ever heard in my life came from Il Duce while he's fending off the broom: "What the *hell* are you hittin' *ME* for? I look pretty good today!" [laughs]

♦ **JB:** Somebody told me about a time when he called up a big department store which had a big Xerox machine out in the open. He claimed he was from the company and was checking up to see how the machine was working. He said, "You have to put a paper clip here, and you've got to put *this* over here," etc. Then the person on the other end yelled, "Ohmigod, the machine's *smoking;* it's on fire!" Il Duce goes, "Ha ha ha ha!" and puts the phone down.

Now for the *Pranks* project, should we open the door to Reed stories? Reed was the world's most magnificently incompetent studio owner. He was constantly doing weird things to cut corners and save money, that would blow up in his face every single time. So at its peak, with him and Al as ringmaster at the other end, working at Chicago Trax was like walking into the middle of a Marx Brothers movie. I didn't believe any of Al's stories were true until I started seeing it happen.

Negativeland put out a CD where the title of the CD was stickered on the front cover in dayglo orange with points coming out, just like a grocery store markdown label, and the title of the album was *FREE.* So all these people began walking out with them, thus freaking out the stores. Negativland has become more and more intense as time has gone by. They put out a single titled *U2.* U2 wasn't even on it, but they put the title really big on the front cover and used samples of this commercial disc jockey, Casey Kasem, caught unaware the microphone was on, completely attacking U2. So they got a sample of that, put some music to it, and put it out as a single, and U2 sued them, as well as SST Records, who released it. Then SST in turn sued Negativland, claiming that Negativland's contract indemnifies them from lawsuits, so they should have to pay off U2, and it turned into such a big legal circus that Negativland put out an entire book about the whole affair, *The Letter U and the Numeral 2.* Your *Pranks* book has to have Negativland in it.

Another person who has to be in your *Pranks* book is Nardwuar the Human Serviette. Long before there was Ali G . . . It's done by a comedian named Sasha something-or-other Cohen, and he becomes this character named Ali G who's this supposedly-hip London hip hop talk show host, but the character he plays is absolutely clueless about who he's interviewing, and asks the interviewee just completely annoying questions.

Among his victims are James Baker, Newt Gingrich, Ralph Nader—somehow or other these people get booked on his show, not knowing who he is. And it's fun to watch them all squirm and get really annoyed. Ralph caught on after awhile and went with the flow.

But long before there was Ali G, there was Nardwuar the Human Serviette, based out of Vancouver, Canada. And unlike Ali G, he didn't have a budget or a name, so he didn't have his own show, he'd just barge into press conferences with celebrities, politicians; accost musicians either before or after they played, and ask them the most annoying, stupid question he could think of with his super-nasal voice. And among his victims was Mikhail Gorbachev: "So of all the world leaders you've met, who wears the biggest pants?" holding out a mic to see what the flustered Gorbachev would do. It's like being "Nardwuared"—he's so skilled at this now.

Dan Quayle was doing a book signing in Vancouver—I wonder how many words of the book he actually wrote, let alone read. And Nardwuar barged in, asking, "So, Vice President Quayle, who's the Prime Minister of Canada?" Quayle doesn't know and starts trying to dodge the question. "No, that's *not* what I asked you—*who's the Prime Minister of Canada?*" And Quayle was at the end of his term as Vice-President of the United States, a heartbeat away from the Presidency. And it was the same Prime Minister who had been in office the whole time he had been Vice-President, and he didn't know who the fuck it was!

Yet he's still probably smarter than George W. Bush, and even serves (if that's the word) on the Pentagon Advisory Council with people like Richard Perl and Newt Gingrich who "advise" the Bush administration on how to run the war on Iraq. Doesn't it make you feel safer from nuclear holocaust and the real terrorists, that our President is actually accepting advice from Dan Quayle?! ♦♦♦

was in the L.A. Cacophony Society, went on the road with Chicken John on a "Punk Rock Circus" tour, and makes custom-bicycles. He is a founder of Cyclecide Bike Rodeo, and plays in the band Los Baños.

♦ **VALE:** *Unfortunately, a very important part of doing a prank is knowing in advance how to deal with the police, so as to maximize your chances of not being arrested.*

♦ **JARICO REESCE:** I live by the SubGenius motto, "Act like a dumb shit and they'll treat you like an equal." It's never a good idea to act smart in front of the authorities. Just don't talk too much, and never volunteer any information.

I used to work at Ace Auto junkyard in San Francisco. All kinds of artists would come in looking for weird things to make art with: everyone from SRL to People Hater to Kal Spelletich and the Seemen. The owner, Billy, would be generous enough to let them go through everything. Usually they would trade some beer or White Russians or something and they could then take whatever they wanted.

But there aren't a lot of junkyards like Ace anymore. It was really disorganized. We worked Monday through Saturday; scrapping out cars, computers—anything metal. In the trunks of the cars we found everything from blow-up dolls, old magazines and newspapers, to a dead dog—that was terrible. We once found two vending machines that had 350 dollars in coins. One time a woman brought in an old car and then just started crying over it.

♦ *V: Well, you're like car morticians!*

♦ **JR:** Pretty much. You take the tires off, drain the transmission fluid and oil, take the starter and the alternator off, drop the fuel tank and take out the radio. Then we cable, like, nine cars down onto a flat-bed truck and take them to Oakland where there's a big shredder that shreds 'em.

At the end, there's a big magnet that separates the metal from the plastic, and then it gets baled in a baler machine, put into these forty-foot containers and sent off to China. And then a couple of years later it comes back as a toaster, or rebar—the brittle, flexible metal that's used for concrete forms. That's kinda how you can look at your life: everything you own is pretty much going to end up in a forty-foot container, recycled, or in land-fill.

♦ *V: Tell us about your earlier pranks—*

♦ **JR:** I grew up in Minneapolis and L.A. When I was twelve years old, I had this amplifier and one midnight I made an announcement that everyone had to evacuate their house NOW, and for some reason everyone believed me. I got in big trouble for that! I remember pranking my teachers a lot, and stretching shrink wrap on toilets so people would pee on themselves. In shop class I threw some ketchup packets into a band saw and people started screaming cuz they thought someone had had their finger cut off! In high school I would put up flyers to fake music shows— that was fun.

Then, when I was about nineteen, at Mondo Video in L.A. I came upon the L.A. Cacophony Society newsletter called *The Zone,* which Reverend Al used to put out. One of the first events I participated in was *Drunken Doctors.* We all cut our hair, dressed in thrift store suits, and went to Ye Olde Rustic Inn, near a hospital where doctors went. I'd never been treated so respectfully in my life! Then our conversations started going like, "Geez, I've got surgery in twenty minutes—I better get another drink!" It got to the point where people were becoming appalled and horrified. Finally, the management realized we weren't *real* doctors and they told us to get out. Reverend Al headed for the door and then executed a perfect fake fall, and we rushed to his aid, screaming, "Let's go back to the hospital!" They didn't know what hit them . . .

L.A. Cacophony did sidewalk events wearing clown costumes. Sometimes we would stage fake accident scenes on the street, and make chalk outlines that looked like a clown had been run over. I made this one outline of a clown and put a bunch of bullet casings around it.

We visited the Church of Scientology and asked how their religion relates to *Star Trek.* We dressed as clowns and invaded the Magic Castle, a very posh place where David Copperfield-type magicians went. We started hitting each other on the heads with balloons, and they called the police. The police made us line up against a wall, and one cop yelled through his megaphone, "Put the balloon animals down!" Then they started wondering what they were getting into, so they let us go.

I participated in the *Bandage Boy at Chuck E. Cheese* prank, where Rev. Al dressed up as a burn victim. I brought a piñata filled with uncooked

Jarico Reesce Photo: Marian Wallace

pinto beans, and when it broke, kids started diving for them and putting the pinto beans in their mouths, then spitting them out. Parents were horrified. Most of the families just left.

Then I moved to San Francisco and hosted a Cacophony event called the *Frank Sinatra Burial at Sands*. We built this little Viking ship, made an effigy of Frank Sinatra holding a cigarette and a cocktail, and took it out to the Hunters Point Railroad Museum.

♦ **V:** *I didn't know that museum existed.*

♦ **JR:** It's in the shipyard, open from Tuesday through Saturday. We staged a fake séance where Hal Robins tried to summon Frank Sinatra's spirit. Mr. Lucky did a Frank Sinatra impersonation, singing "I Did It My Way," then we launched the boat out into the bay, setting it on fire. We were all wearing nice suits, and some of them got kinda wrecked as we pushed the boat out in the water.

We also did a Viking Ship burial for Hunter S. Thompson when he died. I made an effigy of him with a gun pointed at his head. We set it on fire and launched it into the Bay, but this time it headed toward a local power plant! Fortunately, it fizzled out just before it got there.

In San Francisco, I've also done fake flyers and "Lost" posters. I made one that said: "Lost contact lens / Please help me / I can only see out of one eye." I found a really weird name in the phone book and listed his phone number, then distributed flyers all over town. I also did a flyer for a "Lost Bic Lighter," offering a ten-dollar reward.

I used to make fake newspapers and put them in newspaper boxes. Once I made a picture of George Bush with a Santa Claus hat riding on a missile, like in *Doctor Strangelove*. The headline said, "Bush Promises Seven New Missiles by Christmas." Using all this military terminology, I wrote a fake article about how we were expected to shoot missiles to various countries with payloads of Christmas gifts, and that governments had been warned not to shoot their missiles in retaliation, because these are just Christmas gifts.

I was also part of the *Circus Redickuless*. This was a Punk Rock Circus started in 1995 by Chicken John. For five years we toured all over the country in a bus. It was a parody of a circus sideshow; our "Man-Eating Chicken" was just someone on stage eating chicken. "The Vegan Geek" would be biting the head off a lettuce. The "magician" (me) *pretended* to be a great magician, but couldn't do any tricks (Chicken had this dog that actually *could* do a few tricks).

One person, David Apocalypse, was genuinely talented; he did the "Pinhead" and "Human Blockhead" and straitjacket act. And we had

"Speed Metal Tap-Dancing" where tap dancers would try to keep up with this insanely fast music. It was all sort of ridiculous.

The whole idea was that you could take a bunch of idiots on the road without any talent whatsoever! I think we succeeded in "lowering the standards," so to speak. And that in itself was kind of a prank, because what people were expecting was *Cirque du Soleil* or the *Jim Rose Circus Sideshow*. Sometimes club owners would refuse to pay us: "This isn't entertainment!" But our message was: "You can have your *own* circus! To be a real freak you don't necessarily have to be a real mutant." We billed ourselves as "The Worst Show on Earth"!

Probably our best prank happened in Austin. We'd been on the road for about four days and the bus was just a mess—it was stinky, nobody had washed anything, and this was our first stop. David Apocalypse and I called the news stations and said, "We stopped at this park, and two of our monkeys escaped! They're wearing red fezs and vests, and their names are Helter and Skelter." So a news van came out and watched us calling up into the trees, "Helter! Skelter!"

I was playing the role of the disgruntled bus driver—really angry about the whole monkey business. David was going, "Oh, they're my monkeys, and they're normally really well-behaved." I'm like, "They're *not* well-behaved! Look what they did to this bus!" We kept them there for an hour before they finally smelled a rat and gave up. This was a publicity stunt for our show, to get people to come out.

♦ **V:** *What have you done recently?*

♦ **JR:** Now I do *Cyclecide Bike Rodeo*. Basically, we take bikes that our wonderful disposable society throws away and make pedal-powered rides. We have a ferris wheel that goes seventeen feet into the air, and we have a ride called the *Cyclo-Fuge* that's like those flying chair rides at carnivals. We have a carousel of twelve bikes that goes around. Our shows parody a rodeo. We've made hinged swing bikes that swing back and forth, we have choppers, and we have the "Mad Cow Bike"—it's an exercise bike that looks like a cow. We have a bike that spanks you. Sometimes a kid will get on it and when he gets spanked, he'll go, "That's not *funny,* man!"

The motto for our bike club is, "Too Dum to Die/No Brakes, No Problems." We have bike joustings, and a mosh pit called "The Mosh Pit of Recklessness." We've toured as far south as Mexico City, and as far east as New York City.

Some of us drove out to New York with John Law, who was taking his Doggy Diner Heads to the

Cacophony event at CBGBs. (This was documented in the movie *Head Trip*.) So the Doggy Diner heads were displayed on their trailer in front of CBGBs, and someone told us there was a dachshund convention nearby. We drove there and sure enough, there were 300 dachshunds all dressed up in little outfits—it was surreal. New Yorkers flipped out, seeing our giant Doggy Diner heads.

Doing these tours, I felt like we were doing a *real* rock 'n' roll tour with an edge, and wondered, "Is this where rock 'n' roll has gone? Because there doesn't seem to be any music scene nowadays with a bite to it. Maybe these new circuses that are touring are the new rock 'n' roll." But one thing that I like about the younger generation: they know about everything—they'll talk to you about heavy metal or Martin Denny or Joe Strummer!

Our tours kinda produced *prank environments.*

The intention was to be funny, not condescending or insulting. I love doing pranks because they aren't based on malicious intent or motive.

♦ **V:** *Someone said that our consciousness is imprisoned by our five senses, but the sense of humor is a sixth sense that offers an escape hatch—*

♦ **JR:** Well, if you look at a lot of comedians' personal lives, they were wrecks! They were alcoholics and super-depressed, but onstage they were really funny. I think a lot of performers have a stage persona—

♦ **V:** *—that can channel from some other crazy, hidden parallel dimension.*

♦ **JR:** You don't even know where it comes from. You can invent a whole new persona onstage. Sometimes you get surprised; you think, "Did *that* come out of *my* mouth?"

We did one prank which we called Critical Mass-turbation. Critical Mass is a monthly event, founded by Chris Carlson, in San Francisco to show people that they can bicycle to work. Hundreds or thousands of people on bikes ride in a big long parade, at 5 PM on the last Friday of the month.

So what we did was: we rode into the mass and blocked everybody. People got really mad at us, especially the spandex mountain bike types. The bike community is mixed. You have mountain bike types, bike messenger types who have fixed gears, hippies—a whole assortment of people. So I'd like to think our group added the fun and goofy element, with our tall, weird-looking, altered bikes.

Now there are lots of altered bike clubs across the county, in part because of us touring all over. It was very contagious. There are so many ways to build a tall bike, and it's fun to see all the variations people have come up with—there are no wrong ways to build one. I'd like to think we're spreading the corruption of youth—and youth can mean any age. To me bikes are a very democratic thing, and that's why I think the bicycle is one of the greatest machines to ever have been invented.

Cyclecide did a "Pedal Camp" one year at Burning Man. We built a big shack, and had an exchange going where, "You trade us gear or drugs or liquor, and in exchange we build your bike or help you build a bike." But I guess we were too punk rock or our music was blaring too loud, so we were kind of disapproved of. Next year I wrote Burning Man a proposal asking them for $2,500 *not* to go, claiming this would help improve their community, and that we felt that "giving nothing is actually giving something." I got all these ballistic responses: "How *dare* you?" Somehow we also got accused of selling drugs off our bikes, so we just confirmed all these rumors and made them even more ridiculous and absurd, saying that we had also smuggled orphans and prostitutes into Burning Man.

It's funny how things take off from their original purpose or source. I participated in the Cacophony Society's Portland SantaCon in 1996. People were just horrified at the sight of 300 rampaging Santa Clauses! But now it has become an institutionalized event, where it's just a given that there's going to be rampaging Santa Clauses somewhere, and they don't even have anything to do with the Cacophony Society anymore. But you know, Burning Man started out as a Cacophony event at Baker Beach, and now it doesn't have anything to do with Cacophony anymore. It's funny how these ideas get co-opted and become kind of mainstream in a weird way . . . ♦♦♦

B AMBI LAKE

was in the seventies punk scene in San Francisco, and has written several books. A transgender performer, writer, singer, actress and all-around character, here she tells a prank that repeated itself over a year later.

♦ **BAMBI LAKE:** I heard Gary Numan was coming to town and I didn't want to pay $30 to see him at the Warfield. So I telephoned the Warfield and spoke to the person in charge of the guest list: "I want to talk to Gary Numan's manager." He comes on the line and I say [British accent], "This is Charlotte Rampling. I'm in town doing interviews for my latest film. I'm an actress—have you seen Visconti's *The Damned?*" He goes, "No, but I've seen *Goodbye, My Lovely. This* is Charlotte Rampling?" I said, "Yes. I knew Gary Numan from Tubeway Army. My husband's a jazz musician; I live in Paris." So I got on the guest list, called my friend Ginger Coyote and told her, and she shrieked.

That night I went to the Warfield. I got out of a cab in a Missoni dress and expensive heels; it was dark, and I was young. I showed up at the Warfield, smiled, and said, "I'm on the guest list. I'm Charlotte Rampling." I walked right in as Charlotte Rampling and they put me in a box seat and I got free drinks. During the performance, Gary Numan played to me as though I were really her.

At the end of the show someone came in: "Miss Rampling, could you come with me?" I thought, "What am I going to *do?* Now it's 'close-up' time!" I got backstage, opened the door, and somebody asked [British accent], "What do YOU want?" They took a good look at me and slammed the door: "You fuckin' bitch!" They were so mad.

A year later I tried to do the same thing with Peter Murphy of Bauhaus, who was on a solo tour. I asked Ginger, "Shall I try it?" and she said, "Oh, yes!" I called the I-Beam and asked [British accent], "Could I talk to Peter Murphy? It's Charlotte Rampling." The person who answered said [British accent], "Oh, it's YOU?" It was the same manager! He had never been told about the pre-

vious Gary Numan prank, because they were all so embarrassed about being "taken in." He went, "Ohmigosh. I remember you. What happened last time? I never heard. So, you'd like to get on the guest list—well, it's rather late; the show's almost over. Peter's staying at the York hotel; go right on up."

So I show up at the hotel and the other members of the band go, "Miss Rampling; up here." In England Charlotte Rampling is an icon, but because the band members were kind of jocks, they couldn't really tell about the "Queen" thing. The manager was fooled when he saw me. Peter was upstairs doing his make-up; he didn't want to come down, and I didn't want to go up and go face-to-face with him, thinking that maybe if he doesn't like me I won't be able to hang out and drink all the free booze with the other guys.

Now there was another famous groupie named Corinne in the room and as soon as she saw me she went, "That's not Charlotte; that's Bambi." But there was only one girl in the room, so they went, "Whatever, come on in, baby." I'm like, "*Hi!*" And I tell Corinne that Charlotte was still at the hotel and had sent me in her place, so Corinne's satisfied; she didn't know who Charlotte Rampling *was.* So we drink all night and I'm having a ball talking to this cute young drummer for the band, and we're drinking whiskey. I'm drunk, so I go upstairs and knock on Peter Murphy's door and he looks at me close up and goes [furious], "Who the hell are YOU? What do you want?" You would think he would've applauded me, but he was just a bitch! Well, he was expecting Charlotte Rampling, poor guy— what a letdown! [laughs] Sorry, Charlie! ♦♦♦

GROUPS

Pranksters are by nature creative, solitary and secretive. Yet pranks themselves require a highly honed sense of humor, and humor is a social phenomenon. The best excuse for bringing people together is to do a project both creative and fun. And if it attacks illegitimate authority, repressive conformity and evil corporate marketing, so much the better.

What better way to exercise group creativity than in, say, a BLF billboard prank, which requires a team of people to execute expeditiously? How about a collaborative SRL machine performance? A prank on the news media, which Joey Skaggs has done for decades, often requires intelligent cohorts. The Suicide Club, Cacophony Society, Yes Men, St. Stupid's Day Parade, Critical Mass, Cyclecide, Obey Giant, C.D.C., and many others have executed numerous group pranks without being repressed by state authoritarianism or betrayed by *agents provocateurs*. Just two people working together can produce exponentially greater results. In unity there is not only strength, but genius.

YES MEN

were founded by Mike B, who lives in Scotland, and Andy, who lives in Paris. Their pranks on global corporations are legendary, captured in a feature film. [More info at *yesmen.org*]. Interview by V. Vale.

MIKE B

♦ VALE: *The Yes Men embody such a brilliant idea, and your website is so amazing. Are you web designers?*

♦ MB: We rip it off; we're good at ripping things off. Andy is especially good at the Internet stuff.

♦ V: *It's amazing how you can create a virtual world on your website, which seems to be like an elaborate prank and yet it is deeply educational. Nuts-and-bolts explanations always impress me, and you give a hands-on illustrated lesson on how to dress to infiltrate the W.T.O. or any other kind of corporate stronghold. That's very valuable. You illustrate how to tie a tie! That could be essential information to someone who never learned how. You're not assuming anything, which shows how completely sincere you are in spreading the virus of the Yes Men. First, you should tell me what the "Yes Men virus" is, because I don't want to misrepresent it.*

♦ MB: That's a good question: what is the virus? The idea is to spread the joy of mischievous rebellion against injustice everywhere.

♦ V: *Amen! Well, Hegel says that the only way to judge true progress in a society is to ask whether it's going in the direction of more consciousness and more justice for more people. But nobody reads Hegel anymore, or any history, for that matter. We're all supposed to be living in an eternal present where consumption is everything—*

♦ MB: It does seem like that. I've been forced to consume a lot lately, myself—mostly bad news.

♦ V: *Lately, even people who don't care about politics have become politically conscious. When our entire world is being hijacked by corportions and politicians and all our mental and public space is overrun with advertising, everyone has to become politically engaged somehow. The Yes Men have found a really brilliant and funny way of doing that. What you do seems a little scary to me, though—I don't think I could do any of the pranks that you pull off. How did you two get together to*

hatch this project?

♦ MB: Well, we were introduced to each other by mutual friends awhile back. I had done this project called the Barbie Liberation Organization where I switched the voice boxes on Barbie dolls and GI Joes and put them back on store shelves. Andy had done this hack of a computer game called "Sim Copter." A mutual friend who knew we had done these projects suggested that we meet each other—that was around 1996. So we got together and started exploring all the possibilities to "Fuck with The Man" through mischief.

♦ V: *Including impersonations, put-ons, fake press releases—all the ways to—*

♦ MB: —shed light on things! We are engaging in deeds like masquerades and we're being mischievous, but it's all meant to reveal things, to give people *more* information rather than to hide things from them. In the end, everybody should learn a little more about what *really* goes on. Rather than the usual kind of trickery that we get from the people who are in power, where you have huge matters that can influence your life being decided by other people, and you have no idea about it.

♦ V: *This is a crazy thought, but you're doing Buddha's work: "spreading enlightenment."*

♦ MB: Yeah, I like to think of us as being the trickster. Throughout mythological traditions, the trickster does something that ends with everyone learning a lesson. Sometimes the trickster ends up getting tricked in the end. So, this way of interacting with the world is as old as humans. "Trickstering" is another way of teaching and spreading the word—and it's fun! We have a really good time doing it; it's what we like to do.

What I'm trying to say is that a lot of people approach what we're doing as something totally new and unique, and that we are changing the face of social protest, but no, it's not actually new and it's not necessarily better. But we do everything we can to engage the mass media and get the word out to as many people as possible. By the

way, your first *Pranks* volume was an influential book. People like Andy and I read it and were inspired by it when we were just spring chickens (or in our case, slightly-jaded, not-so-young-kind-of guys). I was in the university and Andy was slightly post-university when he read it. But yeah, when I was working on some projects around 1990, that book was out on the floor for people to read. We had a big group and we were doing all kinds of strange things in Portland, Oregon, and that was the *reference* book, the source that you cite. It was very important in our development.

♦ *V: Well, thanks. The Yes Men seem to have figured out how to do pranks and get them into the mass media so that the ideas get out there and spread, like a meme or a virus. The whole idea is to inspire people to do something imaginative and funny—*

♦ **MB:** It comes out of the recognition that there is this huge problem in the world, stemming from communication being at the scale of one's wealth, where entities with more money can speak at higher volumes because they have the access to all that media. It's not like there are just these mega-lomaniacs at the top who want to dominate everything, but there is this whole complex machine that all kinds of writers and editors are involved with. I think most journalists *want* to investigate and write interesting, strange and unusual stories. However, they aren't given the *opportunity* very often to write about, say, countercultural interventions. But when they do, they really eat it up. So we try to make these stories available to them, with enough humor to get them past the *editors* as well—

♦ *V: Humor is the camouflage that sneaks the message under people's noses—*

♦ **MB:** It's been key to everything that we do. If you tell a funny story, other people want to retell it; the humor is part of what makes it contagious. It's like the jokes that get passed around. If you tell a really dire, serious story; if it isn't *monumentally* tragic or unusual, it doesn't get passed around. Humor is a really good strategy for getting into the media "no fly" zone.

♦ *V: What do mean by that?*

♦ **MB:** There are places where ordinary citizens are not allowed to go. For instance, you normally wouldn't be able to get something published in the *New York Times* unless you are an important celebrity, respected politician or a captain of industry. Humor is a smokescreen that can dis-

guise who you are and allow you to slip some things in there. Another way is to do something really horrific, like put on a trenchcoat and go to your high school and mow down a bunch of your classmates. But that is a really repugnant way to go about venting your frustrations.

♦ *V: I don't think the Columbine teen-killers even left behind an enlightening suicide note.*

♦ **MB:** No, that's a really sad tale. Nothing good could possibly come of that sort of action.

♦ *V: If only they had figured out how to channel that anger in different ways—*

♦ **MB:** Maybe if they had a little more guidance and a little less "gun" in their lives. If only they had had a more creative way of engaging their community—

♦ *V: Well, it seems like most mainstream media are trying to implant everyone with just two emotions: fear or pity. Hardly anything else. Supposedly, those are the two principal emotions that Shakespeare was dealing with in his tragedies.*

♦ **MB:** Well, you certainly aren't going to see a lot of pleasure in a tragedy.

♦ *V: Shakespeare saves that for his comedies.*

♦ **MB:** Exactly. What we often are trying to do is to peddle pleasure with a larger message of tragedy. [!] That's really it. What's happening in the world with something like global trade is a tragedy. For a lot of people who are on the receiving end of the big stick, it's kind of nasty. But we try to "frame" a problem like that with a little bit of humor so that people will want to keep talking about it and try to figure out what is going on. Right now we're working on a film that is about disasters. It starts with a relatively small disaster that also happens to be the worst industrial accident in history (according to some sources), the Bhopal catastrophe. Eight thousand people died on the spot, and in the long run it has been esti-

mated that twenty thousand people died. People are still dying today because of contaminated water—they never cleaned up the mess So we are making a black comedy about Bhopal

Hopefully, through the repetition of people communicating with each other, some kind of change might occur. It's hard to see what's going to happen with our future; it seems kind of bleak because of all these things like global warming, which are these unstoppable inevitabilities that are going to be incredibly catastrophic and weird. We are going to plunge civilization into some strange New Dark Age.

♦ **V:** *Last Saturday night I heard this great song called "New Dark Ages" performed by an original '70s punk band who recently reunited, the Mutants.*

♦ **MB:** Well, I can easily see something like a New Dark Age coming, maybe within our lifetime.

♦ **V:** *The world seems to have been immersed in a search for "authenticity" during the last decade or so—*

♦ **MB:** I feel I've been kind of lucky in some ways. Right now I'm in the U.K., and some of the newspapers here are very high quality—generally much higher than what you get in the U.S. I had enormous frustration a few years ago living in the U.S. because you have to read between the lines of every news story. Like, is this the Soviet Union under Stalin? In the U.K., newspapers don't pretend that they are unbiased, and writers are allowed to actually have an opinion.

♦ **V:** *In Europe, a lot more pictures of Iraq war casualties get printed than in America—*

♦ **MB:** You actually get to see them here. That's a major difference: they show them on TV. The BBC television news is really quite good, but they do have a remit to be unbiased because they are kind of a monopoly. So they put all this effort into making sure everything is balanced . . . It makes it more fun if you get to appear on some unbiased news program to speak on behalf of Dow Chemical or something like that.

♦ **V:** *Speaking of that, what were your greatest media coups?*

♦ **MB:** The biggest coup performed by the Yes Men to date would have to be our announcement on BBC World Television. We impersonated Dow Chemical, stating that after twenty years, Dow Chemical was going to clean up the mess from the disaster in Bhopal. This was on the twentieth anniversary of Bhopal! BBC World Television is the most-watched news program in the world. Our appearance forced Dow Chemical to say something about Bhopal on the anniversary of the disaster—something they'd never normally do, because they still deny responsibility for it!

Dow Chemical bought Union Carbide, and when they did they said they weren't buying any of its liabilities in India. The Bhopal disaster was an iconic example of corporate inequity and everything that is wrong with the global-corporatism picture.

♦ **V:** *So how did you pull off the impersonation of Dow Chemical Corporation?*

♦ **MB:** We had a website with the URL "DOWETHICS.com" and a BBC researcher made a basic mistake when they were looking for someone to speak on behalf of Dow Chemical on the anniversary of the disaster. So they contacted us and we said we'd send somebody. Andy was in Paris and he quickly got to London so I could work with him making preparations. He went to the BBC and luckily they shot it live.

The other major consequence of what we did was that the Dow stock price immediately dropped three billion dollars! This rebounded once the traders found out that the thing was a hoax, but the idea was to shake them up a bit. It seems to have worked, because the next year they also spent a *great* deal of time at the shareholder meeting (which we went to) talking about Bhopal and what happened.

The thing is, what we were doing in Bhopal was only possible because of this incredibly interesting group of activists there who formed out of the survivors of the catastrophe. It's mostly women—hundreds of women—who are really active, agitating and trying to get Dow to be accountable.

We went to Bhopal this year and were really happy that they weren't angry at all with us—they were really happy to see us. The big achievement was that we got to mess with Dow; hundreds of stories about Bhopal appeared in newspapers. In the United States, most people have forgotten about it and assumed that it got cleaned up long ago.

♦ **V:** *I'm impressed that you pulled off the camouflage of appearing to be a Dow corporate executive—*

♦ **MB:** It was just a standard business suit, which you can get at any thrift store. The thing is, if you walk in the door and people *think* you're someone important, unless you give them a *really serious* reason to doubt it, generally speaking, they're going to believe you. It's not like you have to be a truly great actor, because their belief comes "pre-suspended"—there's no suspension of disbelief because they think you're somebody else! So you don't even have to be a good actor. In fact, the more bumbling you are, maybe the better, because it just seems more real.

But you do have to work the part: you put on

the suit and everything; you minimize the chances that they're going to raise their eyebrows and wonder whether you are who you say you are. You look it; you sound it; you get a little of that gel for your hair; get a haircut; get a shave—whatever it takes; pluck a nose hair or two. But you can wear whatever you want *under* the suit just to make yourself comfortable—

♦ **V:** *—like women's underwear; whatever. On your website you have a joke: "There are some executives who don't wear underwear as an expression of their internal freedom."*

♦ **MB:** I forgot about that! With most pranks, the more "professional" one is, the better the impact. If you go to a really extreme length to get your message across, people get truly confounded. First of all, there's no money in a prank. This blows people's minds—they go, "*Why* would anybody do that?!"

♦ **V:** *Right. In a capitalist society, everything is about money and profit, including marriage.*

♦ **MB:** Exactly. We used to run a corporation, www.artmark.com, which was basically a clearinghouse for anti-corporate, activist pranks. It was a website where people could meet each other, if they had money to fund pranks, or ideas for pranks, or particular skills they wanted to donate to activist pranks—pranks with a message or a purpose. People couldn't believe it and were blown away by the notion that somebody would set up a corporation whose goal was to be anti-corporate! It wasn't going to make any money. It was a slap in the face; it got people to wonder why it even existed. And it ended up being quite functional as a publicity engine.

One of Artmark's earliest projects was a CD called *Deconstructing Beck*. It was an anti-copyright, illegal project that probably wouldn't have gotten much attention except that we sent out a press release stating that "anonymous investors have paid $4,000 to see this illegal recording happen, and they didn't expect any financial return." Essentially this was a stock market for pranks, where people didn't expect any money back. This was in the '90s, during the rise of the dot-coms

and all this hype about the stock market, and because of that context it became a story in the *New York Times*. For some reason it was a scary thing that anonymous donors would be giving money to something whose goal was to fuck with the system!

♦ **V:** *So to pull off a corporate-impersonation prank, besides the costume, the verbal delivery is very important—*

♦ **MB:** Everybody, to some degree, knows the language of business, because it's what we're surrounded with all the time. We see it in commercials, television, reality-TV shows, and many people experience it in the office-place. Sometimes it's a bit difficult. We've had to learn entire new vocabularies before going to, say, a textiles conference [laughs] . . . and learn about the regulatory agencies that oversee textile trade. So you do learn this esoteric bullshit, but then it doesn't take much to deploy it. The thing is, even if you make up your own language—refer to acronyms that other people don't know, for example—they're usually going to assume that you know what you're talking about. There's no reason to assume that you've *made up* an acronym. The thing about going to a conference and having a conversation with somebody, or listening to somebody make a speech: *why* would anybody make something up? There's no reason for that!

♦ **V:** *You could look at the rise of the dot-coms in the '90s as a huge prank, with twenty-somethings overnight getting millions of dollars in capitalization to sell pet food on the Internet, or any number of bogus schemes. The thing is, a lot of high-tech, neologism-ridden, con-man language was invented then. What a snow job—*

♦ **MB:** It was a total snow job, the whole funny pyramid scheme. There were a few good pitches in there. Andy and I also capitalized on that hype, because there was a fascination and romance with all the dot-com bullshit—

♦ **V:** *Well, we're ruled and controlled by language sound bites and well-chosen, powerful visual images—*

♦ **MB:** And so we try to do the same: "Team Bush

hates our freedom!"

♦ **V:** *And bin Laden comes up with good sound bites; he called Bush "The Butcher of Washington." Tell me the* modus operandi *of how you do a prank, like the Bhopal one.*

♦ **MB:** First we do research. Usually we enlist the help of other more expert, activist-type people, for guidance on what we're gonna say. With Bhopal we had less than a week to prepare a speech and figure what the spin is; what angles to take. We do write out the points we're trying to make. If we're giving a lecture, we often write it out completely and mix it with slides. But for live TV you can't really be reading off a script—unless you have a teleprompter like George Bush. We don't want to hand over a piece of paper to the station and say, "Type this into the teleprompter"—that would blow it! So, it's talking points plus improv.

For the Bhopal TV appearance, Andy practiced quite a bit beforehand. We worked out what needed to be said a good *day* in advance. Then he practiced over and over, adding dramaturgy. It all depends on how important it is. It was clear that Bhopal would be important and therefore intimidating; Andy was extremely nervous. Doing an impersonation is a really nerve-wracking kind of thing, in general.

Our other big success story was when we were able to announce that the W.T.O. was closing its doors, when we were in Sydney, Australia, at a Yearly Accounting Conference. For a moment, in the minds of the people there, the W.T.O. *was* over; it had ended. And all the accountants were actually enthusiastic about ending the W.T.O. and building a new organization that had the interests of *people* as its bottom line, rather than the interests of profit. It sort of demonstrated that, to use a cliché, "another world is possible." [laughs]

♦ **V:** *It's only relatively recently I started using the phrase "economic justice." All the value in the world is created by workers; why not give them a living wage . . . So how did YOU get invited to this Accounting Conference?*

♦ **MB:** We had a website, *www.gatt.org.* GATT means General Agreement on Tariffs and Trade; GATT was the predecessor to the W.T.O. People looking for the W.T.O. site ended up at gatt.org. We got really good search-engine rankings, simply because several news stories were written about the fake site. Over time we had more and more people thinking we *were* the W.T.O., even though if you actually read the site, it was clearly a satire.

Over the course of several years we ended up impersonating the W.T.O. at many different conferences and business meetings and on television as well, including CNBC in Europe. All this is in

a movie and a book. We asked our friends Sarah Price and Dan Ollman, who've made movies before, to follow us around and make a film. We also put out a book telling the same story about what happened. [title here].

♦ **V:** *So you've put up a number of websites—*

♦ **MB:** A website is an easy way to masquerade as somebody else.

♦ **V:** *People take you seriously as "authority figures." What a strategy—*

♦ **MB:** It's not that different from many other people who have masqueraded in the past; it's just that doing what we've done seems to be particularly easy. When you go to a conference as somebody else, it's very important to have a *business card*. That is key. Other than that, there aren't that many other things that are necessary. I don't think what we do is unique; we've just maybe developed it more than other people care to . . . or more than most people have *time* to. We've been lucky in that we were born in the right place, and we developed skills that allowed us to make enough money so that we could spend most of our time on this entertaining "hobby" of ours.

♦ **V:** *How did you and Andy start working together when you didn't know each other very well? Your skills have to be complementary. You do video, and he does the website—*

♦ **MB:** We work out ideas together; we both do some writing. We divide labor; each has certain skills to contribute. Then we work on the ideas together.

♦ **V:** *Well, the Yes Men website is so clear and easy to navigate—*

♦ **MB:** That website was designed by our friends Matt and Christy. Andy is great at the coding and the ripping off of other sites, but he's not as good at the design work—he's not as "visual." I'm usually coming more from a visual place, while he's coming more from a language and mathematical place.

♦ **V:** *So, in your work you're trying to expose the real machinations of power and propagandizing. If you accept the premise that everything these days is turned into advertising/marketing, and if you hate that and want to fight it, then . . .*

MB: Television is both addictive and sedative.

♦ **V:** *Burroughs said that television simulates the flow of dream imagery in your mind. Someone else said that when you watch an ad on TV, you consent to enter into a little dream or fantasy world for a time. Obviously, you've tapped into the power of advertising to pull off what you do—*

♦ **MB:** We do engage in a lot of mimicry. We imitate. Since we were little kids we've learned that

if somebody says something stupid, somebody else imitates it in a funnier voice, and it's meant to reflect back on the stupid thing, or make everybody think about the stupidity of the thing origi-

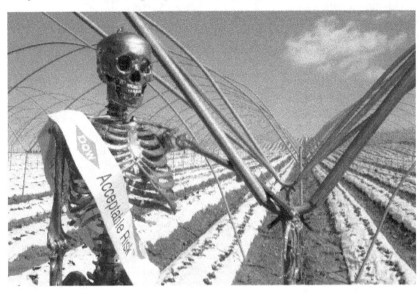

nally said.

♦ **V:** *Again, we're interested in the* modus operandi *of how you pull off your pranks—*

♦ **MB:** Well, one of the key things is that in general people don't *do* these sorts of things. You don't run across them in your everyday, daily life. This is why con artists can do what they do so successfully. It's not that it's actually that *hard* to claim you're somebody else—it's actually pretty easy, because people have a great capacity to imagine and to believe in things—any kinds of things, whether they're fictions or religions. We have a great capacity to believe stories and believe the invisible.

What we do is much easier than what people might imagine; it's just a matter of whether you do it or not. In our case our motivations are not to defraud people; they're not the standard motivation in our culture, which is to make money. There's not much case history for prosecuting the types of activities we engage in, because all of the case history is about fraud cases where people are actually making money off impersonating other people. The lawyers we've consulted who really think about what do usually say, "I don't know."

Most of the time we're not breaking any criminal laws, so it has to be a civil case, and then people would have to prove that we defrauded them. So in the case of a lecture we gave to a group of students in Plantsburg, New York, where we pretended to be the W.T.O. and somebody from McDonalds (we had two representatives) . . . we handed out hamburgers from McDonalds at the beginning of the lecture, and by the end of the lecture, which was about global hunger and the way trade works, we explained to people that the hamburger they ate at the beginning was an experimental hamburger that was made of 60% post-consumer waste (so it was a shitburger). If McDonalds wanted to take us to civil court and sue us for that, they would have had to argue that the people in the audience could legitimately be fooled into thinking that they had really eaten a shitburger. So they would basically have to argue that their hamburgers were similar enough to shitburgers that it was a believable story! When you've got that kind of a situation, why would they *want* to take that to court and admit they make shitburgers?

♦ **V:** *I hadn't thought of couching every single prank in a legal context—*

♦ **MB:** We've ended up *having* to think of that, because almost every time we start to do a thing like that, people say, "Don't do it." Generally speaking they say, "You're gonna get in trouble. You're gonna get your ass kicked. They're gonna sue you." And in general, you're not gonna know whether that's gonna happen until you do it. So we've been doing this research to see if we actually do get sued, and we've been wanting to get sued, but so far nobody's followed through. It's been a real drag that way!

♦ **V:** *For you, a lawsuit would be a means of getting publicity and spreading more Yes Men viruses—*

♦ **MB:** Exactly. The McLibel Duo have really taken the "Art of Being Sued" to a new level.

♦ **V:** *Who's that?*

♦ **MB:** In the U.K. there are these two people who had been pamphleteering outside McDonalds in the '90s, and McDonalds sued them. For the next six years they were in the longest-running court battle in the history of the U.K. McDonalds were suing them claiming they were spreading lies about McDonalds hamburgers. The two were giving out pamphlets telling how McDonalds hamburgers were made from beef that damaged the rain forests, and how it wasn't good to eat meat—

things like that. So McDonalds had to argue with them in court, in front of journalists, for years about these issues. In the process they got really, really bad press.

This was a standard David-and-Goliath story. Basically this case set some precedents; it was really a warning sign for other corporations not to push it too far with individual activists who had nothing—no assets—to lose.

If somebody's willing to get sued, and the corporation has something that they would like to hide, then the only way for that person to get a large voice is for the corporation to give them some of their power—in other words, to attack them. Once you've got that kind of dynamic, you've got a story with a classic narrative structure: a good guy and a bad guy, a big guy picking on a little guy, a little guy fighting for justice. We've been hoping to become that, but nobody wants it. But it may happen . . .

♦ *V: You're lucky you get to lecture to college students—that's the last time most people are receptive to new ideas: in college.*

♦ **MB:** We discovered that firsthand—those students we gave that hamburger lecture to did revolt and started throwing things at us! Whereas no "business" audience ever reacted in a negative way to the things we were saying—no matter how horrific they were.

When we posed as the W.T.O., the students were angry with us almost from the first paragraph of the lecture. They were immediately offended. Whereas the business people were too polite, or simply not offended by the things we were saying—and that's where the real horror was. They were so indoctrinated and trained by the business "system" that they had lost their capacity to actually think and reason; everything just fit into the way that business can legitimize doing all kinds of corrupt things.

♦ *V: People actually believe that "Profit justifies anything. The ends justify the means." I have "The Corporation" abstracted down to a DNA principle: "Do whatever it takes to make maximum profit as fast as possible."*

♦ **MB:** Wow.

♦ *V: Concern for ethics, morals, human well-being, other species—*

♦ **MB:** It's just not part of the corporate DNA. It isn't there.

For a long time we didn't realize we were doing "theater" or performance art—we didn't know it at first, but after awhile we figured it out. Now we've gotten some grants from the Creative Capital Foundation, the Herb Alpert Foundation. We've been able to do quite a bit of traveling around the world, and have fun, too. Art has been good to us! ♦♦♦

ANDY

♦ **ANDY:** Many years ago I used your *Pranks* book in teaching. It was a reference; it was a formative thing. It was amazing. At a certain point it felt like *everyone* had that book.

♦ *VALE: Thanks—for me, it doesn't get better than that. When I heard about the Yes Men, I first thought that just two people getting together can produce something exponentially greater than the sum of two parts. The two of you have the facade of a huge organization, and I'm sure a lot of friends and allies help you, too. In our Western world we have a planet of consumers whose religion is advertising, and everything George W. Bush says is part of an ad campaign. All the news is a kind of advertising as well. You know that most of what appears in corporate media is all lies, and when you get sick of it all, then you want to DO something, because everything has become branding, marketing and advertising. I think the Yes Men are a "good" kind of ad agency countering* this propaganda—

♦ **A:** That's it; we try to make our own ads. And there's so much of that, that we don't expect more from the news, as you say.

♦ *V: A lot of the power of the Yes Men's website derives from its professionalism: the text, the imagery. In the old days, when you published an underground paper, it was badly typeset, with crooked layout—it* looked *underground. But to do culture-jamming these days, you have to work on some other level, and computers have given us the ability to do that—*

♦ **A:** I guess so. With underground paper publishing, it was hard to imitate *Time* magazine. You needed a *budget* to do that. You don't need a budget to put together an okay website.

♦ *V: —or a really good video, either. You pull off seamless impersonations of a corporate CEO or spokesperson, showing up at a TV studio—*

♦ **A:** It seems surprisingly easy to convince people that we're "real." We work a lot and polish things, but once we're in there, what are they gonna do when we show up at a studio or a conference . . . say we're not "real"? *They* really have a stake in believing we are who we are. Otherwise, it might be hard to convince them.

♦ *V: Tell us how the Yes Men evolved—*

♦ **A:** You hit on it when you said that just two people can do exponentially more than one. That's really it. We can be eight times as foolish as an individual. It's like two *cubed,* or something.

It just gets much easier to goad each other on, or whatever. Say, one of us gets an idea and wouldn't necessarily feel confident acting on it (at least *I* wouldn't), but with Mike there, he kinda echoes it back, or vice versa, and pretty soon it seems reasonable! [laughs] And then we *do* it, and it's okay.

It also enables us to vet things; sometimes we have ideas that are just terrible. Like, we had an idea not long ago that was shot down by a fourteen-year-old girl. She just said, "That's ridiculous! You can't do that!" And she was right. But we're able, because we're two of us, to kind of encourage ourselves to go that far with it, to where it can be shot down, or where we can actually do it. And sometimes it's just obvious.

It's just easier to be more courageous when you're two people . . . I think! I mean, some people may be very courageous individuals—there are many. But if you're *not,* then . . .

♦ *V: It doesn't hurt to have encouragement. And you have other friends helping you, too. For example, your website is amazingly simple to navigate—*

♦ **A:** A friend of ours did that. Others have done the crazy animations that make people want to watch our videos, and liven up presentations. Others have built costumes. If you go to the Yes Men website and find the W.T.O. section, and then the "Finland" speech, there's one costume there. At *www.yesmen.org/risk*, there's a picture of a recent prop that we used—it's not quite a cos-

tume, but . . . We built a whole bus—well, we decorated a Bush campaign bus for the 2004 election; obviously, we couldn't do *that* ourselves.

♦ *V: Great, a fake George W. Bush campaign bus—*

♦ **A:** Actually, it turned out not to actually work very well—both mechanically and as something to convince people. Cuz no matter how far we took it, it seemed people still believed it was real.

♦ *V: That's sad, or sick, or something—*

♦ **A:** Yeah; we couldn't do much. It broke down and that was all for the best. We just walked around and knocked on people's doors and told them not to vote for him. That worked better. Sad ending!

♦ *V: But I like the idea of a prankster Bush campaign bus—great idea!*

♦ **A:** Yeah. And maybe it would have worked in a different situation, somehow.

♦ *V: You needed a bus mechanic on your team—*

♦ **A:** Maybe that's it! [laughs] Bus mechanic, strategist . . . there were some problems. Well, not everything can work.

♦ *V: But at least you have to try. And you can have fun trying—it's all a kind of play, anyway! It's seri-ous play . . .*

♦ **A:** Yeah. Like, if it doesn't work, it's bad, but at least we're having fun with it.

♦ *V: Maybe when you're trying to invent a bicycle or something, the first prototype doesn't work, but eventually you get it—*

♦ **A:** Right, that's all play: inventing things, figuring it out . . .

♦ **V:** *How do you like living in Paris?*

♦ **A:** Well, it's a bit quiescent right now. The days of May '68 aren't here anymore.

♦ **V:** *But some lastingly great slogans got hatched then, like "All power to the imagination!" and "Neither God Nor Master"—*

♦ **A:** "Under the paving stones, the beach!"

♦ **V:** *Oh, that's a beautiful one.*

♦ **A:** There's still a bit of that. There are these people who deface ads; they call themselves the Anti-Degonslef. There's a big deflation of S.U.V. tires being done by people who have a pretty high media profile. They also throw stink bombs into GAP stores—stuff like that.

♦ **V:** *Wow, that doesn't get reported over here.*

♦ **A:** It's not very high-profile *here*, either. But it will be, I think. The deflation of S.U.V. tires is something that could really spread to San Francisco!

♦ **V:** *S.U.V.'s are too big, and the parking places are too small in this town.*

♦ **A:** Paris is even worse for that. They're always parked on the sidewalk. There have been things in San Francisco like giving S.U.V.'s "tickets." Some people scratched or "keyed" them for awhile, during the dot-com days. But deflation: they can't really pursue you, legally, for that. It refers, somehow, to impotence, too. And since that's what they're all about! I just love that metaphor: deflation.

♦ **V:** *I should finally ask you how the Yes Men began—*

♦ **A:** We met on the Internet. I had just done this SIM Copter hack thing. I had this job at a computer company in the Bay Area, Maxis, that made Sim City. I was working on this computer program, Sim Copter. I was in charge of the characters in this computer game, and I put all these boys in swim suits that just started kissing each other at key moments in this macho action game. For whatever reason, I did that—and they fired me! I just thought, "Whatever . . . that was silly." But I didn't really want the job anymore, anyway.

I told a reporter about it and he said, "Ohmigod, that's such a weird story; I can't believe it!" He wrote an article about it in *Wired*, and suddenly it was a big media story. That was really thrilling for me, 'cuz I realized, "Ohmigod, you can get this huge media story out of *nothing!*" (Or very little—all I did was this little stupid prank.) Somebody saw that article, and knew the Barbie Liberation Front stuff that Mike had done, and said, "You guys should meet and talk."

So we started working together, thinking of things to do. Right at the beginning we thought of some projects and did them. We found that all we needed to do, really, was to write press releases about these things, and kinda invent *some* of the details, and kinda seem respectable, like a press agency, and then we could get articles written about things.

And then it just kept going and going until finally we ended up setting up these websites. I guess that started with . . . Maybe the most thrilling thing, early on, was before the 2000 election. We set up a fake Bush website [*www.gwbush.com*], and Bush actually reacted to it on TV. He said, "There ought to be limits to freedom," referring to the website. [laughs] You can see that also on our website.

♦ **V:** *He's the one who uses the word "freedom" more than any other word in his ghostwritten speeches—*

♦ **A:**—and what he really means is just the opposite: just put a beep wherever he says freedom. That was pretty revelatory, at that point.

♦ **V:** *Well, the President noticed you—*

♦ **A:** The future so-called "President"—

♦ **V:** *Right, the fake elections; the election fraud.*

♦ **A:** We thought, "We're gonna bring him down!" That resulted in a huge flurry of press, of course.

♦ **V:** *What did they do with the site? Did they still leave it up?*

♦ **A:** Yeah, they couldn't do anything about it; they couldn't touch it. But unfortunately, we were working with someone else on it, and they decided they didn't like our "approach" and took

it back. If only the Bush administration had shut it down, it would have been a better story. Instead, it was just this stupid squabble.

Bush stole the first election; it was really a coup—there's no question. They attacked Iraq for the hell of it, and lied through their teeth—absolute criminality, much worse than Nixon. Now, why do we focus on things like Enron? It's a terrible thing that Enron stole all this electricity from grandmothers in California and all, but where did that energy come from? A lot of it came from oil and coal, which is of course creating global warming, which is a much bigger crime than stealing electricity from California. Here, the real issues underneath are much bigger than the surface scandals.

The Monica Lewinsky scandal is a perfect example. Chantal Mouffe, a French philosopher I have the good fortune to know (she's worth reading), said there was absolutely nothing for the Republicans to argue with about Clinton's policies—because they were Republican! [laughs] He used this method called "triangulation" to find a middle way, like Tony Blair. So the Republicans had nothing to focus on except a blow job—otherwise, they would have attacked him on policies. It was the only thing they had, which is kind of sad.

Have you read the Thomas Frank book, *What's the Matter with Kansas?* It's great. The lack of any substance in the Democrat policies left the door open for the Republicans to come in with their morality arguments. William Jennings Bryan was opposed to Darwinism because he thought it would lead to Social Darwinism—which it has. Now, just because there's social welfare doesn't mean that everybody's gonna *want* to live on welfare. The countries that have it do quite well, like Sweden, which is kind of socialist and has one of the most vibrant economies in the world.

♦ **V:** *You know, in America, we never hear news about socialist countries doing well—*

♦ **A:** It's strange how little example is taken from other places and how others do things. Like how medical care is set up: nobody actually looks at other socialized economies and how they work, and actually evaluates whether they work better or not. They actually *do* work better! They're better for people; the standard of living is higher. People are happier. But to the American media, this is sort of irrelevant, or is just not mentioned.

♦ **V:** *Not mentioned. But as soon as the iPod comes out, everyone's supposed to buy one—*

♦ **A:** Yeah, that takes the place of *everything!*

♦ **V:** *You can be in your sonic cocoon—*

♦ **A:** No more "human" problem.

♦ **V:** *So to do a project, you send each other back-and-forth emails, and talk on the phone—*

♦ **A:** We do sometimes get together in person.

♦ **V:** *Every project has to have a kind of business plan, or strategy, or outline—*

♦ **A:** We're constantly making outlines, divisions of labor, and timelines (this week we do this; next week, if we have to have something done by then, we have to line up the people to help us with this). It's not that *hard;* it's like, sending an email and saying, "Hey, can you help us do this?" We write it down, we make timelines, people-lines, help lines . . . we're very, very business-like about it. We try to keep organized as much as possible, even though it's not always possible ...

♦ **V:** *Your press releases are a form of an ad, in a way, to persuade people of* something—

♦ **A:** Yeah. We write them before the event, or sometimes after the event if we haven't had time. We hope that gets reprinted in the media, or gets passed around by bored workers in the office—the "Bored Office Workers' Network," as Jonah Peretti called it. [laughs] Sometimes *that* has a lot more readers than any newspaper or website. People circulating email messages can sometimes be seen by millions—

♦ **V:** *It's the humor. People are always wanting something funny and witty—*

♦ **A:** Exactly: "Hey, can you believe *this?*" They have oodles of time, because really, they don't want to actually *do* any of the work they're told to do . . . with good reason!

♦ **V:** *Because it's meaningless, not satisfying, not benefiting the human race, usually—*

♦ **A:** Right, which means that there's *not* much reason to do it. There's a French word invented by Michel Desarto: "perruque," which means: *the principle of using time at work to do your own stuff.* Nice concept: a widespread practice that just needed a word!

♦ **V:** *We need that word in English! Seemingly, you have to change things in language before you can bring about social or behavioral change. Although actually, it's usually technology that brings about social change. In the Philippines, cell phone text messaging was used to bring down a conservative government.*

♦ **A:** And we have Google now: you want to know something, just type it in. It's crazy. I just can't remember what it was like to go to the library! But, do you think people forget things more easily now?

♦ **V:** *Absolutely; they have no memories at all.*

♦ **A:** Is that related to the Internet, I wonder?

♦ **V:** *Well, as a kid I read a statement by an*

American humorist named Corey Ford: "You can't pour a gallon of knowledge into a one-quart brain."

♦ **A:** Ah, nice. I know: there's so much *pouring* going on that our brains have become, like, *sieves.* [Googling] I found it: "In January 2001, President Estrada of the Philippines was on trial facing charges of bribery, corruption, and breach of the public trust. Despite mounting evidence against him, the President was let off the hook. That sparked it. People saw it on television and a lot of people revolted. They started text-messaging each other, sending each other messages over the Internet, and it created a combustion. Within two hours, 200,000 people converged in the main street of Manila, and the vigil lasted four days and four nights until he finally resigned." Wild!

♦ **V:** *Wow. That was definitely under-reported in America. It wasn't on Fox News!*

♦ **A:** Imagine if we did that in Washington: what would happen?

♦ **V:** *In terms of cell phone usage, the Philippines were way ahead of us in America. We still barely have text-messaging in this country. And, this is key: cell-phone usage is far cheaper over there than here.*

♦ **A:** Right, I'm sure. Mike and I were both in India for a month, and everybody text-messages there. We went to Bhopal for the 21st anniversary and traveled on trains everywhere. It was pretty great. We shot a lot of video footage and interviewed a lot of people, and we're gonna turn it into a film.

♦ **V:** *This is all made possible by the invention of the MacIntosh computer and the cheap mini-DV video-tape—*

♦ **A:** Totally. But it makes you wonder, too . . . I was on the BBC, a year and three months ago, representing DOW [!]. We thought it was such a big thing. I went to London a year after that and asked about thirty people if they had heard about it, and only two had.

♦ **V:** *We're in a hurricane of media now, and if something happened yesterday, it's already been blotted out of your memory bank by today's blitzkrieg—*

♦ **A:** There's so much information; that's exactly it. The Internet gives us a lot *more* access, but maybe it's worth a lot less! It used to be that if an article were actually in the paper, it would actually be remembered a little better. Or maybe not?

♦ **V:** *Maybe the solution is to be as wild as possible, because a wildly surrealist image has a better chance of being remembered.*

♦ **A:** Yeah, definitely. Something wildly "right"; wildly "correct." I guess that's what we were trying to do with the BBC thing: show people that this is the way it *should* be. It seems totally surre-

alistic that a company that size would suddenly *do* the right thing in Bhopal, but, y'know, it's *right!* [laughs]

♦ **V:** *Just to end up on BBC and be taken for real, and be able to express all these provocative points of view, is kinda surreal. I look at what you're doing as educational and empowering and inspiring because it shows that a person with very little money can pull something like this off. Of course, you have to look minimally all right on TV.*

♦ **A:** But you don't necessarily need much money. We were in Bhopal and these people have led this struggle for twenty-one years with very little money, very little *anything.* Now they've got a whole clinic that they've built, without taking any corporate money, ever—it's all just donations. They started out just treating people, and built up quite a high profile without money or anything. Sometimes money isn't important for a lot of stuff. Lawyers who try to change unjust laws—it doesn't necessarily take much money to do that.

There are a lot of lawyers who have decided not to defend corporations, but to try to work with social movements. They make a lot less money, but it also doesn't *cost* them any money to do it—it just takes time. And, they have to have the education.

A lot of people see the big media-scape and think, "Oh, it's all about money and how much resources you have," but it isn't, really. You can do it if you don't have any money.

♦ **V:** *In all the pranks you've done, did you encounter any physical endangerment?*

♦ **A:** Only once. It was during the Bush "stuff." We'd fooled all these people with Ph.Ds, and got invited to an event in Florida where we gave this really crazy lecture as the Bush campaign. And the audience totally got that we were satirizing him. And they *chased* us! They chased us into the parking lot, and it got slightly violent. I mean, they didn't actually *hit* us, but they tried to take our microphone, and stuff like that. We didn't have much respect for them; they were called the "International Web Police."

To give some context, we'd be invited to these conferences in Finland and elsewhere as representatives of the W.T.O. Generally, these are highly-educated audiences. We still keep getting invited to give presentations to bankers and others who think we are various "things"—W.T.O., Dow Chemical, or whatever. As long as we dress up correctly and speak right, we can basically present any kind of grotesque idea we want, and people will be fine with that!

If you look at our Finland talk, we even, at one

point, we're talking about slavery and how Third World sweatshop labor is basically *a new kind of slavery*. The only problem is that, as a *manager* of a sweatshop, you don't actually want to go to these places. So we had a solution: it was this inflatable three-foot phallus that I was actually wearing in front of all of these people—I inflated this three-foot phallus. On the end of it was a TV screen showing a Third World sweatshop. Even *that* went over with them; they just applauded! That's the story of the Ph.Ds.—well, they were mostly business people; MBAs and all.

♦ **V:** *Well, you've created an outlet so you can express your critical outrage—*

♦ **A:** People want humor; people want to laugh. That's the way to get things in the media: either it's terribly violent, or it's funny—and then it gets in the media. It doesn't matter if it's *important,* really—it just has to be zappy; there has to be something exciting about it. So we make it funny; we try to use humor, generally.

♦ **V:** *How come you're in Paris? How did that happen?*

♦ **A:** Well, I fled San Francisco during the dotcom boom. I'd always wanted to live in Paris; I grew up speaking French. I thought, "It's either here or New York," and I can't quite stand New York. Doing Yes Men stuff is cheap. I mean, Mike and I have other jobs. Mike teaches, I have taught in the past, and we just kinda keep things going, one way or the other. If I need to work, I can do computer or video stuff . . . although I don't really like to anymore.

♦ **V:** *Who inspires you these days?*

♦ **A:** I would recommend reading Chantal Mouffe. She's just published a book with Routledge: *On the Political*. It's kind of amazing.

♦ **V:** *What films do you like?*

♦ **A:** Bunuel is great. I love Tarkovsky—I think *The Sacrifice* is an amazing movie. And *Solaris,* and *Stalker*. Do you know Guy Madden? He's great. There's a lot of great documentary movies that have come out—tons, including a lot that didn't get seen enough. *The Revolution Will Not Be Televised,* about the coup in Venezuela, is really amazing. It's about how the U.S. engineered the 2002 coup against Chavez there. It might be the [cheap] technology that's enabled so many good documentaries to come out recently.

♦ **V:** *Technology changes society, and I think a lot of what the Yes Men have achieved was made possible by the Internet—*

♦ **A:** I think it was made possible by it; definitely. (There's other ways to do it, too, I guess.) The Yes Men try to get in there and talk about what the people that are kinda running the world are actu-

ally about—not the people who are at the top, but the people who are the legions, the foot soldiers. Just kinda go in there and give a view of 'em to everybody else. They're just people like us, of course . . . but just to show the mentality that's running the world.

♦ **V:** *And you come up with great phrases. On your website, you called George W. Bush "the fundamen-*

talist terrorist."

♦ **A:** Oh really? Oh, wow. I don't even remember that. Yeah, America is a theocracy now. Do you know the Colbert Report? It's like the Daily Show with Jon Stewart, and is on the Comedy Central channel. Colbert was the one who was calling America a theocracy.

♦ **V:** *I was hoping there would be a total end to religion, but it doesn't look like it's gonna happen in my lifetime—*

♦ **A:** No.

♦ **V:** *Although, how did Bunuel put it: "Thank God I'm an atheist!" Now, who thought of the Yes Men name?*

♦ **A:** I think it was Mike, actually. It's just cuz we agree with our audiences; we say Yes to anything they say! We just emphasize it much more than they usually do. So these speeches that we give; we just push 'em as far as we possibly can. These people that we're talking to, they have a certain logic (or we assume they do). If we're speaking to the W.T.O., we just take the W.T.O. logic all the way to the extreme, so it's saying *Yes* way too loudly. And of course, it's about Yes Men who are always in agreement with the boss. ♦♦♦

S UICIDE CLUB

What follows are several histories of the top-secret San Francisco Suicide Club, which specialized in urban topographic adventuring that is extra-legal but harmless to society. Early members John Law and Harry Haller were interviewed separately by V. Vale and Mal Sharpe.

JOHN LAW

John Law has been active in the Suicide Club, Cacophony Society, Survival Research Laboratories (SRL), and Squidlist. He lives in San Francisco, but regularly travels on urban explorations and adventures. Interview by V. Vale.

♦ **VALE:** When did the Suicide Club start?
♦ **JOHN LAW:** 1977. I was just an eighteen-year-old juvenile delinquent who didn't know anything about anything! I was fortunate to join the Suicide Club, which introduced me to a world of adventure. Our motto was: "To live each day as though it were your last." It was about challenging your fears. The club lasted about five years.
♦ **V:** *Now, who started the Suicide Club?*
♦ **JL:** Five people started it. Gary Warne [pronounced "Warn"] was definitely the avatar—the central driving force. He was a truly unique, brilliant character, but very low-key in his demeanor. He was soft-spoken and looked "normal." However, he had these crazy ideas that he would implement in the real world, and get people to come and do events based on his ideas. The Suicide Club was one of them.

Gary was heavily influenced by the Surrealists and the Dadaists. He introduced us to the concept of "synaesthesia"—e.g., to taste a smell, or to feel an image. He wanted to create experiences that would be like living out a fantasy or living out a film. Climbing the Golden Gate Bridge in the fog with a group of people is a surreal experience. The Suicide Club could create an other-worldly, surreal environment. Getting naked on the cable cars was a surreal experience. He wanted a disconnect with "reality" and a connection with "super-reality." 'Cuz knowing you could fall off the bridge and die is a super-real feeling.

Going out to the drawbridge of an abandoned

ghost town and almost being run over by a train coming out of the mist made you realize how "real" the experience was, even though it seemed so unreal and phantasmagoric. Because when a light came toward the group out of the distance, no one could *hear* anything, and everybody thought it was just some guy on a hand-cranked railroad car. But suddenly it became a train going fifty miles an hour bearing down only a hundred yards away. It was like Daffy Duck opening a door and suddenly a train zooms into your room!

At that time, Gary was a chief administrator for the "Communiversity," which started in 1969 at San Francisco State College. It was part of a sixties hippie concept called the "Free School Movement," where people could actually exchange ideas and information without exchanging money. But around 1974, S.F. State started objecting to certain Communiversity classes having to do with jokes and pranks, like "How To Do Clown Make-up."

Gary and a few other people decided to separate from S.F. State and run the Communiversity as a California state non-profit. However, Gary's interests became more arcane and bizarre. He was interested in hosting events based on fear, sex, lying, and other human interactions. He was interested in the way cults test people's freedom of will, especially in light of the cultural brainwashing that we get every day.

Then Gary came up with the idea for the Suicide Club, a group which would seek the most outrageous, extreme and frightening adventures—both physically and psychologically, and push their limitations to the extreme. He set up a phone tree so that members could mobilize to do something on very short notice. Our plan was to visit Fort Point during the next huge Pacific storm.

Finally, around January 20, 1977, a gigantic tempest hit San Francisco. Four people got together: Gary Warne, David T. Warren (a carny;

he's a whole book in himself), Adrienne Burke, and Nancy Prussia. The fifth person, who didn't make the trip but helped plan it, was Kathy Hearty. So, four people convened at the west side of Fort Point, which faces the ocean. (It's now closed off because of "Homeland Security.") There was a huge, heavy-duty sea chain acting as a protective barrier.

In the middle of this huge storm, with eighty-mile-an-hour winds and giant waves crashing, the four people ran out, grabbed the chain and held on really tight. They held on tight because the sea was hitting below you on this wall, and right in front of your feet was a drop-off that went thirty or forty feet. So the waves would hit this wall and send up a massive wave that crested and fell down on you. If you had taken the full force of the wave, it would probably kill you and sweep you away. But the force of the wave was broken by the wall, so you could hold onto the chain and not die. But it was still very dangerous. Because if you let go of the chain or were knocked unconscious, you'd be swept out to sea and probably never be seen again.

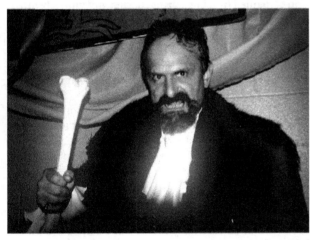

So the four founders of the Suicide Club did that and survived. They were so invigorated and blown away by the experience that they sat down and decided to start the Suicide Club right then and there.

♦ **V:** *So it was a quest for an intense group experience?*

♦ **JL:** Absolutely. And the core of the philosophy was inspired by that statement, "The road of excess leads to the palace of wisdom" (William Blake). The Suicide Club was a secret society, but it lacked any dogma that you had to adhere to (except secrecy)—you didn't have to sign anything in blood.

Years later, I worked with Survival Research Laboratories, which on its own is one of the most amazing enterprises that exists in the world. The Cacophony Society, which began a few years after the Suicide Club's demise, also took up a lot of my time, and in general I've been a part of "urban adventuring" for years. All of these experiences grew directly out of the Suicide Club and out of Gary Warne's philosophy.

♦ **V:** *Gary also got you into "intellectual adventuring": searching out and reading the fantastic literature of Clark Ashton Smith and others—*

♦ **JL:** Absolutely. Well, the authors that I knew as a teenager were Fritz Leiber, H.P. Lovecraft, Ray Bradbury, Arthur C. Clarke, and the standard Sci-Fi writers like Heinlein. When I moved to San Francisco, Don Herron and Gary Warne were the two people I met who expanded my reading to include Arthur Machen, M.P. Shiel [author of *The Purple Cloud],* William Hope Hodgson, Robert Louis Stevenson, and others.

♦ **V:** *I was introduced to them through another gateway: the Chicago Surrealist Group.*

♦ **JL:** Lovecraft for me is one of the most powerful writers ever, despite the weak-minded critics who disparage him. I think he should be in the canon of great writers, although he's viewed as a pulp writer. It's the pulp writers and writers of the fantastic who will survive through the ages—look at Mary Shelley's *Frankenstein* and Bram Stoker's *Dracula!* And Homer and Shakespeare wrote fantasy, fer chrissakes! Some of Shakespeare's best work is fantastical: *A Midsummer Night's Dream,* and *The Tempest.* I get really angry when I see these snooty critics still refusing to acknowledge Lovecraft as among the classics—they really are behind the times.

Anyway, Lovecraft and writers like him were a big influence on the Suicide Club. And so was pulp fiction—the *noir* stuff. You know, when I started reading science fiction, I ran into the Ballantine "Adult Fantasy Series"—

♦ **V:** *That was a great publishing enterprise—*

♦ **JL:** I started seeing them begin to appear in the 8th grade, and I just got every one as they were published. And nine out of ten were excellent. Ballantine Books turned me onto a world of truly weird fiction.

♦ **V:** *So, did you organize any events for the Suicide Club?*

♦ **JL:** The first event I ever organized for the Suicide Club was a sewer walk in Oakland around May, 1977. It became a repeat event and a year or so later we decided that *this* time we would dress "formal." But since we were walking

in water, we wore formal dress from the waist up, and blue jeans and hip-waders from the waist down.

We had about forty people exploring these storm tunnels—they're not actually "shit sewers." We had been in these same sewers three times, but the last time had been a year before. It turned out that construction was taking place, and the sewers had been re-routed. When we finally discovered a way out, we found ourselves in a vacant lot in the middle of East Oakland.

There were forty of us dressed in formal wear, with top hats, white shirts and tuxedos, crouched down trying to be invisible in this lot between these run-down houses behind a Burger King on East 14th Street. We had two scouts inside the sewer, trying to find a route back. Meanwhile, we'd been spotted. Some old guy had called the cops, saying that the Ku Klux Klan were having a rally in his backyard. These two Oakland cops show up—and this is in a really bad, bombed-out, fucking dangerous neighborhood. We're crouching in this lot filled with rusty tin cans, old plastic bags, and all kinds of crud. These cops are like, "What the fuck are you people doing here? You could be killed. We got a call about the Ku Klux Klan and—what are *you* doing here?!"

We tried to explain that we were just doing a sewer walk, and didn't realize that the sewers had changed, so we got lost. We're just waiting before we go back in and try to find the "right" sewer tunnel. These cops are looking at us like, "Are you people insane?!" Finally, one of the cops looks at the other one and says, "Fuck this, Joe—let's go fight some crime!" And they got in their car and drove away! [laughs]

PIE-ING CHARLES COLSON

♦ **JL:** I'll tell you a story. Do you remember Charles "Chuck" Colson? He was famous for saying that he would walk all over his grandmother for Richard Nixon. Colson was a repugnant hatchet-man for Nixon, and ended up doing two years in prison for the Watergate burglary of Democratic headquarters.

While in jail, he saw God and became a born-again Christian. He started a prison campaign to re-Christianize prisoners, and got a pretty good following. He ended up writing a book called *Born Again,* which was a best-selling paperback. So he went on a national book tour and was scheduled to be at the Fairmont Hotel at 8 AM on a Sunday for a prayer breakfast for the Young Presidents Society, a group of young corporation presidents who were under the age of forty, heading corporations which grossed more than $10 million a year. In other words, this would be a room full of possibly ruthless, high-powered people.

My buddy Jerome was a local freelance journalist and he enlisted me to have some fun with Chuck Colson. We went to Aron's bakery, bought two chocolate cream pies, and put them in two satchels. Jerome brought a photographer with him; I brought my girlfriend Joyce, and we all waited outside the Gold Room in the Fairmont while these corporation heads were inside listening to Colson. My role was to pretend to be a Colson groupie; I had a copy of his book out ready for him to autograph.

Joyce and I are sitting twenty feet across the room from Jerome and his photographer. I felt like we were all in a conspiracy to kill Colson. My stomach was turning in knots, there were beads of sweat on my forehead, and I was clenching and unclenching my hands. It was really scary; we were waiting *forever.*

Finally, these guys come out, all wearing polo shirts, nice sweaters, and loafers. Then Charles Colson comes out, and he's a stocky guy accompanied by a big, barrel-chested guy with a beard—obviously a bodyguard. All these people flock up to and surround Colson, patting him on the back and saying, "God, that was a great talk." Meanwhile we're sitting there sweating bullets. I'm thinking, "Ohmigod, we're going to get killed."

Finally Jerome walks up to Colson and says, "Hi, I'm here to interview you." Jerome's talking, twitching and sweating while fumbling with the strap on his satchel, and he just can't get it undone. Finally, he's done with the interview and he walks away.

Jerome and I are standing outside the Fairmont, shaking our heads and kicking the wall. Jerome's saying, "I can't believe I didn't—fuck it, man, it's now or never!" And he pulls out the pie, runs back in carrying it all the way across the lobby of the Fairmont, around the corner and we see Colson heading towards an elevator. We race up and Jerome says, "Mr. Colson, just one more thing," and he throws the pie at him inside the elevator and races away. But the bodyguard is right after him and tackles him right in the middle of the lobby and has him down on the carpet in a bear hug. He's shouting, "Why did you pie Mr. Colson? Why did you pie Mr. Colson?" Then Colson walks out of the elevator, wiping pie out of his eyes like Curly Howard of the Three Stooges, and Jerome goes, "I pied him because Jesus Christ came to me in a dream and told me to smite this man with a chocolate cream pie from

Aron's Bakery." And the bodyguard goes, "What?!"

Colson walks up—by this time there's a whole crowd of people gathered in the lobby of the Fairmont. Some hotel security personnel run up asking, "What the hell is going on?" Colson realizes it's a hit, and he says something to the effect of: "Fuck it, I don't want to press charges—I'm out of here." The security people take us into a room and ask, "Who was that guy?" Jerome says, "That's Charles Colson; he was giving a talk in the Gold Room. He was one of Nixon's guys in Watergate. I pied him." Then Jerome offered to pay to clean up the elevator, but the security chief says, "No, don't worry about it, housekeeping will get it. *Nixon's* guy, huh? You guys just get out of here *right now.*" So no charges were filed and we got away with it! *The Chronicle* published a short piece about this . . .

MORTUARY

♦ **JL:** A funeral home at Market and Duboce Street had gone out of business, and we thought that would be a good place to have a vampire event. First, a few of us sneaked in to do reconnaissance. There was an enclosed carriageway where the hearses could drive in, drop off the corpses, and then drive off. So you could climb up a chain on a ten-foot wall, drop down, enter the carriageway and then "get" into the building.

Once inside, we discovered there was a giant atrium or walkway, with all these hidden corridors at the stairways, plus offices upstairs. This had also been a mortician's school, so there were all these metal bays where bodies could be laid out. We thought this was the perfect place to have a vampire game, with people playing different characters. After months of preparation, Barbara Vince, R.H. Pepper and a few other Suicide Club regulars designed an elaborate game based on Bram Stoker's novel. Forty people attended dressed as vampires, peasants, English vampire hunters, etc. We brought a giant coffin with us to house the lead vampire, did the game, and had a potluck dinner afterwards. Normally we clean up any mess we make, but we were so exhausted that we put all our leftover supplies into the coffin, and then left, intending to come back next week for our coffin.

A week later, four of us parked in the back with a truck, climbed over the wall, went into the building to retrieve what we'd left behind, and our fucking coffin was gone! Someone had swiped *our* coffin out of an abandoned mortuary. We're thinking, "This is pretty weird . . ." Suddenly four cops showed up—a neighbor had

called in saying that people were in the mortuary. That was weird, because a week earlier forty of us had partied there all night and nothing had happened.

These cops ask us, "Hi, how's it going? What are you doing here?" We looked normal and calm as possible, like we belonged here, and we said, "We're here just looking for our coffin." They

PREDISPOSING FACTORS

said, "Oh . . ." Then we told them about the vampire game we had done last week, describing our vampire costumes and our Transylvanian peasant outfits, and gave a full description of our missing black coffin with its gold handles.

The cops looked at us, going, "Is this your building? Do you own the building?" We said, "No, no, we don't own the building. We're just doing our game in here." And they said, "Oh. Well, you know who owns the building, right?" And we said, "No, not really." They're going, "So you're looking for your coffin in this building and it's not your building? You mean you broke into this place?" We said, "No, we didn't break in. This is a great place; this is a mortuary. This is the best place you could possibly do a vampire game. Where could you do a better vampire game than an abandoned mortuary?" They said, "It's not your building, and you went in here to play a game? You must have broken in here!" We said, "No, no, we didn't break in here." They asked, "Well, how did you get in? How did you get into the building?"

One of the strongest philosophies that informed the club was our desire to leave the environments we visited unchanged. We would never "break into" a place. If we couldn't find a way to climb into an abandoned building without breaking a window, forcing a door or whatever, then we were simply lame. This mortuary had a walled, open-topped carriageway that was part of

the rear of the building. This wall was about ten feet high. There was a chain hanging down the backside of the wall in the open parking lot we parked in.

To get in the building, one guy would climb up the chain, straddle the wall and jump down inside the carriageway. He could then open the locked door from the inside, letting in the whole crew. Jerome (not a real name) shows the younger cop how we got in without "Breaking and Entering": "Well, you just climb up that chain over there and jump over the fence." The cop looked at the chain and said, "That's bullshit—you couldn't do that!" And my buddy says, "No, seriously, I'll show you." So he climbs up the chain and jumps over the wall into the carriageway. The young cop, who's macho, tries to follow him, but he fell and Jerome caught him and said, "Well, you're wearing that gun belt and those hard shoes. It would be a lot easier if you were wearing tennis shoes like I am." The cop was pretty sheepish, but felt better with our encouragement.

Meanwhile, I'm talking to the sergeant outside. The cops are just trying to figure out what the fuck we are doing in this abandoned building. And we just told them the complete truth; we didn't tell a single lie. (You never, ever, lie to cops.) The sergeant is intelligent, trying to understand and get a handle on the situation. Finally I said, "Well, we're kind of like a theatrical group." He goes, "Oh, a *theatrical* group!" He could handle that.

Then he spotted our pickup truck which had a bumper sticker that said, "Gravity is the 4th Dimension." (At the time, that slogan was graffitied all over town.) So the sergeant says [getting excited], "Oh, you guys are those vandals that have spray-painted that slogan everywhere!" I said, "No! I've never spray-painted anything, anywhere!" He says, "Well, what the hell does that mean: 'Gravity is the 4th Dimension'?"

I said, "Well, the writer Kent Robinson wrote this book which was an extrapolation on Einstein's Unified Field Theory. Basically, he theorized that gravity is the fourth dimension coming at right angles out of the third dimension. He thought his book was really important, and he wanted to promote it, so he spray-painted this graffiti everywhere." I was trying to explain more about Kent Robinson's Unified Field Theory to this cop, while he's scratching his head and trying to figure out what the fuck we're talking about. The cops do a walk through the building and see there's nothing broken, nothing damaged. Finally the sergeant says, "Look, you guys get into your truck and get the fuck out of here." By now he's talking to us like we're slightly retarded but harmless kids, doing us a favor. "You can't just go into abandoned buildings; you have to talk to the owner and get his permission first. Now get out of here and don't go into this building again!" So, they just let us go.

♦ **V:** *I think the phrase "theatrical group" turned the tide for you . . .*

HEARSE & SCYTHE

♦ **JL:** Some members of the Suicide Club and I got together and bought an old 1963 Pontiac hearse—we each kicked in like fifty bucks. We were doing the only "above ground" commercial event the Club ever did, a film benefit at the Roxie titled "A Tribute to Paranoia." We showed *The Five Thousand Fingers of Dr. T*, a truly bizarre film designed and written by Dr. Seuss, and the funniest film I've ever seen: an Italian comedy titled *Catch as Catch Can*. This film starred Vittorio Gassman as a vain TV commercial star who hates dirt and is hated and attacked constantly by ANY animals he runs into. I laughed so hard I broke the chair I was sitting in!

A friend of mine ordered a full-size scythe from a shop called "Poor Taste" in North Beach for a little pre-show sidewalk theater the Club had planned. On the day of the event we went to pick it up in our hearse. I was playing "Death" that night, and I already had on my Death's head mask as we drove up Grant Avenue. I double-parked in front of the shop and walked in still wearing my death mask. In a deep voice I said to the counter-man, "I've come for my scythe." Without missing a beat the man said, "Was that the large model or small?" "YOU KNOW WHICH ONE!" I replied. These two girls wearing sweaters that said "Iowa" and "Kansas" turned around and dropped their purses . . .

I got the scythe and resumed driving through Chinatown, in this hearse with me dressed up like Death. I stopped for a red light and this little ninety-year-old Chinese lady was walking through the intersection, head down, when she looked up and saw me, and she absolutely *leaped* back onto the curb. She would not cross the street in front of me; she stood there clutching her chest. I think she thought I was the real thing! I mean, you don't want to cross the street in front of Death. Or maybe she had watched too many Ingmar Bergman films!

NAKED CABLE CAR RIDE

♦ **JL:** On April 1, 1977 (April Fool's Day), about thirty Suicide Club members showed up at the cable car barn at Mason and Sacramento Streets.

We met at 7 AM so we could hop on the first cable car out of the barn. We were all wearing raincoats, and we proceeded to strip naked. Then we rode it for several blocks to where we had a couple of photographers set up in the street. The conductor and the grip-man halted the cable car: "Okay, we're going to just stop here until you're done." We took a bunch of photos and that was that. This was a prank that Nancy Prussia, one of the founders of the Suicide Club, had always wanted to do—she had a bit of exhibitionist in her.

The other big prank in the Suicide Club that I really liked was when we took over the three elevators in the Union Square parking garage. When the elevators went to the bottom, we set up different theatrical scenes in each one.

In one elevator there was a guy in a reclining chair getting a haircut, a shoe-shine and a manicure all at the same time. It would open up on different floors and the shoppers and the business

people would be so surprised that they wouldn't get on; they'd wait for the next one.

Another elevator had a gorilla in it, with four people bound and gagged on the floor. The next elevator had a couple sitting at a table with a checkered tablecloth eating a full spaghetti dinner, with a guy in a suit and top hat playing the violin and serenading them. I was in yet another scene where we had a shower curtain strung across half the elevator. I was behind the shower curtain with a tape recorder playing the sound of running water. I was singing in the shower while there were three people wearing towels, holding bars of soap and waiting in line for the shower. These two nicely-dressed old ladies didn't even look as they walked into our elevator. Suddenly they realized they were surrounded by nearly-naked people, and they started tittering. I looked over the shower curtain and said, "All right, ladies, you're gonna have to take off your clothes

and get in line just like everyone else!"

The grand finale, before we raced out of there, was when Dave Warren and his lovely assistant did a fire-eating act (this was before fire-eating was more common). The elevator door would open and Dave (Flammo Le Grande!) would blow a twelve-foot flame out into the lot. Sure enough, just as we were driving away in our vans, the cops started to show up. That was one of my favorite pranks—just the fact that we barely got away with it.

♦ **MAL SHARPE:** I heard about a prank where fifty people went to City Hall and walked down the staircase in extreme slow motion. This made everyone else look like they were moving really fast. Another prank was when twenty couples met at Union Square and they all started kissing on the corner. So when the light changed, all the other pedestrians had to somehow get through them—these couples were like roadblocks. Then one of the couples started making out at the bottom of the escalator at that nice little mall downtown, the San Francisco Center. All these people had to step over them to get by.

♦ **JL:** The Suicide Club did an event with clowns that years later on got re-enacted by the Cacophony Society. The Geary bus line is one of the longest in the city. One morning we had forty people dressed up as clowns waiting at Geary bus stops for about thirty blocks. They'd get on the bus and be holding a briefcase and reading the paper, completely ignoring the other clowns. There were enough clowns that more than one bus was needed. One of the bus drivers got fed up and started grumbling, "I'm not picking up any more clowns."

♦ **MS:** That's great. I love the idea that they don't talk to each other.

♦ **JL:** Yeah, we acted totally normal.

INFILTRATIONS

The Suicide Club also did a lot of street theater at the time. Most of it was pretty amateurish—the point was to challenge our fears. One category of our events was "Infiltrations": we infiltrated weird cults.

♦ **V:** *Did you infiltrate Jim Jones' People's Temple?*

♦ **JL:** Gary and Adrienne and others went to revivals Jones did in the mid-Seventies. The problem was: most of the constituency were inner-city blacks, and we would have really stood out. After the 1978 murder-suicide of eight hundred Jim Jones followers in Guyana, one of our group got a

job cleaning out the People's Temple on Geary Street, and salvaged boxes of memorabilia. There were all these hand-written letters from kids addressed to "Father"; a lot of creepy stuff.

It's difficult to impart to people today how horrifying Jonestown was, and just what an impact it had on San Francisco and the world. Two months after Jonestown, we infiltrated the Moonies, another nefarious and weird mind-control cult. They had a very well-developed indoctrination/-brainwashing program that worked beautifully. They separated individuals coming in from any kind of outside stimulus, and isolated them with a group of like-minded people. Their target audience was 18-year-old runaways with backpacks, and they snared a lot of folks. So some of us stayed with the Moonies for a weekend at a retreat, and that was perhaps our most successful infiltration.

Fawn Brodie wrote a brilliant biography [*No Man Knows My History*] of Joseph Smith, the founder of the Mormons. She documented the literal contradictions and lies that were part of the initial genesis and growth of the Mormon Church, from court documents and newspaper accounts from the 1830s. Smith's creation theories were the ravings of a lunatic—much like virgin birth or the underpinnings of these other silly religions. She was excommunicated from the Mormon church, and she later died under mysterious circumstances. She wrote biographies of Thomas Jefferson, Thaddeus Stevens, Nixon, but Joseph Smith is my favorite. The Mormon church tried to suppress that book; they bought up copies of it. It's hard to find. Unfortunately, I gave my only copy to Larry Harvey, back when he was first starting the Burning Man cult, and I think he took a lot of lessons that Joseph Smith laid out to heart.

We infiltrated the American Nazi Party; Eckankar (a peculiar "spiritual" group led by Paul Twitchell); and we tried to do est, but it was too expensive. We took a bunch of Scientology personality tests, but just as with est, at a certain point you have to start giving them major amounts of money, and we were all broke.

When we actually met the American Nazis and were around them, they weren't obvious, hideous, monstrous ogres. Yes, they had monstrous, horrible beliefs, but they were married and had families; they loved their kids; they had jobs; they were human beings who, aside from these odious views, seemed fairly normal. I found that profoundly disturbing, because aside from their confused ideas, they reminded me of people I knew. *That* was most disturbing.

EXPLORATIONS

In the later adventures of the Suicide Club, we did an exploration of an abandoned mortuary college on Gough Street. Ten of us went into this beautiful mortuary sciences building and walked everywhere. We looked at old paperwork left behind in offices. The steel body trays were still in the embalming room, and in the basement we found a five-gallon bucket of formaldehyde with an entire human torso skin in it from below the head to the navel. Chris De Monterey took it home and put it in his refrigerator, but didn't know what to do with it. I told him, "Take it over to SRL and give it to Mark; he'll figure something out." So he did, and SRL ending up tanning it, tattooing it, and put a nipple ring in the nipple—they made an art piece which they put in an art show. That was an early eighties Suicide Club/SRL connection.

Going out in canoes and rafts to the abandoned mothball ships that were part of the Naval Reserve Fleet in Suisun Bay—that was an incredibly dangerous thing to do. We were doing illegal things but we were *not* criminals, and this broadened a lot of people's perceptions, and made our perceptions more valuable to us.

It was so surreal going on these giant ghost warships at night and exploring all over them—they all had gangplanks between them. We were dressed as pirates and had a big potluck dinner—it was a living application of that William Blake quote, "The road of excess leads to the palace of wisdom." This was organized by Gary Warne, who felt it was necessary to expand the palette of one's emotional life and the senses as well. And

this goal drove the Suicide Club in its adventures: trying to attain this other-worldly, super-real feeling. It was really too brilliant to last longer than a few years.

HARRY HALLER

Harry Haller was a member of the Suicide Club and Cacophony Society. He lives in San Francisco, but frequently travels on urban explorations and adventures. He spends his spare time studying history and taking photographs. Interview by V. Vale.

♦ *VALE: What's the archetype for the Suicide Club?*
♦ **HARRY HALLER:** Well, if you're talking about your classic Jungian archetypes, the one that comes closest is the Trickster. A lot of people describe the founder Gary Warne as a "visionary," but I view him as a guy who wanted to have as much fun as possible, and who used his imagination to figure out some ways to do it.

Gary had a small used bookstore, Circus of the Soul, on Judah Street. Gary was an intelligent guy with a lot of philosophical ideas, but he was also a professional clown. He could juggle; he could create make-up; he could make clown costumes, and would occasionally put them on for various events. He often talked about the "Need to Have Fun," and the necessity of coming up with ways to do it.

For example, he proposed a Suicide Club event called "Lock yourself in a room with ? other people and see if you can agree." *Of course* nobody could agree. Eventually they had to give it up.

Gary said that he wanted to live out all his fantasies before he died. For him, the Suicide Club was a way to do that. One guy remembers him as "highly manipulative," but personally, I thought he was a pretty nice guy with a surprisingly high tolerance for interpersonal conflict.

Now, at his events there was often quite a bit of conflict. There were several different kinds of events: *theatrical,* like Steve Mobia's "Decoy Street." Steve's name was an acronym for "movie beast." Remember the decoy vice cops in the Tenderloin in the mid-seventies? You'd see a suspiciously well-dressed man lying on the sidewalk with his wallet sticking out of his pocket. He'd usually have a two-way radio, and if someone reached for the decoy's wallet, all these cops would appear out of nowhere and arrest the would-be mugger.

Steve had us dress up as different characters: decoy hookers, decoy drug addicts, decoy muggers, and decoy decoys. Then we'd end up in a particular Tenderloin block acting these roles out. So that's an example of a *theatrical* event.

Then there was a group of people who got together to sing folk songs—a much more conventional event. Another group staged a food fight at McDonalds. One group just went to movies together—they called themselves the "Movie of the Month Club." Some people taught classes because they wanted to learn about something, and others got together to do political activism, like protesting the Diablo Canyon Nuclear Plant. But there was a lot of overlap between the groups.

♦ *V: Groups within groups. What was the basic organizing principle of the Suicide Club?*
♦ **HH:** It was very simple, and in a way a mark of genius itself. The only organization was the Suicide Club Newsletter, sometimes called the *"Nooseletter."* Gary edited the first year's worth of them, but afterward each month had a new editor. Anybody could submit any event they wanted . . . and they did. And the events *I* preferred were the "adventures" or "explorations."
♦ *V: How did you join the Suicide Club?*
♦ **HH:** I was running a volunteer program at the Haight-Ashbury Free Medical Clinic and one of my volunteers kept encouraging me to join—I finally did, in June, 1977. Many of the Suicide Club lived in the inner Sunset and would hang out with Gary at his bookstore. After I joined, one evening a guy named John Law came up to me and said, "So, are you going to climb the

Golden Gate Bridge with me?" [laughs] John's the kind of guy who, if he wasn't sure of you, would throw down a dare to see if you "had it in you" or not. So I picked up the gauntlet. The two of us spent the evening scouting out the bridge and climbing it—which up to that time was definitely the most adventurous thing I'd ever done. A couple months later we led a group of about thirty Suicide Club members up the bridge—and got away with it, too.

♦ **V:** *How did you climb the bridge?*

♦ **HH:** We went over to the Marin side, parked by the abandoned bunkers, and walked the ridge down to the flat land below the bridge. We threw a rope over a girder and John Law climbed the rope and let down the rope ladder. We all climbed up that, walked the girder lines out to the tower, and got in a tower through a hatchway and climbed the ladders up to near the top.

♦ **V:** *So inside the towers are ladders—*

♦ **HH:** Yes, the towers are hollow inside, with ladders and hatchways every thirty feet going straight up. We weren't going to climb up the cables. Cables are for people trying to get attention. We were just trying to have fun, not get caught.

♦ **V:** *That still sounds a bit risky to me—*

♦ **HH:** It was one of the scariest things I've ever done!

It's exciting to explore abandoned buildings. I organized an exploration of the old Harkness Hospital near Fell and Baker Streets. People signed up for a "mystery event" and I delivered to their addresses the instructions—I'd slip 'em under a doorway, ring their bell, and run like hell! [describes complicated event, with a trail of instructions left in phone booths, leading to a simulated kidnapping victim, threats of a serial killer, a blindfolded excursion to the hospital, ending with a whipped-cream pie fight].

There's an abandoned armory near 14th and Mission Streets I've always wanted to explore, but it's too hard to break into. Do you know what armories were originally for? There didn't used to be police until relatively recently. When there were riots, the military were called in. Union Square in San Francisco used to be a site for political rallies and protests, and there was an armory at the corner of Post and Powell ready to spring into action.

INFILTRATIONS

Another infiltration involved John Wickett, who had a Museum of Exotica. He came from old Metro-Life money by way of Atherton, and was the family black sheep. Somebody in the Suicide Club had discovered there was a weekly orgy in Pacific Heights, and organized a group of people to infiltrate it. It turned out the orgies had been organized by John Wickett. To attend, you had to be accompanied by a woman—you couldn't go as a single male. So those were a couple of examples of infiltrations. There were other people hosting orgies during that time [late seventies]—John Wickett's wasn't the only one.

Gary had heard about the National

Speleological Society [NSS, for cave explorations], and thought the Suicide Club should infiltrate one of their meetings. There was a local chapter in Palo Alto. It turned out they were a very small group, and there was a whole bunch of us, so they immediately knew something was up. But they were perfectly happy to welcome us, and they ended up teaching us rope-climbing and other techniques, which came in handy on adventures. A small group of Suicide Club members stuck with the NSA and went to Mexico to descend a 1,200-foot-deep cave pit, in which you slid down a rope 1,200 feet to the bottom and then climbed it back up again—using equipment, of course. That was one of the rare infiltrations which actually worked out into something good.

♦ **V:** *An attempted prank crossed over into a different kind of "reality"—well, expect the unexpected! So you probably learned rappeling technique—*

♦ **HH:** Yes. Well, the *first* time I rappeled off a building was back in the late seventies. I met this guy named Jim Eller who was in the National Speleological Society—he was a "caver," someone who does a lot of climbing and descending with ropes. He was also a graduate student in Computer Engineering at U.C. Berkeley. We had

been talking about the British climber Edwin Drummond, who scaled the Transamerica Pyramid in the seventies, and Jim said, "Hey, let's rappel off the Computer Science Building [ten stories tall]—I have a key to the roof."

So we went over to Berkeley, and Jim got us onto the roof. I had a really long caving rope, long enough for us to "rap" all the way down. We did that, and had a helluva good time. Afterwards—this was about one in the morning—we went into the computer lab, and he parked me in front of a computer—I'd never been in front of one my entire life, and taught me a simple Komputer game which involved being stuck in a cave and finding your way out. Being the kind of guy I am with computers, I immediately got lost. In frustration, I typed "goddam it" on the keyboard and pressed "enter," and the screen flashed back at me, "Watch it!" [laughs]

Another time, I took John Law up the concrete tower of the S.F. cable anchorage. An earlier time, he took me up to the top of the Golden Gate Bridge. Then inside the tower, we rappeled down to the bottom, where we found a rescue stretcher! After that, we "rapped" off all sorts of places.

Downtown Detroit now has literally dozens of abandoned skyscrapers. Remember the Detroit race riots of the sixties? Detroit's population shifted from being, like, 80% white to being 75% black and 10% white, and many businesses just left these buildings behind. Two decades later in the Cacophony Society, I visited some friends there, brought my climbing equipment, and we spent an entire week entering abandoned skyscrapers and rappeling off them. And we didn't get caught. I love Detroit—it's a great place if you like "urban exploration."

◆ **V:** *Rappeling is one way to conquer vertigo. I don't know if you can conquer claustrophobia—*

◆ **HH:** Right; I already mentioned the lock-your-self-into-a-room type of event—"Conceptual Claustrophobia"? There were also occasional all-weekend adventures. Then there were the "Enter the Unknown" events. Once Gary took his book-store and covered all the bookshelves with plastic sheeting, then filled the space with balloons. When the people who had signed up for the event showed up, he had everybody disrobe, smear themselves with Crisco and then enter the balloon room.

At one point eleven of us pooled our money and bought a 1963 Chrysler hearse, so we'd often go to Suicide Club events in a hearse. We had to form a hearse committee to share responsibility for maintaining it, and there was a sign-up book so you could reserve the hearse for events.

◆ **V:** *Tell us about another favorite event—*

◆ **HH:** Someone organized an event which involved stringing ourselves along Geary Street dressed in clown costumes. The idea was that we were supposed to be clowns going to work—clown executives, clown sales people, clown short-order cooks, etc. So the first set of clowns would get on at the beach, then at each stop more and more clowns would get on, until the bus was almost totally filled with clowns.

But what *actually* happened was: the organizer, who was at the beach, forgot about the "limited" express buses and boarded one! So, the limited bus with the first few clowns in it raced by the bus stop where the next group of clowns was waiting. This set of clowns went racing down Geary Street after the bus! They ran into the next group of clowns which the bus had sped past also. This went on all the way down Geary Street to the next express stop. So, instead of a bus being gradually filled with clowns, a huge group of panting, sweaty, hot, clown makeup-dripping and thoroughly disheveled wannabe clowns finally got on this bus.

◆ **V:** *That's kind of sad—*

◆ **HH:** Well, it's the actual story. But in terms of urban mythology, it's better to just remember the original idea.

One of my favorite explorations or adventures was: we canoed out on Suisun Bay and climbed aboard the mothball fleets there and spent all night exploring the World War II Victory and Liberty ships. Some of them were reactivated for the Vietnam War; I found a map of Saigon harbor in one. Remember the Glomar Explorer, the Howard Hughes ship which the C.I.A. refitted to go out and salvage the Russian submarine that had gone down in an accident? It's parked there, too. I just love exploring places where you don't normally get to go and see stuff.

The Suicide Club did another event where we rented canoes and explored underneath the wharves of the Embarcadero at night. We tried the same thing at Islais Creek but it was much less successful. But, there are some great buildings there to explore.

◆ **V:** *Have you done any other events in abandoned buildings?*

◆ **HH:** Some people in the Suicide Club, Steve Mobia and Carla Wood, knew some strippers. Now the Victoria Theater (on 16th St. at Capp St.), it started as a live theater in 1907 and was converted to a nickelodeon in 1914. It went through other incarnations before being named the Victoria. In the forties and fifties, strippers worked at the Capitol on Ellis Street, later at the

President Follies on McAllister Street, and when those two venues closed, they moved to the Victoria and stripped there in the sixties. It was S.F.'s last burlesque house.

The Victoria Theater had been abandoned, and one of the Suicide Club members got the idea to sneak in and stage an old-fashioned burlesque show with some of the original strippers. We got about a hundred people together, bussed them there, sneaked into a side entrance, and staged an actual strip show, with an emcee, comedian, slapstick, strippers, a snake act, a "Little Girl" act—you name it. The music was stripper-style fifties Big-Band, like David Rose's "The Stripper." This got perfectly pulled off, without anybody getting caught. And I don't know where the electricity came from . . . You know how some events you can't get to work right for love nor money? Other events are blessed; everything works perfectly from A to Z. This event was like that.

♦ **V:** *Did the Suicide Club have initiations?*

♦ **HH:** Every four months there would be a Suicide Club initiation, plus an occasional garage sale to raise money to pay for publishing and distributing the newsletter. You haven't *lived* until you've escorted fifty to a hundred blindfolded people down a city street to a destination! When I was initiated, they put little cut-out pieces of dough over people's eyes and *then* blindfolded them, so people couldn't cheat. We were all taken on a Muni bus and had no idea where we were going—it was pretty funny.

♦ **V:** *I'm sure it looked strange. By the way, where did the name "Suicide Club" come from?*

♦ **HH:** The name Suicide Club was taken from Robert Louis Stevenson's short story of the same name. He came to San Francisco to marry a woman who was breaking up with her husband. After staying several months, he left for Tahiti with his new wife. Gary Warne chose the name, and he employed a manifesto: "Members have agreed to get all their worldly affairs in order, to adhere to the world of chaos, cacophony and dark saturnalia, and to live each day as if it were their last." Also, "solidarity" was a necessity, because the only way to do an event safely was to be unified in your purpose.

In my opinion, the Suicide Club's best year was the first year. There were ten to twenty events listed in each monthly newsletter, and it lasted from the Spring of 1977 until 1982 or '83. The visionary founder, Gary Warne, started to lose interest after the first year, and he let others keep things going. Also, the Communiversity,

which had provided a constant source of "new blood," started excluding the Suicide Club initiations from their course catalogs. So those two events caused a slow demise.

♦ **V:** *How old was Gary Warne when he died? I went to his bookstore a few times and he looked quite young, with a ponytail. I don't remember him telling me about the Suicide Club, much less about how it got started.*

♦ **HH:** He died when he was in his thirties. And the Suicide Club was *very* underground, because the only thing that allows group pranks like this to continue happening is *secrecy.* The Internet is seductive when it comes to publicity and fame—everybody wants their fifteen minutes—and everything gets publicized, and in no time "The Man," who uses computers just as well as the rest of us, gets wind of it and implements measures so you can't do it anymore. And *now,* you mostly *can't* do things like this anymore, so you may as well talk about what's been done.

♦ **V:** *What was the dark side of the Suicide Club?*

♦ **HH:** I have to give Gary Warne credit for being an unusually responsible individual in emphasizing safety, organization, and taking care of people. So the dark side was relatively minimal, I thought. Gary died on Thanksgiving Day, 1983; he was John Law's best friend, and to this day John celebrates Thanksgiving by going to one junk or B movie after another in memory of Gary—that's what they liked to do together. The Suicide Club died off gradually. ♦♦♦

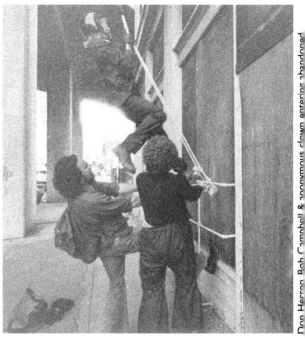

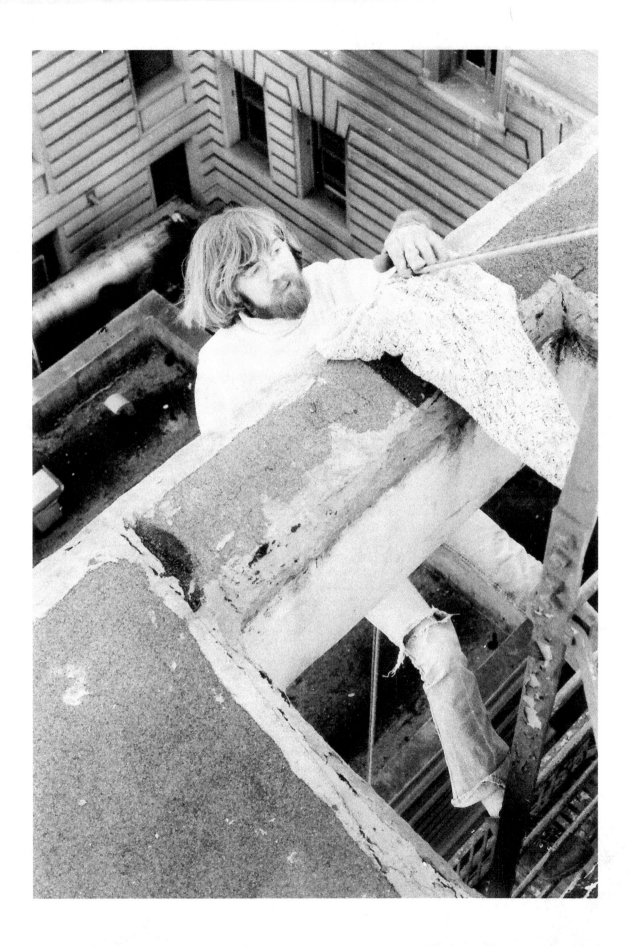

CACOPHONY SOCIETY

The following Cacophony Society interviews took place over several days. They included John Law, Chris Radcliffe, Sebastian Melmoth, Peter Doty, Marian Wallace and V. Vale. Like the movie *Rashomon*, we present several versions of the Cacophony Society's history.

YOU MAY ALREADY BE A MEMBER

♦ **JOHN LAW:** The Cacophony Society was entirely formed by members of the Suicide Club in 1986. The Cacophony Society's tagline was "You may already be a member." The Suicide Club's newsletter had been christened the "nooseletter" by Don Herron, and the Cacophony Society's newsletter was titled "Rough Draft" because we couldn't come up with a better title.

The Suicide Club and the Cacophony Society shared one thing in common: both were *amateur* groups. We were stumblebum goofballs and social rejects, and we remained that way. There was no hipster cachet whatsoever. People were genuinely interested in a handful of activities: exploring, doing bizarre and interesting events that pushed their boundaries, and getting laid—anyone who joins a social group is usually interested in getting laid, unless they're already involved with somebody.

♦ **VALE:** *Now, Harry Haller said the main difference is that the Cacophony Society was more interested in doing street theater and getting publicity, whereas the Suicide Club was extremely secretive.*

♦ **JL:** That's a good point. Cacophony was a much more open group, with more street theater and far less organizing of illegal events. For every article that appeared, ten or twelve new people would show up at our monthly meetings, and out of that one good person was sucked into our evil cult and never left! Whereas with the Suicide Club, we were worried that the cops were going to read about us and start doing surveillance, but in retrospect, we were such a minor group that the cops didn't care *what* we were doing.

In the current "Urban Exploration" movement which is worldwide, there is a lot of controversy over publicity. Julia Solis, who's gotten a lot of well-deserved press and who wrote a book titled *Underground New York*—her original inspiration was the Suicide Club. In the late Nineties she was a founder of the Brooklyn Cacophony Society, which then morphed into Dark Passage and Ars Subterranea, which are her underground exploration groups. However, she only mentions "above-ground" underground sites and locations that are already "outed." She's very quiet about locations the groups don't want publicized.

Last year we spent 24 hours underground in Paris limestone catacombs a hundred feet underneath the city. Very few people know where the entrances are. Same thing in Berlin; we hooked up with the people who wrote *Underground Berlin,* and they took us to underground chambers left over from World War II—we were in the secret escape tunnel which Goering used to exit the Reichs Chancellor Building . . .

Back to Cacophony: because most of us weren't professional actors, doing street theater was a challenge. It challenged your fears, although in a smaller capacity than in the Suicide Club, and gave you a small "rush."

Caré Galbraith and Phil Bewley were fans of the filmmaker Tarkovsky, and they came up with the idea of "Zone Trips." The idea was to go in another "zone," as though you were in another, or parallel, universe. It was "Surreal Tourism." It helped you look at wherever you were in a completely different way, almost like a William Burroughs cut-up. This group would have all these crazy ideas about where you might go, and you tried to have no pre-conceptions about what it would be like when you arrived.

So a group of us took a trip to Los Angeles, and agreed to do whatever people's fantasies dictated. We stayed at the Royal Viking Hotel—ten people in one room. We ended up climbing the giant "HOLLYWOOD" sign (which you could still climb at the time), and visited an abandoned neighborhood close to LAX Airport. It was a really creepy, weird place with these huge planes continuously flying right over you. One person was fanatical about "date shakes," so we drove to Indio and went to the Royal House of Shields, a date farm where they have an ongoing theater playing a film called *The Sex Life of Dates*. On the way there, we saw the giant Brontosaurus roadside attraction. We visited the Bradbury Building and the Million Dollar Movie Building which are on Broadway in downtown L.A.—I think both buildings were used as exteriors for the movie *Blade Runner*.

We also visited West Covina, the archetypal bland, boring, completely flat L.A. suburb, at 6:30 AM. We were wearing white jumpsuits and started handing out questionnaires to anyone on the street, and a number of these were actually mailed back to us. Some of the questions were about oranges, because West Covina had been an orange grove at one time, and a lot of the others were absurdist questions.

We tried to explore the Bradbury Building but it was pretty locked up. But the Million Dollar Movie Building was open and about 90% abandoned. The movie theater was still in operation, showing triple-billings of Spanish-language films, with about ten floors of offices above. We got up on the roof through a side stairwell—and this is an incredible building with bas-reliefs of Hollywood icons on the side. One of the abandoned offices had belonged to the movie producer Harry M. Popkin, who had produced B-movies in the fifties, including *D.O.A.* with Edmund O'Brien. The door was unlocked and everything was still there, including a bunch of movie posters.

In 1988 what became Burning Man was happening at Baker Beach in San Francisco, with about two hundred people having a barbecue and burning a stick figure on the beach. By 1990 it was bigger with 300–400 people; Michael Mikel and I formed a security team with

other people to help out with that, and we got shut down by the cops. Kevin Evans, Sebastian Hyde, P Segal and I had been to Black Rock desert before, and when Burning Man got shut down it just seemed obvious: let's take the whole thing out to the desert.

At the time you could go out to Black Rock, and 99 out of 100 days you'd not see a single car on the playa. An adjunct to Cacophony was the Bolt-Action Rifle Club, with Carrie Galbraith, Eric Chipchase, and other people who liked dressing up in period military garb. They went to Black Rock and were shooting at targets in their British military uniforms while sipping tea. So that was the first Cacophony event at Black Rock, the location that would later host Burning Man. This most influential Cacophony Society zone trip took place in 1990, when about seventy of us went out to Black Rock Desert.

◆ **V:** *Tell us about the Santa Claus pranks—*

◆ **JL:** First of all, the first time [1994] a large group of us went downtown all wearing Santa Claus suits, this was a powerful image nobody had seen before: people's jaws dropped, and little kids went nuts! (Of course, after this happened for years, it became somewhat diluted: "Oh yeah, the Santas again.")

◆ **V:** *Who thought of the idea?*

◆ **JL:** The evil mind behind the Santa thing was Rob Schmidt. Rob is a really quiet guy who blends in and never makes a scene. You'd never know that *he* was the guy causing all the trouble. He was responsible for a lot of Cacophony's best-known shticks: "Kill Your TV," where we smashed over 500 TVs in a variety of creative fashions, and the "Salmon Upstream Run" at the

SF Bay to Breakers that has become one of the signatures of that huge annual event. Michael Mikel and I organized the Santas and "Kill Your TV" with Rob, but he was the idea guy.

At the beginning, we had about thirty-four Cacophony people dressed in Santa Claus costumes meet at the Embarcadero ice skating rink by the Vaillancourt Fountain. First thing we did was to get into a big snowball fight with all these kids, because there was a huge pile of ice shavings just sitting there, left by the maintenance crew's machine, which has to regularly skim the rink to keep it smooth. Then we headed downtown, hitting some bars on the way before we invaded the Fairmont Hotel. After going through a bunch of other hotels, we finally ended up at Macy's where we walked through the store chanting, "Charge it! Charge it! Charge it!"

The Santa event had been a lot of fun, so the next year we announced it and this time a hundred Santas showed up. For the second time I strapped on a full-body harness underneath my Santa suit and mingled with a hundred other Santas on Market Street. At one point, I started running down Market Street and about thirty Santas ran me down and started beating me up, wrestling me to the ground. They hoisted me up over their heads, threw a rope over a lamppost and strung me up so I was hanging about twenty feet in the air. Then all the Santas started chanting, "Kill the scab Santa! Kill the scab Santa!" [laughs] It looked like I'd just been executed by a lynch mob of Santa Clauses! That's when we realized where the line is drawn between a group and a mob—it's probably just below a hundred. We had procured bullhorns for a couple of "Control Santas" who ostensibly were supposed to lead this mob, but as you can guess that didn't work very well.

We went to the Hyatt at the end of Market Street, and Santas started sliding down the escalators to the bar there. Then we all tried to take the elevators up, but the management started chasing us out of there. Next we took over several cable cars going up the California Street hill, where we regrouped at the Fairmont. One of the Santas, Nik Phelps, the Sprocket Ensemble bandleader, had worked at the Fairmont as a pick-up musician, and knew a secret way into the Venetian Room, so a hundred of us Santas burst into the room, right into the middle of a debutante ball around nine o'clock. The room was filled with all these teenage girls with their rich grannies and families. A hundred of us walked in shouting, "Merry Christmas!" and everyone thought we were part of the show, because we're all dressed in Santa costumes. Immediately we start dancing with the grandmas, swiping $200 bottles of wine off the tables and passing them around . . . of course, within ten minutes we got kicked out by the hotel security. We saw them coming and the whole shtick with the "Santa thing" is to keep moving—you never want to stay in one place very long. Because people think you're *supposed* to be there when you first show up, but eventually they start noticing that the suits have vomit on them and are dirty, and that some of the Santas are really drunk . . .

We moved out of there and tried to descend to the Tonga Room, but security headed us off at the pass. We left the Fairmont and walked down Powell Street to Macy's, and again chanted "Charge it! Charge it!" as we swarmed through the store. Then we crossed Market Street to the Emporium, because we wanted to go on the roof where they have little carousel rides.

Our intention was to go to the roof and ride the ferris wheel up there. However, some of the Santas were really drunk, and they got into an altercation with the Emporium security guys, who were these young punks. One of the Santas had taken a wreath off the wall and was wearing it, and another Santa had "borrowed" one of those velvet ropes. We left the Emporium when security called the police, and headed for a local bar.

Now I had a portable police scanner with an earphone in my ear and I discovered that the Emporium had called in a complaint against the Santas and that four paddy wagons had been requested. I thought, "Oh shit, they're going to try to arrest us!" I got all the Santas to try to hop on the Geary bus and get out of downtown—then maybe the police would leave us alone. So we're standing at a bus stop while a police lieutenant is watching us from across the street and I'm thinking, "Shit, I've got to at least *try* and diffuse this."

I took off my police scanner radio, handed it to somebody, walked across the street and said, "Hi. I just wanna let you know that things got a little out of hand, but we're leaving the downtown area now. Sorry." And he goes, "What are you guys protesting?" I went, "Gee, we're not protesting—I didn't even vote." He said, "Well, what are you doing?" I said, "It was just a party of Santas and things got a little out of control. Some of the Santas had a little too much to drink, and we're taking them to a private party out in the Avenues. We're leaving the downtown area." And the lieutenant said, "Okay, get out of here!"

We got on the bus. However, the Emporium had filed a complaint against us, so that meant

that the cops *had* to pull us over. By the time the Geary bus had arrived at 34th Avenue and Geary, these cops pulled the bus over. It turned out that a line of cop cars had been following us, like lampreys following a whale. The cops made all the Santas get off the bus and take off their beards. We got it on video; it's really funny. The cops picked out two guys, one of whom was an actual culprit and another guy who was innocent. They ended up spending the night in jail for being in a tussle, although they dropped the charges later. The rest of us continued on to the Legion of Honor where the *S.F. Chronicle* Christmas party was happening. But we got thrown out of that after only about ten minutes . . .

That was the second Santa get-together. The third year, we went to Portland, and that's another story—that was insane. The fourth year we went to Los Angeles where we had 200 Santas show up, and the fifth year we went to New York where 150 Santas convened. Check the website *www.santarchy.com*. This site collects photos and information from everyone else who's doing this event all over the world. Scott Beale made a short movie out of our Santa events titled *You Better Watch Out!*

♦ **V:** *The Santarchy became like a virus that replicates itself.*

♦ **JL:** All thanks to the Internet, which also

helped Burning Man become such a big thing.

PORTLAND SANTAS

The first Cacophony event in Portland took place in a gigantic abandoned Greyhound bus repair facility. People dressed in costume and did theatrical things.

Chuck Palahnuiak joined in '94 and became

good friends with Chuck Linville and Marcy McFarland, some of the Portland Cacophony organizers. I met him when we did the third Santa Claus event, which was in Portland. The first was in '94 in San Francisco, the second one was in '95 and turned into a mob scene—several Santas were arrested—so we decided we wouldn't do it again. (The thing about "annual" events is that they tend to become too predictable and encrusted; often there's not a lot of creativity the second or third time you do something, and certainly not by the fourth or fifth.)

The third Santa event in 1996 took place in Portland—that seemed like such a nice, quiet town. We advertised this in the S.F. Cacophony newsletter and Reverend Al, the Cacophony avatar of the Los Angeles group, put the word out. We ended up with a planeload of *seventy* Santas leaving San Francisco. One of the Cacophony members was a travel agent, Nancy Freiburg, who was also a member of the Bolt Action Rifle Club. Thirty more came up from San Francisco in Chicken John's bus, there were thirty from L.A., and easily a hundred from Portland. So there were more than two hundred Santas altogether.

Somebody ratted us out. The Portland police contacted the San Francisco police and got the police incident report from our Santa event the year before. So they were prepared for us. They sent flyers to local merchants saying that Sant-anarchists were planning to trash the town, and the police may have even tapped our phones or were monitoring our emails. We got off the plane and were met at the airport by three officers of the Portland Police Intelligence Bureau.

We said, "Look, we're like the Elks Club. We're gonna spend money in Portland. We're not here to trash businesses. It's just a fun event. We're just a bunch of morons in red suits; give us a break!" They ended up following us around for the entire weekend. There are a lot of stories because some of the groups split off and did different things. My group, which had about thirty people, decided to take a public bus to a roller skating rink near outer Portland, and there were two cop cars following the bus. There were cop cars following each group; they must have deployed fifty to sixty cops following Santas this weekend.

Then we took the bus to Chuck Linville's house, who's one of the main Portland organizers.

He's also an Art Car guy, and works for the Post Office. We decided to see if we could ditch the cops. So the bus stops a couple blocks before Chuck's house, and as soon as the door opens, everyone runs like hell and hides behind a wall. The cop car squeals around the corner, doesn't see thirty Santas, and starts going two miles an hour, looking for us. Then we all jump out from behind the wall and go, "Surprise!"

All these Santas convene on Chuck's suburban lawn, while four cop cars are parked at surrounding intersections, watching us. Finally, the cops start to realize that we're just partying; we're not some hardcore black bag anarchists. Some Santa girls are going up to them, asking, "Have *you* been naughty or nice?" The beat cops are thinking, "This is a waste of time; why are we following these Santas?"

The culmination came at sunset, when all the Santas were going to meet at the giant Lloyds Center mall in downtown Portland, with this ice skating rink where Tonya Harding skated. By this time the police had been following all of us for a day and a half, and now there was a line of police cars parked, completely blocking our entrance to the mall. We tell the cops, "Look, we want to go into the mall and sing Christmas carols. Think of the wonderful image of all these Santas in your mall."

They said, "The mall is private property. We don't care if there's two hundred of you; if you go in, we'll have to arrest all of you." So all the Santas were despondent: "What are we gonna do? We gotta do *something.*" There was a line of cops standing there in body armor and truncheons, so we formed a line and started singing "Jingle Bells" to them. Then we yelled, "Merry Christmas!" and turned around and took the train downtown.

To me, the Santa event in Portland was the greatest thing Cacophony ever did. The visual image of two hundred Santas facing a line of riot cops was amazing; nobody had ever seen that before. You're messing with and subverting this commercial icon. We knew that the cops weren't our enemy; they're just working class Joe's doing their job, which is protecting property. And having a phalanx of cops protecting a suburban mall from Santas who really weren't a danger to them (they're a danger to the *symbol,* but not the mall) —I thought we pointed something out, there. It was a pretty brilliant moment, and it was fun.

NEW YORK SANTAS

♦ **JOHN LAW:** The last time I participated in a Santa event was in 1998 in New York City. By then the event had taken off as a cultural meme through the Internet; happening in America, Tokyo, London, and Auckland, New Zealand. Cacophony regular "Sandwich Girl" even organized a Santa event at the South Pole!

Scott Beale and I went to the New York Santa event, and a couple interesting things happened

that were unique to New York. Santa Dennis from Detroit and I climbed the cables to the top of the Brooklyn Bridge in Santa suits, while seventy Santas were on the promenade deck below, ready to give us cover if the cops showed up. No cops saw it, and Scott filmed it.

Wearing Santa suits, we took subways all over the place. We went rock climbing in Central Park, swarmed through the Plaza Hotel and were immediately surrounded by security who shunted us out through a side door. Then a hundred Santas went to nearby Central Park and came across a pond filled with two hundred people ice skating. As soon as we appeared over the rise of a hill, they all stopped and stared at us. We came up

to them and said, "Merry Christmas!" And that was it. Since I'd always hated Christmas, it felt good to take that commercial iconography and turn it into a personal event. And since the original Santa had been a kind of prankster or trickster, I felt we'd somewhat restored the original intent.

MANUFACTURED PRANK "PRODUCTS"

♦ **JOHN LAW:** In the nineties, the Cacophony Society actually manufactured fake commercial products and put them into stores. We didn't get a lot of attention for this 'cuz we didn't do a full-on press barrage; it was just fun to do.

One was: we manufactured a *My Bloody Valentine Severed Penis Novelty Toy.* First, we designed and printed cardboard product containers, which looked exactly like something you'd see at a Hallmark store or a Safeway. Then we "manufactured" some severed penises. We built these penis molds out of plaster—I'm not going to say whose penis was the model, but it wasn't mine! We could make twenty of these at a time using commercial liquid rubber that you pour into a mold, and we made hundreds of them. Then we sealed them inside small sandwich bags, put them in the boxes and placed them in stores.

We even manufactured a "John Bobbitt" severed penis. The label read, "Cacophony Imports Limited, concept by Lorena Bobbitt, made in the U.S.A." The back of the label said, "Ten percent of net sale proceeds from this novelty are donated to *Up with Eunuchs*, a non-profit organization dedicated to the continuing separation of men from their tools of oppression. We invented other groups endorsing our product: *Partners Without Penises, Pen-Anon,* and groups that were acronyms: *R.A.G.E.,* which was *Radical Alliance for Gender Equality,* and *C.H.O.P,* which was the *Committee to Hatchet Offensive Parts.* Joe Fenton, Vanessa Kuemmerle, Michael Mikel, myself and others were involved in this prank.

We manufactured another product called *Laughing Bitch Brand Severed Penis Chew Toy*—it was a rubber chew toy for your dog that was a penis. We "borrowed" a barcode from an actual product, put it on the labels, and placed them at Safeway, so when people would buy it, the cash register would record it as "chicken sausage"! We also placed these in a couple of Hallmark Stores, which are in malls, as well as other stores around the Bay Area.

Lance Alexander is a Cacophony prankster who wrote the original Cacophony Manifesto, taking a lot from Gary Warne's Suicide Club philosophy while adding his own unique twists. He's also a wonderful graphic artist. He designed and printed a perfectly-executed *Hello Kitty* T-shirt, which at first glance resembles two little kitties playing. But if you looked closely, you'd notice that one of the kitties is holding a little gun, and the other kitty has blood splattering out of the back of its head. The caption read *Goodbye Kitty.* The graphic was so professionally done that you really had to do a double-take to notice that it wasn't *Hello Kitty.*

We put some of these in the Sanrio store near Union Square, San Francisco. Whenever I wear that shirt around, people either love it or they try to hit me! This never got any publicity, although we could have made a much bigger deal out of it.

♦ **V:** *That's a good example of an anti-consumerism prank.*

♦ **JL:** Lance did another prank T-shirt that had a big blood splatters across the front, with a caption underneath that read *Handgun Accidents Are a Product of Natural Selection.* People who were pro-gun control thought it was against them, and people who were anti-gun control thought it was against *them!* This was definitely an ambiguous message: was it saying that it's *good* to have handgun accidents, or bad?! That was a favorite T-shirt that I wore for years.

AND MORE PRANKS

♦ **V:** *Tell us another Cacophony Society prank—*

♦ **JL:** We were up in Portland, Oregon, getting together with members of the Portland Cacophony society. On a whim, we rented a Lincoln Continental Town Car and staged an event right in the middle of downtown Portland. Vanessa Kuemmerle was walking down the street really nicely dressed, right in the middle of the day. The streets were packed with business people going out for lunch or walking around. We screeched into the middle of a major intersection in this brand-new Lincoln Continental, leaped out, grabbed Vanessa and threw her into the trunk of the car, then sped away. Just to see if anybody would do anything. They didn't. Nobody called the cops, even.

♦ **V:** *That's pathetic.*

♦ **JL:** Yeah, it's totally pathetic. Not a single cop car chased us . . .

♦ **V:** *That sounds like something out of a film. Actually, have you ever thought about the topic of pranks in American films?*

♦ **JL:** I immediately think of the Three Stooges. In some ways the Three Stooges are distillation of American culture—a crystallization of everything that's important to Americans. They're violent; they hit people over the head with hammers and pots and pans . . . but my favorite thing is when Moe took his index and middle finger and stuck 'em into both nostrils of Curly's nose and dragged him along. It's sort of a metaphor for our current foreign policy—it seems to work pretty well for some people but not that well for others.

♦ **MARIAN WALLACE:** My mom wouldn't let us watch the "Three Stooges" because she was afraid we might imitate what was going on, like hitting someone over the head with a hammer—

♦ **JL:** Yes, but that's just part of the ongoing natural selection process! The dark end of the prankster spectrum owes a lot to the Three Stooges, who were always beating each other up and taking their anger out on one another. However, like the Marx Brothers, they were also attacking and insulting the upper classes—not by intent, but they'd be hired as plumbers or carpenters or chauffeurs or whatever and they'd end up working around rich people and always end up screwing up whatever the rich people were trying to do—by default. And that was a pretty cool thing—I always liked that.

The Marx Brothers were more intelligent about their assaults on the upper classes. The Three Stooges were like the *id* and the Marx Brothers were like the superego of American violent prankster culture.

♦ **V:** *You're right, the Marx Brothers weren't so violent; they were more about breaching social conventionality—*

♦ **JL:** They were very insulting, inflicting an intellectual affront—

♦ **V:** *Especially in a movie like* A Night at the Opera.

♦ **JL:** Whereas the Three Stooges were like a flat-out, stupid, violent, frontal assault.

♦ **V:** *You're right; the Three Stooges would never stage a scene at an opera.*

♦ **MW:** They were more working-class.

♦ **JL:** I'll bet that cartoon characters were a big influence on most pranksters—if you were to survey them, I would guess that most of them have a particular superhero or comic character they relate to.

♦ **V:** *The Chicago surrealists exalted Bugs Bunny as a supreme prankster—*

♦ **JL:** The Warner Brothers cartoons had a huge influence on *me*: Bugs Bunny, Daffy Duck (who was always the butt of Bugs Bunny's joke; so was

Elmer Fudd). Depending on which filmmaker—Tex Avery and Chuck Jones—was making the cartoon, Bugs could be randomly cruel, too. And for the surrealists, the perfect action was to walk down the street and fire a gun randomly at people.

♦ **V:** *But I don't think any surrealist ever really did that! What are some other films?*

♦ **JL:** *City of Lost Children,* directed by Marc Caro and Jean-Pierre Jeunet. They also made *Delicatessen* together. We did our first Santa Claus prank in 1994 and I saw that film shortly thereafter. It had a really scary, demented, psychedelic Santa Claus sequence at the very beginning. In my mind it related completely to the Santa event we had just done, and seemed like some kind of weird, cosmic synchronicity. Suddenly the Santa icon started being analyzed and it mutated on so many different levels—magazine articles, books and studies came out analyzing the "Santa" phenomenon: how it had been promoted and almost *created* by Coca-Cola. Santa Claus was based on a woodland Scandinavian/Germanic/Russian myth from hundreds of years ago. Commercialism mutated those Kris Kringle/Santa Claus icons into more of a commercial icon, starting in the 1880s and 1890s.

However, when we did our Santa pranks, we had no preconceived notion or intellectual construct in mind; we just wanted to fuck shit up. But curiously, a lot of academics were starting to review and deconstruct the Santa Claus icon around that same time. There's an entire book devoted to how Coca-Cola marketed the Santa icon all over the world. Even the red suit was a Coca-Cola invention; formerly, Kris Kringle was running around in a *green* suit . . .

♦ **V:** *These are prank archetypes that other people adopt and modify—*

♦ **JL:** Right. Just like people are doing billboard modifications all over the country. And the original Survival Research Laboratories machine art performances have turned into robot wars and "commercial" junkyard wars, but SRL is the one who started that archetype. Unfortunately, SRL doesn't get any money from these spinoffs. The Santas are replicating themselves in various cities, too.

Actually, the San Francisco Cacophony group has done some excellent pranks in more recent years. Their funniest one was when they announced they were having a "Pigeon Roast" in Union Square at the same time PETA (People for the Ethical Treatment of Animals) was holding a rally there. The Cacophony folk went to Chinatown and bought some squab (but claimed they were pigeons) and started roasting them

right there, and the cops had to protect them from the PETA people. These PETA people were trying to hit them. The Cacophony people were going, "Come on—have a sense of humor. These pigeons are just 'meat on the wing,' y'know."

This was really just a humorous assault on the "True Believer" mindset. If people honestly believe in not eating meat, there is a lot of proof that factory-produced meat is pretty awful. Certainly, cosmetic testing is not acceptable, but as for using animals for medical testing—I know several people who wouldn't be alive if it weren't for that. You have to decide what's more important.

♦ **MW:** The people or the animals?

♦ **JL:** I go with people. But my brother, *he* likes animals more than people. He wouldn't be worried if 90% of humanity were annihilated tomorrow.

♦ **V:** *Neither would I, in a way . . . as long as I wasn't one of them!*

CHRIS RADCLIFFE & SEBASTIAN MELMOTH

♦ **VALE:** *You look like an actor—you'd be great playing a cowboy in a Western movie. What's your prankster pseudonym? And tell us a prank—*

♦ **CHRIS RADCLIFFE:** [laughs] As an homage to both Timothy Leary and G. Gordon Liddy, I decided to christen myself "Timothy Liddy." During a foot race in San Francisco, members of the Cacophony Society and I decided to "prank" the race. Hundreds of runners were coming from the south side of the bridge to the north, and we decided to run *toward* them. About thirty of us dressed up in running clothes, all wearing a large label that said in big letters, "1000 - The Race of Death." One guy even brought his kid in a stroller; the child also had "1000" on his bib.

♦ **SEBASTIAN MELMOTH:** This was when the number of people who had jumped off the Golden Gate Bridge [suicide] was nearing 1,000. The thirty of us were nearing the runners heading toward us, and some of us staged a fake fight, with people almost going over the handrail.

Now one of us had brought along a dummy, and in the fight it got dumped over the side of the bridge! Almost immediately a news crew arrived in a minivan, slammed on its brakes, and got out. I jumped in front of their camera and screamed, "Ohmigod—Timothy Liddy's dead! He's killed himself!" And the guy behind the camera asked, "Dude, who's Timothy Liddy?" I said, "Give me

your business card and I'll fax you a press release." The story appeared in the *L.A. Times* about "The thousandth jumper goes off the Golden Gate Bridge . . . tragic circumstances . . . "

♦ **V:** *Where were you living when this happened?*

♦ **CR:** Oakland, about a quarter of a mile (as the crow flies) from Eastmont Mall, the prototypical closed-and-dead mall in an all-black neighborhood in East Oakland. This mall is really desolate and really tough; there were drive-by shootings every night. The local police station had four-foot concrete walls and no windows—it was all armored up. Now my house was a quarter of a mile away, but it was all uphill, and I've never met a crack-head yet that had the ambition to walk uphill to rob anybody, so I always felt fairly safe there.

The Eastmont Mall had a billboard for Tanqueray Gin, featuring an upper-class, older white guy, Mr. Jenkins, who it turned was actually an ad executive in South Carolina. He was from a very old Southern family which at one time had owned a grand plantation. In the ad series, his head (and the heads of good-looking women) were collaged onto little cartoon characters. It struck me as sort of *wonderful* that he would be the one pushing gin in the black community. On the billboard he was seated on a kind of blow-up horse-tube in a swimming pool, with a girl behind him. The tag said, "Mr. Jenkins feels

Chris (look at those biceps!) Radcliffe.

someone eyeing his cocktail."

I thought I could do better than that. The background was a blue that I could easily match with a PMS book. I made a "piece" that I could quickly attach to the billboard. Because if I got caught—

♦ **SM:** They would have killed you. Seriously.

♦ **CR:** Now I had already pranked Eastmont Mall before. I got the fax numbers of a lot of community groups in Oakland and sent them all a group fax. I had managed to "acquire" a City of Oakland Planning Commission letterhead, and I sent some fake minutes of a planning commission meeting suggesting that Eastmont Mall be converted into a prison. Instead of San Mateo jail handling the prison overflow, why not Oakland? It would be closer for relatives to visit, Oakland needed the money more, etc. Cable TV actually showed all these people storming into the City of Oakland Planning Commission office, demanding an explanation . . .

♦ *V: I guess that's funny. But what happened with the billboard modification?*

♦ **CR:** I knew that if I got caught, I'd probably get lynched. So I made a sign about three feet high, put glue on the back, climbed up the back of the billboard to the top, and flipped the sign over so it would attach itself. I rapelled down and got the fuck out of there. And from a block away, the billboard clearly read, "Mr. Jenkins owned your grandparents." The billboard lasted maybe twelve hours before the sign company—or an angry mob of villagers with pitchforks and torches—took it down.

♦ *V: You know, it must have taken hours to send all those faxes—*

♦ **CR:** Oh no, it just took a minute—my girlfriend had a mass fax machine. You just program in a bunch of numbers and it'll fax everybody all at once. We sent it out to every little community church and organization in the city of Oakland. Actually, it took months to get all those fax numbers, but it only took me one trip to the planning commission to find an unlocked desk and some, uh, stationary.

Oh, I did a billboard hit in New Orleans that was pretty good.

♦ **SM:** Oh yeah, and then claimed you were the Billboard Liberation Front.

♦ **CR:** After I did the hit, these kids came running out of the building next door. I thought they were gonna call the cops on us, but instead they asked, "Do you know anything about the Billboard Liberation Front?" I stood up and said, "I *am* the Billboard Liberation Front!" [laughs] So for a minute or two I basked in my obscure

fame.

♦ *V: But what was the billboard modification?*

♦ **CR:** Around the corner from my house was a bar I used to drink at. In New Orleans there were hundreds of the same billboards that said, "The Pride of Louisiana." I couldn't figure out what the fuck they were talking about. But one day walking back from the bar, my friend Big Ass Pete and I looked up at one and said, "Christ, we've got that same color of blue paint." We got a ladder and painted out the "P" in "Pride" so it became, "The Ride of Louisiana." It turned out it was Britney Spears on the billboard, although I didn't know who she was. She was doing a big homecoming show at the Superdome; apparently she was a local girl. And we happened to modify the last billboard you see from the bridge coming into the Superdome from the west bank, where she was staying.

♦ *V: So she would have seen it—*

♦ **CR:** Yes. Then in the Sunday paper I read this whole interview with her, about how she was making a transition from being a teen idol to a pop star, and I realized that going from being the pride of Louisiana to the ride of Louisiana absolutely worked with that.

Oh, I thought of another billboard prank. On the San Francisco side of the Bay Bridge there's a huge lottery sign flashing the amount of money you could win. I had two punker girls stage a fight at the bottom—that drew off security just long enough for me to get up inside the sign. There's a phone modem number you can call to update the lottery prize money number. I got it, then went home and put it on Craigslist. I said, "The first person to crack the programming code to go in it, please print the word "sucker" on the board." Two hours and 40 minutes later, the board started flashing in these huge letters "SUCKER" right next to the lottery sign. I have a photo. The two girls were Tamara and Goth Mary. ♦♦♦

PETER DOTY

♦ **PETER DOTY:** A few of the old Suicide Club people decided to get together to resurrect a new kind of group. They came up with the name "The Cacophony Society" and started publishing a newsletter called "Rough Draft" that they would leave in cafés. So that was more of an "open" kind of thing—if you went to cafés you could find the newsletter and start subscribing. Almost anybody could join; their slogan was "You may already be a member."

The newsletters were full of odd collages and

came with funny stuff in the envelopes. My roommate got me a subscription to "Rough Draft." Then she and I organized our first Cacophony event—that was my first major prank. We had a great time; I thought, "Wow, I've finally found some kindred spirits!" The Cacophony Society became the center of my social life for many years. I'm much less involved now, but I'm still in touch with many of the people.

Our first prank was called the "BART Lounge." We got the idea coming back to San Francisco from the Oakland Rolling Stones concert, 1989. We noticed how plush BART seems compared to other public transportation systems. BART has upholstered seats and carpeting and it's quiet, whisking you along in a way that seems more fancy and upscale. We jokingly came to the conclusion that the only thing missing was live entertainment; then we thought, "Hey, *we* can be the live entertainment!"

Cacophony was the conduit to making this happen. We decided to turn a BART-riding experience into a cheesy Las Vegas lounge. My roommate Sarah Rosenbaum and I morphed into "The Fabulous Dwayne and Dusty"—really bad lounge singers. We went out and got sheet music for "MacArthur Park" and "Candy Man" and other schlocky, horrible songs.

The target date was 6 PM on a Friday in January, 1991, when people were sick of Christmas songs. About thirty to forty Cacophony people got on board and mixed with the "real" commuters. Sarah and I wore glitzy, glittery Las Vegas tuxedo outfits. We had fake microphones made out of toilet-paper tubes and lightbulbs with painted netting over it. We were talking into them and we would go around to people in the audience and stick the microphone into their faces and people would actually lean forward and speak into it the fake mic. I remember I was singing really bombastically, "Silent Night, Holy Night" and Sarah turned around and slapped me in the face, singing, "Grandma Got Run Over by a Reindeer!"

Do you remember Donny and Marie Osmond? They did this bit where she would sing, "I'm a little bit Country" and he would sing, "I'm a little bit Rock 'n' Roll." Well, we did something where she was a little bit of a "Hawk" and I was a little bit of a "Dove." So she was singing jingoistic songs like "Ballad of the Green Berets" and

Marines' marching songs, but I would sing "Give Peace a Chance" and "Universal Soldier"—songs like that, throwing all this schlocky politics into it.

On the BART train we were providing this horrible entertainment, and people getting onto the train would either look aghast or start laughing. We had a clean-cut, official-looking guy wearing a suit and tie passing out questionnaires and pencils, saying "I'm a BART representative. Would you mind filling out a questionnaire?" The questionnaire said, "This is a pilot program to

create a larger program of in-commute entertainment for our riders." People could check boxes for other forms of entertainment they would like to see on BART, like ballet and opera—ridiculous things that would *never* be produced on BART! The "representative" would talk to everybody, acting really serious about wanting to get their feedback.

To add to the Las Vegas atmosphere, we had this cocktail waitress going around with a tray of actual drinks, saying, "Would you like a drink?" But if anyone answered yes she'd go, "Oh . . . I'm sorry. There's no eating or drinking allowed on BART." We also had a woman going around selling cigarettes and condoms; she would say the same thing, "Sorry, there is no smoking allowed on BART." And there was a girl wearing a great leopard-print outfit with a polaroid camera going, "Pictchah?! Pictchah?! Two dollars!" People were having their pictures taken as if it really *was* this classy nightclub.

When we got to MacArthur station I sang, "It's MacArthur Park and someone left their cake

out in the rain," throwing myself down onto the floor during the climax of the song. These black kids were looking at us like we were from Mars but they were laughing, like, "Who are these crazy white people?!"

Then we staged a fake wedding—this was supposed to be Vegas. We set up a crepe paper wedding bell and pretended to marry a couple. At this point our "theater" was almost over and we were just about to get off when the BART police came into the car. Some people made remarks like, "Well, it looks like a party's going on!" The cops didn't look like they were going to bust us, but I felt nervous, so I made a speech: "Folks, the unsung heroes of BART are here and they really deserve a hand. Let's hear it for the BART police, everybody!" And everyone applauded wildly for these cops! They probably had never gotten a round of applause before in their lives, and were just blown away by it. You could tell they were really happy.

I went to bed that night and didn't wash my hair—this hairdresser friend had actually done our hair for us in a style that managed to be both greasy and poofy at the same time, as befits

CACOPHONY

The Cult of Fantasia
When: Sunday, April 28th
In the tradition of The Rocky Horror Picture Show, let us show up at the Castro Theatre as avid, costumed fans or in mock protest outside with signs condemning this satanic occult film. Perhaps we can be on both sides. Lets get together right after the Cacophony meeting on April 22nd and discuss the

my stage persona, "Dwayne Newtron." It was a hideous pompadour with a flip in back, all done with tons of hair gunk.

The next day there was a huge peace march, with at least a quarter of a million people on Market street. I went in character as Dwayne Newtron, singing my medley of peacenik songs. By the time we got to Civic Center, at the end of the parade, I was singing in cheesy Vegas style, "All we are sayin'—hey, looking great—is give peace a chance. Yeah, hey, where you from?" I would point the fake microphone at people and they would lean in to sing, "Give peace a chance." Out of 250,000 people this stranger comes up and says, "That was so much fun on BART last night—thank you for doing that!" This was some commuter who had come in from Concord for the peace march and recognized me. That just blew my mind.

♦ **V:** *You had the guts to sing, regardless of how great your voice sounds—*

♦ **PD:** Actually, I sing pretty well, but I was just singing cheesily for this.

♦ **V:** *People seem to like those fake Elvis and fake Sammy Davis, Jr acts, no matter how they sound. Your BART prank was pretty complicated. It was great you had the BART representative going around with the questionnaire—that added another dimension of credibility.*

♦ **PD:** Right. People were wondering, "Is BART *really* doing this?"

Speaking of people wondering if something is

was real or not, the next event that Cacophony did became an international media hoax. I organized this fake protest against the Disney film *Fantasia*. It started when a group of us attended a screening. The film has a sequence about evolution featuring dinosaurs, and somebody said, "*That'll* piss off the Born-Again Christians!" By the end of the movie we had a ridiculous argument against every sequence in the entire movie. It seemed this could make a really good street theater prank. So I suggested it at the next Cacophony meeting and everyone loved the idea.

At the time I didn't realize how easy it would be to get the media to play along. We got a press list from a friend, worked up a press release and sent it out, and then about eight of us started picketing the Castro theater. We were carrying our phony picket signs denouncing *Fantasia* and people on the street were laughing at us—no one was

really taking it seriously.

Each of our picket signs identified a different organization. One was called C.A.F.E.—Coalition Against *Fantasia's* Exhibition. I was pretending again to be Dwayne Newtron and my group was called S.P.A.S.M.—Sensitive Parents Against Scary Movies. I claimed to have a six-year-old daughter who had had nightmares for weeks after seeing the "Night on Bald Mountain" sequence, featuring scary ghosts and goblins. We also had the "Bay Area Just Say No to Drugs Committee" which opposed the dancing mushrooms, opium poppies and drunken centaurs in the film. Then we had Dieters United who were offended by the hippopotamus and elephant ballerinas. We had B.A.D.R.A.P.—Bay Area Drought Relief Assistance Program, and they were against Mickey Mouse wasting water in the "Sorcerer's Apprentice" sequence. And there was M.A.S.A., Musicians Against Sappy Arrangements, who were against Tchaikovsky selling out to Walt Disney and allowing his classics to be co-opted by this cheesy Hollywood cartoon.

The press release read, "A variety of religious activists plan to denounce the evolution sequence as well as the Satanic glorification in the 'Night on Bald Mountain' and the nudity in the pastoral scenes. Minority feminists and gay and lesbian activists will voice their opposition to the color-coordinated, stereotypical, heterosexual centaurs from the pastoral who they feel promote racism, sexism and homophobia."

♦ **V:** *Well, it was the Castro neighborhood—*
♦ **PD:** I know, it was preposterous that all these right-wing Christians were suddenly joining forces with these gay rights activists to do this alleged picketing—
♦ **V:** *Yeah, it was a real Rainbow Coalition.*
♦ **PD:** Anyway, almost everyone had a great time. One woman came up to us and said, "I am very disturbed by your demonstration. I'm a union activist and have been involved in picket lines for years. I'm also a lesbian activist and have been involved in the Gay Rights movement. If you guys are making fun of this, it's really a problem for me." And then she paused for a moment and said with a sly smile, "Unless you're part of the San Francisco Cacophony Society and this is a prank." I stayed in character but I thought, "Migod, this woman is so sharp." She wasn't part of our group but she had figured it out.

We picketed that day and then went to the U.C. Theater in Berkeley. My roommate Sarah grabbed the bullhorn and started this rant and I thought, "Damn, she's good!" Then we picketed

Blockbuster on Geary Street in San Francisco. By this point the TV cameras were showing up because we kept sending out more press releases, and we also included some phony newsletters to make it appear we were an established organization.

We returned to the Castro to demonstrate again. This time there was an anti-censorship group present passing out anti-censorship fliers. One of our group was posing as a pro-Disney instigator; he wore a Mickey Mouse mask and was egging the crowd on: "Yay—another person bought a ticket for *Fantasia!* More money for Walt!" So he was *faking* giving us a hard time. That plus the presence of the news cameras created an intense, very confrontational environment, and at one point we were surrounded by a crowd of really angry people who were very close to getting violent with us.

♦ **V:** *Who were they?*
♦ **PD:** Just passers-by on the street. The interesting thing is that when we were there before, they ignored us or laughed us off, but when the TV cameras showed up, they mobilized and got very militant. Luckily, somebody in our group staged this complete freakout, screaming, "WALT DISNEY WAS ON DRUGS!! WALT DISNEY WAS ON DRUGS!!" And we all started chanting, "JUST SAY NO! JUST SAY NO!" Then people realized we were ridiculous and they started laughing at us and then dispersing.

♦ **V:** *What mainstream press did you get?*
♦ **PD:** I got called by the *Wall Street Journal* and *Time* magazine because I sent them a press release with my phone number. Each "leader" of each "sub-group" sent press releases with their phone numbers. For six months their home answering machines had phony messages like "Leave a message for [this organization]" . . .

At first we got local coverage in local newspapers and local TV. Then things snowballed and we got picked up by *Time* magazine because they

were doing a cover story on "Whiners and Crybabies." They included us in their cover story without even contacting us to verify if we were a legitimate organization. This is *Time* magazine, which is supposed to be one of the nation's top news sources! I think they don't care, as long as your press release supports the agenda of the story they're featuring.

This was an experiment to see how easy it might be to manipulate the press, and I was shocked by our results. Well, we did send out press releases and funny newsletters, all with phone numbers, so the prank was fairly elaborate. But at the same time we are just this weird handful of underground artists in San Francisco—it's not like we have any power or anything. So if a small group like us can pull off an international media hoax, what can the government do, as far as manipulating the press and public opinion? What can big business do? What can the military do? It was a big eye-opener seeing how easy it is for information to be distorted and for public opinion to be derailed by media manipulation.

The *Time* magazine article got picked up by the *Washington Post* which got picked up by the *New York Times* and then got picked up by newspapers in Mexico City, Canada—all over.

Our little experiment was a way of showing that people will believe anything in the media.

We had a rule in the Cacophony Society that events must be neither political nor religious. But I thought, "Hey, rules are made to be broken—especially in Cacophony." So I suggested we do an event that was *kind of* political.

In our newsletters we printed funny quotes, like, "We are the rotten egg at the company picnic!" My favorite one was, "We are the saboteurs of the mundane." We wanted to take things out to the street and fuck with people's reality—not in a *bad* way, but just to shake them out of their routines, or make them wonder, "Is what I just saw *real*? What's going on here?" There is so much complacency, passivity and routine in our society that it's really good to stage something where people react: "What the fuck just happened?"

This "political" idea was to stage an event called "Let them eat cake!" I got the idea because I have French aristocrat outfits. Some friends and I thought, "We have to *do* something with these costumes!" At the time, Food Not Bombs [grassroots local group trying to feed the homeless] was getting busted by the cops—I mean *majorly* busted; the riot squad was going out against them.

♦ **V:** *Is Food Not Bombs still around?*

♦ **PD:** I hope so. They were asking, Why are there all these homeless people in this country

when there is so much wealth in this country, and so much of it is going to the military. We could solve this problem and we could solve poverty if some of this money was redirected appropriately. It's not even that radical of a thought.

♦ **V:** *The government did it under Franklin Delano Roosevelt.*

♦ **PD:** Right; it's just a very basic thing: feeding people and letting them live decent lives—

♦ **V:** *—with a roof over their head.*

♦ **PD:** I don't think it's anything that subversive or threatening. Nonetheless, the city would not give Food Not Bombs permits, even though they applied over a hundred times. SWAT teams were going out in full riot gear busting these vegetarian peace activists who don't even serve meat.

So part of our prank involved shame tactics against the city. As "Let Them Eat Cake" activists, we dressed as 18th-century French aristocrats and fed cake to the homeless—not just cake, but *beautiful* cakes that people spent hours making and decorating. I made a wholesome organic carrot cake with all-natural colored frosting flowers. So it was not just cake, but it was elegant, wholesome, healthy, nutritious cake of excellent quality.

We had a guillotine and several times we beheaded in effigy some of the local politicians: Frank Jordan, Anne-Marie Conroy—do you remember her? She was a city supervisor who held up an 8"x10" glossy photo at a Board of Supervisors meeting and said, "If you are a young couple with a condo and a mortgage, how would you like to look out your window and see *this?*" It showed a homeless person sleeping on a park bench. Of course, no one held up an 8x10" glossy photo of a pair of Yuppies and said, "If you are miserable and sleeping outside in the cold, how would you like to look over from your park bench and see these assholes going into their condo?" We turned Anne-Marie Conroy into Marie-Antoinette Conroy, of course, and beheaded her.

After the beheadings and after serving the cake we had this grand procession with classical music playing on a ghetto blaster, and a person dressed up as Mozart playing on a portable keyboard. We took the last of the cake to the mayor's office. A mayor's aide came out and we said, "This is the Copper Crumb Award which we want to present to the mayor for all he has *not* done for San Francisco's homeless population. Bon Appetit!"

We did that for mayors Frank Jordan and Willie Brown—they both got the Copper Crumb Award. Doing this event was a real eye-opener for

me, because most people think homeless people are all crazy, drug addicts or low-lifes, but a lot of them are very intelligent and well-educated—they knew what Bastille Day was and what it meant. A number of them spoke fluent French to us—my French is terrible, and here these homeless people were speaking fluently.

One man asked me if he could play my keyboard, and proceeded to play Mozart from memory, beautifully. From memory! He said, "The worst part about being homeless is that I don't have a piano anymore." That just broke my heart—if only you had heard how beautifully he played and seen how much it meant for him to play the piano. It showed me that you can't believe the stereotypes about what you hear is going on. The homeless really are an underclass, and many of them have fallen through the cracks, been screwed, and had bad luck—and it's not necessarily their fault. They really have been shafted by the city government, the police policy, and the lack of American jobs.

Personally, I thought our "Let Them Eat Cake" prank was a great way to bring attention to the homeless problem. We got a fair amount of media coverage because it was a visually stunning event. You have these people dressed gorgeously as aristocrats giving cake to the homeless people. We also did a reenactment of *Marat/Sade,* the play featuring the assassination of Jean-Paul Marat which took place on Bastille day, several years after the actual fall of the Bastille. So we had that as a sort of entertainment; we created all this spectacle. Another reason Cacophony did this is because there are various places where homeless people can get services, like soup-kitchens and medical treatment centers, but there are not a lot of these, and they are all no-frills. Like, the homeless never get anything that is fun or frivolous or special. I am a great believer in frivolity and I think that *superfluousness is necessary.*

♦ **V:** *One of my "bibles" has been* Homo Ludens, *which defines man not by knowledge (as "homo sapiens" does) but by play; the ability to create games and fantasies—*

♦ **PD:** No one ever puts on a show for the homeless. We were putting on this costume spectacle for these people, we were putting on a play and a political event. We weren't just having people line up to get cake, we had people going out with trays and serving it to them. It was this really special treatment that they never get. That was one of the things that was so magical about the event.

Another event we did for years was the Penny Potlatch Parade. It developed out of the question, "What to do with all my pennies?" I didn't want

San Francisco Chronicle

BAY AREA
AND CALIFORNIA

Cake for the Homeless

Vivian Perry, dressed as a courtier from prerevolutionary France, offered soup and cake to homeless people in San Francisco's Union Square yesterday afternoon as part of a demonstration by the Cacophony Society to protest Proposition J, which would outlaw aggressive panhandling. The Cacophony Society, a political action performance art group, said Proposition J fails to address homelessness while punishing those who beg. The protesters accused Mayor Frank Jordan, who promoted the November ballot measure, of echoing Marie Antoinette's "Let them eat cake" comment about the poor.

to count them and wrap them up in wrappers and take 'em to the bank—that was too much of a pain. We had a Cacophony event where we would stand on a sidewalk and offer passers-by a penny for their thoughts. Sometimes we would ask, "Spare change?" and offer passers-by pennies—that would really blow their minds. A lot of people didn't know what to do; they couldn't believe it, or would just laugh and look at us like, *What the hell is going on?*

The best response we ever had was this guy—I asked, "Spare change?" and without missing a beat he said, "No thanks, I already took mine from the office." After doing this for awhile we marched down the sidewalk singing "Pennies

from Heaven" and "We're in the Money." I put all these old "Money Songs" from the 1930s on a cassette that we'd play on a ghetto blaster. Sometimes we'd throw money on the sidewalk, and afterwards go ride the carousel. It's something we did every year for awhile, where people wear money-themed costumes; one guy came dressed as Abe Lincoln once. It always blows people's minds and is fun because it fucks with people's reality.

♦ **V:** *I like the idea of the "Money Songs." How many songs on the theme of money could there be?*

♦ **PD:** Besides the ones I mentioned, there's "Happy Days Are Here Again," "No Depression in Love" which is from the thirties, and "Million Dollar Baby." All the old Busby Berkeley films.

Cacophony Society did another prank at the turn of the millennium, when 1999 became 2000. We were all complaining because it seemed like you couldn't go out that night without spending a small fortune. New Years Eve is always expensive; it's about gouging people—like, a band that would normally charge ten or fifteen bucks charges fifty or sixty dollars. It was just a total fucking rip-off. People were making such a big deal about the millennium and we were thinking that when it comes down to it, it's just an arbitrary change of numbers—it's not that big of a deal.

There was also this big scare about "Y2K is going to happen—*ohmigod!*" I'm a cyber-phobe; as far as I'm concerned people could lose their computers and it would be a good thing. So we thought, "Why don't we boycott the millennium?" and sent out press releases calling for a daytime protest on December 31, 1999, at the Ferry Building. We showed up and there were a bunch of reporters setting up their trucks. They started crowding around us while I gave a big rant about how "Y2K is a BFD!" Another woman got up and yelled, "When we were kids we were told that by the year 2000 we would have jet-packs and lunar vacations. We want the future and we want it now! Where's my jet pack?!" We got on all the local TV stations, then AP or UPI, and our event went around the world, publicized as one of those "kooky millennial events."

♦ **V:** *It seems that the Cacophony Society has made life more fun—*

♦ **PD:** In many ways Cacophony *has* changed my life. I was shy when I was a kid and I'm still a bit shy. When I came to San Francisco I didn't know many people. Cacophony really expanded my social life; it brought me in touch with kindred

Millennial Malcontents: Y2K not OK

spirits who also liked to do weird stuff and have fun and subvert "reality" and make things more interesting for the passer-by.

♦ **V:** *Cacophony did clown events, too—*

♦ **PD:** In San Francisco there's a little hamburger joint called Clown Alley, so we did an event where about twenty of us went there all dressed as clowns. We filtered in, one at a time, and sat at different tables so that it didn't seem like we were part of the same group. Passers-by looking in the window saw that this is where clowns go after a hard day's work! The people working there thought it was hysterical, and people on the street kept stopping and staring at us.

Then we went to the Lusty Lady which has little booths—you go into them, put in a quarter and a shade goes up and you see a room with go-go-dancing topless women. Gradually we took

11 Protesters Insist 2000 Is Nothing to Celebrate

over all the booths, until all you could see was clowns watching the dancers. They were trying to be sexy, but then they just stopped and started cracking up.

♦ **V:** *That must have been fun, including making the clown outfits.*

♦ **PD:** If you're not born as part of the plutocracy or some kind of aristocrat, there is not a whole lot that individuals can do. I do vote, although it's obvious how rigged voting is, a lot of the time. Voting just doesn't have that much of an effect, because "they" still just do what they want. I personally may not have much of a voice, but by doing a prank I can get into the papers and make a point very well. That's where my only power is.

♦ **V:** *An important part of the prank is getting the media to work for you—*

♦ **PD:** Yes. I really consider myself to be more of a satirist than a prankster. Satire is the basis of many of my ideas for pranks.

♦ **V:** *The Jonathan Swift tradition. There is a fascinating history of the effectiveness of satire going all the way back to the classical societies in Greece and Rome, especially in their play-writing. And legally, satire is considered protected free speech. To me, the*

best pranks are the ones that have something unquantifiable to them, where there's a surreal quality. I like enigmatic acts where you can't really pin down the appeal.

♦ **PD:** To me there is a big difference between a prank and a trick. Like, tying someone's shoelaces together is a trick, but I think it's stupid and kind of mean. That's not the kind of thing that I'm into.

♦ **V:** *Was Andy Kaufman a big influence on you?*

♦ **PD:** I grew up in a small town in Maine. The 1970s was a bad enough decade, but here I was in this dreary town, with people with really bad haircuts and ugly clothes listening to really conventional music. There was nothing there except woods and potato farms. I coped with this by being in the first punk rock band in the state of Maine, called the Slaves of Liberty. My stage name was Ricky Vomit.

♦ **V:** *What year was this?*

♦ **PD:** 1979 or so. The other thing that got me through the '70s in high school was seeing Andy Kaufman on TV. I just love, love, loved Andy Kaufman. He was my idol, my hero. He saved my sanity, actually. He gave me hope that you could be weird, funny and offbeat. Here was this guy who was on TV, yet he was completely wacky and had a huge cult following. I admired that he could do this completely outrageous stuff and get away with it. I felt like maybe this world isn't so bad after all.

♦ **V:** *I wonder if it was the beatniks who first originated the put-on? Because they would put on the squares a lot—Ferlinghetti talks about that. Then Andy Kaufman took the put-on and almost crossed the line of sanity to where the put-on became almost real and hard to figure out.*

♦ **PD:** He wouldn't give up and he would still do things even *after* they stopped being funny, but then they would become funny again because he kept doing it! It was brilliant. The man was a genius, an absolute comic genius.

♦ **V:** *He had to be "possessed," or something.*

♦ **PD:** Well, he really was a conceptual artist. I think he blurred the distinction between conceptual art and comedy—

♦ **V:** *He really was in touch with his inner psychotic. He could just let it go. That's what was so edgy about him—you couldn't be sure if he had suddenly*

"lost it" sometimes. When it would it go from: wait a minute, I thought he was putting me on, and now it seems real. *Like when he did the female wrestling performance—*

♦ **PD:** I think Andy Kaufman did his whole female wrestling stunt as a prank. It could be argued that he did as much for the feminist movement in the '70s as Gloria Steinem! But he didn't do it by guilt-tripping men or pointing out problems, he did it by being an asshole, *intentionally,* to piss people off so they would go, "Wait a minute—women are just as good as men. What the fuck is he talking about?" He outraged and baited a lot of women who never would have considered themselves as feminists, who didn't even *like* feminists (maybe they were housewives in the Midwest, or born-again Christian women who think that feminists are bra-burning lesbians). He succeeded in awakening this sense of women's equality by pissing off "straight" women. I think he actually advanced the feminist movement in a very subversive kind of way.

It was a cultural mind-fuck. In reality you mostly have "celebrities" who in real life are egotistical assholes, but they go on talk shows and TV and pretend to be nice and friendly; they smile a lot. They have the public persona of being really nice when they *aren't,* and Andy was doing the exact opposite. That is the kind of thing that influenced me, because it's like turning the tables in a situation and creating a different reality—

like passing pennies out to people on the street. His stuff isn't only funny, but it's conceptual and clever. I'd like to think that what the Cacophony Society did was like that, too! ♦♦♦

REVEREND AL

A writer, artist, comedian and performer, Reverend Al Ridenour is the hyper-imaginative founder of the Los Angeles Cacophony Society and The Art of Bleeding, a performance art group. He was interviewed by V. Vale.

♦ **VALE:** *Your name, Reverend Al, is kind of a prank, unless you really are a reverend—*

♦ **REVEREND AL:** I *am* a reverend, but the prank preceded the actual credentials. Picking the name has to do with the very first prank we did with the L.A. Cacophony Society. Our target was UFO Expo West, set at a hotel by the airport where a couple thousand UFO fans and followers would gather. We invented an underground, extraterrestrial-oriented church. I chose the name Reverend Al because while "Reverend" sounds dignified, "Al" sounds "back alley" . . . and besides, it's good to have a catchy name! It helps people remember you.

♦ **V:** *The surrealist Benjamin Peret often dressed like a priest, but would then curse and swear at people on the street—*

♦ **RA:** When wearing my collar, I've actually gotten out of a speeding ticket! I got my credential from the Universal Life Church. Although I became a Reverend semi-satirically, I've actually performed weddings for luminaries like Michael Mikel—that was fun. Also, it can be a kind of tax dodge—that is, if you actually run a church. although I never got into that. Supposedly, if you're a minister you can get discounts on airlines, too.

♦ **V:** *Wow. What did you tell the cop when he stopped you for speeding?*

♦ **RA:** I told him I'd just gotten an idea for a sermon, and since I didn't have a pen, I had to rush home and write it down. When I told him I was a Universal Life Church Minister, he didn't recognize it as a denomination. I think he didn't want to be busted for persecuting some *minority,* so he just let me go. It was a good moment!

I'll wear the collar out sometimes. It seems appropriately inappropriate, depending on where I'm going. I think of it as an experiment, or that dreaded word, "performance art." Sometimes I'll be downtown in some scuzzy neighborhood and get asked where "the mission" is, and I'll try to direct them. I do what I can to fulfill the duties of

a cleric.

♦ **V:** *Well, there are so many shepherds and flocks these days, it's impossible to know where all the pastures are (or whatever they call them).*

♦ **RA:** Today, I don't know that I would pick the same name—that happened fifteen years ago.

♦ **V:** *"Reverend Al" sounds a little shady—it's barely acceptable. But "Reverend Bud" might not be—*

♦ **RA:** You probably wouldn't let your kids go on a camping trip with a Reverend Bud! Anyway, at this UFO Convention we distributed some flyers that promised the arrival of the Space Brothers. Our group, the Brotherhood of the Magnetic Light, had come into the possession of a South American religious icon: a figure of Jesus that functioned as a homing beacon to UFOs. We were going to be demonstrating it at a park near the convention hotel.

After distributing our flyers, we made our way down to the park—actually, a grassy knoll overlooking the beach. We unrolled a roll of tinfoil and made a 200-ft long cross on the ground, weighted down with flowers and incense. We scattered walkie-talkies that made a weird feedback noise. So we had a kind of show ready for people when they showed up.

A bunch of people came from the convention, and a few were immediately wise to us, like one person with a camera who was making a documentary on UFO hoaxes. But a few "true believers" also showed up. One person on crutches seemed to be waiting for his healing from above. Looking at him, I almost felt bad—I *did* feel bad, but in a fun way.

I had written out a ritual, so we followed it, stopping to drink some sacramental wine now and then. We set off flares, and finally launched a hot air balloon that looked like a massive spaceship. Unfortunately, it got caught in some downdraft and landed on the Pacific Coast Highway and got hit by a car. This was actually a very dramatic setting, right on the ocean, and the wind was howling. Nearby a little family was having a

picnic at sunset. We were unrolling all this foil, putting this gigantic cross on the hillside. Suddenly they freaked out, shouting, "A park is no place for Voodoo!" and quickly left. So that was the inaugural event and the christening of the LA Cacophony Lodge.

♦ **V:** *That's brilliant.*

♦ **RA:** We did another prank at the same UFO convention. This was at the height of the "alien abduction" craze, and we distributed flyers equipped with a little plastic bag with an address card (addressed to us), a wet nap, and a leaflet that explained that the bag was for an extraterrestrial sperm bank. Why? Because these aliens seemed obsessed with our reproductive habits; apparently they wanted our DNA reproductive material, so perhaps we could eliminate alien abductions by providing the aliens with sperm. We left them all in the men's rooms, and there were a lot of lonely-looking people eyeing those bags and the wet naps . . .

♦ **V:** *Did you say a "wet nap"?*

♦ **RA:** The wet napkin was for cleaning up afterwards, after you make your donation in this little ziplock bag. I kept going in the men's room and leaving them on the urinals and they kept disappearing. We also left them on other people's tables, and it was fun to see who would notice and who wouldn't notice that they were giving away space jerk-off kits.

The scary thing is, we did receive a handful of sperm mailings that I have to say I failed to open—they weren't adequately refrigerated, anyway. And I didn't have the postage for Alpha Centauri . . .

♦ **V:** *Tell us a brief history of L.A. Cacophony—*

♦ **vRA:** The Los Angeles lodge was really active throughout the Nineties. Our catch-phrase was "Experience beyond the Mainstream." The heart and soul of what we did was the pranking and the sidewalk performances—the guerrilla theater-type stuff. We also did other events that involved going to the "Well of Weirdness," and renewing our own personal resources. Like, we'd go visit some old Folk Art guy out in the desert with a ranch wall made of old saki bottles. We did sort of "field trips" to the fringes of society.

We had events where we made "cement cuddlers": plush teddy bears that we filled with cement and left on the shelves of the Toys "R" Us

stores. [laughs] So, sometimes we made stuff, sometimes we performed, sometimes we went places. We scorned commercially-manufactured "recreation"—actually, that would become fodder for our own entertainment. *It was Do-It-Yourself fun for losers and outcasts with a creative bent* a social club for people who considered themselves outsiders, and who valued the contributions of outsiders, for good or ill, in our society.

♦ **V:** *I'm still trying to figure out the principles of punk rock. Of course, D-I-Y. is one, but I think one of them was from Groucho Marx: "I wouldn't join any club that would have me as a member."*

♦ **RA:** No one needs a group more than outsiders! We have a kind of inborn biological need to *herd,* and as repellent as that notion is to some of us, we still want to have fun. People do like to congregate, so L.A. Cacophony served that function. The people that we drew in had such low tolerance for other human beings that for some weird reason it kind of worked! They enjoyed each other's company, and the sort of rarefied atmosphere that we created: a world of unreality.

I enjoyed the creative aspects: writing the prank flyers, making the props or the fake Jesus icons, whatever. But I didn't have a social network of people that I enjoyed being with, so Cacophony helped with that. It helped a lot of people cross-pollinate: bringing together people

who liked to play with fire, and build robots, and do special-effects makeup. We did some cool stuff, once you raised that banner and saw who came. It was a good mixing ground.

♦ **V:** *It was a kind of think tank.*

♦ **RA:** Yeah. The thing that sort of *reassured* me was that often people would leave in disgust! Maybe they came thinking we were "hipsters," but we would never quite fit that. It was always

off, and sometimes awkward, with some people obviously deeply into their own strange interests. So I was always reassured when certain types of people would never return; I felt like Cacophony was still adhering to its original purpose.

♦ **V:** *Well, it's hard to keep a bunch of weirdos, outcasts, and outsiders together—which is what punk did for awhile.*

♦ **RA:** But it's great to have a larger pool of people, because people can surprise you with what they can do, or what they bring to it. And even if you hate some of the people, it's a lot better having 150 people dressed in Santa suits at one time than having twenty-five *really great* people dressed in Santa suits! Sometimes there's a *quality* in numbers—some stunts worked better with a lot of people, and it's good to throw a wide net. Several hundred of us convened at the Portland Santa event, where the police showed up in riot gear. I set myself on fire there, as a Santa covered in fireworks! That was memorable.

I remember renting two buses for Santas who were all drunk by ten in the morning, walking into the Great Western Gun Show, the largest gun-and-knife exhibition in the country. There were maybe a hundred Santas milling around, looking at handguns and knives. We got a lot of good stocking stuffers there.

We also raided L. Ron Hubbard's "Winter Wonderland" exhibit on Hollywood Boulevard, which is their version of Santa's wonderland for kids. Elves were doing e-meter readings! Our Santas dropped by and mingled inappropriately with the crowd. We walked off with a bunch of their fake gifts, and I think we confused them more than anything else.

We had put up flyers promising that L. Ron Hubbard was going to be speaking from the Other Side, and there can't have been more than a hundred of them put up around town. Months later, we got calls from Scientologists asking us to remove it from our website, and by then it was buried twenty levels down. They're very attentive; in Hollywood they're particularly strong.

♦ **V:** *Did you ever visit Grandma Prisby's Bottle Village?*

♦ **RA:** Yeah, we've been out there many times. They're friends of ours, kind of.

♦ **V:** *It's "magical" to get a group like Cacophony together, that opens up a realm of the marvelous where everyone is a special person for a while—*

♦ **RA:** We were very "special"! [laughs]

♦ **V:** *It's funny how the word "special" now refers to what used to be called "mental retards." Tell us some of the high points of L.A. Cacophony—*

♦ **RA:** I liked the hardcore events where there

were six of us on the sidewalk—those are the ones where your adrenalin flowed the most, when you didn't know what was going to happen, or how the event was going to turn out. For years we'd be dressed as clowns and/or mangy dogs, but by the seventh year even *we* were sick of it.

The L.A. Cacophony lodge went on for about ten years. That's 120 months, and we did like four events a month, so that's almost 500 events. We had some pretty well-worn costumes covered with puke and pee. I kept them in my basement where the cats would pee on them, too. But the clown events were good—they were kind of our stand-by, our *classic.*

We protested the absence of clowns at the Academy Awards. We went to different shopping centers and protested shopping, which is absurd in its own way.

We went to a banjo-and-fiddle festival held in an old movie ranch where they used to film Westerns, so it was very atmospheric; very rustic, for the people who wanted to soak in the banjo-and-fiddle ambience. For us, it was just an excuse to yell at horses and act obnoxious. One of our party actually ended up in the movie jail there; the park ranger said that if he could have, he would have put him in the *real* jail. That was memorable, because no one's ever actually been arrested in L.A. Cacophony. We've always just walked away when that threat arises.

♦ **V:** *But in dog suits—*

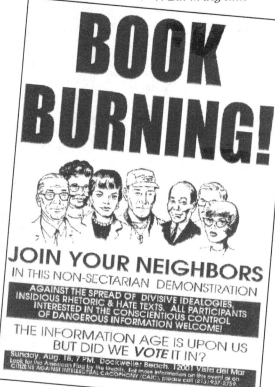

♦ RA: They were patchwork dog suits that were questionable in that you could *sort of* tell they were dogs. We showed up at the Beverly Hills Dog Show and tried to participate in events. There's a traditional Catholic event called the "Blessing of the Animals," and we showed up there dressed in our dog suits and were actually blessed by Cardinal Mahoney and sprinkled with holy water! That was kind of fun. Sometimes we'd go to dog parks and enjoy humping each other, until the park officers were called.

We also did a lot of fake protests. One of the early ones was called "Save Money, Die Early." We handed out Chinese "hell banknotes" and wore skull masks, proposing, "The sooner you die, the more money you save!" This took place on Venice Beach, where suggesting early death was not well received.

We also did a fake welcoming party for a new Starbucks in Silverlake—the kind of event where you *pretend* to side with the thing you really hate. It makes it hard for the subject of the protest to get rid of you! We pretended to be pathologically *avid* Starbucks fans, at the same time implying that Starbucks represents all that is great about White European culture. That made them really nervous.

The protests were fun. We visited the L.A. Democratic National Convention dressed as "Zombies for Gore," and had fun kicking around bloody rubber limbs. A reporter from *MTV* tried to interview us and we refused to break character, just grunting in zombie fashion. She was really angry that we weren't jumping through her media hoop . . .

My favorite protests were the ones that were kind of degrading. We did several covered in mud so we looked prehistoric. Once we went at Christmas-time to Beverly Hills, dressed as a little troupe of mud people. We were walking down Rodeo Drive and of course nobody would let us in their stores. We did manage to get a bunch of sales flyers from a jewelry store and walk around handing them out, grunting. Maybe people thought this was some bizarre, avant-garde shopping gimmick. It was fun, kind of "siding with the enemy."

In fact, *pretend*-siding-with-the-enemy is always fun, and seems to be a good approach. We staged a few book burnings where we actually did burn books—we got a few angry phone calls from that. Our flyer used a really wholesome illustration lifted from an old Boy Scout book, showing a

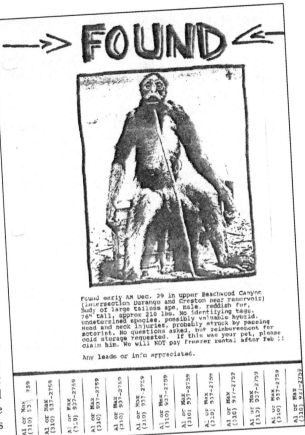

Found early AM Dec. 29 in upper Beachwood Canyon (intersection Durango and Creston near reservoir) Body of large tailess ape, male, reddish fur, 76" tall, approx 210 lbs. No identifying tags. Undetermined species, possibly valuable hybrid. Head and neck injuries, probably struck by passing motorist. No questions asked, but reimbursement for cold storage requested. If this was your pet, please claim him. We will NOT pay freezer rental after Feb !!

Any leads or info appreciated.

Al or Max (310) 93 959	Al or Max (310) 937-2759	Al or Max (310) 937-2759	Al or Max (310) 937-2759	Al or Max (310) 937-2759	Al or Max (310) 937-2759	Al or Max (310) 937-2759	Al or Max (310) 937-2759	Al or Max (310) 937-2759	Al or Max (310) 941-2759	Al or Max (310) 937-2759	Al or Max (310) 937-2759	Al or Max (310) 937-2759

bunch of concerned citizens.

We did that cement teddy bear prank I mentioned, attaching a professional-looking tag with a barcode taken from an "Alien Face Sucker" toy. This was *reverse shopping*: we brought them to a Toys "R" Us store and left them there for others to "buy." The clerk would scan the tag and be puzzled by the tag, which said "Brutal Truth Toys." The text was very Nietzschean, claiming that this hard, cold toy would prepare them for a life of brutal realities.

One of our party tried to "buy" one, just to see what the reaction might be. On the way to the register he dropped it several times, and it was like dropping a bowling bowl—it drew a crowd. He insisted that it hit his foot, and there was a lot of screaming and crying. The clerk couldn't find it in the product registry, and was upset. Our person said it was for his nephew who was in the hospital suffering from a skin disease. We left just as the clerk realized it was a prank.

It was great seeing this, because a lot of our pranks—like putting up a prank flyer—you never see the results. Just that experience of seeing the clerk's brow furrow and knit—that was a sweet moment!

We put up a "Lost Ape" flyer bearing a photo

of a dead orangutan, claiming that it had been found in the Hollywood Hills by the reservoir. I said that I would keep it for two months in cold storage, waiting for its owner to claim it for burial, and then I would have it disposed of. We got a number of calls, including a call from a crack reporter from a local news team who was ready to go down to the cold-storage locker with me to look at the ape. We traded half a dozen phone calls until I told him I hadn't paid the last storage bill and the ape was probably in the dumpster, and I couldn't guarantee it was still there. I think at that point he realized something was fishy, and he stopped calling me. But for awhile, he was very persistent.

We arranged for a "faceless birthday boy" to visit Chuck E. Cheese, and *I* got to be the faceless boy. For some reason, I enjoy acting like somebody with brain damage—it feels very liberating. So my head was swathed in gauze; I looked like Mr Potatohead. We all gathered there; I was at the head of the table, and I flailed around for awhile. Eventually they started their mechanized show, and these little robot mice started singing and I reacted with great fear. Then somebody in a costume came out, and in a sudden fit of fear-energy I threw myself on him and wouldn't let go for, like, twelve minutes. I think the guy in the costume was scared by how I wouldn't let go, and people got very, very quiet. It felt like an eternity.

My mom was a nurse in a mental hospital when I was growing up, and I actually worked there for awhile, too. I got to see retarded people, and they were very savvy; they *knew* when someone was afraid of them and would take advantage of that. There was one guy who was seven feet tall and had a glass eye; he loved taking it out in front of people and popping it in his mouth. Because of that experience, I can do a pretty good impersonation of somebody with brain damage or Downs Syndrome—I can pass myself off as a "retard" pretty well.

♦ **V:** *It's hard to keep a group going forever. You did five hundred performances, and that seems amazing—*

♦ **RA:** I stepped away because it became repetitive. Some of the things that were outrageous in the beginning were so much fun that people naturally wanted to repeat them. Like, every year during the L.A. marathon we had a table set up where we'd give away "Power Smokes" [cigarettes], donuts, and pieces of bacon dangled from fishing poles to try to lure runners off their route. After a few years, people started going, "Oh, there's that wacky Cacophony table again!" and even though people wanted to keep doing it, to

me it felt less rewarding.

In 1999, when I kinda stopped doing Cacophony, we did maybe our best prank. It was geared at the prankster audience itself. We hoaxed the death of one of our members who was moving out of town. Nobody had seen him, and there hadn't been an event for months since our very wild Halloween party. I "leaked" the news that there had been a drunk driving accident after the party—and *nobody* jokes about drunk driving. So that was why there hadn't been any events for awhile. Also, by this time most of the people "in" Cacophony were just on-line and didn't actually *know* many of the people involved, so it was very easy to hoax that.

So the emerging "On-line Cacophony" incarnation kind of imploded as I leaked out more and more clues about the "new direction" we were taking after this unfortunate death. Supposedly I was transitioning Cacophony into this radical/alternative/anarchist Christian group—it was plausible, sort of. This really angered a lot of people, and caused a lot of internal strife. When finally the truth came out that nobody had been killed and that these "radical Bible studies" weren't really taking place, everybody had been fighting so much that nobody wanted to do Cacophony anymore—at least for a year or so.

A lot of people didn't want to admit they'd ever been hoaxed by this. Using religion was perhaps the only way to piss people off in this little, insular, avant-garde, counterculture scene—to really shake people up! [laughs] Eventually, I was burned in effigy, literally, out in the desert. So that was my official retirement, and it was too good to go back. I had ideas for other events after that, but I'd had "poetic closure" to Cacophony, and it was the end of the 20th Century, so I still haven't shed the name "Reverend Al." I tried to transition to "Doctor," but it hasn't quite worked.

My new project has an ambulance. Remember when firemen would bring a fire truck to grade school and give a presentation on fire safety? It's based on the traveling, informational bookmobile idea. We have a talking gorilla mascot. It's sort of child-like but also dark and esoteric, in a bizarre way. The project is called "The Art of Bleeding."

In an old Cacophony event, we had given out free casts, saying this was a new fashion trend or a great way to get out of work. Now we have girls dressed in nurse uniforms and we take the ambulance around and park it outside a club or theater, offering people "safety casts" that are either a talisman or a reminder to "Be Safe." We can set the siren off if we want, and we have all the props,

including our logo monogrammed on doctor's coats. Our nurses are more latex and vinyl types, however. We call it a "Medicine Show," but without any cure. We have a talking gorilla and a robot that bicker bitterly, puppets, and a lot of blood and bodily fluids. Cacophony people are involved in this.

It's actually great having a large ambulance, because I can transport big art—for example, this seven-foot fetus with a fifteen-foot umbilical cord, in a womb.

♦ **V:** *How did you get weird? Most people don't turn out like you—*

♦ **RA:** I think weirdness is thrust upon us.

♦ **V:** *Yeah, like greatness.*

♦ **RA:** Possibly; being an unpopular kid helps! Since my family moved around a lot, I was always in the role of being a new kid in whatever school I came to. So I went with what amused everybody, and kept the "weird"—and it worked. Like I said, I worked in a mental hospital, and there was a lot of disease and religious fanaticism in my house, so I had a lot to work with. My younger brother turned out weird, too, and we've made lots of corpses and fetuses together. He works on The Art of Bleeding, too.

I guess there's genetics, nurturing and nature combined here. Growing up in Texas, Kentucky, the Midwest as well as Southern California, we had genuine Bible-thumpers around us, so I really know that scene very well. To this day people will lament to me the fact that L.A. Cacophony became a religious group, and that pleases me to no end! And I do credit my up-bringing to being able to pull that off. If I hadn't had my other brother (who runs a Bible bookstore), it would never have happened.

When doing group pranks, there's a certain number that *works*. When the Santa events got too big, there wasn't the adrenalin that was present in earlier events. If you have, say, twenty people, they start feeling they're on a field trip instead of an "adventure." I've done a few "solo" adventures, but it's better to have a couple people with you so you can go over the event after it happened—that's definitely the reward.

I came from a middle-class, conservative background, but my parents encouraged me to pursue art as a hobby. I don't have a problem talking about Cacophony as a sort of artistic endeavor, but it certainly was not the kind of artistic endeavor my parents thought about when they set me on that road. I was a good illustrator; I sure could draw. I took drawing lessons and worked as an animator for ten years. I talked to my family about that, but I don't think they'd understand if I said, "Well, I got drunk and went into this office building dressed in a dog suit and said, 'I'm here for the office party!'" They wouldn't be able to get from Point A to Point B.

Thank god we have the handle of "performance art" now. It's expanded from academic, Fluxus-oriented projects to a more clubby, underground atmosphere in places where what you do would never get you an art grant. But when you get in that world, I think you become an "art grant mobster" and start scheming all the time how to get the next grant. You get addicted—

♦ **V:** *You get addicted to that money and want more and more of it.*

♦ **RA:** We always tried to have fun, although we also did things that were painful and humiliating.

♦ **V:** *People always ask me, "What's the next thing to happen that's gonna be edgy?" I haven't the faintest idea.*

♦ **RA:** These days, anything that's "edgy" and "underground" is immediately reprocessed and sprayed out as commercial media. It's in the media a week after it happens!

Doing Cacophony events, we discovered that when people don't understand what you're doing, you often become almost invisible to them. When we were walking down the street dressed in mud or as a clown or a dog, people really don't see you. They don't want to see you and they don't see you—they don't have to react to you, especially if you're in a more urban area. Well, at least they're not calling the cops on you! But it's funny how people will do their best to ignore anything that seems *unexplainable*.

Did you hear that during an interview, Werner Herzog got shot by an air gun by a fan? I was

watching his documentary, *The White Diamond*, about an engineer who designed a 150-foot balloon so he could go to Guyana and study the canopy of the rain forest there. He thought the "natives" would get all excited when he flew over them, but just the opposite happened—when people did see his balloon, they'd just go back into their huts. Maybe it's a safety mechanism—if something's too difficult to explain, you don't have to explain to yourself why somebody dresses like a dog or covers themselves in mud . . .

♦ **V:** *It's probably easier to do your ambulance events now—*

♦ **RA:** The Cacophony Society did extend an open invitation, which brings that troublesome "democratic" principle into play, which is really hard to manage. The ambulance crew is hand-picked and there's less feeling of wild cards—people who don't seem to fit with the original intent of Cacophony. And that's nice. And I get to structure things more; it's nice to be able to control things a bit, as opposed to letting things wildly unfurl.

Cacophony was open, and new people would show up all the time, and you never know what they were gonna do. And I actually had kinda *friends* who would show up with guns, drunk, and start threatening people. At Burning Man we had people stealing other people's guns 'cuz they thought it wasn't safe . . . *that* kind of "safety-mindedness"! That's why I had to found The Art of Bleeding . . . because of the people on acid trying to steal other people's guns to make the world safer!

♦ **V:** *What are the Cacophony Society's germinative DNA principles?*

♦ **RA:** We were trying to create little pockets of mystery in the day-to-day. Nowadays kids are really jaded and cynical by the age of eight or nine; they think they know everything, and they have another sixty years to live like that, and that's kind of awful. So if you can create a hole in that kind of reality; a little peephole into something a little more wonderful—well, it might be kind of scary and awful and nauseating and might smell funny, but at least it's a novelty and might get the gears upstairs grinding a little bit. That's what our sidewalk events were.

Our tag was "the pursuit of experiences beyond the mainstream," and pranks certainly fell in there, because pranks toy with people's "reality" and make them pause and re-evaluate. It was a whole bunch of fuckin' fun, too! There were wild cards, and friction, and that was kinda good sometimes, too. It was like a great, warm, wonderful group of people that didn't necessarily like humanity that well, as it exists today in our field of vision. It was kinda like a joyful misanthropy, really—that was what I liked about it.

The only humor I've ever been able to enjoy has been really bleak, black and diseased. It was great to meet some people who shared that humor—acting out, being rebellious in a pretty safe way, I suppose . . . at least it was a creative way. A lot of the stuff we did was creative enough that it was actually *worth* having the police show up—it wasn't just a parking ticket. In fact, you'd be kinda happy seeing the police: "Well, now you've *done* something!"

You know, whenever we *did* see the police, it seemed it was never a question of them bringing us in, because what we were doing didn't fit any of the *forms* they have to fill out! Cops don't like to do paperwork, and if they think some *pro bono* lawyer is gonna come in and say, "Ah, it's art" (and it may become a national media fiasco), they often just let you go, because they don't know what may happen, and it's too confusing. Thank god! If the situation is very *slippery,* that's good.

♦ **V:** *That's what needs illumination: these slippery gray areas between what's legal and what's not; territory where you can still express wild, creative, poetic "metaphors" . . .*

♦ **RA:** What's the charge gonna be when you leave, in a toy store, a toy that's not for sale? And the police don't want to look stupid. Of course, since 9/11, I'm sure you've talked to a lot of people who've lamented that it's much harder to do "stuff" now.

When the first *Pranks* book came out, it was such a great, influential book for me. My copy is all dog-eared. It was like the *Bible.* I saw it in a bookstore next to the *Book of the SubGenius* and realized, "Oh, there are other paths." *Pranks* gave me models. There were helpful suggestions, inspiration—there were lots of laughs. It was hilarious reading about Boyd Rice trying to present a skinned sheep's head to the First Lady—

♦ **V:** *If you tried to do that today, you'd be in Guantanamo Bay for life.*

♦ **RA:** Right. When we flew all those Santas from one state to another for the Portland event, I was drunk and made some joke about *not* having bombs. It was a stupid, stupid thing to do then, but now you'd be beheaded for that! At the time it seemed worthwhile because I *was* in a Santa suit. Now you'd be executed, or sent to Egypt for torture!

I think Bush is worse than anything I've ever lived through; he makes me *miss* Reagan! But maybe you need that opposition; undergrounds thrive on that kind of environment. Punk rock

was happening during the Reagan years. In this case it's actually scarier, because the boot's heavier, but it certainly creates a wonderful environment for satire and angry tirades. There's definitely an overall oppressive atmosphere.

I can't believe I now live in a country where we're *soft* on torture—we're kind of "okay" with torture. [laughs] Torture's kind of "in" again! And I love the Middle East; I've traveled there. Iran is the cradle of civilization; they've been around a lot longer than we have. It's a very sophisticated culture. But lord knows, the Islamic world also has incredibly narrow-minded jihadists—can you imagine being that Danish cartoonist? [threatened with death by Muslim decree] I've noticed how his name has never been used; I guess he's now living under an assumed name somewhere. He's worse off than Salman Rushdie! I just have this "Fuck 'em if they can't take a joke" attitude—but that's why I'm not in politics. Well, no more jokes about Allah, I guess.

I love to eat Persian and Middle-Eastern and Armenian food, but I've noticed that all the restaurants are now flying American flags, as if to say, "Hey, don't firebomb us!" It's kind of galling to see that, because you know they're doing that out of fear—I don't think the flag is just celebrating America! It's kind of like putting the lamb's blood over your door so Death will walk on by— hey, I know my Bible! I've actually read a lot about the different ways religion has been played with and used culturally. I'm very interested in the history of religion.

♦ **V:** *I've been reading the* Mahabharata, *which is at least 5,000 years old. It has the idea that time comes in cycles and now we're in the Kali Yuga—the darkest age. There's a theory that the Gobi Desert is now a desert because nuclear weapons were detonated there, thousands of years ago.*

♦ **RA:** I think you're in Art Bell territory! . . . Cacophony today has kinda become this on-line, virtual phenomena, and now there's all this on-line fighting with people who have mailing lists and tribe groups, which is kinda funny because it's really not that much work to "lead" something on-line—it's a very small investment. There's so much more bickering and staking of claims that I never saw happen when Cacophony was more vital in the *real* world.

I enjoyed writing the L.A. Cacophony flyers— a lot of the times our events were much better on paper than they really went! There's a certain amount of salesmanship in writing the events up, and that was fun for me, because my other work sometimes was boring for me.

♦ **V:** *I think all this embodies a kind of poetry which deals with startling imagery, black humor, play—*

♦ **RA:** But I also occasionally enjoy throwing a firecracker near the gas can! I do have some scars to show for it from those days—mainly from the unwise use of *fire.* That's definitely a theme that continues in The Art of Bleeding. I do a souped-up version of the faceless boy that went into Chuck E. Cheese, covered head-to-toe in a surgical gown, completely swathed. He's been out on the streets of Hollywood in a wheelchair . . .

But Cacophony was also about using language in unconventional ways. I wrote the newsletters, and I had a lot of people say they were fans of Cacophony *on paper.* One reason I did Cacophony was because I enjoyed *writing* about it; giving it that form. In fact that's the only way I *could* give

it any form; the events themselves tended to be rather anarchic—they'd sprawl, and sag, and go this way and that. But on paper they could look theatrical and kinda planned. As much as I enjoyed the chaos of it all, I also am a pretty big control freak, too. So it was always the thrill of balancing those two elements, I think . . . ♦♦♦

JULIA SOLIS

is an author, rare book collector and photographer (*New York Underground*, etc) who currently lives in Brooklyn. A former Cacophony Society member, she has organized the urban adventuring groups Dark Passage and Ars Subterranea, and often travels. Interview by V. Vale.

♦ **VALE:** *I was trying to think of all the possible categories of pranks that are fundamentally anti-authoritarian, whereas the kind you see on TV victimize people that are already victims. One category of pranks is Internet pranks, like the fake George Bush site, www.georgebush.com.*

♦ **JULIA SOLIS:** Right. What about the Bonsai Kitten? That's the site with photographs of cute little kittens living inside jars. Allegedly this kept the kittens small, like a bonsai tree. It was a prank, but it got millions of people to respond who were outraged, emailing about how horrible it was and how it had to stop—people got so up in arms. I'm sure there are lots of sites like that, but this is the first one to come to mind.

♦ **V:** *There are media pranks like Joey Skaggs does. There are also pranks that are public events, like Critical Mass. In San Francisco, on the last Friday of the month it's legal for hundreds of bicyclists to ride their bikes together at 6 PM and outrage motorists by taking over the streets—*

♦ **JS:** Yeah, but they've been having lots of problems in New York. The first court case involving eight bike riders is coming up here in New York. Actually, ever since the Republican National Convention, the cops have been cracking down, throwing them in jail or at least arresting them.

♦ **V:** *Hmm. In San Francisco, a man named Ed Holmes has been organizing a parade every year on April Fools Day: the Saint Stupid's Day Parade. People dress crazy and they make funny, sometimes political statements. And the San Francisco Mime Troupe gets permits to put on political and satirical shows in public parks, and they're legal. These are borderline prank areas because some onlookers get outraged and angry, but the events themselves are legal; the permits were had, and the police are even there as escorts.*

♦ **JS:** But a lot of pranks *are* legal, right?

♦ **V:** *Really? I think most pranks probe that shadowy zone between what is legal and illegal, and what is taboo and what is not.*

♦ **JS:** Yeah, but technically something like *www.georgebush.com* is not illegal, right?

♦ **V:** *Well, it's satire—*

♦ **JS:** And it's not against the law?

♦ **V:** *I would hope not, though the Republicans are probably trying to invent laws against it.*

♦ **JS:** Yeah, and what Joey Skaggs does is legal, too, right?

♦ **V:** *Kind of . . . sort of . . . barely!*

♦ **JS:** I like that. I mean, I like that a lot of it is legal; that it's sort of playing within the margins of what is allowed, but turning it on its head a little bit.

♦ **V:** *Right, and whenever conservative people get outraged, then you know your prank had some impact! Let's discuss your explorations of public space, such as sewers or abandoned hospitals and factories. These activities might be in a quasi-legal zone that—well, why don't you just tell us about this possible area of* pranksterdom *that you've carved out for yourself?*

♦ **JS:** Well, I'm not sure—I mean, *you* tell me if these count as pranks, because I've never thought of them as pranks. I am playing with *fake histories*.

♦ **V:** *Fake histories?*

♦ **JS:** Yes. For instance, we did a Mata Hari event. We had access to what a friend claimed was one of the first public rail tunnels in the world. It was began in 1844 and abandoned in 1860; then it was lost. Every decade or so people would get curious and try to find it.

During World War One there was an explosion in a New Jersey ammunition tent. People thought it had been done by Germans who fled through Brooklyn and hid in this tunnel—a rumor spread that they were making mustard gas there. In 1917, two FBI agents actually found the tunnel, and left some graffiti on the wall saying, "Such-and-such projected the first electric light in this tunnel" (the graffiti is still there). But they didn't find anything; the whole mustard gas theory was

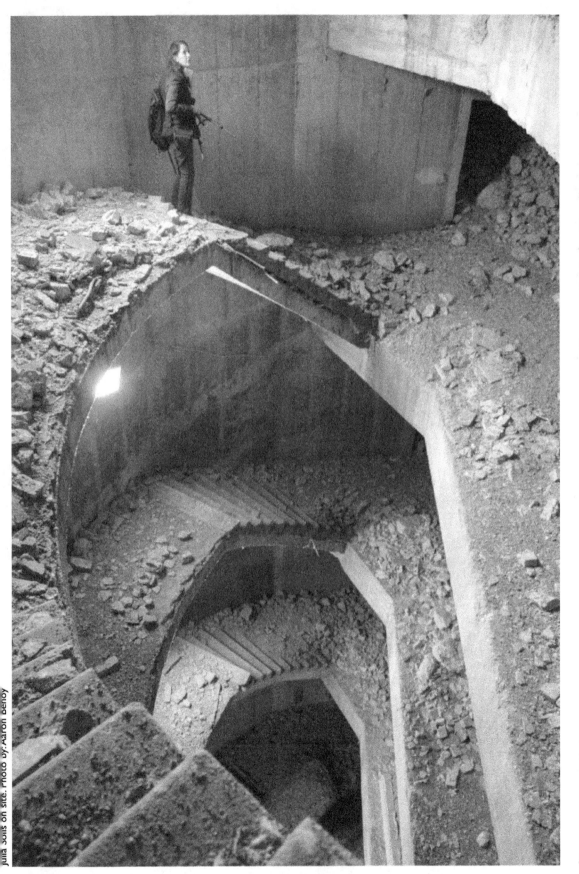

PRANKS 2: JULIA SOLIS

obviously ridiculous. Then the tunnel was walled up and forgotten, and once again it drifted into oblivion.

A few decades later some people got the idea that there might be murder victims inside the tunnel, so they broke into it, found nothing, and sealed it back up. The tunnel kept sort of drifting in and out of people's consciousness.

Then in 1981 this Brooklynite who worked for the city and was a total railroad buff became obsessed with finding this tunnel. He started going through all the city blueprints and found one manhole that seemed a promising lead. He got the Brooklyn gas company to open up this manhole, and he went down and actually found the tunnel. A few people helped him carve out an entrance, drop a rope ladder, and they found this gigantic tunnel made of beautifully arched brick that's over a mile and a half long.

This person got permission to lease the tunnel from the city for exhibitions, and gave an occasional tour. I made friends with him and asked if I could include the tunnel in my book on underground New York. He took me down there and I said, "Wow—this is such an incredible space! It's just gorgeous, and from the street you wouldn't dream it was there." I asked him, "Wouldn't it be great if we could do a Dark Passage event down here?"

So he gave us permission to do it—it was the first time that he ever allowed the tunnel to be open at night. We had to make special street signs to barricade the streets at the tunnel entrance. With his connections, we actually got traffic cops to help us.

Then we started fantasizing about what sort of event we could do which would also be relevant to the tunnel's history. We knew we wanted to have a banquet. I thought of the mustard gas and the FBI agents, and wanted to do some kind of World War One homage to the two FBI agents who had found the tunnel, as well as include Mata Hari [woman executed as a spy in 1917].

A collaborator found this incredible news item claiming that after her execution, Mata Hari's body was taken to a museum in Paris and her head was cut off and put in a jar. Then someone stole the jar! I was like, "Wow! Let's celebrate the search for the head of Mata Hari." So we called the event "The Lost Head of Mata Hari," and designated four groups of people to search for it.

I was working on this project with a close collaborator who always has insane plot advice. We were trying to figure out how to include the mustard gas. We decided that the reason the four groups wanted Mata Hari's head was because she

had incredible teeth. So one group would be these renegade dentists who were searching for her head to get the teeth, so they could determine the secret why her teeth remained so perfect. Another group was the Candy Association of America, who wanted the head for research because they wanted to formulate candy that wouldn't rot teeth. Then there was the American Dental Association, who wanted to destroy the head so nobody could find out how to keep perfect teeth—because then they would be out of business. Lastly, we had the Mata Hari Adoration League, which consisted of guys dressed in World War One uniforms who just wanted to find the head to preserve it; they were not politically motivated.

Each group got an introduction as to what their group was about, and how to dress accordingly. On the appointed day we had all the groups assemble in a room that was World War One-oriented, and we showed them a disinformation film that told the whole back story of Mata Hari and her head. A great filmmaker made a film for us incorporating World War One educational films and *Godzilla* films. Some of us acted out the parts of Mata Hari and her henchmen, trying to leave clues for the groups so they could find where the head was. In the film, mustard gas was used to knock Mata Hari out when she went to the dentist, and then she got an addiction to mustard gas and . . . it was a complicated back story!

So we showed the film to the groups, and no one knew what the hell was going on in the movie! They were all anxious to write down clues and information, but at the end they were more confused than before. So we started our event. First we guided everybody around, looking for World War One memorials and anything having to do with World War One espionage. And in Brooklyn there actually *are* a lot of memorials to fallen heroes of World War One. We visited those, and we had people waiting, dressed in appropriate attire to give out clues and directions. We even had two people dressed up in giant teeth costumes standing in the street, and one of them had a toothbrush and gave out clues inside toothpaste tubes.

We made a fake tombstone for Mata Hari in Prospect Park, and had two "hookers" standing there. Because Mata Hari was a floozy, we had our Mata Hari hootchies next to a tombstone that said, "Mata Hari: always headless, never bedless." We made everyone go inside a rail tunnel and defuse a bomb, which involved fireworks going off. Then everyone visited a dentist, where a tooth got extracted which turned out to have

information inside it. There's a lot more details—there were two guys dressed up as Frenchmen in French striped shirts singing "Alouetta" as our groups, dressed in dental outfits or World War One attire, came into this McDonalds in Brooklyn! You know, just stupid stuff like that.

Finally, around seven o'clock everyone had gotten all the clues (pertaining to mustard gas and various World War One references) and written them down in little books. All the groups ended up at a bar on Atlantic Avenue, where they thought the event had come to an end. People started to order drinks and began exchanging stories. But when everyone had arrived, we herded them out of the bar and down Atlantic Avenue. There they saw cops wearing orange vests next to blinking street barriers, but they didn't know this was all for them.

We all went down a manhole into the tunnel where we had a feast set up at the far end. We had World War One music playing on speakers, and on the table as the centerpiece was the head of Mata Hari, which I had made. This was the grand finale; they had found the head. So with this event, the prankster elements could be the complete and utter fake history involving World War One, Mata Hari, the Atlantic Avenue tunnel, Brooklyn landmarks, military history, and—I don't know if you feel this falls into a pranks category, but . . .

♦ **V:** *Well, it certainly overlaps it. I mean, pranks are fundamentally about disabusing oneself of clichéd reactions and perceptions, as well as thwarting conventional expectations . . . and having fun, too! My favorite pranks involve some sort of surreal element—something that's inexplicable, which you can't ever really explain. There has to be some poetic imagery involved. And this event sounds very complicated, with lots of preparation. So how did you find people to participate?*

♦ **JS:** I have a mailing list.

♦ **V:** *Okay. You'd better backtrack and explain your Dark Passage group. Does it cost money to join? How did it start? You know, that sort of thing.*

♦ **JS:** Dark Passage started in 1998. Most of the core Dark Passage people came from the Brooklyn Cacophony Society, which had attracted all the right people—people who had the prankster attitude, who had been to Burning Man, who knew John Law, and who had that kind of playful conception of reality and fucking with other people. We had a few meetings, and—oh, we did a Starbucks prank in Williamsburg that was really funny—

♦ **V:** *Well, let's hear it.*

♦ **JS:** In 1998, Williamsburg was just getting to be "hipster central," although it wasn't nearly as bad as it is now. But it was definitely becoming a mecca for artists and hipsters. So real estate prices were going up, the stores were getting trendier, there were more cafés, and we felt that the Polish people, who were there before all of us, were getting edged out.

On Bedford and North Twelfth, which is on the main drag of Williamsburg, we decided to pretend that a Starbucks was coming to a vacant lot there. So we made a huge fake Starbucks sign and set up a table covered by a green tablecloth, with decanters where we served horrible coffee. One person played a really convincing wannabe sleazy petty Starbucks manager, and another person played his lackey who was handing out free samples—

♦ **V:** *Of bad stuff, I hope!*

♦ **JS:** Yeah, it was horrible. We brewed it in my apartment, and it tasted really, really bad. One of our guys got free Starbucks cups and little stickers from a real Starbucks, them being the idiots that they are! The cops showed up and said, "What are you doing here?" We said, "Oh, we just want to introduce Starbucks to the neighborhood and get a feel for how we're going to be received by the community." They said, "Well, you're a big corporation, so that's all right," and they took off.

We also passed out a survey which was completely ridiculous. It contained stupid questions like, "Do you own a VCR?" Unfortunately, people were really eager to fill them out and to put their

mailing addresses and email addresses on them. We ended up with several hundred surveys filled out, and it was mostly—I hate to say it—Polish people who were really into having Starbucks there. A lot of "hipsters" were giving us the cold shoulder and looking at us like we were utter slime, and it was so great! It was just really funny.

That was a Brooklyn Cacophony event, and it was a good bonding experience. From there we formed a good crew that met once a month—this went on for a while. I met people from the Madagascar Institute; Caution Mike; Ryan O'Connor; Erok, who is this crazy and really brilliant fireworks guy; and Maureen from San Francisco; and Jeff Stark, who came a little later.

However, the Brooklyn Cacophony was very disorganized—it didn't have any sort of leadership, which is always the problem with Cacophony. Finally this person Rich and I sat down and decided that we really wanted to do something like the Suicide Club: do urban explorations and stage events at abandoned places and unusual locations. We also wanted to incorporate costumes if possible, and we wanted to do that here in New York.

So in January of 1999 we officially founded Dark Passage, after the movie *Dark Passage* with Humphrey Bogart and Lauren Bacall, because that was going to be the subject of our first event. This event was timed to coincide with a BLF (Billboard Liberation Front) exhibit at CBGB's, which Joey Skaggs, Ron English, Scott Beale and others from the West Coast participated in.

This event was also an homage to the [San Francisco] Suicide Club. For that, Harry Haller gave us a lot of the back story for the Suicide Club and how they would organize their events. So we had five teams, all in 1940s costumes, placed all around the city to act out, quite faithfully, parts of the *Dark Passage* drama of Bogart escaping from jail, having to get plastic surgery, having to find his sweetheart . . . you know, that whole story.

We designated Vince Perry as the one who "had" the plastic surgery, and he was generally the victim and instigator for whatever happened. You're probably familiar with the movie; in the end, the hero has to change his identity. He's an innocent man, but he has to go through plastic surgery. He wants to reunite with Lauren Bacall, so he leaves the country and ends up waiting for her in a restaurant in Peru, where they reconnect.

So at the end of our event everyone assembled at a bar (which is usually how these things end) called *Between the Bridges,* located in Brooklyn between the Manhattan and Brooklyn bridges. The groups had assembled their clues, picked up

a bowl of goldfish (which is also in the film), and one of them had had "plastic surgery" done on him, but he hadn't yet met up with his sweetheart Lauren Bacall. So we told the groups that this was the moment that they would go into the restaurant, have the big banquet and meet their love.

Then we led each group, one by one, onto this rickety two-story ladder going up into the Manhattan Bridge which was under construction at the time. Then we led them down the bridge into a subway tunnel where we had found an abandoned track right next to a "live" track. On that abandoned track we had built a banquet table with benches and a coat rack. We had a boom box playing "You're Too Marvelous for Words," which was on the soundtrack for the movie *Dark Passage*. Ryan O'Connor, our chef, had laid out a big gourmet spread on the third rail, and everyone was hungry and ready to eat. All of us enjoyed a meal next to the passing trains, and that was the end of the inaugural event. The fun part was that it really was inside a live subway tunnel, with trains passing just a few feet away while we were eating! That's how we started.

Next we did a Suicide Club-like event of "Hide and Seek" in a cemetery. We had a little bit of a plot, where Death was wearing a cape and everyone that he found and captured had a choice of either becoming one of his army or selling their souls and going back into the game and hiding again. When people were captured, they were led down this dark alley where I was the devil and would try to get them to sell me their souls. Almost everyone sold their soul to me, and I have it in writing in contracts . . . and I'm a very rich woman. And after that, our events were pretty much plot-intensive.

♦ **V:** *Was that in a real cemetery?*

♦ **JS:** Yes, the Lutheran cemetery in Queens. It has hills and trees and a little mausoleum—it's a really huge cemetery where you could hide and never be found. Our last person was never found and was getting bored, so she voluntarily rejoined the rest of us at the end.

Basically, the main criteria for a Dark Passage event is that it involves a location that is not publicly accessible. Also, participants can use their own imagination as a playground and turn the space (along with the costumes and props) into something where they are working with actual Brooklyn landmarks in their own personal way. They play with history.

We did a *Shock Corridor* event based on this schlock movie from the sixties—

♦ **V:** *I think that's actually a truly great movie by*

Samuel Fuller. It's a classic.

♦ **JS:** Of course it's a totally great movie, but the psychiatry that is proposed in that film is total schlock! But it's great. So, we restaged *Shock Corridor* inside an extremely beautiful abandoned mental hospital in Massachusetts. This is an 1860s Gothic beauty of a hospital where we used the tunnels and basements to lead people around. We designated people as patients or attendants, and made a game out of that.

♦ *V: What's the plot synopsis of* Shock Corridor?

♦ **JS:** It involves a journalist who is trying to investigate conditions at a mental hospital by pretending to be insane, so he gets admitted as a patient. But then he actually goes insane and undergoes shock treatment.

♦ *V: I remember a great scene where he's in the hospital and suddenly water starts pouring down through the entire ceiling—*

♦ **JS:** I don't remember that one, but I do remember the "Nympho Room," which we recreated. The main character walks into a room and there's all of these nymphos in ragged dresses. They start attacking him; they all want to fuck him, which is pretty funny. So we had a room where we did that. We also had a "Hypnotist Room," but I don't remember much more of the actual plot other than that. This event wasn't really about the plot; Dark Passage was the only event where we really stuck to the actual plot. Our other events are more about taking an idea and running with it—and the more ridiculous, the better.

We did an event called "The Sphinxes of the Hudson," which was inspired by a 19th-century foundation engineer in New York. He made a map of all the underground streams in New York City, which foundation engineers still use to this day. He was also a general buried at West Point; he designed his own mausoleum, and he made it Egyptian style with a pyramid and two sphinxes guarding the entrance. But when he showed his wife the mausoleum, she objected because the sphinxes were large-breasted. So he had the sphinxes replaced with ones that were less heavily-endowed, and threw the original sphinxes in the Hudson River. And this is real! I mean, how could you *not* make an event around this?!

So again, we dreamed up a complex plot involving Cleopatra's Needle in Central Park, Egyptian imagery, and underground streams. Basically, one of the sphinxes makes its way to

Cleopatra's Needle in Central Park and through underground streams to the Hudson where the sphinx would reunite with its dead body and be reanimated, using one of the masons. Otherwise there was going to be lots of mayhem and destruction, and this had to be prevented at all cost. Again, the event involved a lot of city landmarks and the invention of a completely ridiculous history of what those landmarks mean. So we sent teams out looking for pyramids and obelisks in New York, which was pretty fun.

♦ *V: Are there any?*

♦ **JS:** Yes; once you start looking you find quite a

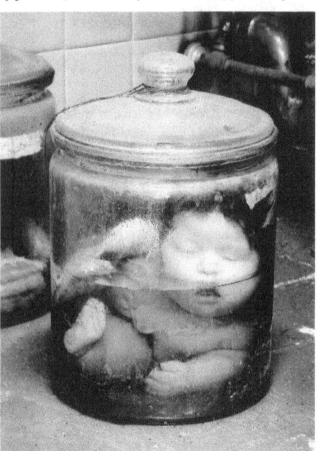

few. There is actually someone buried under an obelisk near Madison Park, which is close to Union Square and the Flatiron building. We also had dowsing; the group who was the fastest got to dowse for underground streams, looking for the buried obelisk where the sphinx was going down the streams. And while we were all standing around we started chanting . . .

♦ *V: Chanting what?*

♦ **JS:** Well, that's the thing, the chant was totally improvised and no one knew what they were doing or could keep a straight face. I thought,

"This is really the difference between Dark Passage and everyone else, that no one can keep a straight face." I mean, we're not performers, we're just really—I don't know—silly.

♦ **V:** *Dowsing is uncanny. As a child I tried it, using a Y-shaped birch stick, and I could feel a powerful pull of the stick toward the ground. It was very strange.*

♦ **JS:** Yeah, it's great. As preparation for this event, I attended a meeting of the American Dowsing Society in Manhattan. There were all these normal-looking people sitting around, and the person who was running the meeting had a bottle of Perrier water and a pendant—because you can do dowsing with either a dowsing rod or a pendant.

♦ **V:** *I didn't know you could use a pendant—*

♦ **JS:** Yeah, you have it on a chain, and where there's water it swings around in a circle. So she held it above the bottle of Perrier, and lo and behold the pendant started to go around in a circle. She said that if it's clear water, the pendant goes faster, but if it's polluted water it goes slower and won't react as much. Then she took a label and covered up the Perrier water and said, "Unclean water," and lo and behold the pendant did not swing as much as before! Then she said, "This tells you that the pendant responds to *words,* and that dowsing responds to words."

♦ **V:** *How did you even find out about this society?*

♦ **JS:** I can't remember. I was hoping we could incorporate an actual meeting into the event, but it was just too *New Age-y.* I mean, if it was a different kind of "insane" it would have been fun, but . . .

♦ **V:** *Yeah, it sounds like this society was* pre-New Age. *Maybe the New Age thing has eclipsed the old occult societies. For years San Francisco had a metaphysical society and bookstore run by this slightly wacko woman, Fritzi Armstrong, but she died.*

Dowsing is not exactly a scientifically sanctioned process, but I remember reading about people who were expert dowsers, and it seemed like wherever they said there was water, you could drill a hole and sink a well. I suppose if they failed a lot, they would be run out of town on a rail or something.

♦ **JS:** Yes. There was this one dowser who was called the Dowser of Madison Avenue. I was doing research on underground streams in New York because that's one of my favorite subjects, and he was someone who died not that long ago. Apparently he was more of a showman type who put on quite a performance while he was dowsing . . . and was actually successful at it.

♦ **V:** *You know, you have taken quite a few very compelling photos. On your website I saw photos that were kind of horrific, taken at some abandoned mental hospital.*

♦ **JS:** I haven't updated that website in eons. Which pictures did you think looked horrific?

♦ **V:** *I don't know, but they looked like they had bloodstains on the sink and on the floor. Surely you must know what I'm talking about?*

♦ **JS:** Yeah, well, they're horrific for different reasons. I'm curious what reasons there are for finding something horrific?

♦ **V:** *Maybe "horrific" is too strong of a word, but whenever you see what appears to be bloodstains, you imagine that violence must have happened.*

♦ **JS:** A couple friends and I visited a classic-looking mental hospital last weekend near Pittsburgh. It's about to be torn down by Wal-Mart. Some of the doors were closed, and so I had to open them because it's my habit to open doors and look at what's behind them.

I noticed that my hands were getting sticky. This guy named Rob was also opening doors, and he said, "Oh shit—I cut myself!" I said, "How did you cut yourself?" And he said, "Well, there's blood on my hand." Sure enough, right on his palm was this big red stain. I looked at my hand and I had the same red stain, and it was from the doorknobs. Then we decided that it wasn't real blood, and that it was just someone else doing a prank. Then we thought that if someone had put it there awhile back, it wouldn't be sticky now, and who knows how long it had been since someone had put it there. Stage blood might still be sticky, but not real blood, I guess—not that *we'd* know! But that was kind of gross.

♦ **V:** *So Julia, no tragedies have befallen you on your excursions through quasi-legal territories and environments, such as in mental hospitals, tunnels, sewers, and all that? You've managed to steer clear of traumas?*

♦ **JS:** You mean physical traumas?

♦ **V:** *Or even psychological.*

♦ **JS:** Well, I almost killed myself on the High Bridge last summer. It used to be my favorite playground in New York. I always said that it was the best ride in town. It's the oldest bridge in town over a river, and it was built to carry an aqueduct. It has gate chambers, siphons, drains, and all of the old pump mechanisms inside it, and it has several levels—it's just a beautiful bridge.

My friend found a siphon that was at a ninety-degree angle leading down into the ground near the Harlem River. We used it as a slide a few times—it's just like a narrow masonry tube that's about four feet in diameter. When you land on the bottom, you hit this mud area filled with all this junk. The bridge is from the 1840s,

and who knows how old this debris is—it's just metal and all kinds of weird stuff sticking out of the black mud.

My two friends Gary and Cramp and I would slide down very fast, but carefully. We would make a sort of train, with our arms and legs around each other, and I'd think that nothing would ever happen to me, although we would slide down really, really fast. But one night we weren't having much luck getting our asses off the ground—we kept getting stuck, and Gary and Cramp just said, "Fuck it," and went down individually. I went last, after them. But I lost my balance and was on my back, flat out, accelerating like a mummy getting shot out of a cannon. I was sliding at top speed, and I knew that I was going to die, so I started screaming. They were at the bottom and heard me, but didn't know what to do to stop me.

It was impossible for me to brake with anything, and I knew I was going to get impaled by some piece of metal at the bottom. But Gary was blocking the exitway and he managed to stop me. However, I lost consciousness—I actually lost my memory for a while, which was really scary. Then it took us an hour to find our way back to the surface from there, through the bridge. I made it back to civilization and had to go to the emergency room.

♦ **V:** *Do you get phone calls from people saying, "Come and check this place out in Pittsburgh, because they're tearing it down!"*

♦ **JS:** Well, not so much. But yeah, sometimes—like the Paris trip, that was on an invitation and that was pretty incredible. I don't know if you heard about some guys who were putting on an underground cinema festival a year ago in Paris?

♦ **V:** *No.*

♦ **JS:** They discovered that underneath this public theater was another theater underground. Paris has two hundred miles of quarries; it has an incredible underground that just totally kicks New York's ass—it's not even comparable! And it's all old quarry tunnels, rooms, chambers, underground hospitals, and lots of rooms below cemeteries—it's all just one gigantic labyrinth.

The group that put on these underground cinema shows called themselves the "Perforated Mexicans." They set up a projector and screen and served food down there. One of the members came to New York and we hooked up and he invited me over to see the underground, and I couldn't refuse! I told John Law, Rob Schmidt and a couple of other friends. We ended up renting an apartment in Paris and we crammed a lot into six days.

We took the official Paris sewers and catacombs tour, but then our new Paris acquaintance took us on a long unofficial tour—we must have walked twenty miles. We spent hours looking for bones in the unofficial tunnels, which we eventually found. And that was such fun. I've done a lot of really good traveling! ♦♦♦

BILLBOARD LIBERATION FRONT

Since 1977, the BLF has consistently improved the urban landscape, modifying billboards with professional élan and flair. They boast that they have never damaged a billboard. Harry Haller and Jack Napier of the BLF had several conversations with V. Vale, Marian Wallace and Mal Sharpe.

♦ **VALE:** *Tell us about the BLF—*

♦ **JACK NAPIER:** The BLF is the longest-standing billboard alteration group in the country—since 1977. If we don't like a billboard, we go up and change it to say something else.

♦ **V:** *You do professional-looking alterations—*

♦ **MAL SHARPE:** Disfiguring—

♦ **JN:** No, actually, we go to great pains to *not* damage the existing billboard. And we go to great pains to *publicize* the fact that we don't damage the existing billboard. We've actually invoiced some of the companies whose billboards we've altered for "advertising services." We look at it as a prank. It's been a fun thing to do for years.

When the Exxon Valdez oil spill happened, we spotted a billboard for a radio station that said, "Hits Happen at New X100" —it was a play on the popular phrase "Shit Happens." The BLF happened to have some 10-foot-high red, white and blue Exxon logos, so some of us went up and changed the billboard to say "Shit Happens" in beautiful lettering that matched the existing style exactly, and added a caption: "New Exxon."

We sent out press releases like we normally we do for each new billboard. These press releases are ostensibly promoting the corporations, like we're trying to *help* them with their advertising. We've gotten a lot of attention over the past twenty-nine years and we're still anonymous and have never been caught. [knocks loudly on table].

♦ **MS:** I met some people who were into modifying billboards; they called themselves "something horse"—

♦ **JN:** Right. Running Horse, I think. This group redid a lot of billboards. They were in a show of billboard alterations that took place in 1999 at The Lab in San Francisco. Running Horse redid some of the Apple billboards in response to what they considered a "spiritual misappropriation of these iconic figures."

The BLF were not quite as serious about their alterations. Apple had a billboard of Amelia Earhart saying "Think Different" and we changed it to "Think Doomed," superimposing a rainbow death skull over the Apple logo. We changed the Dalai Lama's "Think Different" to "Think Disillusioned" and Ted Turner to "Think Dividend." Running Horse's work was still very funny but more serious than ours, definitely.

♦ **MS:** You aren't scared of doing that kind of stuff?

♦ **JN:** You could get hurt: falling off a building, or getting caught by the cops. But we always emphasize that we don't damage the billboards. In at least three separate articles, journalists interviewed representatives from the outdoor advertising industry and these guys said, "Yeah, the BLF doesn't damage the billboards; they're just annoying." We have them in print saying we never damage their billboards, so if it ever goes to a court case, I don't think they would be able to make it stick. We go to great lengths to use paste-overs that will come right off the billboard; we don't just paint on them; we don't damage anything on the billboards. We don't use words like "damage" or "deface" or "vandalism"; we prefer the word "improve"—

♦ **MS:** Perfectly in line with the current administration.

♦ **JN:** We learned this from Nixon's guy, General Al Haig. He was the first really great modern disseminator of double-speak.

♦ **V:** *Now there's a project: the* History of Double-Speak.

♦ **JN:** Well, Orwell nailed it as far as bureaucratic double-speak goes. That's all we get now.

♦ **V:** *I saw an article on the BLF mentioning that they had scouts with walkie-talkies looking out for police—*

♦ **JN:** Most of that is theater, to be honest with

you. Yes, we do have radios and walkie-talkies and we look out for police, but we really ham it up for the journalists, because basically a billboard alteration is a performance piece. We actually are not nearly as efficient as people think we are.

♦ **MS:** Have you saved yourself from being captured?

♦ **JN:** We've been chased by the police twice and gotten away, and that was over a long period of time. One time we modified this huge billboard on the central freeway at 5th and Bryant. It was a big billboard that said at the top "Reno" with two white captions that said "Now playing in Reno" and "Now playing in South Lake Tahoe." We changed it to read "America" at the top and one white caption read, "AIDS Crack the Homeless" and the other caption read, "The White House: Don't Worry, Be Happy!" As this billboard was really big, we were up there working on it for four or five hours.

Tim Redmond of the *San Francisco Bay Guardian* covered this. He agreed to be one of our operatives hiding out in the park below, disguised as a homeless person taking photographs while we were doing it. I had rigged a zip-line cable off the back of the billboard and it went down into the middle of the block under the freeway, where there were ten different directions you could go to

get out of the block. If the police had come, we would have zipped down the zip-line and disappeared. We had a change of clothing hidden in different places, like vomit-encrusted leisure suits, Roman collars or whatever. But they didn't come; we didn't need to use the zip-line. The police drove by a hundred times, and each time our radio people on the ground would call and say, "Cheese it, the cops are coming!"—we would stop moving until they'd drive by. I was almost disappointed that we didn't get chased, because we were ready that time! We *did* get chased once when we did this Fact Cigarette billboard (this story is on our website *www.billboardliberation.com*).

I have a friend who was a nineteen-year-old philosophy major at Reed College. He called me up: "Hey Jack, there's this billboard that says 'Kent,' but I think it should say 'Kant.'" At the time he was really enamored of Kantian philosophy. I said, "Okay, we can change that to 'Kant.'" It turned out to be a big billboard where each letter was fifteen feet tall! However, we were only changing one letter, so we figured how to do it.

I said, "If we're going to do this, you have to write a press release for it." So he wrote "A Prolegomenon to Some Future Heteronomy," and we changed the billboard. Instead of saying, "Kent: the choice is taste" it now said, "Kant: the choice is heteronomy." We came up with this press release about how people shouldn't have to go through the horrible process of decision-making when there are *trained professionals* who can make all your decisions for you, advertising people who can make all the decisions you need. So why be autonomous—why not join the heteronomous mass and be happy?

That billboard was up for a really long time, unlike the "Shit Happens" billboard, which was gone in a day. (We photographed it, but they immediately sent out a crew to take it down.) The Kant billboard stayed up for two months, probably because nobody knew what it meant and it wasn't dirty. In fact, it was up for so long that I had to go back and repair it twice, because it was peeling off and

flapping in the wind.

♦ **MS:** So the BLF is a group of people who are just "into" doing this?

♦ **JN:** Yeah, nobody gets paid. There have been a number of different participants over the years. I've also worked with Survival Research Laboratories, the machine art group—they were in the original *Pranks* book, and I consider what they do as pranking.

I think pranks are so important right now, because it's getting to the point where you can't do any real serious political work without being threatened by the Powers That Be. Court jesters often survived the wrath of the King, even though they pointed out the truth in humorous ways, because he could laugh it off. That's what we always try to do with the billboard alterations: we try to use humorous messages so people aren't *overtly* offended by them. You don't go up and spray-paint "Fuck Exxon" on a billboard, because the average working guy or cop looks at that and they go, "Commies!," you know. Not to mention: it's simply tacky! But if you do something funny that you can laugh at, I think that is really important. Extremely important, actually.

♦ **V:** *I think now, more than ever, we need a resurgence of pranks, done by more and more people, too.*

♦ **MS/JN:** Yeah!

♦ **JN:** We wrote a "How To" manual on billboard modification that's on our website, *http://www.bill-boardliberation.com/guidebook.html*. It's based on over twenty-five years of work. Hopefully we can raise the standards of billboard improvement.

♦ **MS:** There's all this stuff about the press and how totally skittish and bought-off and unreflective they are. What about the WMDs (Weapons of Mass Destruction)? Man, that sure was a prank! And everybody just bought that, hook, line and sinker. Including all the embedded journalists.

♦ **JN:** People did buy it totally, and now they don't care.

♦ **MS:** This is Saddam Hussein's prank: The Americans really thought when they went into Baghdad that all the troops had "disappeared"— like, what happened to them? Well, they just went home.

♦ **JN:** In the movie *Lawrence of Arabia,* the Arabs raided a little bit and then retired back to their encampments for the winter. The German and British military think, "Oh, these bums, they're no army." But they just disbanded and then next spring, they're back raiding and blowing up bridges.

♦ **MS:** Is that right? Same old story, huh . . .

♦ **JN:** I saw it in a David Lean movie so it must be true. [laughs]

♦ **V:** *It is kind of grim when the most influential pranks being pulled now are by the current administration.*

♦ **MS:** Yeah, what a sense of humor . . .

♦ **JN:** Starting with the guy they got running the show. That's the greatest prank on the American public in a long time.

But you can get away with poking fun at politics; the press will cover something if they think it's "funny." If we went up and altered a billboard to say something real serious like "Stop the war, man!" there's no way the press would do an article on *that.* But we get ink all the time for our billboards because we use humor. We want citizens to think, "Wow, some folks went out and altered those billboards." Hopefully, this gets people thinking about the fact that they are looking at billboards, and they have an impact on their lives. We try to keep it funny.

♦ **MARIAN WALLACE:** Right, it needs to be written up in a funny way if it's going to have the right effect.

♦ **JN:** That's one of the reasons we've kept going after twenty-nine years: we've kept it funny. It's not like an "Off the Man!" or "Fight the pigs!" kind of thing.

♦ **V:** *That literal-minded political protest—*

♦ **JN:** People don't want to hear it; people who are not *already* of your political bent don't want to hear it. They just don't care (at least in my experience). But if it's something funny poking fun at the government, they like that.

♦ **V:** *They want humor because there's not enough humor around.*

♦ **JN:** And there's a lot to poke fun at.

♦ **V:** *Say, where did the name Jack Napier come from?*

♦ **JN:** I got it out of *Batman* comics. Jack Napier was the Joker. He was a stand-up comic who gets involved in some horrible, stupid criminal activity and gets dumped into a vat of chemicals and winds up becoming the Joker. Those darker characters were always a lot more attractive than Batman or Superman or the so-called "hero" characters.

FIRST BLF PRANK

♦ **V:** *Harry, what do you think was the first BLF prank?*

♦ **HARRY HALLER:** Well, one of the most famous Suicide Club events involved twenty-seven of us who gathered one night under Central Freeway. There was a lumber warehouse there and we climbed to the roof to alter a billboard

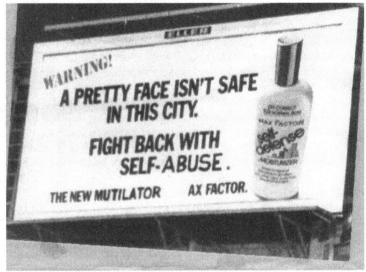

which had the same advertisement on both sides. It was an ad for a facial cream that said, "A pretty face isn't safe in this city. Fight back with Self-Defense—the new moisturizer by Max Factor." Of course, this was obviously a reference to women's issues in the seventies; it was an example of advertising trying to co-opt feminism.

Jack Napier climbed up a pipe with a rope ladder, then we all climbed the rope ladder after him with paper, buckets, paint, etc. We altered one side to say "Fight crap with self-respect," and the other side said, "Fight back with self-abuse." It also said, "The New Mutilator by Ax Factor." We finished around midnight. Then the first police car showed up—

♦ **V:** *You didn't have lookouts with walkie-talkies, like the BLF (Billboard Liberation Front) has—*

♦ **HH:** This is how the BLF was born! Jack Napier got the idea for the BLF from going on this event, which was led by some of the Suicide Club women.

Here's a major problem when you have a group of people doing an "event": somebody *always* wants to leave in the middle, and invariably what happens is they get seen or caught, and because of that the rest of us get busted. One person went down the rope ladder early, and the police saw him coming down. When we discovered the police had arrived, we all hid behind the raised ventilating windows on the roof. After awhile, a gray-haired police sergeant comes walking across the roof with a flashlight.

Before he got to us, a few of us who were more experienced in dealing with cops told everybody, "Don't put your hands in your pockets. Don't make any sudden gestures. Follow orders. Be cooperative, be polite. Don't be an asshole, and we'll get out of this." I asked everybody, "Do any of you have any drugs or illegal substances on you?" Of course, nobody said a word. So I said, "Look. If one of you assholes gets *me* busted on a drug charge because you don't want to give up your little stash, I will personally stick my foot down your throat after this is over. Now get rid of your fuckin' drugs!" People's hands went diving into their pockets; we found a little ventilation pipe, and threw everything down it."

When the sergeant came along, the cops must have figured out what had happened to the billboard, so they weren't expecting anything *really* bad— otherwise it would have been SWAT Team City! This sergeant had us walk to the edge of the building, and down in the street we saw half a dozen cop cars, two or three "ghost" cars (unmarked police cars), a couple TV news vans, a fire truck . . . and worst of all, a couple of paddy wagons.

When the police sergeant saw us, he yelled out, "Pull up the paddy wagon." Then he started count-

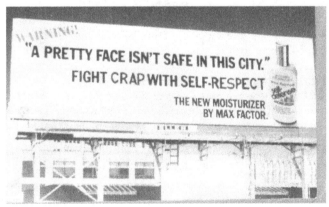

ing us, and yelled out, "Better make it two!" The fire truck had put its ladder up against the building, and we all had to climb down one at a time. By this time, Jack Napier had put on a gorilla suit, trying to kid them out of busting us. When he was climbing down, the cops said, "Oh, here comes King Kong!" Two cops grabbed him, spun him around, put him against the wall, yanked his gorilla head off, *zipped* his suit down—meanwhile, they were searching all of us for drugs or weapons.

Then they loaded us into the paddy wagons—which is how I discovered that paddy wagons in the inside were segregated by sex—at least in San Francisco. There's a chicken wire fence down the middle, with benches on both sides, so the men and women can't get at each other and do any "friggin' in the riggin'." They drove us to the Mission Police Station. The cops just hated us because there were twenty-six of us, and they had to do twenty-six sets of paperwork. This took a couple of hours. They had us in the paddy wagons the whole time.

They eventually brought all of us into the station to sit at a huge table. A photographer took Instamatic photos of us, although we were never actually formally arrested, printed, and booked. We were issued citations telling us to appear in court. The cops called us "the Max Factor 26"!

Now, the organizers of this event, Gary Warne and Adrienne Burke, already had a lawyer retained in case we got busted. The lawyer got us a "conditional discharge"—if we stayed out of trouble for six months, the D.A. would drop the charges. He got us the best possible outcome. So that was a combination of an adventure, an "Enter the Unknown," and a political protest.

♦ **V:** *Jack, tell us about the McDonald's billboard prank*—

McDONALD'S

♦ **JN:** We collaborated with Ron English, who came in from the east coast, to help celebrate the fiftieth anniversary of McDonalds. After some reflection, we realized that McDonald's ultimate goal was "to serve man." We decided to do our part by putting up a billboard close to one of the highest-volume McDonalds retail stores in San Francisco.

People dressed up as "Ronald McDonald" and showed up for our billboard "christening." Ron painted a backdrop of a fat, sardonic Ronald McDonald on the left, a giant alien on the right, a McDonald's gateway arch in the middle, plus a caption, "To Serve Man." In the center we put a life-sized, live-action animatronic Ronald McDonald with a giant Big Mac in his hand, perpetually pushing it into the face of a corpulent eight-year-old kid kneeling in front, like he was taking Communion. There was a live-action tableau on the platform in front, with the billboard painting behind it.

Our press release reflected the fact that we're supporting McDonalds in their 50-year effort to fatten up humanity, to better serve them to the aliens that are coming down!

♦ **V:** *Where do you get Ronald McDonald outfits?*
♦ **JN:** You can get a cheap red wig at a costume store. [Ed. note: Ron English and his wife Tarssa made Ronald costumes; BLF associates made their own, as well as three compelling "Hamburglars!"] Then you need white leggings and a red-and-yellow striped shirt. Our website might list stores where you can get these. I pre-wired the billboard, so all we had to do was put the dummy on a pre-set stand, plug him in, and he started punching the kid in the face with the hamburger.
♦ **V:** *What an idea*—
♦ **JN:** This was inspired by an old "Twilight Zone" episode, "To Serve Man," [Episode 89] where these happy, friendly, aliens arrive on earth and start helping humanity. They have a book they're reading, and a suspicious woman steals a copy and starts translating it. She finds out, to her horror, that it's actually a cookbook!

This McDonalds hit was in the middle of the day, on a Sunday afternoon—Memorial Day, actually—near Golden Gate Park. There were a million people in the street, cops driving around, bicycles and cars constantly going by. We had a van with Viacom stickers on the sides (which is the company that owns the billboard). Four of us were working on the board, and until we put up the animatronic figures, nobody looked askew at us. Our ground crew was watching to see if anybody was suspicious, and if it looked like they were getting on a cell phone to call the cops, they'd try and stop them.

The hit was in a Cala Foods parking lot, and one of our spotters was inside the store. He overheard one person go, "Hey, do you think that's an ad for that movie *Supersize Me?*" He automatically thought it was a legitimate image, even though it was the most bizarre image you could conceive of. As a distraction, we also had about thirty people dressed up as Ronald McDonald—their job was to show up at the last minute and take away attention from us when we were finishing up the billboard.

So we finished, got into our van and escaped a few blocks away. We parked, put on our Ronald McDonald costumes and returned to join the crowd of other Ronald McDonalds. By this time the police had come; the CALA Foods manager had called 'em. The police showed up and couldn't do anything about the billboard. The Fire Department came later and took down the two manikins. But they'd already been up for several hours, and we'd filmed the whole thing. Then the police put the manikins in a paddy wagon, but they couldn't close the rear doors, so their feet

stuck out.

Basically, the cops came, arrested Ronald McDonald, threw him in a paddy wagon, we filmed this and it became part of the feature film *Popaganda,* a film documentary about Ron English—the finale of which is the BLF and Ron English doing this billboard hit. It couldn't have worked out more beautifully—the cops arresting Ronald McDonald was beautiful! For my money, this was the greatest billboard hit I ever heard of, because it was the only one that used live animatronic figures; the only one where we had an entire street theater piece using thirty Ronald McDonalds on the ground, and the police who showed up were part of the event. And we left a good bottle of Scotch on this Ronald McDonald billboard for the sign workers.

Now for me, the best pranks are whimsical and humorous. You could spray-paint "Fuck McDonalds" on a billboard, and people who are already Greenpeace or Adbusters or anti-globalist types will nod their heads in agreement. But that's like preaching to the choir. It's the people who *don't* necessarily think that way that I want to get to. I like it when people pause and look, especially if it's confusing. There'll be that second when they're thinking, "What the hell does *that* mean?" . . . a little glitch that makes people think about *where they are,* and question what advertising really *is.*

There is a ubiquitous, non-stop barrage of corporate advertising and imagery everywhere we go, and we need to yell back at 'em! There are many groups around the country who alter billboards, and we're all just telling people, "Advertising is a language. You're being spoken to constantly through these ads. But you can *talk back* to them! You can make it a dialogue. And you don't necessarily have to climb on up and alter a billboard. So every time you see a Nike swoosh logo, *in your mind* you can change it to a dildo or something you find humorous." So in our billboard alterations, we're simply having a *dialogue* with the advertisers.

♦ **V:** *Now, we didn't find out how the BLF actually began—*

♦ **JN:** Well, the first Billboard "hit" was a

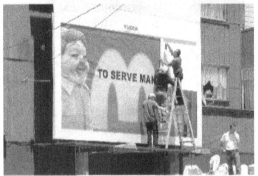

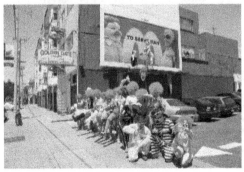

continued next page . . .

Suicide Club event organized by Gary Warne and Adrienne Burke; it was a Max Factor billboard. I was on that event, along with Irving Glick (a graphic artist). It was so much fun that some of us decided to start a group that did billboard alterations expressly. The Suicide Club hit had been far too disorganized, and 26 people is way too many!

My fantasy was to create a group of ninjas—well-trained commandos who would do billboard alterations with much more control and thought and planning. (The Suicide Club hit had been more of a social experiment rather than a tactical exercise.) So this older prankster, Irving Glick, a local journalist named Simon Wagstaff, and I started scouting billboards around town.

Mind you, there were already several groups doing billboard alterations around town: Truth in Advertising, an Australian group called Bugga Up [sic] who did political and anti-smoking billboards—they were ground-breaking because they were a collective, group endeavor. However, the graphics were, in my mind, too political and not really humorous enough.

Irving wanted to do graphics that were so slick you'd think the original company had done them.

♦ **V:** *How do actually DO a billboard alteration?*
♦ **JN:** We have up to four installers to install the pre-made graphic. If the job is large, one person will be the lookout and communication liaison with the ground crew. If it's a big alteration, we'll have a ground crew at four or five locations, with walkie-talkies to keep in touch. Their job is to watch for cops and anybody who's taking undue notice of the billboard. One lead person will be in cell phone communication with the installers up on the billboard. We wear jumpsuits with "Acme Painting" or something stenciled on the back, and act like we really *are* a billboard crew working on a billboard.

The BLF wrote a manifesto as a parody of manifestoes, and it's on our website. I wrote it with John Thomas, our head of security. It's tongue-in-cheek, of course. I don't have any illusions about how influential we might be. But if somebody gets something out of it, great. If somebody looks at advertising differently, that's great, too.

Another aspect of billboard alteration which is so important to me is: when you actually do the hit, you are engaged tactically and strategically with your environment. You really learn about all the variations of the landscape you're in—especially as you're charting out escape routes.

When we climb up on these billboards, we're working together in a team effort. Yes, there's

some danger involved—you could fall off, and some of these billboards are eighty feet above the ground. Yes, we're not killing anybody; we're not blowing up a bridge. The actual criminality is minimal and debatable. You could make an argument that we're damaging these boards, but in reality we go to great pains to never actually damage a board.

♦ **V:** *Do you use any distraction tactics?*
♦ **JN:** Sometimes we've staged "real" photo shoots on the ground, with scantily-clad models. A French video team filmed us doing this on a traffic island in the middle of San Francisco. Anybody who drove by, including several police cars, went, "Oh, a photo shoot!" and looked at that, instead of looking a hundred yards away, over the shoulder of the photo shoot women, at the billboard above that's being altered.

So when you do this you're fully engaged—it's the whole Ninja thing. You're in tune with your senses, your adrenalin is pumping, you're involved in a group activity—you feel much more *alive* when you're doing these projects. It's amazing. And I encourage teenagers everywhere to start groups like this—it's so much fun.

However, these days you have to wear disguises and be aware of electronic security measures and surveillance cameras that are everywhere. But hopefully, kids will figure out how to circumnavigate all this. The more our society tries to control the populace, the more you have to find ways to encourage people to *counter* that.

After BLF started, I started reading about groups in the past that have done similar types of pranks. I realized there is a long history of fiddling with "consensus reality" that goes back through a variety of art movements and social movements over the years. Naomi Klein's *No Logo* cites groups in the 1930s that were altering billboards. Around World War II the whole "Kilroy was here" graffiti was colossal, worldwide—every men's bathroom stall you went into had that, often with a crude drawing of a man poking his nose over a fence. Apparently it was spread by American servicemen.

There are several academic studies of billboard modification, and every few months the BLF gets an enquiry from somebody doing their doctorate on "culture jamming," which is a phrase in current use. This is either the death knell, or another way of spreading the word, 'cuz once the academics get hold of something maybe it's dead—you never know.

♦ **V:** *I don't think rebellion is ever gonna be dead—*
♦ **JN:** The insurgent spirit never dies; it's the tactics that keep changing.

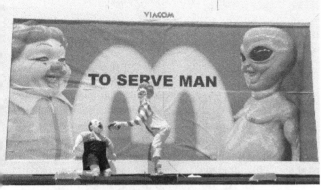

the end

◆ **V:** *And now we're in the age of corporately-manufactured, fake rebellion which channels rebellious impulses just into consuming, really.*

◆ **JN:** The advertisers are brilliant, using techniques that are very successfully coercive. They develop focus groups. Eddie Bernais, Freud's nephew, developed, back in the teens and twenties, my favorite advertising campaign for Lucky Strike cigarettes. He took this failing brand at a time when women's suffrage was gaining force and made smoking part of the women's movement. He organized hundreds of rallies of suffragette women, including one on the steps of the Capitol Building [Washington, D.C.]. Lucky Strike became the top-selling brand in the country!

◆ **V:** *And all these women worked to promote this brand for free, just like kids do now to promote the latest hip-hop brands—*

◆ **JN:** Of course they didn't get paid; they were out there fighting for the right to kill themselves! So this is the power of advertising. And the sophistication employed today is truly amazing. For twenty years corporate ad agencies have paid spies in major cities—

◆ **V:** *They call them "cool hunters."*

◆ **JN:** Right. So any kind of insurgent, nascent youth "thing" that pops up anywhere—within six months or less it's completely a marketing hook. So if there's any blip or glimmer of any new youth movement, it doesn't have any time to gestate—it doesn't have time for the kids to turn it into something that could actually frighten society, like Punk did.

Punk Rock was scary, cuz people didn't understand it. They'd look at it and go, "Wow, where did *they* come from? They came out of nowhere!" They didn't realize this had been percolating underground for several years, and only after a great deal of time did it coalesce from many, many different people into a discernible "image." There was a hugely diverse creative well to draw from. And people thought it should be stopped, like any good youth movement of the past fifty years. In a way Punk was the last gasp; it was so extreme.

Hopefully something like that will happen again, but kids will first

have to decide they don't want to be marketed to. Then they'll have to learn how to avoid the marketers. I'm holding out hope that kids will organically create some kind of response to this overwhelming commercialism.

♦ **V:** *To me, billboard alterations are "art," especially when they're pleasing to the eye. They raise a lot of questions about art and society, which is what any good art supposedly does. And these days the line between art and advertising has vanished.*

♦ **JN:** I would agree, and I think that many of the most creative people go into advertising now. It's their day job, and if they have an alternate creative life, they can afford to do it. Also, it's a fairly creative field.

The Chiat-Day Apple "Think Different" campaign was brilliant. I was not happy that they were taking dead people and using their images to sell things. Living people can pimp their image all they want to; the Dalai Lama can pimp his image and make Richard Gere and Steven Seagal a reincarnated lama or whatever he wants to do to promote his program.

It sorta pisses me off that you can't make fun of the Dalai Lama who's been reincarnated going back how many thousands of years—what a crock! And all these morons thinking, "I wanna be a Zen or Tibetan Buddhist and get enlightenment!" But historically, Tibetan Buddhism was an aristocracy ruled by 3% of the population; the other 97% were poor, slave peasants. Now, I don't mind saving the great parts of the culture, but let's be aware of some reality here—this is the same thing as Jesus Christ being of virgin birth— a bunch of bullshit. Yeah, if you're a rich Marin County type, being a Buddhist makes a lot of sense. If you're a starving Thai, it's a philosophy that *keeps you in your place.* This was why when we changed the Dalai Lama billboard, we changed "Think Different" to "Think Disillusioned." And the Dalai Lama had chosen to sell the use of his image as an advertising icon—he had an excuse! But Alfred Hitchcock didn't have the opportunity to do that, and neither did Amelia Earhart—they were dead. We changed Amelia Earhart to "Think Doomed."

♦ **V:** *The image of the archetypal woman aviator is a modern, liberatory, feminist archetype. I think J.G. Ballard really admired woman aviators—*

♦ **JN:** Precisely. I remember basking in the light emanating from that image, looking up at that twenty-foot-tall, beautiful, cryptic visage of Amelia Earhart, and I was immensely affected— that's the power of advertising; it's overwhelming. And we took that and with one little ju-jitsu flip completely changed the meaning. The ad

agency was using the power of these beautiful, culturally profound images, just to sell their stupid product—

♦ **V:** *—while wrecking our historical memories.*

♦ **JN:** Precisely. It's a psychic violation. Now, when we did our Apple "campaign," we got a lot of flak: "Hey, why aren't you going after Bill Gates?" And Apple Corporation had an internal email barrage about our billboard alterations; people were calling us "shills for Microsoft." We sent Apple an email: "Yeah, we actually *were* paid by Bill Gates to do these billboards"—we were lying, of course. But, people took it so seriously . . .

♦ **V:** *It's because Apple is a cult—*

♦ **JN:** It's a cult, exactly—almost like an underground, rebellious movement. And they think they're rebels because they use Apple and are anti-PC.

You have to be able to look at advertising and judge it as a thing in itself. I can appreciate the Apple campaign and go, "Wow, these ad agents really earned their money on this one. It's a brilliant campaign." But when you put it in its *cultural* context, it's a violation—an incredible violation. But this advertising language has become the language of our culture; it's the language we speak in now.

If you're not on television, you don't exist. This notion is the basis for the "reality TV" upsurge: the general public's complete indoctrination into the notion that if you're not in the media, you simply don't exist. *Everyone* wants to be on *Survivor.* Starting with Morton Downey in the early eighties, people will get on these *devolving* talk shows and publicly admit, "I slept with my retarded cousin." Then they'll have *thirty* people from around the country who slept with their retarded cousin on a panel—Maury Povich is one of those show hosts. They're mining this incredibly base desire for people to become "real" by being part of the media. People will go on these shows and talk about sleeping with their mother; strangling their dog to death while they're having sex with it . . . They'll talk about *anything* just to be on television, just to be real—or *more* real. Like the Tyrell Corporation [*Blade Runner*] said, "More real than real." This is endemic; it's everywhere.

♦ **V:** *Pranksters are kind of in a war against all this—*

♦ **JN:** Yes. But as a prankster, if we're not having fun, we lose. If we're too strident ("Off the Man! Kill the pigs!"), we lose. When I was a kid, I read a story by Harlan Ellison, "Repent Harlequin, Said the Tick Tock Man." This parable is set in a future society where everything is completely

controlled by the clock. The "Tick Tock Man" works a dumb job, and the guy who runs the world is "The Timekeeper." Everything is quantified by time: you have to be on time here, and there. Then there's the "harlequin," the prankster, who spends his time throwing jellybeans, gumming up the works of society—I identified with *that.*

I also read John Brunner's *Stand On Zanzibar.* It featured a character who, whenever he spotted an *officialese* sign, would change it to say something absurd, like "While in the bathroom, please keep your left hand inside your pants pocket—The Management." And if *everyone* did stuff like this; if everyone continually fiddled with the stock language and pronouncements and images of control . . .

Another big influence was William S. Burroughs; it seemed that his work was an "outing" of how control works, pointing out how we create these systems that then control our lives in ways where we no longer even see the mechanism of control. The cut-up technique of Burroughs and Gysin is another way of deciphering and countering how the control process works. On a pop music level, the music group Negativeland invented the term "culture jamming" and did a lot of influential work which is documented in their book *The Letter U and the Number 2.*

♦ **V:** *I like the idea of carrying around official-looking stickers you could attach anywhere, like to the air hand dryer in a public bathroom, and you look closely and—*

♦ **JN:** —maybe it's giving you a conflicting message or nonsensical command. This helps you look at what the *actual* commands are saying.

♦ **V:** *I like that Situationist statement, "The society that has abolished adventure makes the only adventure the abolishing of that society." I mean, what real fun do we have anymore that's not pre-scripted and clichéd, with no surprises?*

♦ **JN:** It's all marketed. We've gone too far: now *all* the communication is corporate-controlled and antithetical to all the Democratic ideals and beliefs we were raised with. A corporate oligarchy is now controlling communication; they're going to own it all. Any insurgency will have to pop up in ways you and I don't even know now. Just like nobody saw the collapse of Soviet Russia coming. The dark corporate oligarchy that's running everything is likewise a paper tiger. It's hollowing out, as it does away with the moral and ethical underpinnings of our culture, and recasts everything as a sales pitch.

The image of the iconic, loner, self-reliant, John Wayne-type American, who comes to the aid of anybody in trouble, is just a sales pitch. It's no longer true. And it's a huge betrayal of our culture. We'll either find another planet to despoil, evolve/devolve into something else, wipe ourselves out, or some other species will supplant us. But for the next twenty years, as long as I have a fast car, some gas, and a gun, I'll be okay! [laughs] Is that too cynical?

With respect to elucidating the media landscape we're immersed in now, I do think that William Burroughs and J.G. Ballard are the most important writers in the English language of the past forty years—I can't think of anybody else. I think this will become clear about twenty years from now. Ballard, especially, explores deeply disturbing areas of the human psyche as it coalesces with this technology we've created—*we're becoming one with the technology.* And that's either the doom, or the hope, for humanity!

♦ **V:** *They don't report this happening here, but in England, they can't seem to filter out the birth control hormones and Prozac-type drugs which are in their water supply.*

♦ **JN:** To me, that's evolution at work. If we alter our environment so that our children hit puberty two or three years earlier, is that bad or good? We'll either evolve in a way that allows humanity to continue existing, or we'll cancel ourselves out. Of course, the continual use of antibiotics is gonna weaken the human system to a point where there'll be a massive threshing out of large parts of the population.

The best time to live in Europe was right after the Black Plague swept through, because there was more land to go around. Once the population jumped back up, life became more oppressive. If 99% of the population were wiped out today, the remaining 1% would have a lot more freedom! You could change your name and move to California like you could in the 1840s, after you've murdered your family and you want to start your life over again without anybody knowing it, and become the pillar of the community in your second life . . . which is what used to happen. All these European prisoners who got shunted off to North and South America and Australia—many of them ended up founding cities. The entire group of people who founded Texas were criminals who got kicked out of Tennessee and Virginia—they're icons now.

It used to be you could change your life, you could change your name, you could go somewhere else, and your earlier mistakes didn't follow you. That's the biggest change in our culture: you can't escape your past mistakes. Your credit

history's gonna stay with you your whole life; your criminal records; your buying habits are known by corporations . . . you can't make the same mistakes you could even forty years ago. You can't reinvent yourself anymore. That type of freedom is now extinct. So maybe 99% of the population dying off could be the best thing that happened for humanity. Who knows?

♦ *V: How would you subvert the iPod advertising campaign? There are no words, just sexy girls and boys in various poses, holding iPods.*

♦ **JN:** You could redesign the iPod as some tentacle thing, with the tentacles going into their brain. I don't know. With advertising being the flat-out language of the culture, it's becoming more difficult to parody it. As a prankster, your goal is to *change* what is said by the advertisers. *Anything* to get people pissed off and thinking is good at this point in time. People are just accepting of what the corporate controllers are allowing us to do, which is: to consume.

♦ *V: Everybody's lost sight of a major goal: to get the largest possible picture of how in reality you may actually be a slave.*

♦ **JN:** All I can do is encourage people to get involved in activities that are not commercial activities. Engage with people in activities which are not commercial activities at all. Back to the Suicide Club: a huge part of the founder Gary Warne's philosophy was that nothing was charged for. No money changed hands.

♦ *V: That's how Punk was in the first two years. It seemed like everybody got in free to clubs; nobody seemed to have any money—*

♦ **JN:** America was created by small business owners; nine out of ten people who signed the Declaration of Independence were small business owners. That was the strength of our culture, and it's being absorbed by this global corporate blob with no real allegiance to any regional or social mores, except to their bottom line and corporate power. And that's antithetical to what America means to me. That's what we're facing: *The Blob.*

♦ *V: As well as the blog—*

♦ **JN:** Blogging just indicates how much people feel they need to advertise in order to exist. How many personal blogs could possibly be truly interesting? Of course, for your immediate circle of friends, it's another way to communicate. So I have mixed feelings about computer communication. A website for an artist or small business or prankster is basically just your ad for yourself— an expansion of the Yellow Pages. Say you're interested in an artist; you can go look at their work on-line and read their *curriculum vitae* and it saves a lot of time.

We used to hand-type and cut-and-paste our press releases, and mimeograph them on Gestetner mimeograph machines. Then we would hand-deliver the press releases for the BLF to KRON, the Chronicle and other local papers. And we'd get tons of press, especially on slow news days, and this spurred us on. Now, you can get a mention on a site like *boing-boing* and a million people read you for thirty seconds, and then you're in the dustbin. I'm not saying that's a bad thing; I'm just not sure what to think of it all, at this point.

♦ *V: Who else does billboard modifications?*

♦ **JN:** Church of Euthanasia (Boston) did some good billboard modifications in the nineties. We all love Ron English, of course. California Department of Corrections (CDC) are fabulous and funny. Their stuff is more pointedly political, so maybe that's why they're not as well-known as BLF. The Situationists were important for exposing the power of symbols and how they're used by the dominant control factor, and then "fiddling" with those symbols. But most of their books—to me, about 20% of a book is readable, and the rest is rehashed Marxist B.S.

♦ *V: Tell us about another billboard alteration—*

♦ **JN:** We're planning to hit an Abercrombie and Fitch billboard, partly as a nod to the upcoming Gay Freedom Day Parade. Abercrombie and Fitch sells elegant, high-end clothing. In their ad campaign they've been aping the standard anorexic female ads, but they're using really beautiful young boy toys who look sixteen or seventeen, scantily clad or almost naked, relaxing in a very sensuous pose. The only caption on the billboard is "Abercrombie and Fitch"—that's all. So we plan go up there and change it to "Abercrombie and Felch."

♦ *V: Right before the Gay Freedom Day Parade-*

♦ **JN:** Then we plan to send out a press release noting how great it is to see that boys are being used as grotesque, simple, sex objects—just like girls, and how this really is leveling the playing field!

♦ *V: Yes, they're bringing* equality *to the sexual-advertising landscape.*

♦ **JN:** Of course, felching isn't necessarily a homosexual act at all. We'll also touch on the ever-increasing omni-sexuality of humanity, and how great *that* is.

♦ *V: That's a word I've never heard before: "omni-sexuality."*

♦ **JN:** Well, I just made it up! ♦♦♦

ON-LINE SATIRE

The corporate-government mass media now demonizes so-called "hackers," equating them to terrorists. But many of them are gifted youth driven by the curiosity to find out everything a computer can do. And everything a hacker does is something a computer connected to the Internet was designed to do.

If hackers lampoon illegitimate authority and greedy corporate marketing scams, isn't that their right? Isn't satire a form of protected speech under our Constitution and Bill of Rights? We say "yes!"

A parody website is in principle no different from an issue of National Lampoon or Mad magazine. Now, we do not regard stealing of credit card information as a prank—it's just plain greed and theft. But if George W. Bush or Enron or the W.T.O. or any other global corporate plunderers and polluters can be satirized and lampooned, then why not?

If on-line satire and parody is demonized and equated to "terrorism," then the U.S.A. has just become the U.S.S.R . . .

ARC POWELL

who has been writing software for almost twenty years, is nearing his thirtieth birthday and morphing from being a programmer and hacker toward the identity of a "Hacker-Chef." Lately he has been concentrating on developing new flavor combinations, using state-of-the-art chemistry technology. Marc Powell travels regularly, but resides primarily in the Bay Area. Interview by V. Vale.

♦ **VALE:** Why do you call yourself a Hacker-Chef?

♦ **MARC POWELL:** The point is that cooking and hacking are the same—both utilize the same nerve pathways in the brain. You can write a piece of software for a girl, but she's not really going to be *that* interested in it! But if you cook food for her, you're releasing chemicals in the brain: "Yeah! Yum! Good! Uhmmm!" Whereas no one really cares if you're just making a website, or writing some software. In my life I write software and hack for six months; then I spend six months trying to "hack with food." Actually, I consider myself a Hacker-*Anarchist*-Chef.

♦ **V:** *How do you define hacking?*

♦ **MP:** Hacking: finding out as much as you can about a system, using your brain. Your brain is *made* to find patterns in things. So hacking is learning, geeking out, finding out as much as you can about a computer, or a cellphone, or a camera, or society, or language, and then using that knowledge in ways that no one's ever thought of before, to either create new things or unravel existing constructs and metaphors. And that's all hacking is.

The first monkey that broke a branch off a tree and beat another monkey to death was hacking that tree. People hack language all the time. George Bush hacked politics. Now, one of the biggest challenges in the hacker world is making people see that hackers aren't "The Other," and that hacking is a quality innate in *all* people. It was in tinkerers and inventors a hundred years ago—people who liked to tinker on cars and make them go faster; modify ham radio sets to receive police broadcasts, and things like that. Anytime someone figures out how to do something unexpected on a cellphone, they're hacking: "Oh, does this work? Look, I can do *this*; they didn't want me to do that."

Again, the challenge now is combating the idea that hackers are The Other, because hacking is a common aspect of existence.

♦ **V:** *But hacking does seem to be outlaw, forbidden, rebellious, at least in the major media—*

♦ **MP:** Well, hacking is REBELLING, too, and here's where the "Anarchist" comes in. Have you ever read *God and the State* by Bakunin? In the first chapter he describes the Garden of Eden and asks the question, "What is it to be a man, *versus* What is it to be an animal?"

In the Garden of Eden, God says to Adam and Eve, "I want you all to be ignorant and not eat the fruit of the tree of knowledge." Basically God wants all humans to be animals. Then the Devil/serpent, or whoever is represented as "evil," comes along and says, "I want you to all disobey and seek out knowledge." So to be a man is to search out knowledge, whereas to be an animal is to remain ignorant. To be an animal is to be herded, and *to be a human is to rebel.*

♦ **V:** *Well, somewhere back in time humans got called "homo sapiens," which implies that the business of being human is to seek out knowledge. So hacking takes that further, to be more about uncovering secret knowledge, telling you how the world really works—*

♦ **MP:** It's also about uncovering resources, too—*controlled* resources.

♦ **V:** *Hmm. The world has changed so radically. It used to take a lot of money to travel and meet people all over the world; now you can meet them through the Internet—*

♦ **MP:** Human existence is like a distributed computer network of all people. There's six billion people in the world, and every person is their own computer that understands a certain number of instructions, concepts, or words. We all have our own language, so I understand different things than you. But we also have the ability to communicate new ideas to each other.

Let's say you wanted to do a huge, almost

insurmountable task: taking in all the radio waves from the sky, analyzing them (looking for alien communications?) and sending in the resulting data to a central depository. So you invent software that spreads the job out to millions of computers; your computer runs a screensaver that takes just a little chunk of the task and sends it back in. The idea is: distributing a task.

Humans are like that, too, in a lot of ways. We're all distributed clients, and we behave like cellular automata, especially in a traffic grid! We all learn from and teach each other. There's a really good book illuminating this, *A New Kind of Science,* by Stephen Wolfram.

♦ **V:** *Back to hacking: these days it's dangerous to call yourself a hacker.*

♦ **MP:** Well, you can't do a hacking book with media reports from the *New York Times!* You have to do a hacking book with media that was generated by the hacker community for the past thirty years, because otherwise it gets co-opted, and it's co-opted out of the *frame* of "hacker."

♦ **V:** *What do you mean?*

♦ **MP:** You have a woman like Annalee Newitz. She writes a column for the *San Francisco Bay Guardian* called "Techsploitation," and on her website she says, "I will reduce any cool computer thing into a five-second soundbite for you." And that's a quick summation of what reporters who *aren't* in the hacker world report to their readers, right? But are they correctly representing the hacker world?

Every mainstream story about hacker media has two implicit assumptions: 1) the person who's writing about it is getting paid for it, or the publication is benefiting from its co-optation of this new cool thing; and 2) they are portraying hackers as evil, because every commercial publication cherishes/sustains/advocates an inherent value for "intellectual property"—which is *not* a value that the hackers share and regard as valid.

Hackers look at intellectual property like any social metaphor: as just something to be hacked. Not "destroyed," but "unraveled." How does all creativity take place? You either create something using an existing system—using already existing intellectual property, like "Creative Commons" has; or you unravel an existing system and find other implications and applications. Taking an example from common technology, you could say, "Look, you can buy these things called VCRs and CD and DVD recording drives. Your intent to legislate scarcity and copyright is actually bullshit because every single communication contains implicit instructions on how to reproduce and modify that signal. Every computer program is just a list of instructions, and any video is just a sequence of photons and soundwaves. A basic hacker value is: *in the universe, there is no such thing as "intellectual property" in Nature.*

♦ **V:** *Can you tell us about any hacking you've done that won't cause the F.B.I. to descend on all of us for the rest of our lives?*

♦ **MP:** Well, contrary to most people's idea of hacking as a solitary geek activity, both hacking and cooking for people are group activities involving group aesthetics. And both contain issues involving copyright and intellectual property. For example, every time someone at a party prepares a salad of sliced tomatoes, mozzarella cheese, basil, and an olive oil/vinaigrette dressing, does a royalty get paid to the original "inventor"? No. And there are countless other examples of this: the BLT, the lowly hamburger, blackened redfish, caesar salad, string beans with slivered almonds, dense chocolate cake with berry sauce—the list goes on and on. Most of our cuisine combines intellectual property from "the commons" with a group aesthetic.

Similarly, hacking involves creating software code (which can be admired for its beauty, sim-

Is this Marc Powell?

plicity and ingenuity) in the context of a larger group aesthetic, which becomes more palpable when you attend a hacker conference. People form hacking confederacies and hacking groups—maybe they never ever meet in person,

but they're like hacker crews, hacker gangs. And they start hacker wars with each other which arguably constitute almost a dynamic new form of "performance art." But it's a kind of art that doesn't make it much into the mainstream media. Or if it does, it's like, "And then they broke the law and went to jail," or, "And then they do all this fucked-up shit to each other." Whereas in reality, a full-scale hacker war can be a beautiful thing.

♦ *V: What do you mean?*

♦ **MP:** Because it's partly about elegance of design and achieving amazing results with minimal coding, strategy and implementation . . . and also, lack of money and huge resources. Well, at least it can be a *funny* thing, or a funny story. For example, last year in New York I attended a hacker conference, "Hope Hackers on Planet Earth," a conference which *2600* magazine does every few years. At a barbecue, I was introduced to this guy from Australia. We started revealing stuff we'd done, and discovered that back around 1994 or '95 we had hacker-warred each other. But it was like *okay,* because we hadn't communicated in quite a while—eventually all your enemies become your friends after you know them long enough, after you're the only ones left standing! We were listing off all this stuff we had done to each other back then—some of which we didn't even know had taken place.

Back then a small group of us had taken Australia off the Internet! At the time, there were only three or four links into Australia, so we could just turn off all the packets that go in and out of Australia (you can't do that anymore). This guy had been the sys-admin for this really famous server that a lot of software came from. The FBI telephoned him during a kiddie-porn investigation, cuz they found it on his server, and he went into all the files he was going to give 'em and put my name in all of them! Luckily, I had planted a fake name with him, so the name he'd put in it was Mark Wilson, the son of Scott Wilson who's an FBI agent. So the investigation was stymied. It was hilarious talking about this years later, without having had to deal with a lot of distressing repercussions!

Unfortunately, a lot of young hackers coming up these days are fifteen to twenty years old and doing a lot of crazy shit. They don't care about going to jail. Cuz now you can go through any country and not get caught—you can go through North Korea or Russia or Austria or South Korea or Japan, and make it so that seemingly, your tracks are all covered.

Now with wireless you can do anything, especially in a city, and not get traced. Well, it's harder to do it in London because there's CCTVs (closed-circuit television cameras) everywhere. But even then you can plant a little hub that bounces you out, and routes you around other people's traffic, and routes you through people's home DSL modems, so you don't get caught. (Nevertheless, people still get caught.)

♦ *V: What's this wireless Internet access you're talking about?*

♦ **MP:** Well, there's a map on the Internet of San Francisco wireless coverage (Argus Internet Archive), and it shows you every location. I have a 25dpi grid antenna on my roof that picks up probably a couple hundred wireless stations. It's a nice, strong antenna. You can get free Internet access all over San Francisco—the whole city is free. Of course, there are a lot of cafes that offer free Internet access. And even if they encrypt it, it takes about two minutes to decrypt it. It's usually the kind of encryption where "A is 1, B is 2"—something really simple—it's not really encrypted, it's just encoded. Computers encode things.

So if I ever went to court for hacking, the tact I would take is that hacking is not illegal. Hacking is doing what the computer wanted me to do. Someone designed a computer to do everything it does. Software is a legal document that declares, "Hey, if you do this, I'll do that. If you send me a certain packet, I'll show you banking account passwords." It's not *me* telling your computer to do that; the fact is that it's *your* computer and *your* Microsoft software just doing what it is designed to do.

Of course Microsoft does a great card trick—a great deflection—which is, "That is totally not our fault." Why? I think that basically Microsoft makes a value judgement based on their stock price. They say, "Well, we can release the software now, when we told our investors we were going to release it, or we can spend six more months doing security on it. Let's just release it now." So who holds them accountable for that? Nobody.

Why not? Because there's *money* in arresting people. There's millions or billions of dollars a year in the security industry. A lot of the dot-com money is going towards biotech and police-state stuff now. Companies are saying, "Well, we're writing software that allows the Department of Homeland Security to detect someone's face in a video-stream." It's still "tech," right? And all this kind of illustrates how the hacker world was co-opted by corporations and government.

In the eighties, the hacker world was very

adversarial, and corporations responded by saying, "That software you stole from us—that's worth ten million dollars. Cuz it cost ten million dollars to develop it, or a hundred million. So Kevin Mitnick, who went to jail for stealing Sun software—that software that he stole Sun gives away for free now, 'cuz it's like open source or whatever. So we had these adversarial relationships in the past between corporations/governments and hackers, and governments would raid people and point guns at fourteen-year-old kids, arresting them.

Now, it's all kinda being co-opted. Some friends of mine from Boston who call themselves the "L0pht" [loft] testified in front of Congress that they could break into anything within thirty minutes—something like that, and that they could take down the whole Internet. The direct result of that was the formation of the NIPC (National Infrastructure Protection Center), and FBI cybercrime funding went up. A huge amount of money went from the government into the security industry.

Today a lot of big security firms are cashing in: "We've created this whole system for you. But you *also* have to pay for our security systems." And a lot of hackers built security companies that are basically not only securing machines (which I think is a fucked-up concept, but more on that later), and worse, are getting paid to put other hackers in jail.

Now our tax dollars pay for not only government security, but to a large extent, also for corporate security. Meaning that some kid will write a Ph.D paper on how to make a better chip, and Intel will just *do* that process and copyright it. Another thing: originally the Internet was developed by the Department of Defense with taxpayer money, and then the government just gave it to private industry like AT&T, Sprint, and MCI. So I wonder, "How can I go to jail for compromising the security of something these companies fucking stole from the "commons"?

The media seems to like to confuse notions of personal security with corporate security. Most people want personal security: "I don't want to be stalked by a crazy person; I should have my email not read," even though companies like *Google* read your email just to advertise to you. Corporate security is often about the security of a company's "right" to have a profit, and if it's a security company, it's about getting rich by helping to put kids in jail . . .

There's a money incentive to put people in jail. The FBI, NIPC and corporations have *budgets* to spend on security. Consequently, hacker conferences have become security conferences. I was arrested at a Defcon a couple of years ago for trying to shut it down, because it's sponsored by Microsoft. It basically became a "selling hacker culture conference to kids" event. It was like a rave. You pay a hundred dollars to get in, five dollars for a bottle of water, twenty dollars for a T-shirt. And then, they ask CEOs to come to their White Hat, above-ground, thousand-dollar conference, and the CEOs come to learn how to be afraid of hackers and why they should spend

Or is *this* Marc Powell?

more money on "security." So it's like a double-pronged attack on hacker culture.

So hacker conferences become security conferences. And people say, "Sure, hackers are interested in securing things," but they're also interested in unsecuring things . . . maybe everything shouldn't be secure that is secure. Maybe the right of private property shouldn't be secure. Maybe the right of owning information and being able to say, "This is 100% mine," shouldn't be secure.

♦ *V: I'm still not clear on your concept of legitimate ownership. If you write a song, shouldn't you be*

allowed to get royalties?

♦ **MP:** Well, does anybody own guitar notes or guitar chords or riffs? A group called KLF put out *The Manual: How to Have a #1 Hit the Easy Way.* They postulate that because copyright rules are written by white people for music, it's half rhythm, half lyrics, but if they're written by Black people, it would be like 70% of the song goes to whoever invented the bass line, and 30% is everything else. They seem to be saying that you can steal any bass line you hear and put it in your own song and not get sued for it. In other words, laws reflect the perspective of the people in power.

♦ **V:** *A cultural slant, right.*

♦ **MP:** The same thing when a newspaper talks about hackers. They don't say, "I'm a hacker and all my friends are hackers." They basically say that hackers are evil people who are attacking everybody else. But this is a form of racism, in a way, having to do with *restricting the realm of dialogue.* I mean, if you go to college you can't take a course called "Being an Anti-Colonialist Warrior," or "How to Hack the Fuck out of Corporations and Erase Debt."

♦ **V:** *That's for sure. Can we go back to hacking, and talk about something that won't put you behind bars?*

♦ **MP:** The F.B.I. issued a grand jury call for a hacking group in a certain city, so the group hacked the voicemail of the local F.B.I. office to find out *why.* However, the investigation slammed to a halt because all the F.B.I.'s interns (the computer geeks) were going home for the summer!

We could discuss hacker wars in which people "own each other up." They own each other's email, chatlogs, website, social security number, bank account number—whatever they can get to. Sometimes they can get into the NCIC and put criminal records in for a person, or get into the phone system and change the records of where incoming or outgoing call numbers went to. If you can access someone's phone records, you can find where all their long distance calls go to and then "own" all of those people.

The most famous hacker war was between LOD and MOD, Legion of Doom and Masters of Deception. They are a Texas hacking group and a New York hacking group that had a huge all-out hacking brawl throughout the nineties. At least one of them ended up in jail. Bruce Sterling wrote about that in a book called *Hacker Crackdown.*

There have been a lot of "secret" hacker conferences that are invitation-only, and sometimes they get broken up by the cops. It's usually every-body coming together and getting drunk and doing drugs in some hotel rooms. Like, my first hacker conference was in Austin, Texas when I was only like sixteen years old. Most people registered under fake names and gave phone numbers that went away in a week. Awhile ago I went to an underground festival in Holland that was fun, and another recently in New York City. People hacked subway signs to say different things, including the signs at Madison Square Garden!

Hacker groups can be pretty amazing, because even though they exist in virtual confederacies, they can still have actual hacker crash pads and "safe" houses where everyone who lives there are hackers. I was at a place in Boston called New Hack City. In Chicago, a group of hackers formed a free school called the Autonomous Zone that gave free hacking classes as well as English and Spanish classes. Imagine every town having a community space where you can teach eighth-graders how to clone a cell phone, read people's email, or set up a radio transmitter!

Actually, the virus scene is an example of hacker wars between hackers and the establishment. People write a virus, send it out and the security people, the self-appointed guardians of your computer who write anti-virus software, write an anti-virus program. But then the virus writer writes an even better version of it. These wars are usually won by the viruses, because the anti-virus software is usually not that great.

A similar hacker war occurs between hackers and direct TV/satellite companies. So if you have a satellite card, it contains a chip that allows you to receive all the channels and pay-for-view programs, but people hack these and sell them cheaply. So the satellite company employs hackers that rain down electronic black death onto all the "illegitimate" cards that are out there.

Or take TIVO. Even though you own it and it's in your house and you're not making money off it and you're not a competitor thinking about how to make a better unit, nevertheless you can't access everything it's capable of doing. It's like DVD encoding into region 1, region 2, region 3. It's *your* DVD player; you bought it; you should be able to take it from one region to another. They can't legislate that it is illegal for you to take the DVD player to different regions, but they can write a region code and then create a law which makes it illegal for you to disable the code.

♦ **V:** *There seems to be a war between those who still want more liberty for more people on the planet, and those who want to erase all freedom in the name of the "War on Terrorism"—*

♦ MP: Terence McKenna thought that in 2012 the Mayan calendar ends, and that innovation would end, too. Personally, I see ramps up toward liberty or to oppression. The one toward liberty is anarchist utopia, where we are all rewarded for being creative and taking care of ourselves. The oppression-lovers' goal is nuclear war and apocalypse. Peak Oil has been predicted for 2007, so get your transatlantic flights in now!

♦ V: *What do you think we should do? Where should we move to?*

♦ MP: Wherever you move, don't move to an island!

♦ V: *Now, do you really call yourself a Hacker-Anarchist-Chef? I've been reading this book of writings by Luis Bunuel, and I liked this quotation: "I'm always on the side of those who seek the truth, but I part company with them when they think they've found it." In another essay he said, "I refused to call myself either an anarchist or a communist," even though in his movies he shows a lot of anarchist and communist principles. Personally, I hate labeling myself anything—*

♦ MP: I hear you. For a long time I didn't want to call myself a hacker, because it was something I really wanted to be, and something I had a lot of respect for, but I had doubts as to my self-worth. Now I'm saying, "It's okay to identify myself as a hacker without fear of retribution, especially from any government institution." When you're on an airplane and you tell the person sitting next to you that you're a hacker, it's like, "Oh, maybe you shouldn't say that, 'cuz you could go to jail!" Same thing with "anarchist," too. My father told me, "I wouldn't tell people *that* if I were you. You're not an anarchist; you're not a person who's trying to throw molotov cocktails." I said, "To me, anarchism means getting rid of illegitimate authority." Nowadays I like inviting people into a discussion, so I usually identify myself as a Hacker-Anarchist-Chef.

And being a chef means being creative in a kind of scientific way. There is a food movement called Molecular Gastronomy where people combine the science of chemistry with cooking. They use autoclaves, spectrometers and liquid nitrogen tanks and invent concoctions like smoked bacon-and-egg ice cream that explodes in your mouth. They have oak-infused chocolate, leather-infused chocolate, tobacco-infused chocolate, christmas-tree-and-mango puree. They examine the chemistry of foods and extrapolate complimentary combinations.

I've been experimenting with using thujone, the active ingredient in wormwood. It's a ketone that inhibits the re-uptake of GABA (gamma-amino-butyric acid) which is a chemical in your head that occludes memory-formation—when you drink alcohol, you get a lot of GABA-formation. Fuzone clears up memory-occlusion, so you can have more lucid dreams and things like spirit quests. I think this helps people prepare for entering into the experience of a great meal.

Also, I'm writing genetic algorithms for food which function like flavor profiling, addressing the question: "Does this ingredient go with that?" I'm hoping that with just a computer and spectrometers, you can discover more interesting combinations of food.

♦ V: *Sounds like we're just at the very beginning of cuisine innovation. Whoever thought of bringing true science into the art of cuisine?*

♦ MP: Well, there are a lot of amazing restaurants in the world that are doing this. In a larger context, cooking is implicitly *partnering:* "You are the guest, I am the chef. How can I make you feel feted? How can I make you feel like an honored guest by making you feel amazing?" Sometimes I host a dinner party where everybody contributes, say, ten bucks, and the whole group gets nine courses of really amazing food.

♦ V: *That's a great concept: the ten-dollar gourmet food party. More people should have these parties!*

♦ MP: Yeah. And people sit around and talk about politics and whatever most concerns them. People exchange their versions of reality, which reminds me of something that Ian MacKaye said: "High school is the last time you're around people you have anything in common with." Geographical regionalism is very important. Other than that, you have nothing . . .

♦ V: *What are you working on now?*

♦ MP: I've been writing software, doing this thing that I've done ever since I was a kid. But doing it for money really made me not want to do it anymore; really made me not enjoy what I did. Now I'm writing political and art software that my friends use. And I cook food. Because I was thinking, "What if Katrina happens here? What if there's no computers in the world?" If a big earthquake comes, there's not gonna be any more *www.craigslist* to help organize things. So what do I do to help out my friends? Well, there will always be a need for *food* . . . ♦♦♦

FRANK DISCUSSION

founded the Feederz, a hardcore Punk band featuring Situationist graphics and anarchist lyrics, in 1977. Their first album was titled, *Did You Ever Feel Like Killing Your Boss?*—'nuff said! Frank was featured in the first *Pranks!* book and *Search & Destroy #10*. Recently he released a new Feederz album, *Taking the Night,* available from feederz.com. After a checkered career which included working for Microsoft in Seattle and doing "hacking" as a hobby, he moved to Los Angeles. Interview by V. Vale.

♦ **VALE:** *Frank, has the statute of limitations run out? By now, your whole life could almost be viewed as a prank, on some level—*

♦ **FRANK DISCUSSION:** I'm sure my parents thought so.

♦ **V:** *Are they still alive?*

♦ **FD:** Um, well—there's such a thing as *rolling in the grave*, so to speak.

♦ **V:** *There's also the* living dead.

♦ **FD:** Yeah, I know—I go to work!

♦ **V:** *First of all, how did you learn about computers?*

♦ **FD:** I've always been addicted to learning, so that made it a lot easier for me. In punk rock, I learned how to write songs, do graphics and make records. Then I learned about computers and hacking. Right now I'm in the process of learning how to make movies.

♦ **V:** *Why movies?*

♦ **FD:** What happened is that I stumbled onto a book by Robert Rodriguez titled *Rebel Without a Crew*. Essentially he made his first feature film, *El Mariachi*, for $7,000. And Columbia ended up buying it. It kinda ruined the idea that you require millions to make a feature film. For years I had labored under that falsity myself; I thought that making a movie would cost a huge amount of money, so forget it! But when I stumbled on Robert Rodriguez's book, he talks about the ability to go ahead and do it without a lot of the things that are generally considered necessary.

So it was kind of like with music—nowadays you have digital technology. With all the leaps made, you don't even have to buy film. And some of the digital footage looks pretty close to film. So I started putting together different clips from ads and documentaries—

♦ **V:** *Was it a Situationist-type collage?*

♦ **FD:** You might say that. I was essentially making a so-called music video for *Taking the Night*. I changed the timing, popped in title areas, and collaged material that I stole. So I'm constantly learning stuff—I can't stop! I'm always having to learn something; I can't go for very long without trying to suck in something. I guess it's a disease.

♦ **V:** *You never had a fear of computers—*

♦ **FD:** Yeah, and that was rather unfortunate, because it's like Lewis Carroll in *Through the Looking Glass,* where Alice says, "The question is whether you can make words mean one thing or another," to which is replied, "The question is: *Which* is to be mastered? That's all." With technology that becomes drastically important, because computers are often used to subjugate us—

♦ **V:** *That's for sure!*

♦ **FD:** Yet computers have also democratized things. Like for instance, now through the use of programs, you can put out pretty slick printouts, rather than cheap mimeographs. Now everyone has a web page, and you can get anything out there to potentially millions of people all over the world, for good or bad.

One thing that's been kind of handy about the Net is that governments *have* tried to rein it in, and of course businesses tried to change it into an *enterprise-only* scenario. But both of them failed miserably. If they say, "Hey, this is illegal," then the server ends up in Tonga. You have a globalized economy, but you also have all of the escape hatches being globalized, too. The Situationists said that the "train of our occupation" is everywhere, so the revolution (the fight) can also be taken everywhere. So as the occupation has

become globalized—

♦ **V:** *—the resistance has become globalized, too. I keep seeing articles that our government's going to crack down on the Internet, and it's going to cost a lot more money—*

♦ **FD:** They're always saying that, and they always are wanting to, but it never works. I mean, look at *pirating* . . . see how well they've put a stop to *that!* Just one small area—

♦ **V:** *Pirating of records, you mean?*

♦ **FD:** Yep, pirating of records and movies.

♦ **V:** *I thought they did stop it.*

♦ **FD:** Nope!

♦ **V:** *So you can still download tons of "content" for free, and the government isn't going to come knocking on your door, like they did to a few "ordinary" people?*

♦ **FD:** Well actually, what they did is: they made several "example" cases—

♦ **V:** *And those example cases got a lot of press!*

♦ **FD:** And a lot of times, colleges were involved. So they got the colleges not to allow their servers to be used. But essentially, people are doing it all the time, believe me! All you have to do is go out and get a little application like LimeWire and type in a bunch of band names and see how many hits you get from all these people.

♦ **V:** *And then you can download their songs for free? The Feederz, even?*

♦ **FD:** Oh, yeah!

♦ **V:** *But you wanted that to happen, didn't you?*

♦ **FD:** Yes. That's what I did with our last CD, as opposed to going with the RIAA [Recording Industry Association of America, which represents the U.S. recording industry], which of course wasn't even a consideration—

♦ **V:** *Wait; what does that mean?*

♦ **FD:** The RIAA just wanted you to go out and buy the CD (at inflated prices, and everything). They tried to claim that pirating and downloading was against the artist and all that. But in reality, very rarely was the so-called artist getting paid a cent for any of that—it was just B.S.

Obviously, I wasn't going to join in with the RIAA. Then there's the approach of essentially *whining* about it: "Well, I don't agree with the RIAA." And then the third approach was to actually *encourage* it, which is the route I decided to take. Essentially, I put MP3 versions of the Feederz' songs on the CD itself, so all people had to do was put the

CD in the computer, pull the MP3s down, and it said right there: "For your pirating convenience."

♦ **V:** *Now there's a switch, in a weird way—*

♦ **FD:** Then I also put all the material on *The Feederz* web-page and made it available there. All these people who say, "Well, I'm really not into it for the money"—there's a certain point where you either have to put up, or shut up!

♦ **V:** *Okay, I'm starting to get it. But I thought CDs offered a higher quality listening experience, where you can actually hear the second violins in a symphony, or a tiny rhythm guitar buried in a dense mix. I heard that MP3s lack the quality—*

♦ **FD:** Well, of course the quality varies, depending on how compressed the MP3 is. Essentially, an MP3 is just a means of compressing things to make the file smaller. And if they're made really small, you're going to lose a lot—the more you compress, the more you lose. So if people still want to get a CD, they still have that option.

♦ **V:** *Because that offers better* quality.

♦ **FD:** Right. And also with a CD I put a lot of work into the graphics—

♦ **V:** *I love the Feederz' packaging.*

♦ **FD:** But what if you only have two decent

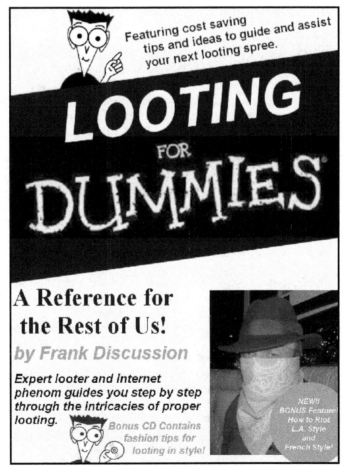

songs on the entire CD, and some trashy bit of art on the cover? [laughs] Why in the hell would you do anything *but* download those two songs and be done with it?!

♦ **V:** *I read that CD sales actually went up last year, and that the popularization of the iPod didn't really harm record sales at all.*

♦ **FD:** See, actually for a long time people were trading and downloading MP3s. Finally companies started making songs less expensive—

♦ **V:** *Ninety-nine cents a song, or something—*

♦ **FD:** Yeah, and so people went, "Ah, that's not a problem." They finally figured out that if they did *that*, then maybe people wouldn't be so quick to steal it. And so they're getting some small success with that. But I think that most people are still going peer-to-peer.

The record companies had a big fight against a company called Napster. Napster had a central server that essentially listed what everybody had on their machines. So when you did a search, it would come back with everything. Since that was *located* at one place, that was the thing that killed Napster. So they nailed them. But the other ones that *have* been successful use what is called *peer-to-peer*. It's a little program that sits there, and when you do a search, it just pings all these people's computers and asks, "Do you have this?" and it comes back with a list of anything that fits that search.

♦ **V:** *So it would be too much work for the Internet cops to go after everyone?*

♦ **FD:** Oh, it would be ridiculous! Essentially, what they have done is: they catch someone that has like 10,000 songs on their hard drive. It's shocking, and they put it in the newspaper because people will go, "Oh man, that's going too far!"

♦ **V:** *So they pretty much only go after these high-profile, prosecutable, newsworthy cases, then?*

♦ **FD:** Right.

♦ **V:** *But there's still zillions of people doing it who aren't so high profile and don't have that many songs?*

♦ **FD:** How embarrassing would it be for the RIAA to kick someone's door down and then go, "Well, we found twenty songs on their hard drive." That would make them look bad, and they know it.

♦ **V:** *Yeah, you don't read about that.*

♦ **FD:** Nor do they *want* you to read about that! So this whole thing is kind of funny, because so many people who claimed they weren't making music for the money are now in a situation where they're asking themselves, "Oh, I hope I really meant that!" I've never really been able to make a

living with Feederz' music, so . . .

♦ **V:** *Well, when punk began, I don't think people were doing it for the money; they were trying to wake people up—*

♦ **FD:** Yeah, and if you're making *some* money doing it, that's fine!

♦ **V:** *I have nothing against paying five or ten bucks to see The Feederz—as long as it's not, like, a hundred bucks.*

♦ **FD:** Because then you're just stealing from people, and the wrong people at that! Not that I have anything against stealing from people. I still strongly believe, for instance, that sabotage and theft are the only ways of keeping any self-respect on the job!

♦ **V:** *Right,* on the job. *But Frank, I hope you don't steal from people who let you stay at their house when you're on tour, if you know what I mean.*

♦ **FD:** No, that's a *very* different thing.

♦ **V:** *Yes. Every single "anarchist" I've ever trusted personally has ripped me off.*

♦ **FD:** Well, obviously they don't have a very good understanding of things. Essentially, you pretty much have *everyone* trying to steal from you, so what do you do? Do *you* go around stealing from each other, too? How exactly is that revolutionary?

♦ **V:** *I agree. But there are people who just don't get it.*

♦ **FD:** Yeah, there's always going to be people who just don't get it.

♦ **V:** *Yes. You know, J.G. Ballard pointed out that the trouble with utopian theories is that they never account for the fact that a certain percentage of the population will always be psychopathic, or unable to work. That's just the way it is.*

♦ **FD:** Well, the least you can do is try to achieve some sort of social *structure* that isn't in itself so psychopathic—

♦ **V:** *—which the current one is!*

♦ **FD:** I think that's made painfully obvious with the society we live in.

♦ **V:** *Everything is about the profit motive now. Everything, including which wife you select—there are now trophy wives! Maybe there always have been . . .*

♦ **FD:** Yeah. This society is sociopathic, if not psychopathic, too. If this society were a person, it'd be Gary Gilmore!

♦ **V:** *Yeah, he was so charming; he was an expert at charming women—*

♦ **FD:** —and killing 'em. A lot of serial killers are psychopathic, but every once in a while they are sociopaths, and sometimes they're both. Essentially a sociopath is someone who doesn't think anything's *wrong* with what they're doing;

their actions don't connect with any sense of repercussion. They don't have any sense of ethics, or the idea that if *I* do this, something will happen to me. That's why when a sociopath gets caught for a murder, they just sit there and go, "Oh sure, [laughs] execute me." They just don't understand what it means.

♦ **V:** *Whereas a psychopath—*

♦ **FD:** —is someone who maybe hallucinates, and is sitting there like in *Silence of the Lambs*, trying to become a woman by wearing their skin. That would be more psychopathic. Kind of like that guy in Wisconsin, Ed Gein—he had a fantastic fashion sense! Most people who go out dancing around in the moonlight wearing a woman's skin—well, I would consider them to be a little *off*. For those who have a fascination with the bizarre, Ed Gein confirms that there may be living, breathing monsters out there. But to actually think they're *okay*, you know—*that's* delusional.

♦ **V:** *Hmm. Let's go back to computer hacking. Did you take classes or read books?*

♦ **FD:** It started when I got a job at a copy shop that also did desktop publishing. I used to spend hours making collages with rubber cement, getting things just so to make them look professional. With computers, suddenly you could do the same thing with a lot less work, and it looked a lot slicker, too. You could create a so-called *real fake thing!*

At one point, what I did on the web—which isn't actually illegal as far as I know—is: I did mock-ups of CNN and Yahoo news—

♦ **V:** *They looked just like them, but weren't?*

♦ **FD:** Right. For instance, when Bush went to Auschwitz a few years ago, I just rewrote the story. The headline was: "Bush Visits Auschwitz to Price Ovens," and stated that "There were some really good deals to be found here." Pausing before the ruins of a crematorium to inquire about the going rate for them, and asking if the gas chambers could be thrown in as part of some sort of package deal, he said, "This should be a strong reminder for terrorists and Muslims of what they have to look forward to." And when he was told that six million Jews had been killed there, he said, "Well, I think that we could do a lot better than that with the Muslims here in the U.S."

♦ **V:** *The funny thing is, that could almost* be *serious.*

♦ **FD:** Right, because it *looks* the same. As a matter of fact, I set it up so if you clicked onto the *CNN* link, you would be back to the *real CNN*. So it was like, "What the hell is this link?" That's one of the things about the Internet being so interconnected: if everything's linked, one moment you can be in Poland, and the next moment in Australia, with just with a click. And with another click the person can be back at *CNN*.

♦ **V:** *Right.*

♦ **FD:** But first you have to *get* them there. And since it's too difficult, at least on *my* level, to be able to hack *CNN*, it's just a matter of supplying people with a link that *looks* like it's *CNN*. At the time—the link doesn't work so good now, but we'd have some web address, people would click

on it, and *voila!* they were at our mock-*CNN* pages.

One of the pages I made apparently got picked up by the news. The "Weapons of Mass Destruction" were being talked about, and the news was building up the impending invasion of Iraq. I put up a page saying that Saddam had bombed Pearl Harbor, and that he was training suicide camels. And someone emailed me, saying, "You're not going to believe this, but they actually believed your story!"

♦ **V:** *About the suicide camels?*

♦ **FD:** No, they reported in the paper that Al Qaeda had a plan to bomb Pearl Harbor! And I was like, "Ah . . ."

♦ **V:** *Well, I think I heard a report about the suicide camels that was serious.*

♦ **FD:** Well, that's another part that I just made up.

♦ **V:** *That's so perfect! I hope that the links are still up there and findable.*

♦ **FD:** They're on *www.feederz.com.* Let's see, here it is. "Bush made Poland the first stop on a week-long trip to Europe and the Middle East, thanking Poles for their support in the war to overthrow Iraq and Saddam Hussein. Bush, with wife Laura, saw the grim complex where 1.5 million Jews, along with many Poles and others, lost their lives during World War Two. Later, Bush was heard to remark, 'I could double that easy!' He was expected to make an appeal across European borders for an end to rancor over the Iraq war, which has strained relations both across the Atlantic and within Europe.

"A senior administration official said Bush's speech would be forward-looking, rather than dwelling on old wounds. Bush came to Poland citing the Holocaust as one of the greatest lessons of the past, and seeking support for using military force in Afghanistan and Iraq. He said, 'I just didn't know there were such bargains to be found here on things we could really use here in America.' "

I had another one that said, "Bush Spells Out His *War is Peace* Policy." "Today, President Bush revealed details of his *War Is Peace* foreign policy initiative in a press conference. Putting the *War Is Peace* policy boldly into action, the Bush administration is strongly supporting Israeli hard-liners and Palestinian dissident groups. The policy is part of a two-part, faith-based *Ignorance is Strength* initiative inaugurated by the Bush camp, the other being the successful domestic *Freedom is Slavery* policy, begun with the enactment of the Patriot Act and the creation of the Department of Homeland Security.

" 'We are *rewriting* history,' President Bush told the assembled press today. 'Who controls the past controls the future; who controls the present controls the past.' Bush continued, 'Day by day, and almost minute by minute, the past will be brought up-to-date.' "

♦ **V:** *That's so perfect, because it could pass for real—in fact, it probably has. I'm sure I heard about the "War is Peace" policy in the "real" news.*

♦ **FD:** It's easy to find stock photos of Bush just sitting there looking serious or whatever. Then you just change the stories.

I put a number of things out, and a lot of times I thought, "Surely, it's obvious this is a joke." And *those* were the ones that would make it to the news. And what's really scary is, like the story I just read you, how can these people who are in their thirties not have read *1984?* And they would actually believe that Saddam Hussein would bomb Pearl Harbor, or use suicide camels? This shows the depth of ignorance that these people are allowing themselves to wallow in.

♦ **V:** *I've started to see phrases in the media saying, "Now we're in the* post-literate *society."*

♦ **FD:** That says a lot, doesn't it?

♦ **V:** *Well, it's scary because many people just believe the TV news now, where all the scripts seem to have been written by the White House or some corporation's ad agency and press agents.*

♦ **FD:** Right. Fox News started making money with their so-called "hard-hitting" news, which were essentially vicious lies, but their viciousness *was* hard-hitting and looked like they were pulling no punches, so people found it more "entertaining." Even competitors like *CNN* started imitating them, doing the same thing. Even if the so-called "news" was becoming just outright lies.

♦ **V:** *The only truthful "news" seems to be in $25 hardback books that take a long time to get to press and which hardly anybody buys, much less reads.*

♦ **FD:** How many times now have we heard Bush go, "Who leaked this information out? I'll *fire* whoever made this leak!" Then it comes out that "I declassified this information," meaning that he lied repeatedly. I'm talking about Bush trying to justify his War on Iraq by proving Saddam Hussein had tried to make deals with Niger to buy yellow cake uranium to make nuclear weapons. Well, Bush was told early that the so-called "evidence" was extremely bad forgeries, but he still put it out there.

♦ **V:** *No matter what outrageous thing happens, nothing changes.*

♦ **FD:** Now we have the *outrage of the day* happening on a daily basis. The Republicans are

pushing a bill whereby if you find an undocumented "immigrant" human being out in the desert dying of thirst and gave him a glass of water, you too would become a felon! Just like when Rosa Parks got busted in the South, people said, "Oh, this isn't a race thing—she was breaking the law. She was being a criminal!" Same thing. Of course, it's a racist bill.

♦ **V:** *But the law that made Rosa Parks a criminal was criminal in itself!*

♦ **FD:** Exactly!

♦ **V:** *That's what wealthy, well-connected people do these days: they just get the laws changed, so what they do isn't criminal any more.*

♦ **FD:** Well, they've *always* done that. It's called *corruption.* I marched at a protest against that law making immigrants criminals, and there were a *million* people there. Yet it hardly got any publicity. I looked around and I only saw five or six white people.

♦ **V:** *That's all?*

♦ **FD:** Ten, tops! And I'm looking at thousands of people. The news also doesn't report what's going on in Latin America. In Argentina, workers have been taking over the factories. Then in Mexico there are whole areas where you see signs saying, "You are in rebel Zapatista territory. The people rule and the government obeys." Also, when the W.T.O. was in Cancun, people were out battling the cops and taking away those big plastic shields from the cops!

♦ **V:** *Well, how are these million people organizing? Through the Internet, or cell phones, or what?*

♦ **FD:** Some of the Spanish-speaking radio stations helped, but also through group text-messaging and cell phones. Again, this technology that is used to enslave us, and alienate people from each other, is being used to connect people for meaningful things. A million people showed up!

♦ **V:** *Okay, tell me how* MySpace *can be used to organize protest?*

♦ **FD:** Well, with *MySpace* you can post one message and it can automatically go out to your entire group. And other people get it and forward it. So if each *MySpace* person has a thousand people in their group—you get the picture. So once again, here's a technological innovation that's a double-edged sword. It was designed for narcissism, but it can end up being used for much better purposes.

♦ **V:** *Well, I'm interested in all the "revolutionary" potential of the so-called technological revolution that's happening—*

♦ **FD:** Here, the thing that you can't replace is a *critical mind.* You immediately ask, "What's useful?" You end up sifting through tons and tons of useless information. Now, there's a *ridiculous* amount of useless information we're bombarded with. So people are pretty much shell-shocked—actually, they're "outrage-shocked" in that they're so used to just one outrage after another that they've become numb, and can't react anymore.

♦ **V:** *We're certainly scandal-shocked. Every day there's a new corporate scandal or a Bush government scandal.*

♦ **FD:** Yeah, or another Republican gets caught trying to seduce some fourteen-year-old girl, or—

♦ **V:** *—got caught stealing eighty million dollars from an Indian tribe.*

♦ **FD:** Right. Or when the Republicans were caught jamming all the phones when the Democrats in Ohio were trying to get people to go out and vote. The people responsible had made over a dozen calls to the White House that same voting day. Sound familiar?

Nobody remembers what Watergate was about. Republicans broke into the Democratic national headquarters at the Watergate Hotel to

PROPER BEHAVIOR AT WORK

IN A SOCIETY THAT ABOLISHES ALL ADVENTURE, THE ONLY ADVENTURE BECOMES ABOLISHING THAT SOCIETY

BRACK!

YOU COULD LOSE YOUR JOB FOR THAT!!

WUMP!

HER INSOLENCE QUICKLY SPREADS

SHE'S RIGHT!

THUD!

NO MORE HALF MEASURES... EVERYTHING MUST GO!!

WUMP!

LIFE HAS BECOME JUST A TEDIOUS COLLECTION OF HOURS WHERE...

WE HAVE TRADED THE POSSIBILITY OF DYING OF STARVATION FOR THE CERTAINTY OF DYING OF BOREDOM

NO MORE BOSSES!

KRRRASH!

END POLITICS, COPS AND BOSSES!

tap the phones, and got caught. It turned out the Watergate burglars were hired by the White House, so almost everybody in Nixon's cabinet ended up getting indicted.

♦ **V:** *Why can't that happen now? Why can't Bush get impeached for launching a war based on lies and fraud? Osama bin Laden and Saddam Hussein virtually hated each other.*

♦ **FD:** Well, now the Republicans control the Presidency, the Senate, the House of Representatives, and the Supreme Court. Oh, and the press. So there are no more checks-and-balances. Therefore, no more Democracy. Some of these Republicans were voted in, and some weren't, including George Bush himself. A bunch of people got busted in Ohio for "fixing" the election, but does anyone do anything? No.

My favorite was when Tom DeLay stepped down from being Majority Leader, for money-laundering. So the Republicans had to get together and have a vote over who would replace him. When the votes were counted, there were more votes than there were people voting! So, they couldn't even have a vote amongst themselves without fixing the election. Our democracy is in an "interesting" state at this point.

♦ **V:** *It's not a democracy anymore.*

♦ **FD:** At the beginning it was. But it's kind of interesting how this country has forgotten its revolutionary beginnings. The Second Amendment's idea of the "right to bear arms" was specifically so that people could rise up if the government got out of hand—it was *not* so people could hunt! It was *not* so people could do target practice, it was so people could go out and take things into their own hands if the government got out of hand . . . to just take the government away from them.

♦ **V:** *You can't do that now. They have all the guns and heavy artillery. Plus all the mass media.*

♦ **FD:** Well, governments have always had military superiority, but notice how often they lose. And a lot of times the technological advantages go bye-bye. For instance, it wouldn't go so well for a government to nuke their own people—even though Bush is probably nuts enough to do it. But a lot of times technology ends up not working. Look at Iraq: the army of the most powerful country in the world is being decimated by people with homemade explosives strapped to their clothes. You know, the most important subject to study is *the history of revolt and resistance.*

♦ **V:** *There should be classes on that in every university.*

♦ **FD:** And in every home! I just read about General Cook going after 200 Apaches with an army of 1,200 soldiers. He came back with half his army missing, and didn't succeed in catching these 200 people. So you start looking at the tactics of what worked and what didn't work.

Thomas Jefferson's idea was that there should be a revolution every twenty years. It's funny, because people at this point deny pretty much every aspect of the revolutionary nature that this country is based on.

♦ **V:** *I really think these are the worse times I've ever experienced in my whole life—*

♦ **FD:** Yeah, it's much worse now than it was with Nixon or Reagan. It's very much like 1930s Germany. As a matter of fact, if you look at the Patriot Act and the German Enabling Act, you'll get a little chill! After the Reichstag fire, the German government passed the Enabling Act, which gave Hitler dictatorial power. And he started making sweeping changes, and of course if anyone criticized them—

♦ **V:** *"You're either with us, or you support the terrorists!"*

♦ **FD:** It's the same sort of thing. Then it came out later that it was actually the Nazis themselves that started the fire. So the historical lesson here is: governments doing that to their own people is not something new.

♦ **V:** *I just learned that among the 140,000 people killed/bombed in Hiroshima, several hundred were American-born. You don't often read about Americans killing their own citizens.*

♦ **FD:** No, and also in Nagasaki. Ground Zero for the atomic bomb was at the only Christian church in the city. How to counter the Machiavellian manipulation and outright dictatorship of the present government? It does as it wishes. That sort of totalitarianism is more in line with fascism. Mussolini referred to fascism as the "corporate state."

♦ **V:** *Which is what we have now.*

♦ **FD:** Yeah, and this brings me back to Jefferson who said, "The end of democracy and the defeat of the American Revolution will occur when the government falls into the hands of the lending institutions, money, and corporations." Not bad for the 1700s! People forget that the American revolution was the first revolution in history, when you come down to it.

The other day at a mall, I went down an escalator and saw a sign that said, "Ideology Clearance" and "Ideology: Slashed Down," which must be a clothing brand. The thing about ideology is that: even the truth, when it becomes an ideology, is turned into a lie!

♦ **V:** *A long time ago you quoted that Situationist question: "Do you have ideas, or do ideas have you?"*

Ideology is when ideas have you.

♦ **FD:** Exactly. At this anti-war march I went to recently, one person was carrying a sign that said, "Revolution is right around the corner." Well, I don't see any change occurring without it eventually becoming a shooting war. Because that is the last card that any government has to play.

♦ **V:** *If you're focusing your reading on the history of revolt and resistance, then you must have done a lot of reading on Kent State, the People's Park in Berkeley, the Weather Underground, the Red Brigades, the RAF, and the Movement 2nd of June. And there even was a huge Communist movement in America at the beginning of the 20th century. That is such a great goal. It's so easy to get distracted these days, and we need to continually bring our focus back to a study of revolt and resistance, and memorizing the lessons to be learned.*

♦ **FD:** I've also been involved with santería groups, which draw a lot of discrimination—it's always good to get discriminated against and stomped on whenever possible! No matter where I go, I seem to run into the same thing: discrimination. And I'm like, "I know who you are—you're cops! You're assholes!" So yeah, I haven't grown so old that I'm not offended by the existence of police.

♦ **V:** *I should try to detour back to actual pranks you've done.*

♦ **FD:** As I said, by putting up a web page you can get a lot of information (or misinformation) out to a large number of people rather quickly and cheaply. You can also, through the Internet, acquire not only pirated movies and music, but also software. People are downloading eight-hundred-dollar programs for free, like film or music editing software. These things are out there and they get hacked. So there is this "underground" out there doing this stuff. It's hard to be a programmer, coding those zeros and ones, and keep 'em in line without someone diverting them somewhere—

♦ **V:** *With the Internet, it's like we're in the Wild West, and hacking is like rustling cattle!*

♦ **FD:** Corporations aren't trying to herd the ones and zeros so much as trying to herd *us* using them! I still work in a ones-and-zeros mindset because it brings in more money than being a busboy. I've been working since thirteen years old and I know all too well what work is—that's why I hate it so much!

♦ **V:** *Yes—I mean, what are we? They want us to be machines and dogs or cows*

they can herd around.

♦ **FD:** I read a brochure for the Harris Ranch that said they play rock music to the cows because it keeps them calm. I thought, "Why not? It seems to work well with people!"

♦ **V:** *Nothing is what it seems, and maybe it never was. Well, I thought that punk rock music expressed rebellion. So did some rock 'n' roll songs—*

♦ **FD:** The thing is that whether the medium is a web page, music or movies—all they are is just *vehicles;* it's the *content* that is always going to matter. They are also vehicles of communication, so if you can make a contact with someone and you happen to be able to say what everyone is already feeling—because you know people are pissed—probably more pissed than they ever have been . . . if you dare to say what is actually on everybody's mind already, it may connect.

I've always thought that if your *content* is revolutionary enough, then you don't have to worry about "selling out." Like, what corporation in its right mind would produce a commercial with our "Burn Warehouse Burn!" song playing in the background? Actually, I'd love to sell out, but corporations aren't so damn stupid that they would buy what *I'm* selling. Would they go, "Hmm, I think I'd like to license this Feederz song that says that people like me should be hung from lampposts by piano wire"?! Sorry, they aren't going to sit there and say, "Well, Frank, I'll give you a million dollars for that. Go at it! And let's put it out for millions of people to have access to it." I mean, I would love for "Burn Warehouse Burn!" to be in a Levi's commercial. Then I'd

Vandalism: Beautiful As A Rock In A Cop's Face

FEEDERZ

start reading the newspapers for the arson reports!

But on the other hand, if your stuff is unthreatening in the first place, then maybe Levi's *can* buy it and do something with it.

♦ *V: Have you ever had any ideas that were just too far-fetched?*

♦ **FD:** At one point I thought about having all these different restaurants. One would serve Cambodian food—they'd just put down a bowl of rice with a lizard in it and have a person standing behind you with an AK-47! I also thought of an Ethiopian restaurant—it was during the drought there—and they just serve you an empty plate. In San Francisco, there's a restaurant called the "Good Karma," and I thought of having one called "Bad Karma" where all the food would be, like, deviled eggs and devil's food cake . . .

♦ *V: I suppose the history of the Feederz might qualify as a prank. You've produced albums with funny lyrics and graphics, Situationist cartoons and sayings—*

♦ **FD:** I do enjoy playing with language!

♦ *V: I like that saying, "Language was given to man so he could make surrealist use of it." Which* includes black humor—your specialty. It certainly appears that you've "kept your edge," so to speak. You're almost the last person from the punk rock days that I would've picked to still be alive in 2006—

♦ **FD:** I don't know how many times I've heard that! It seems many people have voted me "Most likely to die in a hail of police bullets" or something!

♦ *V: Well, I'm glad you didn't die the clichéd counterculture death from a drug overdose—*

♦ **FD:** I never had time to become a good junkie! I'm always driving toward something relating to some aspect of resistance. Now I'm learning how to make movies. There's always something to learn more about. Who wants to become mediocre? Also, I was born with this horrible little thing called a *conscience,* plus a sense of outrage, and they are *not* a good combination! ♦♦♦

C OMEDY

COMEDY & PRANKS

What is the relation between Comedy and Pranks? Ideally, a comedian's act is one continuous prank on the audience, shocking pre-conceived assumptions and beliefs, exposing illegitimate authority, and always provoking the laugh of surprised recognition. Comedians take you on a flight of fantasy, and at the end bring you down to "earth"—except it's a different earth than the one you left.

The mind of a comedian is ever-alert for situations and characters to take to an extreme, elevate or debase, and take completely elsewhere—the more improbable the better. Some comedians critique the human condition by pretending to be aliens visiting earth (Mork and Mindy); others blur the line between "acting" and "reality"—like Andy Kaufman, Lily Tomlin and Sandra Bernhard. If comedy illuminates injustice and illustrates the black humor inherent in the human condition (or La Bête Humaine, as Jean Renoir put it), then it has functioned like a prank. The best comedians are all pranksters ...

115

PAUL KRASSNER

published *The Realist* (1958–present), which became notorious in the sixties as "the most satirical and irreverent journal to appear in America since the days of H.L. Mencken." (*Oui* magazine) Since then he has appeared hundreds of times on television, radio, college campuses and comedy clubs across America, published a score of books, and raised a daughter. Paul Krassner now luxuriates in the Southern California desert. Interview by V. Vale.

♦ **VALE:** *I used to abide by Marcel Duchamp's dictum, "Never repeat, despite the encores," but I realized that when you're taking on a theme like pranks, the possibilities are infinite, particularly as the media landscape changes or the world has changed, so it's not a bad idea to do a second book on pranks, and maybe more—*

♦ **PAUL KRASSNER:** I think it's a whole different ball game now. On the Internet, pranks are much quicker to be spread and much more widespread. In one way, I think this is a good thing, because it forces people to develop a healthy skepticism, which might even extend to print media.

V: Right; you can't be too skeptical these days. A publishing house arose calling itself "Disinformation"—

♦ **PK:** Oh yeah, but they're being ironic because they're presenting what they think is information as an antidote to the disinformation that is scattered about. One of my favorite things about disinformation is: do you remember there was a "Disinformation Office" established? Then, the first thing they did was say that the Office of Disinformation had dissolved, which of course was their first bit of disinformation!

♦ **V:** *You mean the government did this?*

♦ **PK:** Yes, and when the newly formed Office of Disinformation says in one of its first statements that it's dissolved, who would believe that? Except yet another brainwashed American.

♦ **V:** *Unfortunately, I think there's still way too many of* those, *because who else would've voted this guy Bush into office twice? Well, they didn't vote him in; we know that [voting machine fraud, etc.], but even so—*

♦ **PK:** But they supported him; well, his approval rating is going down. But then how would you like to live every day with a bunch of people voting on whether they approve of you or not?

♦ **V:** *Hmm. Maybe it doesn't mean anything, to Bush at least.*

♦ **PK:** Well, it does in the sense that it influenced what he wanted to talk about in his recent State of the Union speech. I mean, he knew people were disheartened about the rise in gas prices, so that was part of the input for him to say that "we're addicted to oil." But it's like Rush Limbaugh complaining that America is addicted to painkillers—

♦ **V:** *Because he is—*

♦ **PK:** Exactly, and so is Bush addicted to oil executives. And it would be like Paris Hilton saying that America is addicted to fame! So that's the ultimate prank with what is going on with the Bush administration, because it's no coincidence that "PR" is the beginning of "prank" and "propaganda." And propaganda is the ultimate prank, really.

I mean, wasn't it a great prank to get more than half of the population to believe that Saddam Hussein and Osama bin Laden were married in Massachusetts and adopted a Chinese baby? So that was a great prank. The *weapons of mass destruction* was an incredible prank! That Iraq was developing a nuclear bomb—what better prank can you have than that?

♦ **V:** *I guess. A prank on the American people—*

♦ **PK:** On the world!

♦ **V:** *Unfortunately. And sadly, over a hundred thousand corpses have piled up as a result.*

♦ **PK:** That's the tragic thing about it. Pie-ing someone is a prank, but if you can pie them, then you can assassinate them. And that's why politicians or cultural figures who get pie-ed (and their security forces) are so freaked out by it, because it could have been somebody with a knife or a gun instead of a pie to get through security and get

that close. So, where do you draw the line between a prank and propaganda? I'm asking you, because it's kind of situational.

♦ **V:** *Well, every situation is unique and has to be judged on its own.*

♦ **PK:** Yeah, like college hazing is a prank of sorts, but somebody can get hurt, and people have been known to die because of those sorts of things. I try to approach reality with a conscious innocence, and the result of that is that civilization seems like a constant prank, in terms of the corruption—every bit of corruption or bribery is a prank! Jack Abramoff [lobbyist, *a.k.a.* briber] is the biggest prankster of all. I'm not sure what the definition of a prank is, but he and the legislators that he bribed were pulling off a prank on the American public—it's just not a very "good" prank. But that's not your category today with pranks.

♦ **V:** *Well, I did write an introduction to the first* Pranks *book saying that the best pranks challenge people's conditioned reflexes, because most* Americans are conditioned to believe what they see on television, and they don't even get to the "dialectics" stage. You used to be taught dialectics in school: all thought is a three-part process involving thesis, antithesis, and then a new synthesis; and you would keep doing that again and again.

♦ **PK:** Well yeah, but there are pranks within pranks. All television is a prank to present commerce in the guise of art. And so there is a conditioning that starts with television commercials; they're playing a prank on somebody because it's impossible visually and time-wise to read the small print on a television ad (or in a newspaper ad) about the possible side effects of the drug that they are tricking you into buying.

A prank involves some kind of manipulation, and virtually all advertising has a manipulative aspect to it. So I see a world that doesn't even see itself as being pranksters, but pulling a hoax seems to be true of every organization or profession! That's why they have their own secret language. Whether it's doctors, attorneys, tax people or mortgage brokers, each has their own language that gets so complicated that you have to depend on them . . . so they can prank you.

♦ **V:** *That's brilliant!*

♦ **PK:** It's amazing to watch it, and that's why, in a kind of twisted karmic way, it's appropriate that Bush is in the White House, because he pranked himself there!

♦ **V:** *Yeah, he sure did, because his Presidency isn't based on logic, solid foundation of achievement, knowledge/theory, vision of the future, or anything.*

♦ **PK:** Well, he's doing what he learned to do in college—he's a cheerleader for the people who essentially tell him what his position is on issues, and that's another great prank: to make him think that he's a leader! The whole State of the Union speech was a prank because he didn't talk about—you know there were people who counted how many times he used the word "freedom" or "hopeful society"; it's all psychographically determined to get people at their most hypnotic center.

♦ **V:** *People are vulnerable and they acquiesce—*

♦ **PK:** It has to do with *accepting authority*, which you learn to do before you can even speak as an infant, and then your authority figures: parents, teachers . . . everywhere a kid goes there's authority. Some people are lucky enough to escape and acquire a sense of themselves and not internalize what has been thrust upon them, but those who accept authority are those who go and do what the commercials say. They ask their doctor, "Is a sample of Viagra good for me?" and the doctor of course gets paid for the visit and mak-

CARNEGIE HALL

57th STREET and 7th AVENUE, NEW YORK

Saturday Evening, January 14, 1939,
8:30 p.m.

FOUR VIOLINISTS

A Recital of Individual Solos
A Most Unusual Presentation

PAUL KRASSNER

GEORGE KRASSNER

RUTH DEMBINSKY

ARNOLD WEISS

ing out the prescription, and the guy goes out happy with the anticipation of a hard-on! And that's America to me!

So the same people who accept the authority of a TV commercial, which is essentially propaganda, are subject to the government's propaganda. That was what was so dismaying to me about the invasion of Iraq: that the people were brainwashed enough to accept the government propaganda. Even John Kerry, who ran against Bush, when asked why he voted for the war, said, "Well, it was my President who was saying that. I believed him. I trusted him." Which is why I thought Kerry would've made a terrible President, because he's such a bad judge of character. Yeah, so I ramble—

◆ **V:** *No, you focus! You got to the heart of the matter, which is that it's all about* obedience to authority. *Stanley Milgram wrote a book titled that—*

◆ **PK:** Oh yeah, based on the experiments that they did at Stanford. Stanford hosted a lot of psychological experimentation. Didn't Stanislav Grof teach there? I'm not positive. Anyway, behavior modification is the name of the game. So if you can get people to be afraid of sex, as they're trying to do now—

◆ **V:** *Of sex? Really?*

◆ **PK:** Yeah, sure. The conservatives didn't want sex education until it included the possibility of *death*. And now even little kids know that STD stands for "sexually transmitted disease." Abstinence is sort of a mini-trend, but it's all out of fear, and then rationalized as, "I want to save 'it' for my future mate."

◆ **V:** *Right!*

◆ **PK:** And the statistics show that it doesn't really work; that the people in the "abstinence clubs" are practicing oral sex while listening to their iPods, just because they've been taught to multi-task!

◆ **V:** *So now there are Christian abstinence clubs?*

◆ **PK:** They're sort of like Alcoholics Anonymous: "Hello, my name is Cynthia and I'm horny, but I'm fighting back. And I have a sponsor, so whenever I'm feeling horny I call him and then we talk about how horny we both are, and it's really comforting!"

◆ **V:** *So instead of doing it, you just talk about it, and somehow this relieves some pressure, at least internally.*

◆ **PK:** Well, you know, as Lenny Bruce once said, "People use *The Prophet* [Sixties "spiritual" best-seller by Kahlil Gibran] to get laid."

◆ **V:** *I'll bet they did!*

◆ **PK:** I'm sure they did. I mean, whatever works.

◆ **V:** *Yeah, it's like these guys who get laid now, they actually read Rimbaud and Lautreamont to con women into thinking they're "sensitive" because they read "hip" poetry—*

◆ **PK:** Yeah, whatever works. And there's the law of supply and demand: every group can have its own groupies. So there were *assassination groupies* and *conspiracy groupies*—they got turned on by plots. Women who might never be seen with a rock star—

◆ **V:** *And they might be a little older, too. Usually the groupies you see with rock stars are teenagers or in their early twenties.*

◆ **PK:** Oh sure. Distinguished authors probably have more middle-aged groupies, depending on what they write. "60 Minutes" was having interviews with people who had gained some level of fame in the music field, and one conductor talked about how women would practically tear his clothes off! You don't think of classical conductors that way, but I'm sure that Leonard Bernstein had plenty of groupies of any gender you can think of!

◆ **V:** *Particularly since it came out that he was gay—*

◆ **PK:** Yeah, bisexual. He was married and had kids. I remember the first time I heard the term *window-dressing*, when Joseph McCarthy was holding his hearings. He got married and people said, "Ah, that's just window-dressing." But there's a thing in the whole gay community that they've had to pull a prank on the public by having to remain in the closet—

◆ **V:** *And even get married as a cover—*

◆ **PK:** Yeah, so that was kind of a "forced prank"—forced by society. And then more and more courageous people came out of the closet—except J. Edgar Hoover; he was too busy busting gays! That's how absurd it is!

◆ **V:** *Yeah, didn't he tape Martin Luther King having sex in a motel?*

◆ **PK:** Then he would play the tapes for Lyndon Johnson! He went to John F. Kennedy and said, "Look, we have these great photos of you having a threesome with Marilyn Monroe and a duck! But don't you worry about it, because it's safe in our files." So that was *implied* blackmail. And maybe he didn't have the photos—*that* would have been a great prank! But it worked, because look how long he was head of the FBI.

◆ **V:** *Paul, you've been on the planet for a spell now. Wouldn't you agree that our media universe has grown exponentially since you were a child? The religion of this country is advertising—everything, all of the news, all the commercial media and slick magazines and newspapers, it's all solidly advertis-*

Comedy Has Returned to the
Purple Onion
140 Columbus at Pacific
in North Beach

Wednesday, May 12
An Evening With
Paul Krassner
Show 9pm, Doors 8pm $10
Reservations Recommended:
purpleonioncomedy.com
415.956.1653

ing—if not for a product, then for an attitude or a way of life and lifestyle.

♦ **PK:** Yeah, like when you see somebody who's a guest on a talk show, you get surprised when they're just *there* and they don't have a new TV series, or are not trying to sell a book or movie, because you get so used to the promotional conveyer belt: "Okay, next! Here's what *I've* done for a little bit of notoriety."

We're the product, the consumers are the real product that are sold to the advertisers by the networks. There's going to be a time when babies are born and will have the drops put in their eyes, they'll be slapped on the ass, and will have a barcode put on the back of their neck, so when they sell us to the advertisers—this can happen at any supermarket—they just scan our barcode.

♦ **V:** *Then they can charge your credit card and you don't even have to carry one anymore. They'll verify who you are by an iris scan or fingerprint and go, "Your credit checks out, you got it!"*

♦ **PK:** I'm glad I've lived to see the changes that the culture has gone through, because kids now are going to think, "You mean people didn't *always* have to take off their shoes when they went to the airport?" Things like that, they're going to take for granted because it's just the world they've been born into. We've seen the ugly head of fascism snarling around, but with icing on it to cover the bitterness underneath. Just like the "Patriot Act"—that sounds pretty good, but it's the icing on a fascist-state-in-the-making. The *ultimate* prank.

♦ **V:** *Cover everything fascist with colorful surface icing, while broadcasting soothing soundbites—*

♦ **PK:** And at the same time they keep prattling on endlessly about "freedom," especially in *other* countries. Meanwhile, what's going on in this country is genuinely frightening: a man who wrote a book about Bush (that Bush didn't like) suddenly found himself on the "No Fly" list, and it's extremely difficult to get off that list!

Just recently Osama bin Laden plugged a book by Bill Blum, *Rogue State*, and suddenly its sales shot way up. Bill Blum is an old lefty, really a truth seeker and sharer, and kind of an uncompromising radical, so instead of his usual small audience—a circle of friends who knew his work and respected him for it—his book is suddenly selling thousands of copies, and the publisher wasn't prepared for this.

Bill has been invited on a lot of TV shows, and he's exhausted, but he knows he's reaching millions of people that would otherwise never have been reached, just because of this freak plug that Osama gave him. So I'm not sending my next book to Oprah Winfrey, I'm sending it to Osama Bin Laden—it gets much better results, and he doesn't put anyone on his video excursions just to insult you and call you a liar!

Now the one thing Bill Blum said was, "I only hope that they don't put me on the 'No Fly' list." He said this with seriousness, because, as I said, it's already been done to another writer. So for the Bush team to keep yapping about freedom is one of the most insidious pranks of all!

119

♦ **V:** *I couldn't agree more. So the Bush team's pranks have to be combated by humor and surreal imagery. You yourself have given images to the world that are purely surreal, but the power comes from them being accepted as reality—I'm referring to the "LBJ fucking JFK's neck wound" story (in the* Realist) *which allegedly took place on Air Force One right after the Kennedy assassination.*

♦ **PK:** That image came from Marvin Garson, who was the editor of *Good Times* in San Francisco. After I published that in the *Realist* I gave him credit for it, and he said I shouldn't have done that because he was scared.

Something like that happened to me another time. In the *Realist* I published a manuscript from the rock critic R. Meltzer on "I was Charles Manson's bunk mate at summer camp." Manson got a copy and was in court holding up that issue of the *Realist* and muttering to his lawyer, "I was only at Boys' Town for two weeks, and I *never* met this guy." It turned out the story had been totally made up—it was satire, and Meltzer had deliberately not put his name on it, but I thought he had just forgotten to, so I put it in. Then Meltzer called me: "*Why* did you put my byline on it?! The Manson people are going to get me now!" So anyway there's no longer a *chilling effect,* there's a *frozen-food effect!*

♦ **V:** *A deep freeze. The* Realist *printed a number of shocking images, such as a photo of the plaster-caster models of Jimi Hendrix's penis next to his band-mates' organs. Images like that are kind of surreal...*

♦ **PK:** Do you remember the *Disneyland Memorial Orgy*? After Walt Disney died in December 1966, I realized that these animated characters were in a suspended state of animation and were mourning. I just pictured at the funeral that Mickey Mouse and Donald Duck and all of the gang would be there—and it's not true, by the way, that Walt Disney was frozen when he died—

♦ **V:** *No? I always thought it was true.*

♦ **PK:** No, cryogenics for Disney was an urban myth. You can check it at *snopes.com,* and I researched it. Anyway, I envisioned that the Seven Dwarves would be pallbearers and that Goofy would deliver the eulogy. Then I realized that these Disney characters were innocent, delightful creatures whose sexuality had been repressed since the 1930s . . .

It seemed like a good idea to release these inhibitions which had been repressed for all those decades. So I assigned Wally Wood, an artist for *Mad* magazine, to do a center-spread for the *Realist* that would show all of Disney's characters suddenly becoming *un-repressed. Time* magazine had just appeared with a cover story, "God Is

Dead," and Disney was *their* God and creator. So Wally gave me a magnificent montage of Goofy fucking Minnie Mouse on a cash register, Dumbo the elephant flying and shitting on Donald Duck, who was infuriated, and Tinkerbell doing a striptease for Jiminy Cricket while Pinocchio's nose gets longer. I think he did a total of sixty-four characters, and his drawing was so popular that we made it into a poster.

The Disney people certainly considered suing me, but they didn't—they never told me to Cease and Desist. Since then, the statute of limitations has lifted. I recently published a new edition of that drawing which is digitally colored. It can be seen on my website: *paulkrassner.com.* But it was a prank because people had one expectation of Disney characters, and then suddenly they were confronted with something else—like a curtain had been pulled.

In a way, Disney did a prank by having his creatures walk around without pants! He was *their* Intelligent Designer. I think the concept of "intelligent design" that's going around is another incredible prank. Because when people try to visualize that—I think that's why Jesus is so popular, because people can *visualize* him. The concept of God is inconceivable, but here at least is "that friendly guy with a beard and a halo!"

♦ **V:** *Yes, and a white robe.*

♦ **PK:** And he's always on a cross—that's his job, but they let him off for lunch! But then every day he goes back to the job: "Okay fellas, I'm ready. And what's for lunch today?" Because they have a caterer, like on a movie set. But we do have Mel Gibson to be grateful to . . . for finally making Jesus more popular than the Beatles!

♦ **V:** *Is there really some revival of interest in religion and Jesus and all that?*

♦ **PK:** Well, people are scared. Christian churches are getting "hip"—first they started doing gospel and jazz, and now they have hip-hop in churches. It's all a prank, "Let them think religion's a lot of fun. Then we'll tell them how they'll burn in Hell if they don't . . ." It's all a big magician's trick of diversion: you divert their attention. That's what the national purpose is: *diverting our attention.*

♦ **V:** *Yeah, from what really matters.*

♦ **PK:** And that's why whether it's the Super Bowl—that was a great prank; it's just like any other football game, but somehow they gave it that magical thing where people were giving each other recipes and it became like a religious holiday. My wife Nancy observed that they all look like monsters wearing all that equipment—they're like SIMS [computer game characters],

and it's getting harder and harder to tell human beings from SIMS. I saw a commercial recently where a woman is looking in the mirror and she sees a SIM as her reflection. I didn't know what they were selling—maybe distortion mirrors?!

♦ **V:** *The* New York Times *printed an article about people implanting little computer chips under their skin, that can open their garage door or access their laptop computer's security codes.*

♦ **PK:** And they think of this as *progress!* I don't know what progress is anymore! Because now at Halloween, you can bring your kids' apples to the Police Station or the Hospital and get a free X-ray, to see if there's a razor blade in them. Now is that progress, or not?

♦ **V:** *And here's another sign of "progress": the statistics that every year, fewer people read books. Newspaper pundits counter, "Oh, now they're doing all of their reading on the Internet."*

♦ **PK:** Well, for people like us this may seem like a sad loss, but my favorite phrase (that I invented) was "If God is evolution, then how do you know he's finished?" I say "he" just for the sake of convenience, not because he's a male chauvinist deity. So if humans have evolved from apes, what's going to evolve from us?

♦ **V:** *I've never thought about that.*

♦ **PK:** Some people think that kids are going to develop more flexible thumbs, because that's all they use to call people on their cell phones.

♦ **V:** *Right: the Blackberries, Treos, and Nintendo Gameboys—*

♦ **PK:** And they're constantly doing instant messaging. Now you and I can think, oh, it's sad, people used to write such wonderful letters: "I've received your great news from the Civil War battlegrounds and I'm so glad you've survived—the stories you told were magnificent! They stirred my imagination like whipped cream!" Whereas with email, you just say, "Cool." So the great treasury of correspondences between two people is just going to be "Way!" "No way!"

♦ **V:** *They don't even use full words. They use all these acronyms and smiley face symbols—everything's as abbreviated as possible. I don't blame them for inventing these shortcuts, because all they're using is their poor little thumbs—*

♦ **PK:** Yeah, everything gets shorter and shorter. I think that's how "How are you?" became "Hi."

♦ **V:** *Right.*

♦ **PK:** And then "Hi" became "Hey" because "Hi" was too formal. I remember when I was

The Winner of the SLOW BICYCLE RACE

growing up and "juvenile delinquents" were a problem—you don't hear *that* phrase much now. But then, even *that* got shortened: some woman—I'll never forget this—leaned out of her window and yelled at us, "Get out of here, you bunch of juveniles!" She just used the adjective and made it into a noun.

♦ **V:** *Well, all we can do is make jokes and try to destabilize authoritarianism in all the millions of places where it gets taken for granted—that's the scary thing: how quickly fascist demands become "normalized." Like, when this "taking your shoes off at the airport" started, there should have been mass riots! Instead, everyone just submitted and did it.*

♦ **PK:** Do you remember Darryl Henriques from San Francisco? He was a comedian who used to be on Scoop Nisker's radio show a lot. He was the "Swami from Miami" and "Joe Carcinogen"—

♦ **V:** *Instead of "Joe Camel"—*

♦ **PK:** Anyway, he wrote a little book called *50 Simple Ways to Pave the Earth.* He says, "We're all doomed—get the champagne!" In the future, people may look back at us and say, "How barbaric: they killed trees so they could have these 'books' as they called them." And they won't miss them at all! Just like when cars came in, people didn't miss horse-and-buggies. So there's the game of *conscious evolution.*

It's hard to say how technology is going to change people. When I was in Ecuador where I lived for a couple of weeks with primitive Indians in the jungle, Yamaha motorboats had come to paradise and suddenly there was noise pollution. People had these, but at the same time they had

boats they had built out of trees. In the midst of this, back in civilization, there were huge skyscrapers being built, but without a thirteenth floor—so people on the fourteenth floor would think they were getting away with it!

♦ *V: That's right—if you're on the fourteenth floor, you're really on the thirteenth floor . . . you fool!*

♦ **PK:** Remember when airplanes had both a smoking section and a non-smoking section? So if the smoking section ended in row fifteen and you're in row sixteen, you allegedly weren't being bothered! If acid rain caused by American corporate pollution falls in Canada, who do you sue? The ultimate prank about the Earth is that the boundaries are all arbitrary—

♦ *V: Yeah, like where Nicaragua ends and Honduras begins—*

♦ **PK:** Right, like where Peru ends and Ecuador begins, or where the United States ends and Mexico begins, and where Canada ends and the United States begins—it's all arbitrary. Wars have literally been fought over where these boundaries "should" be—

♦ *V: And still are, as in Israel.*

♦ **PK:** When I was on the Ecuador border, I stood with a foot on either side of that "line," and I peed on both sides of it! Or maybe I should use a more genteel word, like "splashed"—

♦ *V: So much of life is about reframing; a lot depends on how you look at things.*

♦ **PK:** You know, a lot of dates are pranks. What do you do on a date? You try to make an "impression." And how do you make an impression? By trying to fit the image that you think the person you're trying to impress, wants. Telemarketers asking you how you are, or if you're enjoying your day—is that a prank? You know people want to be liked, so they "put their best foot forward"—which I think is also a prank!

The prank is one of my main filters for perceiving the culture, reality, and politics. I mean, what a prank to say that this war in Iraq was *necessary* . . . and the Bushies pulled it off! You have to give them credit, like you give Hitler credit for pulling it off—what a fucking prank *that* was! I'm sure when he was alone at night with Eva Braun he'd say, "Can you believe it? Look what we're getting away with! I just hated a few Jews in my class, but look what I've got everyone believing now!"

Today the TV newscaster was talking about how nobody ever solved who was spreading anthrax around—you remember that from a few years ago? People reacted to that with, "Oh, that's too bad." I thought that whoever was behind that "prank" was probably going, "Hey, yay for us! We

did it! They'll never find us!" That was probably a moment of triumph for them; those who practice evil really get *pleasure* out of it, and probably convince themselves that they're really doing humanity a *favor.*

That was really Lenny Bruce's brilliance, when he did this audacious routine of seeing the holocaust from Adolf Eichmann's point of view! Yes, Eichmann was very proud; he was a good soldier; and (as Lenny said, based on Thomas Mann's poem) he had pride when he looked through the porthole windows into the gas chambers, that he had done his job *well.* People who work on advertisements for cigarettes have this same kind of moral disconnect: they're able to disassociate themselves from their victims . . . and besides, people need to keep their jobs!

It really has to do with the labeling and the framing. On the radio yesterday I heard a man from the Crystal Cathedral pleading for money to get a TV show going so they can plead for even more money. Now this is a respected radio station and this is an evangelist with millions of followers, so it's *okay.* Whereas it's *against the law* to do aggressive panhandling on the street. But that's what the Crystal Cathedral guy was doing: aggressive panhandling with whipped cream on it! Did you see *The Aristocrats*?

♦ *V: No, I didn't—*

♦ **PK:** But do you know the joke? Well, the whole point is—let me put it this way: recently I was interviewed in a funky little hotel where these cockroaches were creeping around. And this hotel was called "The Cadillac!" This exemplifies that principle of trying to give something that's sleazy a respectable name and fake facade of respectability.

Now the joke of *The Aristocrats* is that this family group does their act for a theatrical booker. They indulge in incest, bestiality, sodomy (and a little bit of Gomorrah), and scatology. Finally the booking agent asks them, "Well, that's very interesting. What do you call yourselves?" And the answer is, "The Aristocrats!" It's that same thing of trying to give a name to yourself that you're not, whether it's the "Aristocrats" or the "Patriot Act" or "Homeland Security Act"—you keep using the name and people begin to believe in it.

In the meantime, "authorities" are trying to stop medical marijuana patients from taking their medicine and to prevent folks from dying with dignity. People are afraid *Roe vs. Wade* has the possibility of being overturned in the Supreme Court. The authorities are going after pornography—and it's all in the name of pandering to the

paul krassner

FOREWORD BY Harry Shearer • INTRODUCTION BY Lewis Black

reports from an investigative satirist

onehandjerking

religious right, not compassion, nor reason. And whatever the next evolution is going to be (and to the pessimist it's going to be the fish coming out of the ocean and starting all over: "Hey look, I'm an amphibian!" "Well, I'm an ambidexterist!") And the optimist thinks of a thousand years of love and peace—but whatever the next step in evolution will be, I think people in the future are going to look back at us as *barbarians:* "You put that teenager in prison for smoking an herb that grew in the ground?"

And you know money is involved; if I don't understand something it always has to do with money, power, ego, sex or greed! Sometimes it's two or three of those combined.

Another great hoax is the "War on Drugs," or the "War on some people who use some drugs some of the time!" On the basis of that, a government can arbitrarily designate which drugs are legal and which ones are illegal, so that in effect anyone who is in prison on a drug charge is a political prisoner. Whereas cigarettes kill twelve hundred people a day in this country alone, marijuana doesn't kill anybody. The prescription drug *Prozac* is supposed to cure depression, but it may give you suicidal triggering. There are other ones that will lower your cholesterol, but one of the side effects is *anal leakage!* So the priorities are insane, and the fact that we try to talk about it rationally has a level of absurdity to it.

♦ **V:** *I'll say! I was shocked to read in the* New York Times *that a hundred million people, one third of the population, are taking* Prozac *(or its imitations).*

♦ **PK:** Well, this shows that you're not jaded! Look at what the kids see as they grow up: they see their parents using all these pills and prescription drugs.

They see commercials showing people who can't do this or that, who can't pick up their grandchildren, who can't play with you; they're unhappy and frowning . . . and suddenly there's a *pill*—they take it and start laughing, playing, throwing their grandchildren in the air—and kids absorb that. It's a vicious prank, but that's the imagery they are learning: that *products will make you happy;* that is the message.

And the authorities do these little things to make you obey, like put "under God" in the Pledge of Allegiance, which only serves to subconsciously underscore the prank of a supernatural being as dwelling up in the clouds above you, because it's *one nation under God,* instead of, say, a polymorphous deity: *one nation INSIDE God!*

♦ **V:** *Yeah, we should be inside!*

♦ **PK:** At least! Since God knows there's no such thing as up or down.

♦ **V:** *And God is everywhere, so he must be around us, or we're inside him.*

♦ **PK:** Of all the pranks, I think God is the greatest! I say that from the point of view of an atheist who sees the absurdity and the tragedy of people fighting and dying over this "God" that I don't believe exists—what a fucking prank that is! I'm trying to find an analogy for it—it's so beyond a bizarre expression of religion to—

♦ **V:** *I know, like the* fatwa *against those Muslim-challenging cartoons that were printed in a Danish newspaper.*

♦ **PK:** They were printed in a Danish newspaper and then reproduced throughout Europe. But you'll notice that in the United States, the networks and the cable news networks are *not* showing these, and neither are the newspapers printing them. They've made a conscious decision.

♦ **V:** *You can find them on the Internet—*

♦ **PK:** Of course, but you have to take the initiative and search for them. I've seen them on the Internet, and that's the thing about the Internet: everybody is a reporter, commentator, or artist, and the hype won't get you to a site as much as word of mouth will—or *electronic word of mouth.* My last book—I mean my most recent book—

♦ **V:** *Let's not call it your* last *one!*

♦ **PK:** Yeah! My latest book, *One Hand Jerking:*

Reports from an Investigative Satirist (which has a foreword by Harry Shearer and an introduction by Lewis Black) was produced electronically, it didn't have to touch paper. It used to be that publishers required a double-spaced typed manuscript. Now they require an electronic attachment of the manuscript—it's not even a manuscript anymore, it's a cyber-script. So that book was all electronic until it was published for the bookstores.

I've become as much in awe at technology as I am in awe of nature, in the sense that I can't understand either of them. I just try to appreciate what they can do and how nature is blind—although tornados, floods, and earthquakes are *maybe* caused by all of those nuclear tests underground—maybe human technology is behind all of those "natural" disasters.

The technological revolution, I've been told by people in the field, is just *beginning,* and I don't know what that means—in the future, are they going to be able to have sex with their cell phones?!

Now I wrote something that was true—it was so incredible that people thought I was making it up . . . that certain porn stars have their moans and groans available to be used as cell phone ringtones. Cingular is already involved in that process—

♦ **V:** *It's probably already here. We've seen the arrival of "respectable" porn superstars like Jenna Jameson, who write books and are featured in "art" photography monographs. I'll bet she even has a signature moan or sound that she makes, which people are putting on their ringtones—I wouldn't doubt it.*

♦ **PK:** I don't know if they do it themselves and sell it to the ringtone company; I don't know how that works—

♦ **V:** *Well, she's a super-marketer of herself, so she probably licenses her moans—*

♦ **PK:** But what about bootleggers? It could be an imitator.

V: *Or the understudy! I bet porn movies have understudies just like in plays. You know, the porn star suddenly becomes ill, and the understudy just does the* close-up meat action.

♦ **PK:** Or wears a wig. You know what would be a nice hoax? If you weren't really taping this!

V: *No, that would be awful! I am—I hope! God, I didn't expect you to say all this—*

♦ **PK:** Well, I didn't expect to say all of this either.

♦ **V:** *Well, you aren't necessarily kidding when you say that, because we all know that cliché:* Some of my best ideas come in the shower. *It's true, sometimes these sort of mundane activities engage your superficial mind, thus allowing your "deeper" mind to get brought to the surface.*

♦ **PK:** Well, that's one of the reasons I thought we should do this right away, instead of setting a time for it later . . . because I *didn't* have time to prepare for it, so it was a leap of faith that I would have anything to say, because my mind was blank! But I know that Lenny Bruce and Mort Sahl both would just clear their minds before they would go on stage, and Allen Ginsberg would meditate before he would write a poem, to see what words, phrases and images would break their way through that meditative haze to where he could write. And marijuana can work in that way, too—it can be an aid to conceptualizing—

♦ **V:** *Perhaps smoking marijuana can cause different pathways of synapses to form—Burroughs was always after that. We tend to go down the same old well-worn paths of associations—that's why Burroughs used the cut-up method to try and break them. Anything to have a fresh thought;* you put the sewing machine on the dissection table with the umbrella . . . *anything to go somewhere new in your head!*

♦ **PK:** Recently, I gave to Wavy Gravy this Donald Duck with eight arms. It was either *Shiva-Duck* or *Donald-Sutra.* I would sort of use that as my icon, just to focus on something, because I always wondered, "When people think about God, do they visualize anything?" The best I could do was think of—what was that figure—the baking character?

♦ **V:** *The Pillsbury Doughboy?*

♦ **PK:** Yeah, the Pillsbury Doughboy! That's about the best I could visualize when I "pray."

♦ **V:** *I was raised fundamentalist, and grew up thinking of "God" as this enormous white-bearded man with a huge beard that was 100 miles long. I remember wondering if his penis was 200 miles long—*

♦ **PK:** When people pray, they're really just talking to themselves . . . but if you do it out loud, other people think you're crazy! However, if you're in a "church" with a bunch of people who are doing it out loud, then there's the force of numbers, so you're not crazy. So, it's okay to say that you talk to God, but when you say that God talks to you, then most people think you're crazy . . . unless you're George Bush! Then they think you're the president!

♦ **V:** *I know! That's a good ending—*

♦ **PK:** Yeah, this has been really refreshing. ♦♦♦

M ARGARET CHO

Growing up in the San Francisco Bay Area, Margaret Cho had to move to Los Angeles to find commercial renown and meet her husband, Reverend Al of the Los Angeles Cacophony Society. An incessant blogger and deeply thoughtful comedian, Margaret Cho is also a dancer, actress, writer and social critic (Google "Margaret Cho" to find out more). Interview done over several days by V. Vale.

♦ **VALE:** *You know, it occurred to me that in the history of the whole world you may be the first Asian-American woman comedian. I certainly don't know of anyone else—*

♦ **MARGARET CHO:** Hmm . . . I guess I am.

♦ **V:** *And in fact there have hardly been any Asian-American actresses. There was Anna Mae Wong in the Marlene Dietrich movies from the forties. Who else? Well, whoever played the wife of Charlie Chan. The presence just hasn't been there, so you're like the first. Don't you think that's amazing?*

♦ **MC:** Yeah, I think that's great.

♦ **V:** *But how did you become who you are?*

♦ **MC:** Well, I found my own environment to be pretty stifling, and feeling so limited in what I could do as an Asian-American or Korean-American, I branched out and did a bunch of different things.

♦ **V:** *Right, but that isn't easy. Was your peer-group other Asian Americans?*

♦ **MC:** No. I was raised in a really diverse community—I grew up in San Francisco where there are lots of other Asian-Americans and many other ethnic minorities, gender minorities, and sexual minorities, so it was pretty wide-open and quite a different place to grow up.

♦ **V:** *Well, it's not exactly a prank, but in context, to be an Asian-American or a female comedian is kind of an amazing thing. Remember how Asian women were "supposed to be" back in the bad old days?*

♦ **MC:** It was so weird—

♦ **V:** *You weren't supposed to stick your neck out at all—*

♦ **MC:** No. But because of that and because of my identity, I actually participated in doing a prank for this group of businessmen. This was a breakfast club meeting in Petaluma, probably in the late eighties, for conservative businessmen—lots of Republican guys. They actually told racist jokes during breakfast. So they hired me to show up and "attack" the main head guy, to almost give him a heart attack, and then it would be like: "Ah, it's a joke!"

♦ **V:** *That's weird—*

♦ **MC:** It was horrible! And I didn't know any better. I was taking *any* paying job I could get, and I was probably about seventeen years old, and these guys saw me at the Holy City Zoo [San

Francisco comedy club] where I used to work all time—

♦ **V:** *Wow, at seventeen—*

♦ **MC:** So they saw me and they loved me. And these older guys—I mean I had no idea what they wanted from me—they said, "Well, we have a gig that we'd love for you to do, and we'll pay seventy-five dollars." To me that was a huge amount of money, so I said, "Absolutely, that would be great!" And they're like, "It's early in the morning. All you have to do is come down and meet us here at 7 AM and come into the meeting and listen for a while. You're welcome to have breakfast with us, and just get really offended by what we're going to talk about. And then at whatever point you feel, really, like just *exploding*, just go off and yell! Yell mostly at the chairman, because we really want to get at *him,* but just yell about what's going on and how terrible this all is and how there aren't any other women or people of color, and how they are all rich, and how they are allowing this moment where they can be white and rich and tell racist jokes and congratulate themselves on being so rich and so white!" So I was like, "Oh, okay!" I thought, "This is really interesting."

So I went, and they paid me in advance. I was sitting at the breakfast table with them and they were all giving me strange looks, because it was all old men in their fifties and beyond, and obviously all successful businessmen—the parking lot was full of Mercedes and BMWs. So they weren't sure what to make of me, but nobody was saying anything, and I was just there in my little business suit about to have breakfast with everyone.

So the breakfast started, and the guy who was running it, the chairman, opened the floor and told some very racist joke—I can't remember what it was—but it was a really racist joke about black people, the type you could never tell in mixed company (or any kind of company) but he told it and everybody laughed. Then somebody else told a joke about Affirmative Action, and everybody laughed. At that point I just stood up and started screaming: "You can't do this! This is absolutely wrong and I can't believe you're doing this! It's so racist and sexist and you should be ashamed of yourself! This is *not* what this is supposed to be—this is non-inclusionary—this is the worst *ivory tower* that I've ever seen!"

At first they were afraid because they weren't sure what I was doing there, and then they realized that clearly somebody had put me up to it, and then they all just laughed and applauded—they were so excited, and the chairman was just *tickled pink!* It couldn't have been better if I'd

popped *out of a cake!* It was just this perfect thing: "Here's this woman, she's a minority, she's talking about all of the minorities—and I can't stand minorities! And they've combined every minority into one, and it's coming at me—and it's a joke!" And so it was this intense relief for the chairman—it was a very complicated political prank.

♦ **V:** *Wow, maybe that* was *the new form of "popping out of a cake." Of course, I immediately thought of what I've read about the master-slave relationship, and how a lot of these powerful executive-types have a secret life where they want to be tied up and whipped in a bondage situation—*

♦ **MC:** Right, they want to be beat upon! They want to be yelled at, to alleviate their guilt—they *know* they've done wrong! And to alleviate their guilt they occasionally host little "events" like this. Whereas it was funny at the time because it was in the context of *good humor,* now I look back on it and think, "That's terrible! They really took advantage of me!" I was so young—

♦ **V:** *Right, you were like a "trophy Asian"! There are white men who fetishize Asian girls—I'm sure you know all about that—*

♦ **MC:** Oh yeah, but I was so young that I couldn't be aware of all that. I think I was chosen just because I was politically the *right kind of person* for the job: the perfect minority who they felt so guilty about and wanted to make fun of somehow to alleviate their own guilt, or—

♦ **V:** *A lot of these business types have a sick sense of humor—*

♦ **MC:** *I know!* They're a sick group because their life is all about greed, and it isn't really about compassion—

♦ **V:** *It's about greed and lying and swindling and defrauding the consumer—*

♦ **MC:** —swindling the consumer and swindling each other and . . . It's a weird world. But they're human beings; they're not such monsters. They have needs, but their needs are met in different ways.

♦ **V:** *Oh, how compassionate of you!*

♦ **MC:** Yes . . . well, *maybe* they are actually like human beings, and I like that they have these desires and needs that need to be taken care of.

♦ **V:** *Well, we're in a capitalist society where the highest good is profit and everyone is out for themselves, making sure that they get the maximum they think they're entitled to. So wives become* trophy wives, *kids become* trophy children—*it's all part of some vast, status-seeking, pyramid scheme—*

♦ **MC:** But where is *life* in all of that? Where is enjoyment and living and all of that?

♦ **V:** *Right; where is the true lasting humor? Well,*

now you're at a point where you don't have to have a day job anymore, and you can say what you want to in your art form . . . isn't that amazing, the freedom?

♦ **MC:** Yes, it's amazing. I'm so grateful for it. It's incredible that I get to do what I do, and it's incredible to me that there aren't more women doing it—

♦ *V: Right; it was hard to find women to be included in this* Pranks *project. It's not just about physically doing pranks—it's more about destabilizing clichéd perceptions of role models and roles; lampooning behavioral clichés and clichéd situations, etc. It's primarily anti-authoritarian, but with humor—obviously pranks need humor, and crazy surrealist metaphors get generated—things like Reverend Al has done—*

♦ **MC:** Hell yeah!

♦ *V: The best pranks generate images you'll never forget once you've seen them—you can't figure them out!*

♦ **MC:** It's true; they'll stay with you forever. It's so strange . . .

♦ *V: So how have you kept true to a vision? It couldn't have been that easy—*

♦ **MC:** I think I just trusted that I didn't want to do what my parents wanted me to do. And I didn't have it in me to have that much drive towards education, which is such a big thing for Asian Americans—

♦ *V: Asian Americans are all supposed to be doctors or engineers—*

♦ **MC:** Yeah, and that's all my parents wanted from me. I don't think they even wanted me to be a doctor because they thought even that was dirty somehow; it wasn't right or appropriate. They wanted me to be in school, which is something that I didn't want to do. In that regard I disappointed my parents so much that it wasn't a big deal anymore to disappoint them—they got *used* to being disappointed. I think that so many people are afraid of hurting their families that they don't really *live*. I got over that.

♦ *V: That's the first step. In a way this book is about freedom and extending its boundaries. But didn't you have to have some awful day jobs?*

♦ **MC:** Oh, I had a million day jobs; I did everything. I was Raggedy Ann at FAO Schwarz—

♦ *V: At least that was a kind of theater acting—*

♦ **MC:** Right, but it's also kind of a weird, creepy job to work around children who are buying toys at FAO Schwarz, which is very upscale. A lot of parents tried to purchase *me* along with the toys—they thought that because I got along so well with children, I should be on sale, too! Lots of men tried to purchase me because Raggedy

Ann is a very weird sexual icon—she's so indestructible and soft. That was weird, too—the sexual identity of Raggedy Ann, which is very—I don't know, it's something that I found out a lot about.

Let's see, what else did I do? I worked at Stormy Leather in San Francisco—

♦ *V: Oh, you'd be great at selling sexy leather—*

♦ **MC:** Leather and dildos and all that stuff. I worked there for a year. That was a great job; I had health insurance and everything.

♦ *V: Why was it a good job?*

♦ **MC:** Because it was so easy, and people who are into S&M are very polite! They're really considerate. Everybody has good manners; it's not a sleazy kind of operation because the people who are doing it are not sleazy. It's not a typical sex-worker job because the people involved have thought about sexuality a lot. People into S&M are very interesting because there is so much thought that goes into what they do that there isn't enough *time* to be sleazy!

♦ *V: Oh, they're like scholars. I never thought about that—*

♦ **MC:** It's so intellectualized that it never gets to a gross point.

♦ *V: Because it's conceptual—*

♦ **MC:** *So* conceptual! I never felt like I was working in the sex industry, even though I was for many years. They treated me well and I had a really good time with those girls there. I know that it's been "bought out" and it's a different operation now, but when it was a co-op it was quite a lovely kind of utopia.

♦ *V: All your life you've been increasing your knowledge of power dynamics, including when you worked in S&M. You transfer that insight into life in general and get comedy out of it, right?*

♦ **MC:** Well, yeah! Because you have to look at the audience and think of them as if you are the *Top.* You have to look at the experience as a Top would, and it's about being the ultimate Top: you have to cut through and you're taking your Bottom on a journey. That's what all Tops do: tell the Bottom a story. All of it is play and story, and you're in control of it, and that's what Tops are known for and that's what they do. They take charge of the moment and take the Bottoms through a story. That's definitely something that I learned.

♦ *V: Right. And you probably got exposed to many different social classes and ages, all wrestling with common problems involving power dynamics—*

♦ **MC:** Yeah, you want to find that perfect Top, or be that perfect Top. You look for ways to improve, and equipment to help you improve. A Top has to

read and study to improve toward being a better Top. Bottoms are always looking for the ultimate Top—

♦ **V:** *Is it easier to be a Bottom or a Top?*

♦ **MC:** It's probably much easier to be a Bottom, but it's not as enjoyable unless you have a really great Top. It's hard to find a really great Top, because there aren't a lot of natural ones, but the ones that are good at doing it are surprising because it's not just about S&M—they're good at *everything*. Not that I'm a good S&M Top, mind you—I'm terrible at that! But I am good at being a Top in my work.

♦ **V:** *Right; it's a metaphor. In your comedy act you're a storyteller, a theater director, a casting director, a costumer—*

♦ **MC:** Everything!

♦ **V:** *And where do your ideas come from?*

♦ **MC:** A number of things. Also from observing how sexuality is so basic and not so exotic and not so scary, and that everybody has this sort of insecurity. Everybody is full of need no matter where they are sexually or gender-wise—

♦ **V:** *—or economically—*

♦ **MC:** Anything; we're all kind of the same in that regard. I still deal with entitlement issues. Like, if I'm ever reviewed negatively, that's usually where the critic tends to go, "Who does she think she is? Where does she get off saying that?" Like, if I ever talk about the government or foreign and domestic policy, it's, "How does she get the right to do that?" And I just have to not question it within myself. I have to entitle myself to do things, because if I didn't, nobody else would give me that validation. Because I want to, I have to entitle myself to do all of the things I do.

♦ **V:** *You could make a button:* Entitle Yourself.

♦ **MC:** I mean you *have* to. If you're not white and privileged and you haven't been given a voice, then you *won't* be given a voice. So you have to create your own and trust that that's okay.

♦ **V:** *Right. The philosopher Hegel measured "progress" in history as: more consciousness and more justice for more people—and that includes economic justice. So how did you work your way up in the ladder of comedy? You started at small clubs; someone gave you an opportunity to go to Petaluma; then you tried to work as many clubs as possible?*

♦ **MC:** I just did as much as I could. I didn't get discouraged by anything; I just really loved it!

♦ **V:** *But what kept you going?*

♦ **MC:** I had nowhere else to go. I didn't have any college that would take me—I flunked out of school. I couldn't go back to my parents, because they didn't want to have anything to do with me because I didn't go to school. I *had* to be success-

ful. I couldn't stop working on it; I *had* to work, I had to be a comedian; I had to make a living at it. There was no choice in the matter.

♦ **V:** *If you only do one thing, that makes your life simple—*

♦ **MC:** Yeah! You make your life really simple and just do the one thing, and you have to put everything into that and that's going to be the thing you do. And that's how things happen—that's how *miracles* happen!

♦ **V:** *Right. There are a lot of miracles in life that we take for granted—even the fact that we're talking on the phone and you're 500 miles away. That's amazing—*

♦ **MC:** It's totally amazing!

♦ **V:** *Well, don't you do a lot of hard work and preparation on paper or at the computer?*

♦ **MC:** Yes, all the time. A lot of what I do is written out, measured, and scripted beforehand. I can be spontaneous, but I spend a lot of time working it out: writing and focusing all of my attention on the words, and the economy of the words, and *what* words. A big part of what I do is working it out that way.

♦ **V:** *I'm glad to hear that. Behind everything worthwhile there's a lot of solitary work—*

♦ **MC:** Right. It's supposed to look effortless and totally easy, but it's not. It takes a lot of practice.

♦ **V:** *Right. So you didn't really have professional theater training?*

♦ **MC:** No—

♦ **V:** *But you've learned a lot somehow; everything in life is theater—*

♦ **MC:** Yes, of course.

♦ **V:** *And what makes one person become a comedian and 999,999 of the others not?*

♦ **MC:** Determination and drive: this is your entire existence; this is the only thing you're going to do. You have to have that single-minded focus that just won't allow you to be lazy. You won't take a job that doesn't let you do shows at night. It is just that incredible focus and drive; you just don't give yourself any choices to do anything else . . . It's like a work ethic—that definitely had a lot to do with it. I had such a strong upbringing and work ethic, a need to excel. My parents had a need for me to excel so much so I couldn't have escaped it—it was always going to be a part of my psyche.

♦ **V:** *Even if you were willing to turn "counter-culture"—*

♦ **MC:** Yes, that didn't change the fact that I was going to be driven.

♦ **V:** *A lot of your material comes from having finely-tuned antennae for injustice and outrage—*

♦ **MC:** Yes, outrage—I have a wonderful opportu-

nity to go into things that outrage me; to have a voice there. That's really remarkable.

♦ **V:** *Society needs it—*

♦ **MC:** —and I enjoy it!

♦ **V:** *Can you measure success by the number of people you've offended or outraged?*

♦ **MC:** Well, last year, another Republican-type group invited me to do their big fundraiser. I was a last-minute hire. I didn't know who they were, and *they didn't know* what they were getting when they hired me, obviously—

♦ **V:** *This is pranks territory—*

♦ **MC:** It was a pranks kind of a thing. So they hired me to do an actual show, and I started talking about the horrible things happening at Abu Ghraib prison, and the inhumanity of the soldiers involved—

♦ **V:** *Right, the American right to torture!*

♦ **MC:** Yes, and the audience started to bellow. They were laughing, but they were also screaming and angry, and apparently I didn't realize this! These conservative Republicans then turned off my microphone and asked me to leave the stage, and I wouldn't because I just *won't*—even if an audience doesn't like me, I'm going to make it really hard for them . . . I'm determined to make them *hate* me!

So I wouldn't leave the stage, and I was still screaming and doing hand gestures and doing my show, so they got the band onstage behind me to start playing "Sweet Home Alabama." At that point Reverend Al, who is my lovely husband, came up onstage and said, "Sweetie, I don't think they want you to perform anymore." I said, "Yeah, well I'm not done," and he said, "Well, maybe we should just go." I said, "Well . . . all right." So I left the stage with my husband, and they ended up having to pay me double because I was so angry. Somebody somewhere had pulled a prank; this was a prank gone awry. Someone had thought it would be funny to hire a liberal person for this extremely conservative event, like, "Let's see what'll happen!" And it was so bad that they had to pay dearly for the privilege.

I was offended by the unwillingness of the audience to even *listen* to what I had to say, and they were offended by the fact that I was bringing up these topics that they would never even discuss! So that was disheartening, because I felt that as a comedian I was at a point where I could speak to *any* audience—that I had that skill. But sometimes politics is too hard. People stop listening and don't want to hear *anything* they might disagree with.

♦ **V:** *So how could have you redone the show?*

♦ **MC:** Umm . . . I don't think I could have. It would have always come back to the same situation: them pulling the plug on the microphone, me screaming. . . .We were essentially coming at each other from who we are, not from what we can do . . . But I'd like to reach everybody—that's

what it's all about: connecting and being able to talk to everyone.

♦ **V:** *Well, I also think that all comedians and artists who have any audience at all have to speak out against the war, if their instinct tells them to—*

♦ **MC:** Right! My instinct is to talk about these issues and to find some humor there, because if there's humor there, then there's hope there, and we can actually find a way to be hopeful. That's the most important thing: to find hope.

♦ **V:** *I agree: humor is the only way to find hope.*

♦ **MC:** I know! That's how I'm looking at it, and that's how I can continue: by trying to find a hopeful side. I ask, what is it that's going to make me feel hopeful about the situation? What's going to make me feel like I should keep going? And I'm still looking . . . it's hard!

♦ **V:** *I'm sure. You maintain an extensive website and blog; does that help you get feedback that encourages you to keep going?*

♦ **MC:** Yes. It helps me think about going on and keeping everything in perspective. People are so

great and supportive about it, and that's lovely. When you have a strong sense of people really getting into what you do, and really understanding it, and really wanting you to keep telling your story—that's beautiful. So yeah, I love doing my blog and I love the fact that I have that option and outlet.

♦ **V:** *Right; you can reach so many people all over the world—*

♦ **MC:** It's a great way to connect with people and a great way just to write and keep connecting—I write about everything. A lot of times what I'm doing is not necessarily political, but it's just about continuing to have a voice and while doing so providing a good example for others so they may think, "I can entitle myself with my voice, too."

♦ **V:** *Right. The Internet has definitely enabled more people to express their own experiences. All the various ethnicities and genders—it's only relatively recently that we've realized there's a third sex. Maybe there's more than three—*

♦ **MC:** There's probably more—

♦ **V:** *Exactly. And yet we're all human; we're all fallible, I think. Lenny Bruce had this funny line about if he were ever threatened with torture: "I'll confess to anything—just don't pour that hot lead up my ass!" That's one of the phrases he contributed to our culture—*

♦ **MC:** That's so funny! I don't know what I've contributed like that. The world is full of ideas and catch phrases that are never ours and are never created by us.

♦ **V:** *I'm always looking for phrases to live by. Sam Goldwyn said, "In any social situation there are always at least three truths: your truth, my truth, and the truth." My ten-year-old daughter loves the Marx Brothers and will watch the same movie over and over again so she can memorize the good lines—*

♦ **MC:** That's so cute!

♦ **V:** *She's always looking for snappy comebacks. What's your history of being exposed to comedic influences?*

♦ **MC:** I don't know who my favorite comedians were when I was younger. Maybe people like Flip Wilson, because he was such a gender pioneer. He was always doing "Geraldine," the character that was this crazy and angry woman. Such a funny idea—a man playing a woman, and so he was very influential. Beyond that, people like Whoopi Goldberg were hugely inspiring. Today I love Wanda Sykes—she's amazing! She's pretty much the best. She's really great, so funny. I love comedy; I'm a big fan of comedy.

♦ **V:** *Well, that's your area of artistry. My daughter says she wants to become a graphic novelist—*

♦ **MC:** It's a very honorable profession. I think Dan Clowes really changed the comic strip forever; he made them a legitimate art form. People like him and Peter Bagge and Chris Ware and Adrian Tomine—they really created a new art form in underground comics—and I guess Art Spiegelman is there, too. They are a huge influence on me. Especially Dan Clowes; he is truly one of the only living American geniuses!

♦ **V:** *Who are the other ones? I'd like to know—*

♦ **MC:** Ed Hardy [the tattoo artist/designer/-painter]—

♦ **V:** *I agree, and I'm glad to hear you say that.*

♦ **MC:** There are very few. I love Joe Coleman, and Mink Stole—she's really a genius.

♦ **V:** *You're right! No one ever mentions her—*

♦ **MC:** No, because they think of her in the same mind as John Waters. John Waters is great, too.

♦ **V:** *Definitely. My other favorite living film directors include David Lynch, David Cronenberg, and Dario Argento—*

♦ **MC:** Oh, I love Dario Argento—he's wonderful! Like *Deep Red;* his films are so great and so elegant and scary. I love Mario Bava too, but he's dead. And Pasolini, but he's also dead . . . but mysteriously dead, like Bob Crane. Bob Crane was on "Hogan's Heroes." He was sort of a sex maniac and a swinger, and he was bludgeoned to death. There's a film about this called *Auto-Focus.* His story is very crazy and very interesting.

♦ **V:** *There's probably a book out, too—*

♦ **MC:** Yeah, there is—a very lurid Hollywood story.

♦ **V:** *I'm glad you know about Dario Argento. I love Inferno—it's about a woman in quest of a very rare book titled* The Three Mothers—

♦ **MC:** Oh, I've never seen that one—

♦ **V:** *You've got to rent it! I love that film so much that I have to watch it, whether I want to or not, every two years. A poster by my desk shows a favorite scene where a woman drops her ring into a mysterious basement filled with water . . . Anyway, please rent it!*

♦ **MC:** I will. You know, I have movies I love so much that I have to watch them over and over again, like *Belle Du Jour*—

♦ **V:** *I love that film! Bunuel is my favorite director of all time.*

♦ **MC:** I love him—he's so great. That's probably my favorite film. It's so beautiful and so perverse and odd and strange. I also like *Women In Love*—that's Ken Russell, and it's got the beautiful Glenda Jackson and Oliver Reed and Alan Bates and nude wrestling—it's a very good film! Another one is *Withnail and I*—that's a beautiful film. I think Bruce Robinson directed it.

I watched a new movie called *The Lolly Madonna War*. It's a movie from the seventies about a Hatfields-and-McCoys confrontation in the backwoods. Appalachia is really scary to me, so I always want to learn more about it, and this is a really good, weird movie about that. I love *The Great Gatsby*—it's a very odd kind of film and very beautiful and very seventies. These movies you have to watch over and over again.

♦ **V:** *Thanks for recommending some good films. We were talking about movies you liked, like* Belle du Jour—

♦ **MC:** That's a good one to *own*. The sixties was a really great time for movies. I loved the films of Roger Vadim. *Dangerous Liaisons* (1960) was a great one. I love Jeanne Moreau in anything, and *Jules and Jim* is such a beautiful film—*all* of Truffaut's films are so beautiful. It seems like they had better movie stars who seemed cooler, somehow.

♦ **V:** *Just mentioning the* titles *of those movies almost puts one in a small trance—*

♦ **MC:** I know. I love those films that are so beautiful, where the images just *last* in your head, like *Blowup*—that's such a great, beautiful movie. All the images are so arresting, and everybody's so cool in it.

♦ **V:** *That film has wild and anarchic moments in it, like when those underage teenagers come into his photo studio. You couldn't film that today—*

♦ **MC:** I know. It's a really exciting, sexy film. I also love Polanski in the sixties and seventies; I love *The Tenant*. A good double feature is *The Tenant* and *The Servant*, which is a Joseph Losey movie with Dirk Bogarde and James Fox. Or *The Tenant* and *Performance*, which is another genius film, also with James Fox. It's the same *paranoid-feeling* kind of movie. Polanski's *Repulsion* is also a favorite film; the young Catherine Deneuve is so great. And she's *still* doing movies and is just a phenomenal *presence*—she's awesome and in fact iconic.

There are iconic women whose images are almost like what people used to think of as gods and goddesses—they had this incredible power just in their images. I don't know if there are movie stars today that do that; they don't have the same kind of visual power as somebody like Jeanne Moreau. She's so beautiful, but it's not her

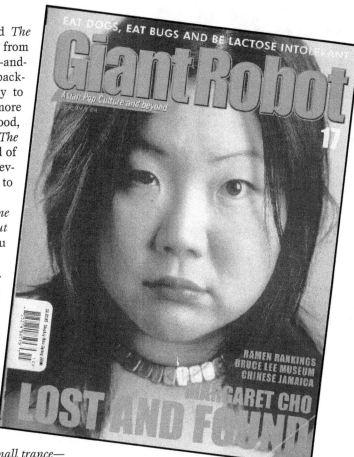

beauty that makes her so great; it's something else other than her beauty. Maybe there are some things that are not beautiful about her that make her so compelling.

♦ **V:** *It does seem like there's some depth of sadness to her.*

♦ **MC:** Yes, she just looks like she's just so worn out—like, emotionally really wrung out, and you *believe* her. She's so great. Then there's Simone Signoret in *Diabolique*, which is so genius. To me, the dark side is more interesting—the darker aspects of human beings . . . that to me is more exciting, and so great to explore in film. And you can experience something again and again in film.

I think my favorite film of all time is *In Cold Blood*. That's so beautiful. I know there's a new 35mm print of it with a new soundtrack. Sometimes you don't know how beautiful a black-and-white film is until it's restored and shown again on the big screen. That's the best performance, by real-life murderer Robert Blake!

♦ **V:** *Yes, art can spill over into real life now and then—*

♦ **MC:** I know, which is so cool. And actually, Scott Wilson, his accomplice in the film In *Cold*

Blood, was a character witness at his trial . . . which I think is so *nice!* [laughs]

♦ **V:** *Did you ever see the film* Detour *by Edgar G. Ulmer?*

♦ **MC:** No.

♦ **V:** *It's one of my favorite films of all time, low-budget, just over an hour long. It starred a piano player/hitchhiker named Tom Neal, and in the film you can see him really playing the piano. He gets involved with an amazing woman, Ann Savage, who's still alive and recently appeared at San Francisco's Castro Theater. In the film there's an accidental killing committed, and in real life the actor Tom Neal also killed someone and got put away in jail for it.*

♦ **MC:** Oh, wow. I have to see that. It sounds really familiar, and I've heard that name a bunch of times from people who really love movies. I love the film noir genre . . . it's what it's all about! So cool.

I'm just starting to get into the new Japanese horror films like *Audition* and *Judu*—the American remake was called *The Grudge. Judu* is the scariest film I have ever seen—sometimes I think about it in the middle of the night and I can't go back to sleep! You should see it. And there are some great Korean filmmakers, too. The *Vengeance* series which starts with *Old Boy* and *Sympathy for Mister Vengeance,* and *Sympathy for Lady Vengeanc* . . . those are great new Korean noir.

Do you know Chris DesJardins? He's an early punk rock guy—

♦ **V:** *I met him; he was in a band called the* Flesheaters.

♦ **MC:** He's really great. He wrote a book, *Outlaw Masters of Japanese Film,* all about Japanese cinema, focusing on all these great films from the seventies. They're sort of sexploitation but also espionage. They're yakuza and noir but so brightly colored—they're really beautiful. Chris writes all about it and has had something to do with the release of DVDs of them. He's bringing in a whole new group of films to love. He's a great authority on this really bizarre genre of films that sorta gets lost—sometimes these Asian films are not as widely known, so it's good to get a "heads up" there.

♦ **V:** *This is an exciting detour, because I love to get turned on to films, but only from someone I can trust. Because sadly, you can't trust most people's film recommendations.*

♦ **MC:** Right. They have no idea; it's so funny!

♦ **V:** *You know, I found an interview with you (in the* San Francisco Chronicle Pink Section *from June 12, 2005) that had a great pull quote from you:*

"I think that getting a lot of hate mail—that's so hot!" I realized that you make comedy out of that which oppresses and horrifies you—that's the only way to deal with all that—

♦ **MC:** Oh, I know. So true.

♦ **V:** *Have you actually gotten a lot of hate mail?*

♦ **MC:** Well, people that write hate mail are so stupid—*it's* so stupid. Smart people never write hate mail! Smart people—if they hate something, they just don't even think about it, or they don't even look at it. Hate mail's just so funny, and it should be *encouraged!*

♦ **V:** *I was looking at our old* Pranks *book and the only woman in it was Karen Finley. And in this book,* Pranks 2, *you're the only woman so far—*

♦ **MC:** Oh, wow. Well, maybe pranks are kind of a male ritual. I don't know. I'm not such a "pranks person"; I think women just don't have *time.* Men seem to have more time for these kinds of things, like prank phone calls or prank this or prank that. I don't know. They seem to have more of a *culture of fooling.* There are more male comedians. There are more male *everything,* but generally, in comedy, there aren't a lot of women. I don't know.

I was never so big on pranks, just because I always had to work or do something else that I didn't have that ability to just sort of have *fun.*

♦ **V:** *I like your line: the "culture of fooling." It seems the whole media culture has become that. The bad thing is that the men in power also have technological toys that can kill you—*

♦ **MC:** Or not-so-technological, like Dick Cheney, who just shotgunned his hunting partner while hunting. I wonder if he killed him, and that's why we haven't heard from him. He just doesn't get the fact that *he's* the one who's supposed to be shot! I think the news blackout on it is very strange.

♦ **V:** *He's guilty.*

♦ **MC:** I'm sure. He's guilty of many more crimes than that. It would be funny if that would be the one thing they did get him on.

♦ **V:** *I'm sure the Bush Team has had some think-tank the size of a city building strategizing how to get Cheney out of this one.*

♦ **MC:** Yeah. Well, they've been able to get him out of a lot, so it wouldn't be surprising.

♦ **V:** *You know, personally, I've never done a prank in my life—*

♦ **MC:** Maybe it's a "white" thing. People who have that sort of *culture of privilege* can do things like that. There seems to be no equivalent of April Fool's Day outside of America or Europe—nobody in the rest of the world has the time to play the fool, and nobody has time to be fooled.

They're all poor and working and trying to live. Also, to me it's a very fraternal thing. It makes me think of frat houses and white men.

♦ **V:** *Well, fraternities are associated with some pretty gnarly "rites of passage"—*

♦ **MC:** Like hazing—that's very much a "Privileged Culture" thing . . . going from something that's under-privileged to privileged is a very painful transition.

♦ **V:** *It's definitely against the grain for you, as an Asian woman, to be taking belly-dancing lessons—*

♦ **MC:** Yeah. It's wonderful because I've spent so much time and so much of my life and career about being *verbal.* Belly dancing is learning how to communicate in a different way. It's very challenging and scary. There's one thing about belly dance that's really terrifying: you can't talk. So you have to move and be with people in that *movement,* and it's so very strange to do that. I really love it for that reason.

♦ **V:** *Liberation is not just about the mind but the body also; some Buddhists use the phrase "body-mind" to try to erase that dichotomy. White men in power have long been lampooned for their stiff and jerky movements—*

♦ **MC:** —which is very funny. It's so true. It always amazes me; they're just so uncool. How can they have all the power when they're so uncool?!

♦ **V:** *There are some obvious questions to ask you, like, did any weird things happen in your childhood to inspire you to go on the path you're on?*

♦ **MC:** No. My childhood was utterly humorless, utterly desperate, really very typical of immigrant families: a really ultra-conservative, really painful upbringing. I was kind of forced to be really silent. My family was really religious, so we actually had church in our *house.* We had a church service that would happen in our house every day! It was just depressing to grow up in this stifling environment. The only thing I thought of was to escape. So maybe that's how my childhood contributed to my choice of career and wanting to leave quickly; maybe it taught me to have a sense of humor about things. My family is utterly humorless; I had a kind of depressing and dour dad.

Koreans especially love misery and whining and complaining and tragedy . . . so their most favorite form of entertainment is soap opera, and the most popular export is soap operas. It's typical. So . . . I was born out of tragedy, not comedy at all. Maybe that makes sense; that's why I do what I do because there was so much misery

around.

♦ **V:** *That's certainly a dialectical response, or reaction—*

♦ **MC:** Yeah. I'm just trying to keep doing what I'm doing, and am glad that I'm able to. I'm trying to encourage others—especially Asian-

Americans—to kinda get out and do *something* if they want to. It's weird; we have no real image within the culture. We don't really have a solid relationship to America. It doesn't exist in television and film; we're always made foreign.

I love that film *Memoirs of a Geisha,* which I just saw. It kind of reinforces the idea of a foreign identity of an Asian-American.

♦ **V:** *The film got a negative review in the* New York Times—

♦ **MC:** The film was cool and I love all the actors. Yet it just reinforces this exoticism that would be great if it were exoticism *by choice,* that a slum that America doesn't necessarily think of is like that. But they kinda do . . . and it's kinda weird.

♦ **V:** *Well, in the old days if you were a Japanese male you were automatically a gardener—*

♦ **MC:** No choices at all; you're *totally* a gardener. Actually, there were a lot of gardening people in my family, but some of my family lived in Japan. My grandfather spoke Japanese and he was very much into plants.

♦ **V:** *If you're Chinese, you open up a restaurant or a laundromat. Koreans were off the map—*

♦ **MC:** They went into *wigs and liquor.* I don't know why; maybe they thought, "These are the things that are going to be profitable. Everybody wants to get drunk, and everybody wants hair." [laughs] If you want to learn about the history of Asian-Americans in this country, you have to learn about it on your own; it's not taught in schools. You have to seek it out. I don't know that much, but I'm getting curious.

♦ *V: So am I. I just read my first mystery novel written by a Japanese-American:* The Gasa Gasa Girl *by Naomi Hirihara. It was really fun to read, and I learned things like, some Japanese living in New York City were incarcerated in North Carolina during World War II. There's a special word for Japanese who were born in America* (kibei)*, grew up in Japan and then returned to America to live.*

♦ **MC:** How funny . . . I like Amy Tan a lot. But I don't know anybody else, really; there's just not a lot.

♦ *V: Were there any books in your past that "turned a corner" for you, or that stand out.*

♦ **MC:** Well, I loved all the RE/Search books— that was like a big deal. My parents owned the Paperback Traffic bookstore at the corner of Polk and California Streets. We carried all the RE/Search books. To me they really opened up a whole world. Ed Hardy came by and he would drop off his *Tattootime* books. He tattooed quite a few of the employees who worked there; they were into the *Modern Primitives* activities like opening up their ears slowly, stretching out the earlobes—that was the thing. It was a very important book for me. The *Bodily Fluids* book was really great. They were all very influential, including the J.G. Ballard *Atrocity Exhibition*—

♦ *V: I think that's my least accessible book for the general reading public*—

♦ **MC:** That and *The Torture Garden.* They were great, though. They were books that really meant a lot. So that was a great contribution of yours to *my* life.

♦ *V: Wow; thanks . . . You know, one of the things that impressed me about the actress Kim Novak was the fact that she retired quite young—completely fled Hollywood to Big Sur and started a large animal ranch or shelter*—

♦ **MC:** Kim Novak—she's cool. Hollywood is not kind to women; the profession leaves women behind. After a certain age, you become irrelevant—which is very depressing—

♦ *V: —unless you can switch gears and become a director, which is what Ida Lupino did. Betty Thomas did that, too*—

♦ **MC:** She's a great character actress. And then she became kind of a *big* director; she did a lot of commercial films like The *Beverly Hillbillies*—no, that was Penelope Spheeris.

♦ *V: You'll probably meet her; you're in that same 300 square miles*—

♦ **MC:** You eventually meet everybody. It's this small, insular, weird little world where there's, like, very little space between people.

♦ *V: Everybody probably asks you how you keep your soul and integrity down in L.A.*—

♦ **MC:** I guess because with the kind of work I do, everything is so personally generated. I have to do so much just to survive here that I don't even get the chance to sell my soul. I've been really—I don't know if it's *fortunate* exactly—but I don't *work* enough to sell my soul; I don't have those kinds of opportunities. I'm not in anywhere like Tom Cruise-land where that's all you do. For people like me, one of the good things is that we just keep surviving. I'm not like an ingenue; I don't have to worry about it.

♦ *V: The best revenge is to just keep going*—

♦ **MC:** And just sustain—

♦ *V: And don't give up. That's the best: to keep having a voice 'til the bitter end.*

♦ **MC:** I don't really consider myself that much a part of this particular industry, even though I *am,* but I'm also not. It's not so bad.

♦ *V: So you're part of a subculture in L.A. that's trying to do "real" work*—

♦ **MC:** Yeah, I think there is one. There are people I really like; people like Dan Clowes. I also like Miranda July a lot. She's sort of new; she just directed a film and she's also a singer-songwriter; her work is beautiful. There's people like that that I turn to, to be inspired by. Some of the gay artists that do work here—that's what's really new and thrilling. So, those are the things that I'm kind of into.

I don't know. I've managed to survive in this business in Hollywood without self-destructing, which is amazing. And I think that is the best prank of all: is that I continue, and be subversive and live and enjoy myself and work and grow. So that's the prank on this very repressive, racist, society! That's my big prank! ♦♦♦

ART AS PRANK

A scending from the cultural matrix of Dada and Surrealism, the founding artist of 20th-century conceptual modernity, Marcel Duchamp, was a prankster supreme and philosophical provocateur. A master of the enigmatic pronouncement, especially on "art" matters, he purchased some of his raw objects at hardware stores or commissioned them from factories, signing the final "artworks" as an ironic after-thought before presenting them to gallerists and patrons.

Duchamp's spiritual heir Andy Warhol continued the "tradition" of posing puzzling paradigms to journalists in interviews, while inventing his own Factory to produce stylistically "generic-looking" artworks by mechanical reproduction—a slap in the face of the artist as a Rembrandt-type virtuoso. Performance Art gave the *coup de grace* to the notion of art as something publicly accessible, and today's art is distinguished by a complex context of references to other art, involving irony, puns, identity politics, political commentary—basically, a comprehensive eclipsing of H.W. Janson's *History of Art*. With the ascension of Banksy, complementing innovators such as Bruce Conner, John Waters, Ron English, Joey Skaggs, Lydia Lunch, Monte Cazazza, Jeff Koons, Damien Hirst, Tracey Emin, and others, the symbiosis between Art and Pranks appears to be gathering a kind of critical mass. Nowadays, if you don't laugh, it isn't art! The eternal trickster has reincarnated itself as a 21st century conceptual artist and prankster.

JOHN WATERS

has been dubbed "The Pope of Trash" by William S. Burroughs. Best known for his many outrageous movies, he debuted his first film, *Mondo Trasho*, in 1969. Since then he has also written books, launched an art career and infiltrated the world of television. All of his work uses dark humor to illuminate absurd social taboos and make his own subversive pleasures palatable to a pop audience—often through surprise and cutting wit. By toying with and dismantling conservative media of all kinds, while reveling in his own obsessions, Waters gleefully exemplifies the eternal spirit of the prankster. Interview by V. Vale

♦ **VALE:** *Well, it's not a new thing to say that you've been probing the boundaries of taboos all your life, in the art you've done—*

♦**JOHN WATERS:** Well, I guess I try to use subject matter that there's no easy answer to, because that's what always interests me and that's what always gets me obsessed. But at the same time, you know, like Johnny Walker Lindh—I'm obsessed by him—but friends say, "Don't write him, John—you'll be sorry!" But nobody else believes what Bush said about the war; why do they believe anything about him? Because it's the first thing they heard: that he was this American Taliban. What he was, was this *kid* that god knows, was well-traveled, and went there and learned the language and got to meet bin Laden. Bin Laden had a great speech recently—he's a better writer than our speech writers. In his speech he said, "Does the underwater swimmer fear the rain?" What a good line! And I don't like bin Laden; bin Laden would *kill* me if he had a chance, but still, you have to respect a good speech!

♦ **V:** *That's a poetic line—*

♦ **JW:** Yeah, I think we should kill bin Laden and kidnap his speech writer!

♦ **V:** *Put him to work as Bush's speech writer—*

♦ **JW:** Maybe they could just do that, and let each other live. [laughs]

♦ **V:** *Well, who said, "If bin Laden did not exist, it would have been necessary to invent him?"*

♦ **JW:** I agree. You know where I live; it's like a very blue-collar neighborhood. When 9-11 happened, the post office had a "Wanted" poster of bin Laden—as if *he* was in Hamden, in that outfit, walking up and down 36th Street, buying a sub! As they say there, "Oh yeah, I *seen* him! Saw him up on the *Avenue.*" I mean, it was so hilarious: "Have you seen this man?" "Well, no, I haven't."

♦ **V:** *I'm interested in your fine art career as a serious artist shown in galleries, museums—*

♦ **JW:** I don't know how "serious" I am. I'm hopefully, I guess, taken seriously, but I use humor . . . my new show is called "Unwatchable." And that is the meanest thing you can say about movies . . . but when you take weird frames and isolate them and put them in a new narrative, then you learn to *see.* You can't see a movie . . . you can't watch a movie in an art gallery. So it's two very distinct things that I'm working with. "Unwatchable" in the art world, I think, is actually a compliment, whereas in the film world it's the meanest thing you can say.

♦ **V:** *I thought you were the first person in the world to exhibit a painting of people inside an airline that's crashing—*

♦ **JW:** All the pictures are mostly taken off the TV screen, and that one was called "Buckle Up." It was just hideous different shots of the worst things that can happen during an airplane crash. You know, my work is sold in editions, and that

was an edition of eight, and what's amazing is: many flight attendants bought them, which I find really great! I thought, "I wouldn't want to check through security with that art piece . . . it ends in a ball of fire!" And it has images of pilots freaking out and people shaking in the seat . . . every bit of fear you could have in an airplane crash.

♦ **V:** *It's true, you wouldn't want to tempt fate by carrying that one on a plane—*

♦ **JW:** No. And 9/11 brought a big *halt* to the sales of that piece. But it's back to normal now—flight attendants are buying them again!

♦ **V:** *Yes, I realize that in this year, 2006, I've thought about 9/11 the least.*

♦ **JW:** I have a piece in my new art show called "9/11" and it's just the two titles, "Dr. Doolittle 2" and "A Knightly Quest" because those are the movies that were scheduled to play on the planes that smashed into the building. That is very frightening: those banal movies . . . they never even got to see them because the planes were hijacked before the movies got shown . . . which is *better,* because imagine if that were the last thing you saw?!

♦ **V:** *That's so funny—*

♦ **JW:** It's not *funny,* really . . . it's actually the terrible banality of those two titles . . . movies that were pretty forgotten—they weren't hated or loved; no one even remembers they came out, almost, except the people who made them. So when you see the piece you think, "What's that?" There are no possible references until you realize that, "Well, that's what was on the planes up there." So it is trying to find some kind of "show business" news, and even the most horrible un-show business kind of moments.

I've always said that my work in art galleries is about the terrible depression normal people must feel every day when they wake up and realize they're not in show business! Somebody said, "That's the snottiest thing you've ever said!" I said, "I don't mean that to be snotty—I think it's just true." There is a certain *depression* when they look in the mirror and realize that there are no paparazzi out front. Only once in my life did I look outside my house and see a "Hard Copy" truck there—that was a scary feeling! It was about Traci Lords—it was back when they were doing that story and they were trying to "find" her, I guess. And it was a good place to look! But she wasn't here . . . *that* day.

♦ **V:** *What are the taboos left that you can confront and deal with?*

♦ **JW:** Well, there are still taboos; certainly, kiddy porn is a taboo.

♦ **V:** *That will permanently remain a taboo—*

♦ **JW:** And it probably should be. The only thing I don't agree with is: you can't even *write* about it, or think it up—you can't do a comic book about it or something. Although, I guess, you know, I'm torn on that; I don't know. I'm so happy I'm not a pedophile, because you can't change—you can only learn to lie. And they think it's right. I don't think anybody *chooses* to be one. I don't think they say, "This is what *I'm* going to be." I'm just really glad I'm not one, or an "adult baby" (that would be a horrible life) or some of these things—I'm just so happy I'm not one.

♦ **V:** *But being an artist, you can have a parallel life for a time on some fantasy level—*

♦ **JW:** Yes, you can *investigate* it. In *A Dirty Shame* I showed all those kind of things. Yeah, but if you can get it out of your system—! But every once in a while I see things from porno and go, "I never even *thought* of that!" And that's *good,* I think—you need something for your older years. I saw this one film and went, "What is that?" Well, this guy pisses up another one's ass and then sucks it out—I never heard of that one

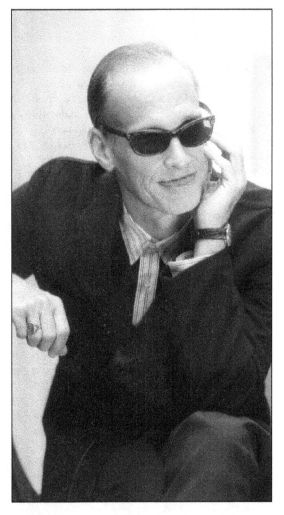

before. I don't even know the term for that—it's *beyond* felching. And I thought, "That's a really odd one . . . at least it's your *own* piss." I don't know which would be worse—I don't know. The film's called "Detention," in case you'd like to watch it.

♦ **V:** *Thanks!*

♦ **JW:** Well, that was a prank, in a way. Thinking up a new sex act in a porn movie is a prank, isn't it?

♦ **V:** *I guess I thought it had all been thought of, but—no!*

♦ **JW:** No. Then there are these horrible extreme blow-job movies; the hetero movies are so *mean* now. I think Bush's white, like, heterosexual porn *is* obscene now . . . all these movies where girls puke, and their gums are bleeding from getting face-fucked . . . that's a whole *genre!* There are many movies like that [makes vomiting sound]— Oh, *gawd!* There's one where they're holding her nose while they're doing it—that shocked me. That one's called *Slap Happy,* I believe, in case you're interested. Or *Gag Factor*—there are seventeen sequels to that movie. These are *hetero* movies. [laughs]

♦ **V:** *I think most people never think of you as either gay or hetero—*

♦ **JW:** That's good. But I'm interested in both, and I always identify with people who don't fit in, in either world. I like the ones that don't fit in their own minorities, much less the majorities.

♦ **V:** *One of my mottos came from Groucho Marx: "I wouldn't join any club that would have me as a member."*

♦ **JW:** Yes. One of my art pieces says, "Gay Is Not Enough," and it's really the altered title of Jacqueline Susann's *Once Is Not Enough.* And it really isn't. It may have been a good start, but it's not anymore ...

♦ **V:** *You've illuminated how society has changed, in that everyone thinks they're an outsider now—*

♦ **JW:** I know; that's why I tell people they have to "come in"—that's the next trend. It would be really perverse to have gay men "experimenting" with women. That is a new kind of perversity— *that's* politically incorrect . . . in the gay world. I'm for that, even though I don't do it; I like the *idea* of it. Greg Araki did it for awhile, and he got so much shit about it. I thought, "*Why?*"

♦ **V:** *Well, that's one alternative that's left. History proceeds by dialectics—something occurs, then it becomes banal, and something opposite happens.*

♦ **JW:** Yeah.

♦ **V:** *That's the big challenge now: to try and embrace as much contradiction as possible, without being dogmatic—*

♦ **JW:** Exactly, because everything now is so "liberally" accepted. And basically I'm *for* everything being so liberally accepted, but at the same time I get mad when they are! Why? Because of the *smugness* of the acceptance! Liberals can get on my nerves, but I know way more liberals . . .

♦ **V:** *How long have you been having shows in the world of art galleries and museums?*

♦ **JW:** I did the first one in 1992, so it's been a while. I never promoted it, so my film fans didn't know about it. But that was the best way for me to enter that world, to keep it very separate— celebrity is viewed with great suspicion, probably, in the art world. And so I mocked my celebrity; all the panels in my show are low-definition and on one of my self-portraits I just took my headshots and stamped "overexposed" all over it. I tried to nullify my celebrity in a humorous way because I knew that was important in the art world.

♦ **V:** *That sounds like an essay, "How to Succeed in the Art World"—*

♦ **JW:** I don't know—god no, I would never say that! I've tried to very much make fun of myself in my art work, in a good way. I have a new piece called "Bad Director's Chair" and it's a director's chair that's stencilled and carved with every insult, like, "Bring Up the Numbers" and "Didn't Test Well" and "No Shot Matches" and "PGA Reject"—every mean thing that can be said about a director. And even the script pads have a leatherbound cover that says "Piece of Shit" gold-embossed on the front! So it's kind of about your fears and about how really terrifying it is to take a risk in the art world—it's much scarier than the movie world to me.

♦ **V:** *Really?*

♦ **JW:** In a way, yeah. Because in the art world you have to appeal differently—if everyone likes it, it's *terrible.* And in the movie world nobody always likes my movies, but they always have to pretend like they're going to. It's the opposite pitch. So it's a completely different way of measuring success.

The best thing in the art world (and by the way, I collect contemporary art; I mean, I buy it) is that the phrase "totally impenetrable" means sometimes really good . . . which is the exact worst thing in the movie business. Or something that defiantly shows no hand of the artist—I like that a lot.

♦ **V:** *So do I. You've done that whole "appropriation" thing that Duchamp started.*

♦ **JW:** There's a whole history of many, many artists who have done that—Andy Warhol did that, Richard Prince—everybody. Almost *everybody's* an artist of appropriation in contemporary

art now—

♦ **V:** —*whether people are aware of that or not.*

♦ **JW:** I think in the art world, the art world only has to appeal to a certain number of people. That's why they purposefully open galleries in out-of-the-way neighborhoods, because they don't feel like having people come in and say stupid things! Many people have—this is what they say in A.A.—"contempt before investigation"! That means they just *hate* it before they even look at it. And that *is* what most people feel about contemporary art. Because they think *you* think they're stupid because they can't understand it—and they're right: I *do* think they're stupid because they can't understand it. [!]

I'm really against "art for the people"—I think that's a terrible idea. I really think the elitism of the art world is what keeps it clever and funny. You just have to learn to see in a new way. You have to listen. You have to get over that "contempt before investigation" which is the great Berlin Wall of the art world . . . but it's *encouraged,* and almost used on purpose, as . . . what do you have to do before you join a fraternity? Hazing. It's that kind of thing in a way—it's *mental* hazing.

♦ **V:** *It's like entering any niche world—*

♦ **JW:** You have to learn a new vocabulary—a secret language. Kids look really cute in the art world; I think they look cuter than in the movies.

♦ **V:** *Nothing wrong with cuteness—*

♦ **JW:** It helps!

♦ **V:** *It seems that through your life you haven't compromised at all, yet you've become a household word now—*

♦ **JW:** The only thing my mother tells me now is that I used to be the hardest answer on "Jeopardy," and now I'm the easiest. That means I'm more famous. [laughs]

♦ **V:** *Wow, what a fame index—*

♦ **JW:** I'm hardly a household word in some communities, I promise you. They still yell at me in Baltimore, "Mr. Walters!" Or, "Hey, Barry!" (Barry Levinson, which always makes me laugh.) Somebody said to me recently on a plane, "Oh, I *love* your movie, *Pink Cadillac!*" You hear that kind of stuff all the time; I'm used to it. But have I never compromised?

I think I've *always* compromised. I'm a businessman in a way; my movies get made. It's not so much "compromising" as being "realistic" about the fact that you are in a *business,* and you somehow have to reinvent yourself to keep up with the times and whatever is happening. But at the same time I think that all my movies, from *Hairspray,* which has the most family-friendly rating of any of my movies, to *A Dirty Shame,* which got the worst . . . I think they're all the same, really—I think you can pick any of 'em out and know what a John Waters movie is. But certainly I pick stars. My movies have to get made; you have to pick stars that the studios approve. I listen to notes, I go through stuff, I go market testing and everything. But I think I have learned how to negotiate. I don't think negotiating is compromising.

♦ **V:** *I thought the last film you made was outrageous—*

♦ **JW:** Yes, but I had real problems. This NC-17 rating was a nightmare for me, and they wouldn't let me cut anything and my contract said it had to be an R rating. I was very lucky to have had a long, long experience with New Line Cinema, who's owned by Time-Warner, who just didn't change any of their rules, but since it was a non-explicit movie and because of my history with the company, they just let it go. I thought the MPAA couldn't hurt me, but it did.

Even in San Francisco—you know the Landmark Theater chain, the Embarcadero . . .

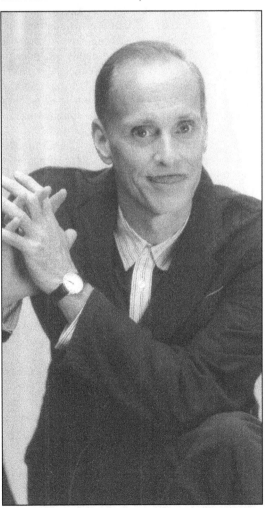

you'd think the Landmark Theater chain would certainly play an NC-17 movie, right? And they would. But the Embarcadero landlord won't let them—it's in their lease. Things like that. And my movies always play there; I want 'em to play there; it's a good theater. But just little things like that . . . the kind of censorship that's really corporate censorship, and where you *least* expect it.

♦ **V:** *It didn't occur to me that I wasn't being allowed to see it at my neighborhood theater—*

♦ **JW:** Oh no, it played in San Francisco—it didn't play where my last films played. That theater is the one probably where most everyone wants to play; it's the top-grossing one with the most prestigious kind of art movies, in a way. You know, little things like that. I love the Landmark chain—thank god for them; they always play my movies. But at the same time, who would have ever thought? It's liberal censorship that is the new kind; that is, I have to negotiate with them; I have to do it, and it's more frustrating because it's always surprising.

I'm used to *stupid* censors—they're easy! At the MPAA there's this new documentary that premiered at Sundance that I'm in . . . they're really going to be mean to me now because it exposes the MPAA and names names and goes to their house and stalks them. It's called *This Movie Is Not Rated,* and it got an NC-17 rating which is really for *me,* I think. But they're *nice*—that was what was horrible: they were nice and pleasant to deal with, and you don't know what to do.

I'm used to the old days of the Maryland censor board when she would say stupid things. But when they say to you, "Well, wouldn't you think that when most American families saw this movie, they wouldn't think it should play for people under 17?" and she's right. The problem is, most American families *wouldn't* see my movies. So the thing is, the families that *would,* would be fine with their kids seeing it. But that's not an argument to them, because that isn't their job. They say they're there to say what most American families would see. The fallacy of that is: most American families don't see *any* movies. And they certainly don't see *art* movies, or my kind of movies—

♦ **V:** *Or foreign movies.*

♦ **JW:** Yeah. So, that's the kind of intellectual censorship that is much harder, and is really what I have to deal with today. Very seldom does a movie get banned in Boston—that doesn't happen anymore.

Now, *they* would prefer it were the other way around. They don't like this. They would rather that everybody was happy with an NC-17. What they want is an NC-17 hit movie, but there isn't one, and I don't know that there *can* be one. But that's what they want: they want a giant-grossing NC-17 movie—then all the heat's off them.

♦ **V:** *But you don't think it's possible.*

♦ **JW:** No. I don't anymore, because—well, anything's possible, but what I'm saying is that people think that now, since they have porn in their house—you know, it's no big deal watching people piss up each other's ass and drink it up—still, that's at *home;* that's okay. But they don't want it in their community where others can see . . . at least they pretend they don't want to see it, or they say they don't. There are people who don't want to see it, but then *don't go!* It's hard to get anyone to see *any* movie today, much less one they don't want to see.

♦ **V:** *Right, and besides you have to pay ten bucks now—*

♦ **JW:** I know, and the food costs more than the Iraq War!

♦ **V:** *I liked your idea to improve the food at movies, and then maybe more people would go—*

♦ **JW:** I think why people don't go to the movies now is because they want to stay home and eat more. They can't go out of their house for more than two hours without eating. So really what they should have at the concession stand is more fattening food! Troughs . . . Not so much in San Francisco where you live, because it's a different kind of place. But you know, just in malls. Whenever I'm in Las Vegas I'm always shocked by these all-you-can-eat restaurants—I don't understand that concept. All the restaurants that I go to that are good serve tiny portions of vertical food. Imagine if you served that to these people; no, they want, like, troughs. I don't get it. It's not *good* food, it's how much you get. No other country has that, right?

♦ **V:** *Not that I know of.*

♦ **JW:** Well, we're the only country where the poor are fat. Think about it. Because if they do want any food, they want a donut rather than an apple. I'd rather have a donut than an apple, too, if I were lying on the street.

♦ **V:** *In San Francisco, a lot of the homeless finish off take-out containers that have been abandoned—*

♦ **JW:** Well, Chinese food is really fattening. Kung Pao chicken has as many calories as three Big Macs!

♦ **V:** *There didn't seem to be homeless people twenty years ago; we didn't have that word. This world really has changed. Now in the mass media there's so much emphasis on extreme sports, extreme survival scenarios, extreme everything—well, what's next? The reverse of that?*

JW: I don't know either; I'm not Jeanne Dixon. I've never understood why people, when they have all these places like "Psychics: Know Your Future"—that is so beyond me. I always think, "That has to be money laundering." You see so many of those places, but who is that dumb to go into them? If somebody said to me, "I can predict the rest of your love life, and when you're going to die," I'd think, "What would be the point of *knowing?* That's why you get up every day!" To me, it is a staggering thing why anyone would want to know that. But . . . I always have problems with what everybody else wants . . . thank god!

V: *Well, you're almost in a position where you can almost get anything you want, in a weird way—*

JW: Well, I don't know about *that.* What do you mean—personally, or professionally? I think I'm like anybody—I don't know who's making my next movie. I don't know who I'm sleeping with next. So I don't know if I agree with you. I mean, I sort of probably know who I'll sleep with next, but—you know.

V: *Well, of course I'm hoping you'll make movies up to the bitter end—*

JW: I have my idea for my next movie, but I don't know who's making it yet. Like anybody else, I gotta go find it, and I'm in the middle of that now. So it's not like I'm just sitting around where they're waiting in line, asking, "What would you like to do next?" *"Puke King."*

V: *I think you do have so many projects that—*

JW: I do—I'm not complaining! But I'm saying that still, with each one, I have to figure out how to get it done every time. Or, I work with people who help me do that. But at the same time, it's not like I just have a *waiting list.* No one's taking a number to see me!

V: *Well, you recently narrated some kind of critical documentary on the Salton Sea in Southern California—*

JW: I don't know how *critical* it is; it's a good documentary. The movie was completely finished and they came to me and asked me to narrate it. I said, "Let me see the movie." I liked it because it reminded me—do you know about that area?

V: *Yes, I've been there.*

JW: I haven't. It reminded me of Baltimore and Provincetown put together—the two places I live in. So it is this outsider community—they *are* outsiders, believe me, I'll give 'em that. And it's almost like they're in this cursed heaven. Just the whole subject matter and the whole idea of it appealed to me. It was a place—very seldom do I see new places I would like to see one day, because my idea of a "vacation" is to come home,

because I live in airports, basically. So to me, it was something I knew nothing about, and I don't know that *that* many people know about it. And the people were so bizarre and almost like desert communities which I always like, like going to Needles, California, and places like that—I love the *name,* there. It just was a community that seemed a little bit *Desperate Living . . .* but it could have been the *Riviera* if it just hadn't gone wrong.

V: *I was also going to ask you about your "Court TV" involvement—it's a vehicle to reach a whole different audience, right?*

JW: It is. I have this other show on the Here! TV network which is called "John Waters Presents Movies That Will Corrupt You." Look on Heretv.com to see a trailer. But, "Court TV" is an acting job, really. I didn't write it, I didn't think it up. Jeff Lieberman, who's the director, is someone you could have had in your *Incredibly Strange Films* book—he made *Blue Sunshine*—

V: *That was a great movie.*

JW: Yeah. This series is based on a true crime every week, where the bride or groom kills one another, only it's done with actors, and Court TV has never had a real series that's done with actors. It opens every week at the wedding, and I'm the "Groom Reaper" who's a guest at the wedding, a time-traveler who knows that they're going to kill each other. See, I am a clairvoyant in this. I look at the audience and tell them, "In eighteen days they're going to bludgeon someone with an axe." And then I'm the narrator all through it. It's really an acting job, and I think it came from being in *Chuckie,* which I was in. So I jokingly say that I'm always trying to hijack what's left of of Vincent Price's career, and that's why I never got a facelift, because I want *old* parts.

V: *You're a role model on how to age gracefully—*

JW: I don't know about *that.* But at the same time, Botox—I got it free in a gift bag (you know, it was an appointment), but I never tried it because I thought that I couldn't sneer! That's what I do for a living. If I couldn't sneer, life would really be hard!

I have friends who've had Botox, and it did *work . . .* for crow's feet, that kind of thing. But it's the same reason I don't want to take tranquilizers; who wants to be "even"?

V: *Well, to bring things back to pranks: you've found a way to always present subversive ideas, thoughts, sound bites, memes—whatever you want to call them—no matter what medium you're working in.*

JW: Well, I'm interested in everything. I'm never bored—I mean, I hop out of bed every morning. Talking about face-lifts, I think (and I

might have said this before) that young people, to mock the baby-boomers' fear of aging, should get face-lifts *in reverse,* to look old now, when they're really cute and young. They should get bags put on, and liver spots and everything, just to mock the "so cool." Because in Spain, in the really coolest hip-like kid bars, they open at 7 AM and they have fluorescent emergency-room lighting because everyone's so cute—who cares? That's to keep old people out.

So I think if you went even further and took the cutest kids and purposely drew on old-age makeup and sometimes even had it done permanently just to speed up the process so they wouldn't have to worry about being cute . . . a lot of the cutest actors work hard to look ugly. So you can say, "Oh well, they're not movie stars because they're handsome." And in just the same way, isn't Punk and Goth a great look for ugly girls? It's a godsend! I'm not saying that cute girls can't look like that too, but it's really nice that we have that option! That they don't have to look like bad Playboy bunnies or be sucked into that misogynist way that a woman's supposed to look good. So I'm all for that; in a way I think it's also healthy, really. And I really *am* a healthy person! [laughs]

♦ **V:** *Anything that makes you more healthy and more happy with the genetic body you were given is great.*

♦ **JW:** I'm just saying that basically *you have to make fun of your fears.* That is the key to whatever mental health I've managed to figure out.

♦ **V:** *Maybe that's the key to everything—*

♦ **JW:** That's why you go to a shrink, to tell 'em whatever you're most uptight about and get it over with—you're paying for it.

♦ **V:** *And you use that to make art with—*

♦ **JW:** Well, I try to use everybody's fears and touchiness and at the same time try to *make your fears funny*—and that to me is when you get people to listen.

♦ **V:** *Right; in a way there's no point if they're not listening.*

♦ **JW:** The whole point of the movie business is to *get* the middle of America to accept you. Certainly, in a weird way. At Christmas this year, five of my movies were on television! A play based on one of my movies won the Tony award. So I *am* in the middle. I no longer ever say I'm an outsider—I think that's so pretentious. I'm an insider.

♦ **V:** *Why?*

♦ **JW:** Because now *everyone* thinks they're an outsider!

♦ **V:** *You're right. That's exactly how things have changed so much—*

♦ **JW:** It's now really a *good* thing to say. When I used to say I was an outsider, it meant "bad." But now, don't you think *Bush* thinks he's an "outsider"?! I think he does! That's why I'm really proud to finally be an "insider."

♦ **V:** *In* Crackpot, *you had this essay on "How to be Famous" with ten sections of things to do—*

♦ **JW:** Did you see the new *Crackpot?* It's got a whole bunch of new essays in it. Call my publicist and she'll tell you how to get a free copy. What's really been great about those books [including his first, *Shock Value*] is that both of them have never gone out-of-print. *Shock Value* came out in 1980 and it's stayed in print for twenty-six years. It's so weird that *Shock Value* is taught in schools now—believe me, that is shocking to me! Well, it's not taught in the *public* school system, but ...

♦ **V:** *When* Shock Value *came out I was still in the throes of the Punk Rock cultural revolution, and your book was a definite survival manual—*

♦ **JW:** Don't you still identify, in a way, with Punk Rock?

♦ **V:** *Of course!*

♦ **JW:** Yeah, me too. Even though I see all these eighteen-year-old kids with mohawks and I go, "Do you *think* that's really cutting-edge?" [laughs] It looks to me like *nostalgia!* They look like they're movie extras. But, the "punk rock look" still looks cute on kids. I'm always happy to see 'em. I've always said that I weirdly feel more comfortable in a punk rock bar than I do in a gay bar . . . except in San Francisco— [laughs]

♦ **V:** *—where they can be both at the same time.*

♦ **JW:** I'm a creature of habit. I drink every Friday night—that's it; I'm like a coal miner with a paycheck. I always go out on Friday night, no matter where I am. That's the *only* night I do, usually. Which is a problem in New York, because in New York, Monday and Tuesday nights are the cool club nights, and I can't go out at two o'clock on a Monday night. I *used* to be able to, but I went out *every* night, then. But I start working every day at six in the morning. I get up at six, and then I start work at eight every morning.

♦ **V:** *That's brilliant—*

♦ **JW:** Well, everybody has their way. Some people work all night. I can't think up one thing after five o'clock. You just have to find your hours, that's all.

♦ **V:** *I would have never guessed those hours for you. It's weird, but I was going to ask you how you keep organized—*

♦ **JW:** I'm so organized that it drives *myself* crazy! I get on my *own* nerves sometimes from being organized. Every day I have a file card and I write down every single thing I have to do, and

I *do* it. And if not, I carry it over to the next day and write it down.

I also have three people working for me right now. But I have a lot of projects. I can compartmentalize—what's that term? [multi-task?] I can work on four projects at once but not at the same time—they're *separate.* I do work a full day, every day, but I don't work on weekends usually, so it's not like I'm a workaholic. I'm a workaholic five days, an alcoholic one, and I take off on the other day—I'm a *non-aholic* on one day. Saturday I always have a little bit of a hangover which *forces* me to not do things. I just read all day and lounge around, and Sunday I try not to answer the phone. So on Saturday—I mean, I *do* stuff, but a little bit of a hangover on Saturday makes you not work. Which is good—I mean, for *me*—it might not be for others.

♦ **V:** *I'm amazed at how much you've gotten done. You know, Duchamp was my favorite artist of the early twentieth century, and—*

♦ **JW:** He did everything first before anyone else . . . *every possible thing,* he did first. That biography of him [by Calvin Tomkins] is one of the best books I've ever read in my life—I was amazed by it. He did *everything* first. Every kind of art he did first. Even stuff that's being done right now, he already did it. And then he didn't do anything, for a long time! [laughs] He just kinda quit, 'cuz he did it all. What an amazing life.

♦ **V:** *Right. He said something that I don't quite agree with: "Never repeat, despite the encores."*

♦ **JW:** Well, didn't Alfred Hitchcock say, "Self-imitation is style." That's the opposite end of the same truth.

♦ **V:** *Anyway, you have three big "art" books out now. You had at least two gallery shows here—*

♦ **JW:** I have a lot, because I also have the museum show that traveled all over the world. That was called "Change of Light"; there's a big art book/catalog on that which you might have seen. That opened at the New Museum in New York and then it went to Switzerland and then it went to the Warhol Museum and then to the Orange County Museum. And I have a big, big new show of all-new work opening April 21 at the Marion Boesky Gallery in New York, and April 8 at the Simone de Pury [sic] Gallery in Zurich. So, I've been working on that really hard.

♦ **V:** *But that's what I mean: it's amazing how much you've gotten done—*

♦ **JW:** Well, you know, I have a whole other studio that I go to and work on that. I don't think the movies up in the same place. But you're right, I did a Christmas tour, I have a Christmas album out, I have a spoken word act that we're shooting

in two weeks in New York to be distributed on DVD . . . yeah, I always have to have a couple projects going. You can never have too many jobs. My father always used to say, "Slow down!" I mean, I love my father but he's forever a Republican, pretty normal, but he would tell me to slow down—the hippie son, y'know—not that I was ever really a very good hippie, but . . . if *he* told me to slow down, well maybe I better listen!

♦ **V:** *Well, for all I know, you probably write poetry on the side—*

♦ **JW:** No, I don't write poetry. There are two things I've never done: that, and written a novel, which I'd love to do—but I think that's the hardest thing to do in the world, because any idea I'd have for fiction, it's so hard for me not to think of it as a *movie.*

♦ **V:** *I do think you could write a novel if it were some kind of mystery novel.*

♦ **JW:** I never read mysteries—I read true crime, but that's one genre I've neglected. So I'd be *bad* at it; I don't even know the genre. I know people read them obsessively, like doing jumbo word puzzles. I never understood that; my friend Dennis does them—he buys *books* of them, and does it for enjoyment! That is astounding to me.

♦ **V:** *He must be verbally proficient—*

♦ **JW:** I guess. But to think that would *relax* him—that's what's amazing to me.

♦ **V:** *Right; I think I'd feel the opposite—maybe continual frustration.*

♦ **JW:** That would be a good prank: go into bookstores and fill in all the jumbo word puzzles. People wouldn't realize it until they got home . . . then they'd be so furious! That happens sometimes on airplanes when you open the airline magazine, and someone's filled in the crossword puzzle—not that I care, because I never know one answer in a crossword puzzle; I can't figure *one* of 'em out!

♦ **V:** *You're right, you do see that once in a while—*

♦ **JW:** I belong to the Writers Guild, the Directors Guild, the Screen Actors Guild, ASTRA, and what's the Broadway one, 'cuz my voice is in a Broadway show—I'll think of it in a minute. I guess those are the only *unions* I belong to. But I'm in other organizations, like the Academy Awards one, PEN—the writer's one . . . I mean, I'm not bragging, I'm just saying that I join—and actually, I *am* a fan of the Writers Guild and the Directors Guild because you get residuals! And my movies where I wasn't, I don't. And David Lynch was my sponsor to get into the Academy, so—that's funny; that's a prank!

♦ **V:** *Somehow, I didn't know you had a relationship with him—*

♦ **JW:** Oh, David? Yeah, we're friends. I haven't seen him in a while. He's always been very friendly, because when I was touring for *Female Trouble, Eraserhead* came out, and nobody knew that movie, and I was always, in every interview, talking about how great it was, and so he always thanks me for that. I'm a big fan of David's, and I know him a little bit.

Now his website is pretty amazing. I just hope he keeps making movies. He's into Transcendental Meditation—that's a little surprising to me, but—you know, it's fine. Everybody always says—you know about this, right—John Travolta's playing the Divine role in the *Hairspray* movie of the musical? And Queen Latifah is Motor-Mouth Maybelle . . . it's this big Hollywood movie that New Line is making. So, I don't care about Scientology either. I don't care about any religion as long as they don't try to make *me* do it. Because fine, I don't care.

But they all *seem* to *try* to make you do it . . . that's why that war is happening now. I don't care what people do; I think it's nice if religion brings people comfort. I personally don't have to believe in it, but I'm for the freedom of others to believe in it. But don't make *ME* believe in it! I don't try to make *YOU* believe in what I believe in.

♦ *V: But you do present ideas that make people think—*

♦ **JW:** I try to make people laugh so they'll *listen* to me. Religion never makes people laugh. Religion *never* is funny! Have you ever heard a religious fanatic say something funny?! *Never!* And they might get me to listen if they were funny.

♦ *V: That's funny.*

♦ **JW:** Well, *they* aren't.

♦ *V: In fact, all authoritarian types—they don't countenance any fun being made of them.*

♦ **JW:** No, that's why they invite parody so well. ♦♦♦

RON ENGLISH

♦ **RON ENGLISH:** Picasso was almost like a graffitti artist: you put your four hours in, and then just go hang out.

♦ *VALE: You mean you don't do that, too?*

♦ *RE:* No.

♦ *V: Do you wish you did?*

♦ *RE:* Yeah, it sounds great: go hang out at a café and argue about art. But we're in Jersey City where there's nothing that even looks like a café out here. People won't come here; it's weird. Jersey City is right across the river from the former World Trade Center. Brooklyn's on one side, we're on the other. So it's like going one stop to Brooklyn. But because it's in a different state, people don't want to cross the river.

♦ *V: Are you near where the Mafia buries all those bodies in the swamps?*

♦ *RE:* I think they just throw 'em in the river so they float downstream.

♦ *V: Hmm. Well, good for you for finding a studio where there wasn't already a thriving, rent-raising artists' colony—*

♦ *RE:* Well, we already did that, downtown. We lived where all these luxury apartments are now. We kinda started that whole ball rolling there.

♦ *V: Artists are like missionaries, and realtors are like soldiers coming to invade a country. First the missionaries show up and a few get killed, then the soldiers come to avenge the deaths of the missionaries, and end up colonizing the whole country.*

♦ *RE:* And then the developers come in.

♦ *V: But it's the artists who tough it out for awhile, getting robbed and mugged while they live in areas no one else will rent. So the artist is avant-garde in more ways than one—*

♦ *RE:* Well, in my next life I'll be a real estate developer and just follow artists around—

♦ *V: [laughs] Right. The first person I heard attack real estate interests was Karen Finley, back in the early eighties. At the time I didn't realize how much they are the enemy of artists. Wherever an artist finds cheap rent, they come in and kick the*

For the past two decades, Ron English has developed a dual career as a highly accomplished imaginative painter as well as a billboard improver *par excellence.* He has collaborated with the Billboard Liberation Front (BLF) and his documentary, *Popaganda,* has screened nationally. Currently he lives in New Jersey with his family. Ron's website is *www. popaganda.com.* Interview by V. Vale.

artists out and quadruple the rents . . . Anyway, *this book project is called* Pranks 2, *and is trying to follow in the footsteps of Marcel Duchamp, who submitted a urinal to an art exhibition, retitled it "Fountain" and signed it—*

♦ **RE:** That's funny, I cited him two days ago in an interview as one of the original pranksters—

♦ **V:** *There may be a whole history and tradition of "Art as Pranks." Maybe Manet did that in his "Afternoon on the Grass" painting—*

♦ **RE:** Right, after the Courbet. There have always been pranksters since time began, right?

♦ **V:** *I hope so. Now, it seems one of the only satisfying ways you can express resistance to the status quo is through Pranks as Art, which is what I consider you do. This involves some craft, thinking, planning, sense of humor and maybe beauty, too. If you re-interpret a McDonalds billboard, you've not only left behind an artifact, but you've done a performance. The performance is in installing it—*

♦ **RE:** Right, and in a way it becomes part of the history of McDonalds, too—

♦ **V:** *—as well as the history of art, period. You've obviously gone through a traditional art education just to know how to produce art on canvases for sale. But you also do Art Pranks—why? Most people who try to be artists just end up playing the gallery/fame game.*

♦ **RE:** Well, most people have a desire to please, or they want to be a part of some "scene," so they look around and ask, "What do these people want? Oh, they want abstract expressionism? I can do that." But I remember being in school studying under Peter Saul. Once he came in and looked at me real funny and said, "You know, most of our students spend ten minutes making something and then they want to talk about it for two hours. It's like they can't wait to get affirmation for what they did. But *you*—you just kind of do your own thing. You're really just here to use our studios." Then he said, "I don't know if that's a good thing or a bad thing."

♦ **V:** *I guess that was a high compliment—*

♦ **RE:** Well, what do I care what other students think? I'd rather just put my art out in the real world, y'know.

♦ **V:** *Right. And you discovered you could reach a lot of people fast by doing a billboard modification—*

♦ **RE:** If you send slides of your artwork to a gallery, they rarely ever look at 'em. If they're nice, they send them back rather than making guitar picks out of 'em. So in general, artists have a hard time getting other people to look at their art. But I discovered that if you stick it on a bill-

board, a lot of people see it!

Once I took one of my paintings and just walked around SoHo like I was taking it somewhere. A surprising number of people stopped me, including a dealer who asked who I was and if I was represented. So that's one way to get your art seen. But most people wouldn't think of doing that . . .

When I was a kid I would come to school early and do a big drawing on the blackboard, then leave and show up again with all the other kids. And everybody would be like, "Who the fuck did that?"

♦ **V:** *You were already appropriating public space—*

♦ **RE:** [laughs] I guess so. I can draw realistically and that impresses people, although art-world people don't necessarily like that. Elizabeth Hess once said I couldn't possibly be "sincere," because I'm too technically proficient. What the hell does *that* mean?!

♦ **V:** *That's kind of a reversal of the way things used to be.*

♦ **RE:** What turned a corner for me in the art world was when I did collaborations with Daniel Johnston. Somehow that made me "legitimate." A lot of people who hated me quit hating me. I was making paintings of his drawings, and his drawings are super-crude and weird, and people found them interesting.

♦ **V:** *A documentary came out,* The Devil and Daniel Johnston. *Were you in it?*

♦ **RE:** No. Actually, I was a little mad about that. Basically, my sister and I rediscovered Daniel Johnston living at home in Texas. He hadn't done much for years. We visited him and he gave me a huge stack of drawings, and I ended up making paintings of his drawings. He came to New York and we did a show together; then we did a bunch of shows together. He's been active ever since, painting and making recordings.

It turned out he had been on the wrong medication that had made him kinda crazy, and our visit started a chain of events that got him put on medication that made him "normal" again, so he was able to work again. However, the director of the movie had a particular story in mind. My wife had written a book about our Daniel Johnston experiences, and this director used that book, but didn't give her any credit and he didn't mention me, either. But that's pretty common, I think. Still, it's a good movie.

I'm having art shows with Daniel Johnston, Mark Mothersbaugh, and Gibby Haynes of the Butthole Surfers. Gibby does weird Outsider Art very similar to Daniel's. It's pretty cool.

♦ **V:** *Let's talk about your background: did your parents encourage you to go to art school?*

♦ **RE:** They were Midwestern factory workers and I don't think they had any concept of "college." My dad wanted me to get a job at a factory. But when I went to the job interview, I dropped some LSD first and they thought there was something weird about me. Also, I had hair down to my waist. So I didn't get the job, darn it. [laughs] It was a chemical factory, and almost everyone who worked there eventually got brain tumors.

♦ **V:** *Where was this?*

♦ **RE:** I grew up in Decatur, Illinois. Work ran out and my parents moved to Texas. As far as my work history goes, I remember I got fired from thirty jobs in a row. Everybody said I was just sabotaging myself, but I wasn't doing this on purpose. Then I thought that if I became an artist, I couldn't be fired, right?

♦ **V:** *Not if you work for yourself.*

♦ **RE:** And I would never fire myself because I work so cheap. I never ask for overtime or health insurance or anything—

♦ **V:** *Forget about artists having health insurance. Anyway, you developed an ability to do hard-edge realist paintings—*

♦ **RE:** Well, I always drew, so that was my trick.

On one of my very last jobs, I was hanging sheet rock. We had just done a whole room and the next day I went in early and started drawing a mural over the walls. I figured we were just gonna paint over it anyway, so who cares? I didn't notice, but everybody had come in and were quietly watching. And when I turned around, they all started applauding. One of them said, "Man, what the fuck are you doing *here?*"

When I was a kid I told my parents I wanted to be an artist, and they took me to meet this guy who was using a little shack as a studio. Even then I could tell that this guy had no talent. The next day somebody broke into his studio and stole everything, and I thought that being an artist was just the biggest waste you could possibly be. [laughs] I mean, it didn't seem glamorous or anything. I did think it was better than working at a chemical plant, or being an engineer and building some bridge that caves in and everybody gets killed. At least if you make bad art, who gets hurt?

♦ **V:** *[laughs] Bad art doesn't kill people.*

♦ **RE:** Although they act like it does, sometimes.

♦ **V:** *Yes, well so many people are walking around in a coma, anyway—that may be the job of the artist, to try to wake them up, at least for a minute or two, before they sink back in.*

♦ **RE:** Definitely. And sometimes doing art is hazardous. Take graffiti artists. They're not get-

ting paid. But some of them are so freaking good. Then you'll hear that some judges are giving them a year in prison—they're twenty-year-old kids! And you know there's something fucked-up about a society that doesn't know how to nurture its artists. At the least, somebody should be finding something for these kids to do! Because if you have that kind of talent, you have to show it to people, and if there's no venue for it, then you have to *steal* the venue! You can't just "cap up" something like that—it's unnatural!

In the mainstream press it seems like the only time you hear about art is when they're making fun of it.

♦ **V:** *Right, especially more cutting-edge art.*

out.

This was in Dallas. Then other painters started seeing my billboards, and they asked me if they could do billboards, too. I don't know why they asked my permission, but they did. At that point we all thought, "Let's form a group."

We began to think of billboards as a gigantic outdoor art gallery. We would find a place with several billboards, and alter them all on the same day, then have a party that night which would be like our art opening. But then we got arrested.

♦ **V:** *Oh, no.*

♦ **RE:** We hadn't realized we were a block away from the police station; it had been moved from downtown Dallas to a location where all these

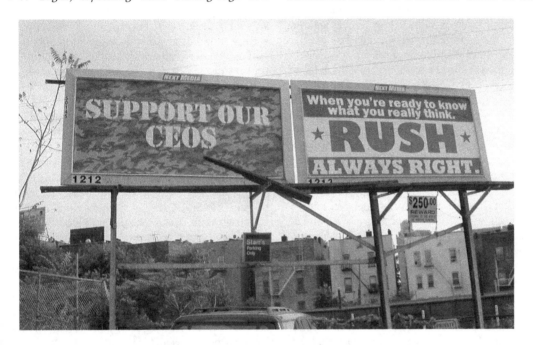

Newspapers delight in pleasing the rubes with stories that snidely describe so-called performance art or installations.

♦ **RE:** Yeah. But I wonder how much artists themselves alter what they're doing to "fit the mold," so they can be in the media—

♦ **V:** *Hmm . . . So how did you start out "improving" billboards?*

♦ **RE: I** was making these weird trick perspective photos. And at one point I wanted to shoot this weird old building, but behind the building was a billboard. I thought, Well, if that billboard's gonna be in the picture, I'd rather it said something different. So I repainted that billboard with my own art. I had these cardboard cut-outs of winos sitting around, and if you make their heads gigantic and their bodies small, you could push 'em together and the camera would flatten everything

highways converged, and there about a hundred billboards all together. We were trying to modify them all, and the cops spotted us simply from looking out from their window. And when they arrested us, that killed the whole group because we all got second-degree felony charges.

♦ **V:** *You didn't have a good art lawyer—*

♦ **RE:** Right. Every lawyer I telephoned said, "I can get you off with a year. If you go with me, all you'll get is just one year in Huntsville Prison—that's all." But I didn't want to do *any* time.

So I just started calling up the billboard company. I said, "I'm the guy who did your billboards." And whoever I talked to said, "Fuck you, you've been doing this for a long time. This isn't the first time you've pulled this shit on us. Now we're tired of this crap." But I kept calling every day. Finally, someone said, "Fuck it; give

147

me thirty-six thousand dollars. That would cover the cost of renting all those billboards you did that day."

I kept calling. Then one guy cut it down to twenty-five thousand. I kept calling him. Finally I said, "Look, our court date's in three weeks and we're all going to prison for a year. And personally, we didn't have anything against your billboards. We were just using your billboards to put up our art. But it wasn't an attack on your billboard company. And we fucked up, you know. We *like* billboards. We're just a bunch of college kids, and if we go to prison, our whole life's gonna turn out different. We'd like to finish college." So finally he said, "Look, the day we caught you, you did eight billboards. So we'll charge you a hundred bucks per billboard for replacing them, and you were lucky that all the ads you hit had already expired. I'll let you go if you pay $800." This happened about a week before the trial date.

♦ **V:** *It's brilliant that you kept calling every day.*

♦ **RE:** Yeah, but I was such a fucking idiot that the day they called me and said, "Come get your billboards and your glue" (because they had been impounded), I went and got 'em, then drove to Austin and put them all up again! This time, we put them on billboards owned by a different company—we thought we were being *pretty smart* about that. It's like we couldn't stop, you know?

♦ **V:** *It was a good idea to call that guy every day, because then you become a "person" to the company. You reframed the situation. Besides, it was true that you were just college kids. There's an innocence about the word "college kid."*

♦ **RE:** It *was* a college prank. You know, I've cried "fraternity prank" many times when I've gotten pulled over, but I've never been in a fraternity in my life! The cops always bought that. It's like you get one "Get Out of Jail Free" card from your college.

One of the reasons we got caught was because we were dressed weird. We used to wear fluorescent suits that said "Dead Artist." And some of my collaborators couldn't draw and they misspelled words, whereas my billboard modifications were, by comparison, super-slick.

About twenty years ago I made a six-page comic book on how to do billboards. I doubt if I have a copy of it anymore. It told people where to get paper, and recommended paints and glue to use. But the funny thing is, the glue I was recommending was rubber cement, which is expensive. Then my uncle gave me a five-gallon drum of wallpaper paste that was pre-mixed, and that worked much better. [laughs] I'll bet those billboard workers hated us for fucking up their bill-

boards with rubber cement.

♦ **V:** *After that, you moved to New York—*

♦ **RE:** Yeah, I had a hard time in New York. I had been a photographer, and I couldn't really afford to print photos when I moved to New York. Once I decided to be a painter, around 1986, it took four years before things finally started to happen for me.

I was learning how to paint, working for other painters and paint companies, figuring that I may as well get paid while I learn. And I worked nights at a nightclub. At the time it seemed like a pretty miserable life. In the daytime I worked for different painters. I drove a truck and then wrecked it. I was living in a basement with rats all over the place, on Avenue D and 3rd Street. It was a big drug block, and somebody was always getting shot on the street. People would duct-tape half-sticks of dynamite together and put 'em under somebody's car. Then the car would go up twenty feet in the air.

♦ **V:** *Wow—*

♦ **RE:** You know, people were just crazy there. Dealers would patrol the street with their Uzis, and occasionally one would get drunk and just start spraying it, while everyone on the street hid in some doorway. I didn't really understand what was happening; I thought it was just firecrackers I'd been hearing. One day someone next to me on the street went down—he'd been killed.

What snapped me out of it was: the girl who's now my wife moved to town. I had known her a little in college and was completely obsessed with her. I thought, "There's no way I could get her to marry me when I'm living in dire poverty on Avenue D and 3rd Street." So after we went out on a few dates, I thought, "I gotta show her that I'm like the real deal."

I was actually able to make thirty thousand dollars in one day, and then we moved together to Tribeca and were there for ten years. At the time Tribeca was a bad neighborhood, or rather it was just deserted. So we were able to afford to rent the top floor of this building. Suddenly, we had six thousand square feet, skylights, and the whole roof was ours.

When we moved in, the two floors below us were empty, so we started throwing two-floor parties and have bands play. It was a great scene for a while. Then Robert DeNiro and John Kennedy and everybody wanted to move to Tribeca, and suddenly my rent went from $1,800 a month to $12,000. So we had to move. But I'm glad, because six months later 9/11 happened, and that whole neighborhood stunk to high heaven for over a year—it would have been pretty mis-

erable to be there. Then we moved across the river to Jersey City.

You know, when I first moved to New York I couldn't get anybody to help me do billboards. I kept telling other artists, "You know, we could get a lot of attention for ourselves if we did billboards," and I guess because everybody's living so hand-to-mouth in New York and their rents are so high, nobody would do it. But in Jersey City I found a crew of guys who got me back into doing it again. Now I have almost a waiting list of people willing to help! We always joked about billboards being this habit you can't break, but it's actually true. Frankly, I become really neurotic if I can't put up some billboards.

download my billboards in Indiana or wherever and go put 'em up locally.

I often offer to help people I meet put up a billboard, but in the last few years nobody seems to want to; they just want to help *me* do it. I don't know what it is.

♦ **V:** *Well, I certainly like the idea of offering on the Internet billboard modifications that anyone on the planet could download, print out, and put up.*

♦ **RE:** Right. The printing could be a bit expensive, like $150 for a small billboard and $300 for a big one. But if you got your friends together and everyone pitched in twenty bucks, you could have a billboard-size print made. However, that idea has my wife worried.

However, my wife is always thinking that at any point her husband could go to jail for a year, and then what the hell is she gonna do? She's gonna have to deal with raising two kids by herself.

♦ **V:** *Hmm. Have your billboards changed?*

♦ **RE:** Well, the newest ones are done photographically so they really look real. I used to spend three days painting a billboard, then paste it up and destroy it. I realized I could spend three days making a painting, sell it and then maybe afford to do *three* billboards.

♦ **V:** *Now that's a kind of alternative capitalist thinking—*

♦ **RE:** Yeah. Recently a kid came to me and he wants to design a website with "high-res" reproductions of billboards that people could download.

♦ **V:** *Wow. You could also do a website of billboards that never really happened, but which look like real billboards—all thanks to the miracle of Photoshop.*

♦ **RE:** But that's like faking a picture of you winning the Super Bowl—it's no good unless you really did it! But the idea is that people could

♦ **V:** *Why?*

♦ **RE:** Because now you're franchising your criminality!

♦ **V:** *[laughs] That's pretty funny.*

♦ **RE:** I guess you could have a website that gives exact information, recommending printers, listing the standard billboard sizes, etc. Some billboard companies charge different rates depending on where the billboard is located. You'd be acting like you're encouraging people to do it *legitimately*. This brings up a whole other issue: periodically I try to put up a billboard *legally*, and the companies just won't let you!

♦ **V:** *Why not? Corporations get to do what they want.*

♦ **RE:** Right. Recently I was in Canada where gay marriage was the big topic. I wanted to make a billboard that just said: "Support Divorce: The Great Heterosexual Institution." And the company refused. They said, "The only compromise we can make is if you say, 'Support marriage.' *Then* we'll let you do that billboard. But your billboard implies you're supporting gay marriage." And I said, "Well yeah, that's sort of the idea." We went back and forth for awhile and then I said, "Well,

I have other billboards I'd like to put up." Then they said, "Look, we don't want *anything* you have to say on any of our billboards. We'd love to take your money, but No Thank You."

♦ **V:** *Wow.*

♦ **RE:** And it's the same here in America. Which billboard could I do? I can't make fun of McDonald's billboards, because McDonald's is a huge client of theirs. I don't think people realize this; they just think, "Well, you could just rent a billboard."

♦ **V:** *You're right, most people don't realize that they can't just rent a billboard. And one thing that must be of highly questionable legality is the absolutely overwhelming corporate intrusion into what used to considered "public space." Everywhere you go now, there are big corporate ads. San Francisco's cityscape used to look beautiful at night. But now there's this huge red neon "Hilton" logo ruining it for night photography.*

♦ **RE:** Yes. There's becoming less and less truly public space. Ballparks used to belong to cities, and now they're licensed to a corporation. People think that malls are a public space, but they're not—they're private space, where you really don't have any freedom of speech.

♦ **V:** *Right. Just try protesting or picketing in one—*

♦ **RE:** Some people say, "Well, I don't give a shit if it's illegal to burn a flag, because I'm never gonna burn a flag." They don't care if there's free speech or not, or if there's public space, because they think, "All I wanna do is shop. I don't wanna have any political opinion about anything, or try to change anybody's mind about anything—I just wanna shop. So what do I care if you're not allowed to have political speech inside the mall because it's private space that's restricted only to commerce."

People don't realize that *everything* is becoming privatized. We're becoming an "ownership society." That means that *you're* not gonna own anything, and everything's gonna be owned by other people, and then you're not gonna be able to really do much of anything. Except, you can pay *them* money to conform to their rules, and do *their* thing. It's gonna be like a little oligarchy.

♦ **V:** *Awhile ago, J.G. Ballard noted the theme-park-ization of everything, especially of what formerly used to be "free public space." Now there are hardly any parks or playgrounds free from corporate branding—*

♦ **RE:** Right. When television first appeared, the TV corporations kinda made a deal: "We'll finance television broadcasting and give it to you free if you allow us to include advertisements. Because they give you free content, advertisers

will be allowed to come into your home and pitch their products, and they'll pay for the operation."

But we've never had that *choice* with billboards. You can't turn off billboards, and you can't shut your eyes when you're driving down the highway. Not gonna work, you know—it's *dangerous.* And billboards don't offer anything of public service—they just bombard you with corporate sales pitches.

It's not like 10% or 20% of all billboards have to give you important public service messages. No. It's not like 90% of the billboards give you some valuable content, and the other 10% are commercials trying to sell you a new Mazda or something, like what happens on TV.

How did this happen? And you can bet that the rich guys that own the billboard companies—there's no billboards in *their* neighborhood!

♦ **V:** *Well, they're rich.*

♦ **RE:** Right. One of the reasons I've been able to get away with what I'm doing for so long is because these rich guys have no fucking idea I'm doing it. Most billboards are all in poor neighborhoods, or they're in places where these guys have a million billboards. They don't know where the fuck they're at and they don't know what's on 'em. They send these guys out for five dollars an hour to replace them and post new ones, and I'm pretty sure that these workers don't report back that, "There were a bunch of weird billboards today."

A lot of billboards are double billboards which share the same platform, and sometimes I'll do two big billboards right next to each other. A week later, workers have pasted over one and left the *other* one intact.

One time, right after I got in the *New York Times,* a bad billboard company employee called me up pretending to be a journalist and wanting to know where the billboards were that I had modified (so he could take them down). I knew right away he wasn't a journalist because *real* journalists identify who they write for right away—they don't say, "I'm a journalist." This employee didn't even know where his company's billboards *were.*

♦ **V:** *That's a genuine liability: getting ink in mainstream corporate media—*

♦ **RE:** But I can get covered in small magazines and that's okay because these billboard company guys don't read them. You can be all over the underground media and these people aren't going to have an awareness of you. As long as you're not in *People* magazine or *Time,* they're not gonna know about you. And you're not doing billboard modifications in *their* neighborhoods; you're

doing them in poor neighborhoods that they would not even go to.

You could be doing billboards in Manhattan, but these billboard company executives probably just drive straight through the Lincoln Tunnel to Park Avenue, avoiding downtown where all the billboards are. Or, they probably actually don't see that many billboards. Also, I try to change the numbers on the billboards, so if they see one somewhere with the number "3625," they'll immediately call up their guys to go change number 3625, and the worker will go change the wrong billboard.

♦ **V:** *Oh, that's brilliant.*

♦ **RE:** Sometimes I also put another company's

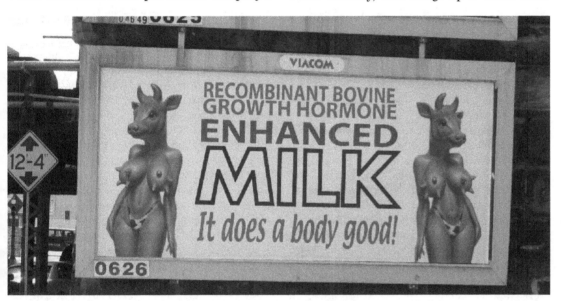

name or logo on the billboard, so it can't be identified as, say, belonging to Viacom. I do that as much as I can: I change the billboard numbers and their ownership logos.

♦ **V:** *Well, you're getting more "famous," with a documentary movie about you and books being published—*

♦ **RE:** I took my wife and kids to check out the Christo installation of "flags" in Central Park. My wife was walking about ten feet behind me, and we passed two policemen. My wife heard one of them say, "That's Ron English."

After I did the "Charles Manson billboard," I went back to check it out again—something I don't normally do. And there were about thirty cops with cameras taking pictures of it. Maybe they were all taking pictures 'cuz they thought it was funny? I don't know. Maybe they do know who I am and they just don't give a shit. I don't know and I have no way of knowing.

♦ **V:** *Well, one thing that doesn't hurt you is: getting*

as much repute as possible for your so-called "real" canvases; gallery-type recognition of your name—

♦ **RE:** But that might piss 'em off more. They might be thinking, "He's making tons of money and he's using the billboards as free promotion so he can sell his paintings for more money."

♦ **V:** *I don't think cops think that way.*

♦ **RE:** Yeah. If somebody calls the cops and complains about a person doing something, they'll go and do something about it. But, somebody at the billboard company, or an advertiser, is gonna have to really get upset for the police to go after some guy.

♦ **V:** *Upset because you maligned their product?*

♦ **RE:** Actually, that brings up a whole other issue of libel. If I change a McDonalds billboard to say that they have bovine growth hormone in their milk and that makes it better, and the modification is really slick, then how would somebody know for sure that McDonalds didn't do that? Well, that could be construed as libel, even though we think of it as satire. And the Republicans are actively eroding away all our free speech defense systems.

♦ **V:** *All the ways we can express dissent?*

♦ **RE:** Our rights, period. Ten years ago during the first Gulf War my ex-girlfriend went to Times Square to protest the war. Protestors climbed on top of the military recruiting center and were pouring blood and oil (red paint and black oil), protesting the war in this huge protest.

♦ **V:** *"No Blood for Oil"—*

♦ **RE:** And they got picked up by the FBI, taken to D.C. and put on trial for being terrorists. The police claimed these protestors were trying to blow up the recruiting center. Why? Because it's

on top of the intersection where all (or most of) the subway systems which pass through Times Square, converge. Then the recruiting center could collapse onto the subway system, taking out several hundred thousand people.

So she had to go on trial as a terrorist. But if this happened today, she'd just be taken to Guantanamo Bay!

♦ **V:** *Right, and we'd never hear about her. And her trial probably wasn't covered in the major media. Did she get out eventually?*

♦ **RE:** I went to her trial. The judge said that *obviously* these people were protesting the war, which is their legal right to do, and that pouring the "blood and oil" was *symbolic* . . . these people are not terrorists. Still, the FBI held 'em for a week.

But today, I doubt if they would even get a trial where a reasonable judge could say, "You know, they were exercising their right to free speech—what's the problem here?"

♦ **V:** *I agree. That is scary . . . Let's return to the topic of billboard modifications—*

♦ **RE:** I could tell you some of my favorites. I did one in Baltimore that was a picture of Jesus holding a Budweiser, and it said, "The King of the Jews for the King of the Beers." I thought, "No one has thought to use Christ as a spokesperson for their product yet!"

For some reason I didn't understand, this got picked up by 200 Christian radio stations throughout the South, and some of them stayed on the story for two weeks. Most of them stayed on it for one full week. You know, all their DJs were talking about "the Great Satan, Ron English, blah blah blah"—

♦ **V:** *They knew it was you; they had your name.*

♦ **RE:** That was a legal billboard I did as part of a big arts festival which a million people attend. I put it up on a Thursday, the festival was on a Saturday, and on Sunday the Christians destroyed it—they just wiped it out. They brought buckets of paint and threw 'em at it.

Another favorite prank was the Charles Manson one.

♦ **V:** *Tell us about that one—*

♦ **RE:** The BLF (Billboard Liberation Front) were coming to town for a show titled "Twenty Years of Billboard Liberation." At the time Apple was doing their big "Think Different" billboard campaign and I suggested putting Charles Manson on one. Actually, I thought the BLF had already done this, and it turned out the only time they had used Charles Manson was in a weird Levi's billboard. So I did it during the actual week of the show. Then I went into my normal paranoia trip

when all the media started calling me up; I pretended like I didn't do it.

♦ **V:** *But you* did *do it—*

♦ **RE:** Yeah, I did it. But I get real nervous when I get a lot of news coverage. You know, every year I count off all the billboards I've done, 'cuz there's a seven-year statute of limitations. So every year, I get to mark one off. Like, next year I'll be able to say, "I did the Manson 'Think Different' billboard—they can't get me for that one anymore!" Of course, I've already done like *thirty* this year, so . . . [laughs]

During the first Gulf War, everybody was going down to D.C. for a big protest. I thought, "You know, I could be just another face in the crowd, or I could do some billboards." So I rolled out a huge scroll and painted "Guernica." On top in fluorescent letters I painted "The New World Order." And that actually went all over the world.

I put it up on a Friday, and by Monday it had been pasted over with a hand-painted "Support Our Troops" billboard. Actually, there were two billboards together. Next to my "Guernica" the Artfux did one with a picture of Uncle Sam, saying, "We want you to die a horrible and meaningless death, to save a lifestyle that will ultimately destroy the world." For some reason, nobody publicized that one—I think it was just too much for people. But my "Guernica" appeared in magazines in Germany and Japan and all over. It was at Houston and Broadway and stayed all weekend. Somebody must have spent all weekend hand-painting a "Support Our Troops" sign that was pasted over mine on Monday. But do you know what happened? Somebody took a paint-gun and blew it all to hell! That was a weird time.

I don't know if you saw any of my "Cancer Kid" billboards. I just took the font of "Camel" and changed it to say "Cancer." Then I made Joe Camel look like a kid, or look like he would be giving cigarettes to kids, or, the camel would have a pacifier in one hand and a cigarette in the other. I started getting in the media over those.

Now, if you buy a building that already has a billboard on it, sometimes you make a licensing deal with the billboard company and they pay you $800 a month (or whatever). One person chose not to do that, and he tracked me down and said, "Dude, it's your billboard!" I put up the "Cancer Kid" and the billboard company came and pasted over it. So I put up another one, and they pasted over it, and finally the media picked up on it. It's funny, because in a way the billboard company had become *me*, because they were pasting over my "Camel Kid" and they didn't actually own the billboard I was using.

♦ **V:** *So they broke the law, trespassed and did that?*

♦ **RE:** They just took it upon themselves to do that. But you know, billboard companies are very interesting, because in their terminology they talk about "occupying neighborhoods" and "resistance"—the terminology is very war-like. They know they're pushing the envelope. Yet they always took the moral high ground that *I* was this criminal, and *they* were legit. In this case, they debunked that very quickly.

♦ **V:** *Hmm. They know they're occupying neighborhoods. Sometimes, in San Francisco's black neighborhoods, you see these obviously inappropriate "white people" ads.*

♦ **RE:** Yeah. You used to see the "Smooth

bites.

♦ **RE:** Right. People are much more visual than you realize.

♦ **V:** *—especially in the last twenty years. People don't read any more. There's been a shift to a "visual culture" or a predominantly visual culture.*

♦ **RE:** It's still also the sound bite culture. If you're able to come up with a really great sound bite like, "The glove don't fit, you must acquit"— that works better than nine months' worth of DNA evidence! [O.J. Simpson reference] It's the same thing with visuals: if you can make a very potent, powerful image that makes your point— sometimes that's better than twenty books, as far as changing people's minds.

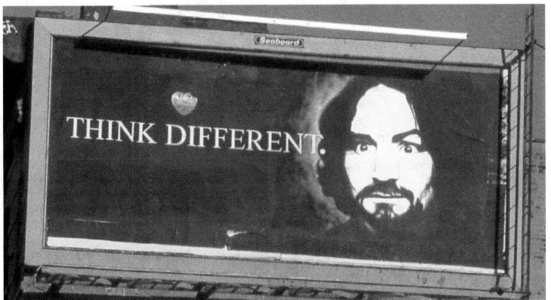

Character" billboards where there's a little baby camel sitting looking up, and there's a big camel hand reaching into the picture holding out a pack of cigarettes. And the little baby camel is smiling, so trustful. That was the main graphic Camel was using. So I did a billboard of a casket with Joe Camel in it. It said, "Close Cover Before Cremating." Then I saw on TV that the tobacco company had just retired Joe Camel; they had gotten so much shit for using cartoon characters to sell cigarettes—

♦ **V:** *Obviously, cartoon advertising is aimed at little kids.*

♦ **RE:** But also, it proves that resistance *isn't* futile! I'm sure people like me helped, y'know. Social change usually comes down to lawyers, but I really think it helps to have good visuals—something people can look at and say, "Oh, now I get it."

♦ **V:** *You need powerful visual bites, not just sound*

♦ **V:** *Right. Now society seems to be ruled by sound bites and visual bites or image bites—whatever you call 'em.*

♦ **RE:** We're mostly ruled by corporations. Did you know that in their charter it's actually illegal for them to not pursue profit by any means possible? Like, if they decided to take it upon themselves to quit dumping PCBs into the river, they could get sued by their shareholders! It's not in their mandate to be socially and morally responsible—only to make money for their shareholders. Which makes it this weird circle jerk where nobody's guilty.

Of course, nobody wants to be the only person doing the right thing while everybody else is getting rich. What we need is a very strong government to regulate the corporations so you don't have to fuck people over, or fuck over the environment, to make money . . . where everybody has to play fair, and a company "wins" because

they have the best product—

♦ **V:** —and also offers the lowest price.

♦ **RE:** But if you offer the lowest price 'cuz you're Wal-Mart and teach your employees to go on welfare, and have the state supplement their health care because you make everybody a thirty-hour-a-week part-time employee, then it just makes it worse for everybody.

♦ **V:** *The corporations have figured out how to "break" the law in every possible way.*

♦ **RE:** But that's why you have a government: so that people don't pull shit like that.

♦ **V:** *Yeah. In San Francisco a law was passed saying that one out of every ten units in an apartment building has to be low income housing. Guess what happened? Every developer makes only nine-unit buildings!*

♦ **RE:** Corruption hurts everybody, you know. Probably all the people working for corporations would rather life be different, so they don't have to be guilty.

♦ **V:** *Well, the "corporation" can be simplified to one DNA principle: "Do whatever it takes to make maximum profit as fast as possible." That's the DNA of a "corporation"—*

♦ **RE:** And our Supreme Court granted "personhood" to corporations so they have all the rights of a human and none of the liabilities—

♦ **V:** *That's what the* Adbusters *publisher is railing against—*

♦ **RE:** But if somebody had the personality type of a typical corporation, we would consider them psychotic and probably have them locked up. They would be considered a sociopath. The interesting thing is: most people wanna know what the rules are, and then they accept them. You try to say, "Things don't have to be this way; this is not the only way it can be." Like, there's no goddam Coca-Cola banner hanging off the Vatican, y'know. Yet people don't quite understand that—most of them go, "Well, that's just the way it is. That's *their* property."

This country voted to eliminate the estate tax. What the fuck did they do that for? They were all deceived into thinking that the estate tax takes money away from them. But what it really means is that, when Bill Gates dies, all his money goes straight to his kids and the country doesn't get a bite of it. None of it's ever gonna be put back into society again. Consequently, these rich people are gonna get more and more powerful. And if ten families and ten corporations have all the money, they're certainly not going to look after *our* interests. It's not in *their* interest to do anything like that.

♦ **V:** *Well, "they" already have the power, money,* media and police-military might in their pockets. So what do we have? Well, we have to be funnier and be having more fun than them, with their hypocritical, ass-kissing, staid, convention-bound lives.

♦ **RE:** Do you remember when "we" had rock 'n' roll? It wasn't a Republican thing—everything fun was *liberal!* And everything stale and boring was Republican.

♦ **V:** *Oh boy, that has changed, hasn't it?*

♦ **RE:** Yeah, but not completely . . . we still have the best performers.

♦ **V:** *I'd like to think so. If you go to a Survival Research Laboratories (SRL) show, well, there's* nothing *like that.*

♦ **RE:** Well, you know, "they" do have something like that. They call it the war! [laughs] Those daisy-cutters are pretty spectacular. Can you imagine being near a daisy-cutter when it goes off? I read that those earthquakes that happened in Afghanistan a couple of months ago may have been a result of those daisy-cutters being dropped. But you never know what information is bullshit and what's real, you know?

♦ **V:** *Hmm—the long term ecological effects of waging war!*

♦ **RE:** So if some geologist says, "This is probably due to all the daisy-cutters," then all the Republicans have to do is hire another guy—they'll tell him, "We'll give you a hundred thousand dollars to say that's bullshit." And then it's like, "Oh yeah, a hundred thousand, huh? Well, I would've done it for fifty." [laughs]

♦ **V:** *You're probably right. That's all they do: whenever there's a* real *scientific study revealing an ecological threat, "they" hire a pseudo-scientist guy who can be bought—someone without any morals or ethics, who can be brought in just to discredit: "No, there's no global warming!"*

♦ **RE:** "Global warming is a *good* thing! You used to have to go to Florida every summer for your holidays; now we can *all* live in Florida! We'll just turn New York into Florida!" Actually, Putin said that he thinks global warming is good, because it's better than pushing coal in Russia, and they can be the benefactors of it.

♦ **V:** *Hmm . . . Back to the question, how do "we" have more fun? Well, I'm sure there's a certain thrill after doing a billboard. Someone said that if you do a billboard alteration, it's very important to have taken a photo beforehand, so you can compare and contrast the two.*

♦ **RE:** I forget to take photos of the "originals." Sometimes I've been foiled because of my timing. For example, I drove by one that said, "Injured? Call 1-800-LAWYERS." And there was this big space underneath "Injured," so I went home and

painted a graphic that said, "Can you fake it?" [laughs] And this billboard was all over town. But by the time I returned to put them up, the billboards had all been changed!

♦ **V:** *You're kidding! They'd already changed it?*

♦ **RE:** That's happened to me quite a few times. Well, you never know when they're going to change a billboard. There was one McDonalds billboard that said, "We're north, east, south, west," showing a bunch of McDonalds, and then it was just blank on the bottom, with a picture of some McDonalds food. So I and a friend just added some text in the same font: "Watch that diet go south," and underneath, "Super-size your thighs." McDonalds had left the bottom blank,

a face for people to identify. Like, if I shaved and cut my hair, you wouldn't recognize me.

♦ **V:** *Well, you're probably right—*

♦ **RE:** I've *done* it! I walked up to one of my best friends and said, "Jeff! Jeff!" and he just looked at me and turned away. Later I told him about that and he said, "I don't remember that—oh fuck, was that *you?*" Well, I just shaved and stuck all of my hair into my hat, and he didn't know who the hell I was anymore! And he'd known me for years.

♦ **V:** *I suppose you can change your glasses, too.*

♦ **RE:** You can also toss a little mud onto your license plate, or use a little piece of tape to change an "O" into an "A." Maybe that stuff's illegal, but

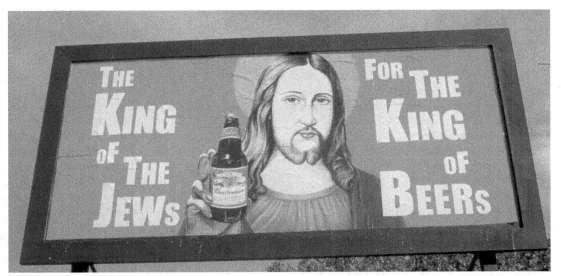

like they *wanted* us to do something! As a matter of fact, the guy who helped me kept looking up at the billboard and saying, "This is a set-up! They made it *too* tempting, to try to catch you."

♦ **V:** *Does every billboard now have its own surveillance camera?*

♦ **RE:** Well, I've had to "pop" cameras before. I'm sure some of the billboards have cameras on them. That might behoove you to get a fake nose or something—

♦ **V:** *—or wear a big floppy hat and huge dark glasses, like the J.T. LeRoy impersonator did.*

♦ **RE:** Yeah, or just add a little beard action. It's really hard to pick somebody out of a lineup if they have a beard and hat. I knew the person who put the flag on the floor in Chicago and created a huge uproar, and he wore a hat and a scarf up to his nose. At the time he was my roommate, and I saw his picture in the newspaper and didn't recognize him, because if you can't see the chin or anything below the nose, it's hard to put together

the slightest bit of confusion will make you harder to find. And remember to always put somebody else's phone number on the billboard.

♦ **V:** *Have you done billboards that weren't successful?*

♦ **RE:** Some just don't get a laugh—I find this out when I do a slide show presentation of all of my billboards. For example, I did one billboard that *I* thought was really weird. It was a fake billboard for "Squirrel Squirt Beer." Squirrels drink 100% natural pure Rocky Mountain spring water, and I painted a big ugly squirrel holding a big penis. I had a rope going from the billboard down to the ground where I placed a plywood "puddle," so it looked like a stream of urine.

Now *I* thought that was hilarious, but people didn't really think it was that funny. I actually wanted to set it up next to a gas station and hook up a hose to the water on the side of the gas station, then drill a hole into the billboard and actually have the squirrel squirting real water, but the rope is about as far I went with that one.

♦ **V:** *It sort of sounds funny, doesn't it?*

♦ **RE:** Well, I guess it's not quick enough. It had too many words on a billboard, and the imagery was too complicated. You have to be really simple and quick.

♦ **V:** *Oh, right.*

♦ **RE:** One that went over really well was just a picture of a little kid dressed like a soldier, looking kind of sullen against a camouflage background. It said in those stencil letters that they put on military equipment: "PLAYDATE IRAN," and people liked that.

♦ **V:** *That's a good one.*

♦ **RE:** There was another one just like it, but it was too complicated and people didn't like it as much. It just said, "Profit before Power" and something else . . . but it was just too many words.

♦ **V:** *"Power" and "profit" are abstract words, in a way.*

♦ **RE:** Yeah, and maybe people identify with power. "Profit before People"—you know, maybe people identify more with profit themselves! Psychologists say that people become Republicans because they like to identify with whoever is in charge—who is ruling. So, whoever has the most power is who you want to be associated with.

♦ **V:** *Even though you have nothing.*

♦ **RE:** Right. For example, nobody talks to the guy who lost as mayor, but if he had won, everyone would be forming a circle around him. Maybe people hope he'll give them a park, or help fix the potholes on their street, or give them a job.

♦ **V:** *Well, a lot of so-called "victims" in our society are so screwed up—it's like the Patty Hearst syndrome—that they identify with their captors, their oppressors.*

♦ **RE:** Maybe they identify with whoever has the loudest voice. Youth can be powerful—the student riots in the sixties changed things for awhile. However, once people become part of the "system," they just buy into it. Once you put a mortgage down on a house, then you won't do things that would jeopardize that mortgage. But students are great, because they're idealistic . . . because they haven't had to sell any of their soul yet, and they have energy and nothing to lose! That's why I feel with the whole billboard stuff: "God—a forty-five-year-old man should not be doing this; a twenty-year-old should be doing this!"

♦ **V:** *[laughs] But they aren't! Maybe a few will read this book and do something.*

♦ **RE:** Well, before the book *Subway Art* was published, graffiti was something that existed in the subway system, done by a few kids from the Bronx and from Brooklyn, and it was a very underground thing. But once it was presented to the world via this one book, then it grew everywhere . . . it was like Johnny Appleseed! It's like, the seeds were in the underground in New York, but once they were transported by the book around the world, they grew everywhere. Maybe it will be that way with billboard modifications. People just never thought of it; it just never occurred to them to do them.

♦ **V:** *Let's hope so. Billboard improvements don't require a huge amount of money or training.*

♦ **RE:** Well, some people complain that they can't do it, because they don't have my kind of artistic chops or my lettering skills. However, most billboards use one of the same 200 fonts that are on everyone's computer. You can take a photo of the billboard, match the typeface on your computer, and print out a new slogan at Kinko's—that's a lot easier now.

It's actually a fun game to always look at billboards to see how you can screw with them! (Now, my way is kind of a bad way, because I usually modify the *entire* billboard—I take over the whole space.) But alterations are kind of more fun, because you have to interact with the actual billboard, and sometimes you can tweak just a little bit and create a major change in the message.

It's a good thing for people to deal with billboards they actually see—ones that are a part of their life. It seems that they almost have the *right* to do those. People like me who drive to different cities and raid billboards—that may be pushing it a bit! But the ones that are actually a part of your life it seems you should have some say over.

♦ **V:** *Especially the ones in your neighborhood. Now, you've made a fundamental distinction between completely re-doing a billboard (which you've done many times), and just altering one.*

♦ **RE:** For me, sometimes it's a lot easier to just remake the whole billboard. In New York City, billboards are mostly on top of buildings, so to get access to one you have to meet someone in the building who will let you get to the roof. And maybe down the street is a "Think Different" sign you would have preferred to alter, but you can't get to it because you don't know anyone in the building. So in that case you may as well just design a whole new billboard. Nowadays, when I go to a party, people come up to me and say, "I have access to this billboard; here's my number!"

♦ **V:** *Nice!*

♦ **RE:** But since 9/11, it's gotten very difficult to gain access to the roofs of buildings.

♦ **V:** *Some billboards are simple to modify. Years ago, when the new generation of push-up bras started being marketed, I saw a billboard showing some*

busty blonde against a yellow background, wearing one of these exhibitionist bras, with a catty caption underneath: "Let them think it was just luck." Obviously, someone replaced that "l" in "luck" with an "f." And that "f" must have been at least a foot-and-a-half tall. At Kinko's you'd need at least 11"x17" paper—

♦ **RE:** No, they can print them out big now.

♦ **V:** *Oh, they can?*

♦ **RE:** You never saw our movie, did you? Because at one point we go to Kinko's, and we're printing out stuff on a big printer. What happened was, when it was time to pay, the cashier said, "Don't worry about it, Ron." The guy knew who I fucking was! It's weird.

there's the "latent" wage.

♦ **RE:** My dad was a factory worker and he always told me, "You know, you've got to steal a certain amount of stuff—that's your *bonus!*" But he also told me, "Never steal from an individual, ever! You only steal from a corporation." And I was like, "Okay, Dad!"

♦ **V:** *I never thought of the concept of the manifest wage and the latent wage before.*

♦ **RE:** Yeah, but that's how a lot of hourly workers get paid.

♦ **V:** *And that's probably how they keep their sanity and keep from killing their bosses. You probably helped those people at Kinko's have a better day, so to speak.*

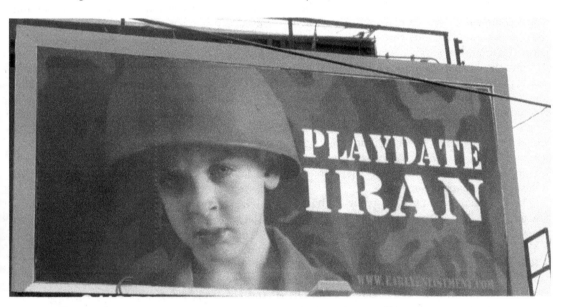

♦ **V:** *Wow—that is cool!*

♦ **RE:** This happens more than you might think. Because if the right people know who you are and what you are up to, they kind of think it's cool. A lot of Kinko's workers are hipster types—a lot of art students work there.

♦ **V:** *Well, in the early punk days people got jobs at copy places and then you could get "favors," shall we say.*

♦ **RE:** You get the job so you can promote your band, right?

♦ **V:** *Especially coveted were the night shifts.*

♦ **RE:** If you can't afford to make copies, you send one of the crew over to get a job at Kinko's.

♦ **V:** *Exactly. That's a form of compensation, because they're usually minimum-wage jobs.*

♦ **RE:** And I'm sure the bosses expect a certain amount of that to go on.

♦ **V:** *I hope so. Because the compensation is not in the wage, that's for sure, or at least the "overt" wage. That's right—there's the "manifest" wage and then*

♦ **RE:** Yeah, but I was far too egregious when I had jobs doing that sort of stuff. I got a job working at a billboard company and probably stole 400 gallons of paint! I literally just pulled a truck in and just packed the back of the truck . . . it was like a "Fuck you!" to them. And I painted a lot of my billboards at their warehouse, too, after hours.

♦ **V:** *That's brilliant—I didn't know you worked at a billboard company.*

♦ **RE:** I did, just long enough to stock up!

♦ **V:** *And apprentice—*

♦ **RE:** Yeah, and to try and pick up any tips.

♦ **V:** *Exactly. Did you pick up any tips?*

♦ **RE:** Actually, I learned how to wrap my brushes at night so they would keep their form, and I learned how to do what they call "cut a line." When I did some billboards with the BLF, they said, "Well, we have a girl who's a professional sign printer you can work with. We had sixteen giant letters to paint, so I started on one side and she started on the other, and she had just finished

her first letter when I "met" her! In other words, I had done like fifteen and she had done one. But that's because I had learned how—it's the *technique;* you can really go fast once you learn it. But I wouldn't have known that if I hadn't worked there. Those companies expect one guy to crank out one billboard per day.

♦ **V:** *Holy cow! Do they have some kind of overhead projector?*

♦ **RE:** I think they print them out now, but back then they had this big projector and this gigantic metal wall, with a pencil hooked up to electricity on a wire plugged in. We would cover the wall with a kind of brown butcher paper, turn on the projector, and then we would trace the thing, and wherever the pencil touched the paper (which would complete the circuit and send out sparks), the sparks would perforate tiny little holes in the paper. Then we would take the same paper, roll it out onto the billboard, and tape it down. Then we would take a sock filled with graphite and pound the whole billboard. We'd remove the paper, and where the little perforations we had drawn were, would be a very fine pencil sketch there—that would be our "guide." When you do a billboard, you're so close to it, and it's impossible to keep backing away so you can see it in perspective. So it has to be all mapped out for you.

The companies don't hand-paint billboards anymore. But it was great when they did; sometimes the results were wonderful to see.

♦ **V:** *What do you mean?*

♦ **RE:** Because they would only pay people five dollars an hour to do this, or minimum wage. Some of the people were really damn good, but some were horrible! I mean, there's nothing more wonderful than a forty-foot billboard painted by some incompetent idiot! Some were so bad that they would just strike you as *amazing!* It was weird, like a kind of new surrealism or something—

♦ **V:** *Wow. I guess I haven't seen too many of those—*

♦ **RE:** That's because they don't hand-paint anything anymore. Also, in New York (and probably the other bigger cities), they probably had a lot more competent painters. And I doubt that whoever did Times Square got paid minimum wage—they probably hired James Rosenquist [pop artist] or someone like that.

Also, in the South we would use oil enamel paint. But believe it or not, the big billboards in Times Square were painted with real oil paint! Yeah, those are real pricey to do. But they had really great guys doing them, and they didn't paint them on location, but at this really big shop. Some of the lettering and stuff were done on loca-tion, but the pictorial stuff was done in a shop. Then they rack them out there.

♦ **V:** *Do they have a huge truck that can carry gigantic rolls of paper and canvas?*

♦ **RE:** No, actually they are big panels of metal which they rack onto the billboards. The panels have hooks on the back of them. A billboard may have twenty-four of these panels, and in the big warehouse you might have a bunch of the same billboard panels. So if you're painting, say, a drop of water on a Budweiser bottle, that drop will be four feet tall, even though from a distance it's just a little drop of water.

♦ **V:** *You'd think they could sell some of these panels as pop art or something, later on.*

♦ **RE:** They're just too big, even for a museum. But now you can get the vinyl sheets that get put on the side of buildings. You can't re-use the vinyl, and apparently it doesn't bio-degrade, so they don't know what the fuck to do with them. Usually if you just ask, they'll *give* them to you.

♦ **V:** *Yeah, somebody gave me a huge photo of William Burroughs appearing in a Gap ad. It was printed on some kind of plasticized paper, and was originally placed in bus shelters, I think. It's about five feet tall.*

♦ **RE:** That wasn't the vinyl that they hang on the side of buildings. The vinyl they stretch on the big billboards, and the ones on the side of buildings, are mesh. With a vinyl billboard on the side of a building, if a little bit of wind gets behind it and rips it, then it falls down and is dangerous. So finally someone figured out to print it on mesh—then the wind will blow right through it. And the thing is, as soon as you get forty feet back from it, you can't see that it's mesh anymore—you just see the image. That's the "trick" they devised to conquer that problem.

♦ **V:** *Hmm. There's probably all kinds of hidden secrets you don't know when you see things.*

♦ **RE:** My best friend's old fraternity buddy is one of the guys who designed that system for printing huge mesh billboards, and he has a bunch of those printers. My friend asked, "Hey, would you print one for Ron?" And he said, "Go to hell!" You see, I wanted to take a picture looking down Broadway, and then blow it up so it's forty foot across. Then I would take that mesh and stretch it across Broadway, so it would be a giant roadblock . . . it would be a picture of what's behind it, like in an old cartoon where someone comes bursting through. But the guy wouldn't do it; it didn't make any sense to him at all.

♦ **V:** *Well, that's the way this society works. One definition of an artist is "somebody who does something creative without the profit motive."*

♦ RE: Yeah, for the holy hell of it! Some people just can't wrap their mind around that.

♦ V: *Right, it just doesn't make sense—it's insane! That's how "they" define sanity: "Am I making any money off it?" If you're not, you're crazy!*

♦ RE: Right, and some people will really treat you like you are crazy. But all you have to do is say, "Well, for every billboard I do, I sell ten extra paintings, and I'm able to tack ten thousand dollars apiece on them, so really it's free advertising, and I'm probably adding a couple hundred thousand dollars to my profit margin every year for doing this." Then people go, "Oh yeah—*now* I get

it!" It's totally not true, but it shuts them up.

♦ V: *[laughs] On some level, it* might *be true. I mean, I don't know, because I really don't know that much about how the art world truly works.*

♦ RE: And even the people running it don't, so … it's just a bunch of people fighting for power, and there's no rule book. Someone who works on Wall Street remarked to me, "Migod, the art world is just insider trading!" It's kind of like a captured market by a few people who control everything. They decide what the prices are for everything. They price-fix and they can pump up things if they want them pumped up, and no one is regulating them.

Once they put the prices on the wall, and that lasted about six months. Then they took the prices off the wall, and you're not even sure what the prices are. You'll notice that when you go to some hoity-toity gallery, nobody tries to sell you anything. As a matter of fact, if you even see somebody in there, it's quite a surprise. So *something's* going on. It's kind of like, "Once a picture is in, we sort of let you look at it from the sidelines, but even if you wanted one of these paintings, we wouldn't sell you one."

♦ V: *I read a book telling how during the era of*

Mary Boone and the rise of art galleries in the eighties, arrivistes *who were* nouveau-riche *moved to New York. These people often were a bit crass, but had the idea that certain paintings would increase their stature in the society they were trying to enter. But the savvy dealers would refuse to sell to them!*

♦ RE: Well, the wall between "us" and "them" is an invisible wall, and you need to know the secret code. A lot of the secret code is having the right art!

♦ V: *Yes, there are a lot of secret codes. The art world is like insider trading, that's for sure—*

♦ RE: But the thing is, I suppose you *could* get in on it if you really wanted to. Awhile back I had a job as an art trucker, so I knew what inside deals were being made. I knew what was going where, what was going back to the artist's studios, and what was going to what collectors. They had these giant rooms in Chelsea before it was the art district, and they were moving in two hundred Basquiats. You'd think, "Shit! These fuckers are making him into art history!"

If I could have gotten my parents to cough up twenty thousand dollars, it would be worth four million now. But I couldn't persuade them. They'd say, "Well, you know, all the money we have, our whole life savings, is twenty thousand," while I'm going, "Yeah, but in a few years this fucking painting will be worth millions!" But to my parents, the painting looks like some little kid made it. Meanwhile, I realized that Basquiat was near death, he was going to die, and these art dealers know what the fuck they're doing! But *I* had no money, and my parents were certainly not going to blow their life savings to buy something that looks like a little kid painted it.

♦ V: *Right. In San Francisco around 1973 there was a show of Hans Bellmer drawings—not lithographs—but actual drawings, that you could purchase for five thousand dollars. They're probably worth a hundred thousand now.*

♦ RE: But this goes back to that whole thing of how money so easily concentrates into a few hands and stays there. These art dealers prefer dead artists because then they have control of a whole body of work, they have control of the image created around the art, and they have the actual physical artwork—they pretty much have control over everything. And the artist doesn't have that much to do with it. If you're a young artist selling your art to friends for cheap, then already you've become very "problematic."

♦ V: *So they don't like that?*

♦ RE: No, they want complete control. That's why some people have had a hard time. In fact, Basquiat was having a hard time at the end,

because he was trading paintings for shots of junk or whatever . . . it was almost like they *had* to kill him!

I mean, they didn't *exactly* kill him, but they said, "Come out to L.A. We're going to stretch out all of these canvases. You paint them, and we'll give you mounds of cocaine and mounds of heroin—all you want to do . . . and if you're on a self-destructive course, we'll certainly help you along with *that*. We just want to make sure we have a bunch of paintings first!"

It's also problematic for people who paint paintings really fast, because you can saturate the market. This happened with Warhol—he made hundreds and hundreds of paintings. Thankfully for his legacy, he had a very intensive estate that took over, and they won't tell how many *Marilyns* there are, and they won't tell how many of *anything* there are—it's like they have the goldmine and they're not going to tell how much . . . it's more like a *diamond* mine, where there's a lot more than what people think, but they have to keep them down, and only reveal a few a year, and not saturate the market with them.

♦ **V:** *The same with Salvador Dali. I read in a* New Yorker *article years ago that he signed a hundred thousand blank sheets of lithograph paper!*

♦ **RE:** Yeah, and that's the reason he's not considered the huge artist that he would have been.

♦ **V:** *Oh, he isn't?*

♦ **RE:** No.

♦ **V:** *A lot of people are fooled, I guess. They still think he's kind of a big deal.*

♦ **RE:** Yeah, but the "Powers That Be" consider Picasso, Duchamp, Jackson Pollock to be top tier . . . and Dali's just like a commercial, pedestrian artist. And I don't think it helps that so many people like him, because it takes away the *elitism* of him. Part of "the wall" is that people *don't* understand it. And if *any* jerk likes it, then it's kind of embarrassing, because also, any jerk likes Thomas Kincaid . . . you know what I mean?

♦ **V:** *[laughs] Although I think I appall people when I tell them I actually like Thomas Kincaid on a certain level: "You* do?!*," but I just have a weird sense of humor.*

♦ **RE:** You know, I used to paint those paintings—

♦ **V:** *You did?*

♦ **RE:** Well, I used to work in one of the "starving artist" factories, and that was a staple—it was before Thomas Kincaid. That was one of the schlock art things that you did, and they sold them at big "starving artists" sales and such—that was like a *standard.*

♦ **V:** *Wait a minute—are we talking about those* galleries that are by Fishermen's Wharf in San Francisco, that are full of all these innocuous landscape paintings that tourists apparently buy?*

♦ **RE:** Right. But the point is: this was a very famous style, and then Thomas Kincaid became the most famous person doing that style, and then it became *his* . . . which I thought was kind of weird, because now nobody seems to have any concept that this was just something that schlock artists did, and that he became the most famous person doing it. Nobody seems to have any memory that there were thousands of people doing it before him!

♦ **V:** *You're right, they don't.*

♦ **RE:** Yeah, so he captured the whole concept.

♦ **V:** *Wow! That was quite a feat, wasn't it? A prank on some level? So you used to work for one of those! You could have been Thomas Kincaid!*

♦ **RE:** Probably not, because I'm too weird, you know . . . there's something wrong with me, right? I mean, *obviously!* I remember one guy came in—one of the big schlock art guys, and he's looking at my paintings, and I had one of Andy Warhol rotting in different panels. And he goes, "Give me Panel One where he looks good! And then here with the Marilyn and Mickey, lose the Mickey! Put a dress on her!" You know, naked girl on the flag—lose the flag!" Or "Lose the girl, keep the flag!"

I mean, he was just a very basic person who knew exactly what people wanted, and he figured that I had the skill to do it, and he was willing to work with me to be that kind of artist—*the guy who paints the flowing flags, he's the flag artist! He's patriotic! He loves America!* It's just *America! America!* And you know, you could really cash in on something like that, but I just couldn't do it. I don't know, it's weird.

♦ **V:** *You could have been the flag artist! The painter of light, the painter of* patriotism!

♦ **RE:** Yeah, the Patriotic Painter! [laughs] There are 200 Christian radio stations I could be promoting myself on, plus television. And you know, I do those Thomas Kincaids. I don't know if you've seen any of those—

♦ **V:** *I guess not.*

♦ **RE:** Well, I do them, but with lowbrow figures in them. I think people like the Thomas Kincaid part of it, so they just "tolerate" the fact that there's a lowbrow figure there! But I was thinking that there are three different art worlds: the schlock art world of Thomas Kincaid and Peter Max; the lowbrow art world of all of those kind of weird illustrator types—that lowbrow tattoo-hot-rod culture stuff; and then there's the "high art" art world. So I was just thinking of the idea that I

would take something from the lowbrow art world, the schlock art world, the high art world, and put them together and present it to the high art world . . .

♦ **V:** *I like that analysis: that three art worlds make up the art world. When becoming famous, a lot depends on coming up with key phrases that describe you. Take Thomas Kincaid—he might not be where he is without the evocative sound bite, "The painter of light."*

♦ **RE:** Well, I'm sure he painted within that "phrase."

♦ **V:** *[laughs] It's always rewarding to read about artists. At a certain point in Warhol's career, one of his friends told him, "Hey, you've done enough plane and car crashes and electric chairs. Paint some flowers!" So he did a whole bunch of flowers, and they sold out right away. He said, "How many more should I do?"*

♦ **RE:** As many as he could sell!

♦ **V:** *Exactly! He just wanted to sell as many as possible.*

♦ **RE:** But you know, sometimes *he* got confused, too, because he liked doing things that got him attention, but things that get you attention don't always sell.

A certain dealer came to him and said, "I want you to do a portfolio for me. Would you do, like, twenty Jewish 'giants'?" (You know, everyone from Einstein to Charlie Chaplin.) And he was like [impersonating Warhol's voice], "Oh yeah, this is sort of an *interesting* idea, but you know . . ." And the dealer said, "Well, I'm going to pay for this up-front." And Warhol says, "Oh, okay, that sounds like a good idea." And the guy sold it out in less than two months—the entire portfolio! Because all the Jewish people wanted to buy it.

I mean, the guy knew exactly what he was doing, he knew who his clientele were. Warhol said: "Well, you know, that portfolio sold out in two months, yet I haven't sold a single *Hammer, Sickle, and Skull.* And this is better! Why isn't anyone buying this?" *Why?* Because adult rich people don't want a picture of a skull! A big time

capitalist doesn't want a picture of a hammer and sickle! Any more questions, Andy?

♦ **V:** *That's funny!*

♦ **RE:** Maybe my next art project should be to make it big in the schlock art world, just to prove I could do it. However, it's a lot of work, just to prove a point. It would take a couple of years of your life.

♦ **V:** *It would probably take more than a couple of years.*

♦ **RE:** I have another idea that I wanted to do. Have you ever watched the progression of an artist's work? Take Jackson Pollock: at first he's kind of a wannabe Thomas Hart Benton, and then he's kind of this weird primal surrealist guy,

and then he *finally* hits on the drips. And then this guy comes out to film him, and he shoots him through glass, and it kind of pisses Jackson off because he thinks it's kind of hokey. But then afterwards he's looking at the glass and he's thinking—and sort of gets this idea a couple of years later thinking, "Shit man, if I painted on glass it would look like these drips are floating in the air!" So he started playing around with painting on glass, but then he died. So my idea was: you could think of a famous artist and say, "What would their *next* show look like?" You could kind

of line up all their art and follow that line, you know, to the next logical step.

♦ **V:** *That's a great idea.*

♦ **RE:** Yeah, but at the same time, that would be a huge ordeal to make Picasso's next show! Also, where are "you" in all this? Because it would be hard to brand it as a Ron English if it's really a Jackson Pollock or . . . you know what I mean?

♦ **V:** *Right, and that's a contemporary paradigm artists have been working with. For example, there's a woman who is making Duchamp replicas (like of a urinal), which were replicas to begin with.*

♦ **RE:** And Mike Bidlo repaints Picassos, but he never painted Picasso's *next* show.

♦ **V:** *No, he didn't think of it.*

♦ **RE:** But also, you could get caught in this tape loop: first you do it in the East Village as a conceptual thing—and people gobble it up! And then you figure out, "Well, if I could redo Duchamp, then I could redo De Chirico, and people will gobble this stuff up!" And the next thing you know, it's twenty years later, and that's how you make your living, that's how you pay off your bills. You're not just going to switch to something else, because it's not going to work. You build a trap when you're not an artist for yourself.

♦ **V:** *Right! Maybe that happened to Bidlo, I guess.*

♦ **RE:** Well, it happens to all artists! I mean, Roy Lichtenstein was probably sick of dots by 1969, but it's like: does he want to give up his glorious lifestyle and his place in art history by switching to something else? It's a rough call.

♦ **V:** *You're absolutely right! That's why Duchamp did what he did.*

♦ **RE:** Well, he was a trust-fund guy—

♦ **V:** *Who, Duchamp?*

♦ **RE:** Yeah, he didn't need money. That's why he was so weird.

♦ **V:** *Oh. Well, that helped him be "free," didn't it?*

♦ **RE:** Yeah, you have a different kind of relationship to money when you never need money. But sometimes people like Lichtenstein, who didn't have a lot of money for so long, probably wouldn't ever screw up his own deal. Because you still have that underlying fear of when you were poor. You know, looking back now we *know* he's in art history—nobody's going to kick him out, but he didn't know that at the time. He didn't know if in two years they were going to go, "You know, what the fuck were we thinking?!" And everybody dumps his work and it becomes worthless.

♦ **V:** *Yeah. I can't think of anyone that that's happened to in the last forty years—*

♦ **RE:** Well, it happened to the graffiti artists. I mean, the professional art critics wrote that big article: "How we Loved them and How We Left Them"—you know, "Graffiti Art: Rest in Peace," and they really trashed it really hard.

♦ **V:** *And that's the official stance now?*

♦ **RE:** Well, now they're making their comeback, but they're making their comeback on the coattails of this whole new generation that looks up to them, because graffiti became like rap . . . so it's spawned hundreds of thousands of graffiti artists who look at these guys as the pioneers, so they are able to *re-cash* in. But as far as the high art world, they're not there. See, I don't know if they're going to get back in there. They may, I don't know, but a lot depends on who in the art world decides to reach down and grab one of them.

♦ **V:** *You're right. Well, they want a sort of mythic tragic figure: the Basquiat type.*

♦ **RE:** Yeah, that's the perfect artist. Because that way you become the complete authority on the artist and you don't have to contend with the *actual* artist being out there. Because some art critic or gallerist could say, "Well, this is what Ron English is doing!" And I could say, "That guy's a fucking idiot! That's absolutely not what I'm doing. He totally doesn't get it! He never gets anything!" It demeans their power to have the artist actually walking around breathing air.

♦ **V:** *I think about ideas like this all the time, trying to figure out the relationship between media, economics, social "values," art, creativity, and political power. My favorite living writer is J.G. Ballard. He's very interested in art, too; he once said that he should have been a visual artist—but he didn't have any talent! However, he writes like a visual artist.*

♦ **RE:** I have a feeling that nobody has "talent" when they start out! My belief system is that when you work on something—like if you write every day, then all those little brain connections that help you write become stronger and stronger. I've seen a documentary on the human brain and this makes sense. Like, I noticed when I was doing those records, and I was writing every day—

♦ **V:** *What records?*

♦ **RE:** Uh, making music.

♦ **V:** *You were making music? I didn't hear about that.*

♦ **RE:** Well, you know I can't play any instruments, which really pisses a lot of people off—

♦ **V:** *Yeah, but that's the punk rock thing!*

♦ **RE:** Well, how I do it is, I say, "Here are the lyrics, here's how it goes," and then I will bring a musician in with a horn and say, "Right here you play *da da da da*" and they'll do it because they're a professional musician, and you kind of put the

whole thing together by humming out all the parts to different studio musicians—

♦ **V:** *That's what Jello Biafra said he did with his band members, teaching them his songs—*

♦ **RE:** The point is, when I was doing that—and I did it for a couple of years—I got really good at coming up with tunes, great lyrics and song ideas. My brain re-wired itself to think about music and words and hooks, and it kind of led to a lot of those little connections for thinking of *visual* ideas dying off. So when I switched back to doing painting, now I really don't think of musical hooks anymore—I think of visual hooks instead

wake up in the middle of the night and go, "Holy shit—that's it!"—because your brain's all wired up to solve that problem, and finally it does, because that's what it's working on.

♦ **V:** *Right! You are totally dead on about the shower, or the middle of the night, or—that's why I love doing the dishes, even though I have a dishwasher, because I think of so many ideas, or even things I forgot to do that are important. There's something about doing some kind of activity that* superficially *engages your attention that somehow lets your subconscious bring important stuff to the surface, or allows ideas to get generated.*

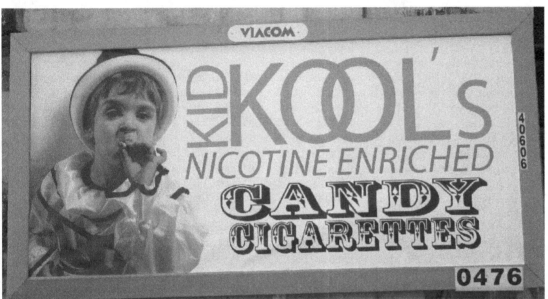

of musical hooks.

♦ **V:** *I've never heard that phrase:* visual hooks—

♦ **RE:** I was thinking about the brain the other day, and I thought: It makes sense that what you are not using kind of dies off—and it can re-grow, but it takes awhile. The little connectors shrivel up.

♦ **V:** *That does make sense.*

♦ **RE:** That's why if a guy wanted to be a visual artist and he started just doing it constantly—I wish I could remember what Einstein said, because they asked him, "How did you come up with the Theory of Relativity?" And he said something like, "Well, that's what I was thinking about." Which makes a lot of sense, because instead of thinking something like, "Got to get a woman! Got to get a woman!" he was thinking, "How does this work? Why does this happen?" So if you're constantly thinking about a problem, then when you're *not* thinking about it you actually *are* thinking about it in a different way. Then you might come up with an idea in the shower, or

♦ **RE:** You know, that's weird, because I've heard a lot of people say that. That's something that really needs to be researched, because it seems to be a real thing. But your brain has to be geared up first. It has to be kind of actively working on that problem, and then when you are doing something else, it actually solves the problem. But if you weren't actually working on the problem, I don't think it would just automatically pull it out of thin air and solve it.

♦ **V:** *Exactly. It's like* foreground / background *computer processing—*

♦ **RE:** Right! Like you need that other part of your brain to work on it for a while.

♦ **V:** *Yeah!*

♦ **RE:** But it's weird when I have ideas, it seems like one-half of my brain is working on coming up with new concepts, and when I am furiously coming up with ideas, then I can't draw! I have no drawing ability whatsoever, and I make these really crude, fucked-up sketches of what I want to do.

Then it's almost like I switch to the other side

of my brain, where I take that idea and I'm very good at drawing it. So the side that thinks of the ideas can't draw them, and the side that draws them can't think of them. It's weird.

♦ **V:** *Going back to the music, what you did is what Duchamp did in a way. In that little valise of a collection of his artwork in miniature, he didn't actually make those things, he took the ideas to the right crafts and manufacturing people and they made them.*

♦ **RE:** So he was like the first Jeff Koons.

♦ **V:** *Absolutely. But you were kind of doing that in the realm of music.*

♦ **RE:** Yes. But you know you can't conquer everything. I mean, when I started making these toys: first, I thought I was going to sculpt them, and then I figured out that there were people who could sculpt so much better than me. So instead of trying to do them, I should just make the sketches and send them to them.

But you know, doing what Jeff Koons does, or—who's that guy who saws cows in half? Damien Hirst! I mean, what they do is actually really hard. Even though they don't physically touch anything, the logistics and problem-solving involved are very difficult. It's like: Where do you find a shark? How do you get them to your studio without rotting? How do you manufacture a big tank with formaldehyde? How do I get this shipped to America, or through customs? How do I get a bunch of rotting beef shipped to New York? I think about how much trouble I have just shipping paintings.

♦ **V:** *I guess you're right. I've absolutely never thought of that before.*

♦ **RE:** Yeah. I mean, who would you get to sculpt a fifty-foot bunny, or a kitty, or whatever Jeff Koons is making? And where do you store all that stuff? How do you raise that kind of money to have that stuff manufactured? And then you have to have people come shoot giant photos of them. It's a lot of work.

♦ **V:** *You're right; it is more than one might think. I mean, I saw, ages ago in San Francisco MOMA, the "Michael Jackson with the Chimp" sculpture.*

♦ **RE:** Yeah, that actually didn't make it to the opening. It came like a week later, because I guess whoever was making it didn't get it done in time.

♦ **V:** *Well, Jeff Koons is this former stockbroker who—*

♦ **RE:** But you know, he went to art school.

♦ **V:** *Oh, he did?*

♦ **RE:** He went to art school, came to New York—he was actually in shows with Ronnie Cutrone and Kenny Scharf and those guys, and every time, they would review the others and ignore him. He was making weird plastic flowers or Play-dough flowers or something. Then one of his friends said, "You're very charismatic; why don't you go down to Wall Street?" This was when things were kind of on fire on Wall Street. So he went there to get a day job and started earning a lot of money. Then he went and started volunteering at the Museum of Modern Art, and he was the first one that called up the "Hundred Thousand Plus Club," trying to weasel money out of them, and he got very good at that. But not only did he get good at that, it's like, "Now I'm on a first-name basis with all the richest people in New York, and all of the richest art collectors!"

I like Koons very much because it seems that everybody is running down the same path, trying to get to the same place, and he just took this detour—but a very smart detour! Because first, he became his own backer by going down to Wall Street and making money, and then he aligned himself with the most important collectors in New York City by working for the MOMA—for free, because he could probably afford it now that he had the Wall Street money, and then he had his first pieces manufactured, and then stuck them in the East Village where everybody was doing Expressionism—and they just stood out like a sore thumb, this manufactured art. So now you're impressed with him, right?

♦ **V:** *Not exactly. But I never knew any of this. I've never looked at him in that way.*

♦ **RE:** It's funny what a backlash you get when people think that you *didn't* go to art school. So the second you say, "Oh, he went to art school," then it's like, "Oh!"

I guess it makes a better story to just think that Jeff Koons was some Wall Street guy that infiltrated the art world. But in this case it's the other way around. He was an art guy who was having a hard time with his art career, and then went down to Wall Street to make some money—to finance his art career! But I think he actually sold those original pieces at a loss: "The Floating Basketballs" sold for $3,000 each, which means the gallery gets half, and it cost $3,500 each to make them, so he lost money.

♦ **V:** *So what's your point?*

♦ **RE:** In other words, I don't think he made money on his first show, where his art was so egregiously different from everything else that was going on in the East Village. But that's also a technique: when you're a young artist, you might have to operate at a loss to get your name out there. The initial art is to get people to *talk* about you, not to make actual money off the art itself.

♦ **V:** *In the* New York Times *I read a little inter-*

view with Ed Ruscha. He said that some of his early work sold recently for millions of dollars, but when he first sold it decades ago, he got paid only three hundred dollars—

♦ **RE:** Yeah, and they probably still owe him that three hundred. They probably bounced the check on him. It's a very hard thing. I mean the same thing has happened to me: the dealer sold it for two thousand and kept my thousand. I mean, I never even got paid for it. It's a very corrupt, weird, fucked-up system.

♦ **V:** *It is a weird system. I read about how cheap Picasso sold his early work for—this was in* Conversations with Kahnweiler, *who was an early dealer of Picasso. It's a pretty good book if you ever see it.*

♦ **RE:** Picasso is what we call one of the first modern artists. He knew the value of publicity, or at least he sensed it.

♦ **V:** *He knew that when you're nobody, you have to get your work out there, even if you're not really making money on it. And you have to get it to the* right *people.*

♦ **RE:** And when you become somebody, you have to make sure that you fucking get paid. Picasso tortured a lot of people who wanted to come get his art; he kind of turned the tables on a lot of people.

♦ **V:** *That's right! I'm sure that happens a lot.*

♦ **RE:** No, most artists are still kind of subservient. They're so used to having their hat in their hand that they don't realize when the power shifts.

♦ **V:** *Right! No, you definitely gave me a different take on Jeff Koons that I've never read or heard of before. One always is trying to improve one's comprehension of so-called "reality"—*

♦ **RE:** Things always end up being far more complicated than they appear.

♦ **V:** *Exactly!*

♦ **RE:** Also, I think something people need to be very aware of is that society is going to make you into a very quick cartoon, and you've got to make sure they at least make you into a cartoon you can live with!

♦ **V:** *Yeah! [laughs] Well, what you read about Jeff Koons was different from what I read about him.*

♦ **RE:** Actually, I don't think I've ever read anything about him. I *know* him and I know a lot of his friends. When I met him years ago, I kind of thought what you thought of him. We were sitting around having some beers with some of his friends, and they said, "No, we went to art school with him. He financed his way through art school by bootlegging tickets to concerts." It's like, "He has always been this person; he's always been onto some kind of scam. He's like the world's greatest vacuum-cleaner salesman." I mean, he's an interesting person.

♦ **V:** *Well, he's a lot more interesting to me now that you've told me this.*

♦ **RE:** But also I think when you're navigating the art world, you realize how insane and treacherous it is, and what the odds actually are that you might "make it." And in a weird way, you sort of have an admiration for anybody who makes it—however they do it. Because if you think about it, it's kind of like a puzzle. How do you solve this puzzle? People who "make it" are people who solve the puzzle.

♦ **V:** *Right! When everybody I knew hated Thomas Kincaid, I sort of decided to like him . . . I mean, on some level.*

♦ **RE:** But you know, I think you can like certain things about people and not like other things about them. I mean, you can break it up and say, "Well, I admire the fact that he was the first artist to go on TV and sell his stuff on the Home Shopping Network!" I mean, he was a pioneer; you've got to admire his audacity. He figured out the right things to say and said them, and they

worked. My best friend, who I met because he started collecting my art years ago—his whole house is decorated with my art. He took me to his parents' house, and guess what it's all done up in?

♦ **V:** *Thomas Kincaid.*

♦ **RE:** Yeah, but not even the real paintings, just idiotic plates and stuff. And you think: Well, what's the appropriate thing to do here? Should you say, "That's great!" Or should you say, "You're getting ripped off. This stuff's not going to be worth what people think it's going to be worth." Like, one of those trends that did fall apart was the frenzy for buying animation film—

♦ **V:** *What are you talking about?*

♦ **RE:** Well, animation film cells became a sort of "market," and people began selling them and started "animation cell galleries." Now, the animation cells from *Snow White* and shit that Michael Jackson has are actually worth a lot of money, because they were actually used to make the movie. Not many survive, because most animation cells were wiped clean and then re-used.

So there became this big market for them. But when the market got bigger than the amount of work that was available, these guys started going to Korea and had people make these little washed backgrounds, then silkscreen Woody Woodpecker on top of it, allegedly in editions of two hundred. They would say, "It's three thousand bucks for one of these. And call me in a couple of weeks, because I think the price on this one is going to go up." Some guy would buy it, and then he would call back checking on the status of the art he'd bought, and the seller would say, "Well, it's actually up to $4,500 now! . . . Now it's five thousand!"

But in reality: try to *find* somebody to buy it for five thousand! These "collectors" were playing a game of hot potato, or something. And Wall Street guys who should have known better (or maybe not) were falling for that stuff. Finally, the whole thing just died off. And there's nothing you can do with those things anymore, because they were just bullshit! They were just made in Korea—they weren't in any movie or had any connection to anything, except connected to the surplus money of Wall Street guys.

♦ **V:** *Well, they were connected to the brand name of Bugs Bunny or whoever.*

♦ **RE:** Yeah, a little bit. But no more than a coloring book . . . I'm just saying that the whole market crashed.

♦ **V:** *I didn't hear about that.*

♦ **RE:** Well, it's kind of like the Beanie Babies—that market crashed, too. So if you wonder why people aren't sure what the hell is going on, it's because you can't really know. Like with their own art careers, or . . . it's just hard to know.

♦ **V:** *Well, you still see ads in slick magazines for collectible little plates, and these ads imply that these "limited edition" plates are gonna increase in value soon . . .*

♦ **RE:** Usually that should be a red flag: that something is being *manufactured* as a "collectible."

♦ **V:** *Absolutely. That should be a red flag right there.*

♦ **RE:** But you know, people are all into vinyl toys now. The reason that G.I. Joe from 1964—even though they manufactured two million of them—has value, is because we all pulled the heads off them and threw them down the sewer, or whatever we did with them. So there are very few of them left intact. But if you are making editions of five hundred of these new toys, then everybody is going to preserve every one of them in perfect condition, and where does that leave you? You have to keep growing with the demand; the demand can't shrink because then the price will collapse.

♦ **V:** *These are issues reminding me of Walter Benjamin's essay "The Work of Art in the Age of Mechanical Reproduction"—*

♦ **RE:** A guy just called me who had bought a hundred dollar print (a poster) and on the website it had said it was an edition of ninety, but when he got it he saw it was an edition of 100, so he was kind of freaking out. I'm sorry, but if there are only a hundred of them, and you only paid a fucking hundred dollars for it—well, it's probably worth fifteen hundred at least . . . there's no difference between an edition of ninety or a hundred! It's the guys who spend a hundred dollars that are the most freaked out, whereas people who buy really huge paintings for $10,000 don't seem to ever bother me at all.

♦ **V:** *That's funny. That's something you have to deal with when you're an artist. And thanks to the Internet you can be your own dealer as well—*

♦ **RE:** And sometimes, people could try to bootleg you.

♦ **V:** *Ohmigod—I didn't think of that.*

♦ **RE:** *That's* why you only have a limited amount of galleries, and that's why in a way it's good to buy from the gallery. I had a friend who bought a Basquiat from Basquiat years ago, and the thing was worth a fucking fortune, but "they" claimed that Basquiat never made that—all they could ask was, "Which dealer did you get that from? No dealer? Then he didn't make that!" Because my friend didn't get it from a dealer, he got it from the artist's studio—that made it

become just a piece of crap.

But then one day he found the actual painting in a photograph of Basquiat's studio, and suddenly it was worth a million bucks! He had found documentation that it *was* in his studio, and that he really *had* gotten it from him. The galleries are going to protect you from the bad—

♦ **V:** *Hmm . . . I see, they protect you.*

♦ **RE:** They'll authenticate anything they sold. The same thing happened with Keith Haring. A lot of stuff he'd just give to his friends, and his estate and his main dealer would say, "That's not a *real* Haring." Even though the dealer knew perfectly well that it was, he'd say is that it wasn't,

and get the estate to say it wasn't—after all, he wasn't making any money off it and the person wasn't one of his clients . . . he didn't give a shit if the person had been one of Keith's friends, and neither did the estate. They want to *minimize* the amount of works that are floating around that they don't have control of. So the weird thing is that Keith gives you a drawing, and then it's not a Keith anymore!

♦ **V:** *That is so strange.*

♦ **RE:** If you ever get a gift from an artist, try to immediately get a photo taken of you two holding it up! It's a stupid thing, but your kids will be thanking you!

♦ **V:** *Yeah, especially if they have to part with it— maybe to prevent them from going to jail or some such thing.*

♦ **RE:** Hopefully, you'll want them to part with it so they can put a down payment on a house. I mean who really needs a piece of art when it comes down to *that* or a house?!

♦ **V:** *You're absolutely right.*

♦ **RE:** I guess I shouldn't be saying that, but . . .

♦ **V:** *That's funny. You know, what's very important for everyone trying to be an artist is this drive to avoid a straight day job—*

♦ **RE:** Or the other thing that people don't think about are people like—I had a roommate, and he said, "I want to keep my art pure; I am going to be a carpenter, and I'm going to make my art at night (and *blah blah blah*) and my art will never be tampered with by commerce." And I thought, "I'd rather fucking paint all day, and if I have to kind of conform what I do to make sure that a certain amount of it sells, then I'll do that!" So art becomes a certain thing that's "built to sell." And it's different than what *his* art ended up being.

♦ **V:** *Well, we are in this schizo-culture caused to some extent by capitalism. You can have several identities, and it's not illegal to have more than one identity.*

♦ **RE:** Right! And you can argue that maybe art is *better* because you have to involve it in commerce—at some point you have to sell it. Does that make it better? Maybe . . . I don't know.

The first time I went to Amsterdam, I went to the museum of all the art collected by the state. The state just *buys* a certain amount of works every year from these state-subsidized "artists," and they don't even really look at these works, they just warehouse them. And the work is mostly crap because there's really no competition—the piece doesn't have to be anything special, it just has to be a piece. This situation apparently takes away all the incentive to do something great. But on the other end of the scale is: being a complete commercial whore, where you make sucky shit, too! So I guess the balance has to be somewhere in the middle.

♦ **V:** *Well, I think of Lichtenstein—I'm amused by him, but he's definitely not one of my favorites. Whereas Warhol is my favorite American artist of the second half of the 20th century, mainly for what I read about him and not for the art.*

♦ **RE:** Yeah, he was much more of a character than an artist.

♦ **V:** *I still haven't read all of the volumes of those huge books that he wrote, like the diaries—that thing must weigh ten pounds. The point is that I really haven't studied Lichtenstein; I just see his work at random—in the newspaper there's occasionally a reproduction.*

♦ **RE:** I think he had a much more low-key life then Warhol. I mean, he went to the same parties and did the circuit, but I think he had a family

and he would go home to Connecticut or wherever, and he had a pretty solid staff that didn't do drugs. He would take them to lunch every day, but for the most part they weren't a debauchery crowd . . . which doesn't make as good a story.

♦ **V:** *Yeah, but every time I see a new work by him I think it's funny. It's sort of a lighter emotional experience.*

♦ **RE:** Yeah, they're super-competent paintings. Whether you like them or not, they are super-well-done. I mean, he definitely had a system, he had great assistants—I knew a couple of people who worked for him, and he made their lives so good that they basically sacrificed their own careers . . . while I'm down the street working for Kostabi, who made my life so miserable that I certainly wasn't going to let my guard down and not quit trying to make my own career . . . *he* wasn't spending money for my health insurance or taking me out to lunch, so I certainly wasn't going to throw in the towel for *him.*

But then Lichtenstein died and kind of left his assistants high and dry, so they ended up having no careers. By the time they said, "Fuck, I better get my own career," it was too late. Once you cross forty, if you're not a name-brand artist, you're screwed.

♦ **V:** *So you worked for Kostabi, whom I know very little about—*

♦ **RE:** Again, I worked there because I wanted to learn how to paint, and it helped me a lot because I sat right next to a man who was a classically trained painter—he painted like Rembrandt. It's like: how else do you learn this shit? They don't teach it to you in school. Even if you do go to painting school, then it comes down to having some guy next to you showing you how to mix the oils and how to do this or that. And a lot of it is just the practical experience of actually *doing* it—I mean, there's no substitute for that, right? And they say you have to make a couple hundred bad paintings before you make your first good painting . . . well, I made my two hundred bad paintings on his time clock!

There was a point when people were coming in going, "I want a Kostabi painted by Ron English." And that's when I knew I'd better get the fuck out of there. It was over. But at the same time, the last few paintings that I painted for him pretty much paid for all those years I was there learning. He always had really huge profit margins, and so it never hurt him.

♦ **V:** *Well, every step of the way you get more knowledge or skill as you're inching your way to more freedom. Freedom is such an important idea to always be thinking about. And now you've got several par-*allel *careers going, yet I have a sense that somehow you're partly anti-careerist.*

♦ **RE:** Well, I have *half* a career.

♦ **V:** *I mean, I dislike people that are blatantly careerist. The instant you meet them they're, "What can you do for* me?"

♦ **RE:** There are artists who, every time they get an interview, just start reading off their resume. They don't say anything funny or insightful, they just start talking about how "I've shown here," "I'm in this museum," and it's like, no one really cares which museum you were in! We care about the art—well, hopefully.

♦ **V:** *Well, we care about the thinking, too. That's why I love to read Warhol. I'll read anything on Warhol I can find, because I always get some new idea or phrase or something.*

♦ **RE:** See, I just read a book by him, and I liked it a lot. Sometimes when you're an artist, it's weird because in a way you don't really have any contemporaries—well, you do and you don't. You don't have anybody that you can talk to every day and go, "How the fuck do I do *this?*" You are always in uncharted territory, and fucked-up shit happens to you.

It's like: Warhol gets a call from the Rolling Stones—this is before he knows them, and they want him to make an album cover for them. He says, "Okay," and they have a meeting. He says, "Here's my idea: I'd like to do a really beautiful cake, and it's on a turntable, and the needle is on top of the cake." And they said, "That idea is fucking stupid. That idea's—Jesus Christ! That's fucking embarrassing!" And they send him on his way. And some months later he's walking along with one of his friends and he sees the new Rolling Stones record in the window and it's a cake on a turntable. Basically, they just took his idea and got somebody who would do it for less money.

♦ **V:** *I didn't know that. What a rip-off!*

♦ **RE:** And the funny part is, that crap happens to me all the time. Then you think, "Well, that's weird, but I'm just a fuck-up—I'm just not paying close enough attention!" You learn from your mistakes, but it's also nice to see that the same shit happens to other artists. Especially running all over the country showing this movie [feature on Ron English], you realize that Warhol did the same thing. He dragged his movies all over the country and spent hours driving from city to city to show them. And we're doing the same thing now: going to all of these festivals to show the movie, and getting all this press in different cities, doing the exact same interview over and over. Reading Warhol, it's nice to know that this is not

a "unique" experience!

We opened our movie in Canada and started getting criticisms. We got the idea that if the criticisms were kind of arbitrary, we wouldn't worry about them, but if there were very consistent criticisms, we could actually solve these problems before we hit America. That's one of the reasons we decided to go to Canada first, because it's kind of *America Junior*. I mean, they don't have exactly the same attitudes—they hate people that make money a lot more than we do, but if some of their criticisms seem legit, then we can address them and maybe fix them.

♦ **V:** *That's brilliant—talk about a focus group! I hate that term, but maybe there's some value to it.*

♦ **RE:** When we first started editing the movie,

the director wanted to screen it to other people, but I didn't, because I think most people are just idiots and I don't want them having any say over my art! But if the movie could be shown to more "legitimate" critics who actually see hundreds of movies a year, and not just some yahoos from a local bar, that would be better. Because everybody has an opinion, but a lot of people don't have a *well-thought-out opinion*—they just have an opinion because they feel *obligated* to have one, and so people will give you all kinds of weird feedback. By the way, did we talk about Wesley Willis yesterday?

♦ **V:** *No, we didn't.*

♦ **RE:** He's kind of like the "Weird Al" of Chicago. He has this pre-programmed Casio keyboard and he plays these weird songs that he makes up. But he's a great example: he's a homeless person who has 23 records out. I mean, go figure: all of your friends complain that they can't get a record put out! And most of his songs are the same fucking song just put out in different ways.

♦ **V:** *Well, the lyrics are all different. I met him and bumped heads with him—*

♦ **RE:** Oh, so you know who he is, then. I thought that no one had ever done a cover of his songs, so I got a band in Dallas to do a cover of "Rock 'n' Roll McDonalds" that we are going to use for the BLF / McDonalds piece. I thought that some people would *get* it—this band's doing a cover of a Wesley Willis song…they are covering a song that was made with just a pre-programmed Casio. So you want to make every part of the movie with some twisted little thing, which might pass over the heads of most people, but which a few hipsters will get as a joke.

♦ **V:** *Well, I'm all for packing in as much potential for interpretation as possible.*

♦ **RE:** Especially if you're trying to sell a DVD later. It's good to make a film which you need to watch a couple of times in order to absorb everything.

♦ **V:** *That's the good thing about DVDs: the interviews, extra material, footage taken out, and even bonus alternate endings . . .*

♦ **RE:** Sometimes you think, "God, some of the shit they took out is better than what they left in!"

♦ **V:** *That's right. At least you can make your own judgment on it.*

♦ **RE:** Right, the DVD is a new medium; it's not totally passive.

♦ **V:** *I just realized—besides doing a cover of a Wesley Willis song, you could be the first to do a cover of a Wesley Willis painting.*

♦ **RE:** Well, I kind of did that with some of Daniel Johnston's drawings. What I did was, I flipped them up so they looked like Disney did them. But they were based on these fucked-up drawings, so they looked both neat *and* weird.

♦ **V:** *I wish I had purchased a Wesley Willis painting when he was in town.*

♦ **RE:** Did you know he did a song about me?

♦ **V:** *He did? Is that in the movie? It should be!*

♦ **RE:** We just couldn't find a place where it fit in. Maybe I could put a clip of it somewhere.

♦ **V:** *Or on the DVD release. What's the name of the song?*

♦ **RE:** "Ron English." You know, he just does songs about people.

♦ *V: Oh, I don't have all of his CDs; just a couple—*

♦ **RE:** If you have a couple of his albums, then you have pretty much all of his stuff! Well, I guess *some* of his songs are different, like "Paranoid Schizophrenia" and some others—he has some good stuff. I really like how he does the ads in all of his songs, like he totally has the Patty Hearst Syndrome, culturally.

♦ *V: The Patty Hearst Syndrome?*

♦ **RE:** Well, he's identifying with his oppressors in that he's putting in commercials for free, but with kind of a weird naiveté.

♦ *V: Definitely naive, but genuinely so. You know, it's getting hard to find* genuine *naiveté anymore. It's all* faux *naiveté these days.*

♦ **RE:** I *know.* Everyone in Brooklyn is doing "Henry Dargers" now. But I think, "You all went to art school! This doesn't count." I guess it's just a stylistic trend now. Well, I never worry about them ripping my stuff because it's too freaking hard!

♦ *V: That's good. That's like what Mark Pauline said recently, "I don't think that anyone's really going to be the next 'me,' because first of all they'd have to steal two hundred thousand dollars' worth of stuff to get started, and then spend thousands of hours learning how to weld and do all this other complicated stuff."*

♦ **RE:** And then blow it up! Well, I guess there's the Seemen.

♦ *V: They're not the same, because Mark's shows are so much bigger in scale.*

♦ **RE:** Well, I mean, Mark's shows weren't that big when he started out.

♦ *V: No, they were smaller, like the Seemen shows. The first was at a gas station, and had just one machine, plus a soundtrack.*

♦ **RE:** Yeah, but the Seemen have sort of hit a brick wall. Like they had this big show booked at Exit Art in New York, and then 9/11 happened and the whole attitude of New York changed—people didn't want things that were violent, just *positive positive . . .* and it's like, "The towers are gone—I'm sorry." I'm tired of the fact that so many people changed their whole life because of 9/11—I think, "Fuck you!" I mean, did the building fall on *you?* No? Well then, fuck you!

♦ *V: I agree. I absolutely hate all of this terrorist hysteria.*

♦ **RE:** And it's not like we would be able to stop them, even if we wanted to.

♦ *V: I know, but at the same time whenever I see a woman in one of those head-to-toe chadors, I wonder if she has a bomb hidden under there. You can't help but wonder these things.*

♦ **RE:** That's funny, I never thought about that—but it must be really hot!

♦ *V: I didn't think of that.*

♦ **RE:** But I also think about how decadent we must seem to them, with billboard-size images of people with bulging genitals posing in their underwear. I mean all of that stuff—gay marriages?—must be freaking their medieval asses out!

♦ *V: Well, for people like Mark Pauline and the Seeman, it's not going to get any easier for them to put on loud explosive shows. Maybe there won't even be any for a while.*

♦ **RE:** Who knows? I think that all of the old guys kind of stare very hard at the new generation to see how in the hell they're going to deal with everything.

♦ *V: In a weird way that's what* we're *doing now, even though you aren't exactly very old.*

♦ **RE:** Oh, I'm old!

♦ *V: At least you have kids.*

♦ **RE:** Yeah, I mean I certainly. . . if only someone were slamming billboards really hard—like Shepard Fairey (and others like that) who people said were gonna "pass me by." But I was actually thrilled about it; like, thank god! Someone else is doing it!

♦ *V: Did he retire?*

♦ **RE:** Well, he kind of pulled back after he got a couple of really hard arrests. Once you've racked up some really hard arrests, it's hard to go into a court and say that you've got a clean record, or that it's your first time in the system, or that you'll never do it again. After your first arrest it changes the dynamic—especially after your first *conviction . . .* ♦♦♦

JOEY SKAGGS

The American godfather of pranks on the media is Joey Skaggs, who has been implementing his imaginative assault on media deceptiveness, political deceptiveness, and casual complacency/received wisdom for over three decades. In the tradition of Alfred Jarry, the founder of Pataphysics, Joey has been campaigning for media literacy and the necessity for a permanently skeptical attitude. Interview by V. Vale.

♦ **JOEY SKAGGS:** I created the first sexual, Virtual Reality hoax on the Internet.

♦ **VALE:** *Really? Tell us about that.*

♦ **JS:** It was called "SEXONIX." In 1993, I had a booth at an "inventors" show in Toronto. I had a banner made that said "SEXONIX," and sent out a provocative press release to the Canadian media describing my new enterprise. I said that I had six "sex pods," an age requirement, a health requirement (no heart conditions), and was promoting new software whereby you could experience a sensational, sensual fantasy.

On opening day there were lines of people waiting to get into my booth, which was empty. I had an announcement put out that I had been busted at the Canadian border, and that $300,000 of my hardware and software had been confiscated. Next I sent out a press release blasting the "repressive policies of the Canadian government," and began doing postings on the Well, an early Internet BBS, under the name "Joseph Skaggs, PhD."

On my Internet posting I explained my plight and asked for help in retrieving my equipment. People responded, blasting the Canadian government for their censorship. But someone finally said, "Wait a minute, Joseph Skaggs—isn't this the guy who did the 'Cathouse for Dogs' prank?" This was before pop-up ads, banner ads and the corporate invasion of the Net, when the early users thought the Internet was their sacred space and that whatever was said on the Internet was "real." One of the Well users was an investigative journalist. He made it his mission to follow the trail, to get to the truth. But when he called Canadian government officials, he could not work his way through the bureaucracy, which I knew would be the case. So the hoax continued.

As a result of the press releases, I got a call from a Canadian television show: "We've heard about what happened to you, and we're really upset with our government's policies. We're doing a show on Virtual Reality, and would like to include you. Do you have anything you can send us?" I said, "Well, the government confiscated everything, but I still have a commercial about SEXONIX." They said, "Send it."

I enlisted computer-animator friends and quickly put together a video commercial featuring a cartoon penis having sex with a cartoon vagina. As the penis is pumping away inside the vagina, they morph into this surreal sixties psychedelic explosion of multi-colored flowers. Finally, when the penis ejaculates, the company's name, "SEXONIX" is formed out of sperm-like letters. Other graphics were fabricated, like a hand connected to some wires moving a body and footage swiped from the movie *Lawnmower Man*. The Canadian TV show fell for it and used it in their hour-long show. They interviewed me and I said something like, "Virtual sex is masturbation of the mind."

♦ **V:** *You were riding the wave of social change. As J.G. Ballard said, "Sex times technology equals the*

Six-month-old Joey.

future."

♦ **JS:** I also believe that *revelation* helps bring about social change, and that's what a prank does. It allows someone to believe in an illusion, and when the prank is revealed, a person's consciousness changes . . . hopefully.

♦ **V:** *Pranks may be our best tool for correcting the fascist direction our society seems to be headed—*

♦ **JS:** The *government* is perpetrating scams on us all the time: leading us into war, rigging voting machines, and allowing New Orleans to be destroyed, but these scams are never revealed . . . whereas my kind of prank is intentionally revealed for the sake of social change and changing consciousness.

♦ **V:** *On your website it says you've done twenty annual April Fools' Day Parades in New York City. How did that come about?*

♦ **JS:** It's the longest-running prank I've ever executed. It began in 1986. Each year I send out an elaborate press release describing the theme, the floats, the celebrity look-alikes who will be marching, and encouraging the public to participate in costume and bring their own floats. The parade route starts at 59th Street and goes down Fifth Avenue to Washington Square Park, where we have concession stands, entertainment, live music, and the crowd nominates the King or Queen of Fools for the year

I send this press announcement out to the "Calendars" or "Editors" of a hundred or more major newspapers and wire services around the United States. If you are a reporter in Ohio and you get this, you might announce that "New York is having its twentieth annual April Fools' Day Parade." I've had radio shows do announcements on the hour, pretending to do color commentary: "I'm talking here with Joey Skaggs. So Joey, what kind of floats are you going to have?" And I describe the floats. In the background it sounds like a bunch of people are preparing for a parade.

This year, I rented a brand-new, extended-cab pickup truck and had actors drive it to 59th Street and Fifth Avenue, where the parade supposedly starts. I paid for giant banners to be placed on either side of the truck, advertising it as "The Airlines' Lost Luggage Float." The back of the truck was filled with a mountain of suitcases, laundry and crushed boxes.

This year, abc.com's Buck Wolf showed up. He approached my actor "plants" with the truck, and when he told them there was no parade, true to their script, they acted really upset:

"What do you mean there isn't going to be a parade?! We rented this truck and came all the way up from college." He believed them, and went out and bought 'em all hot dogs. Then he wrote me a chastising email: "You know, these poor kids spent all this time and money preparing for your parade. One of them even missed a *test.* This is terrible!"

♦ **V:** *You've done that for twenty years! Tell us about another prank.*

♦ **JS:** The Portofess. Playing the role of a priest, I built a confessional booth and mounted it on the back of an industrial-strength tricycle and pedaled it to the 1992 Democratic Convention to hear the confessions of politicians. I had actors dressed up as delegates allegedly coming up to give confession. People would enter the confession booth from the back. There were Gregorian chants playing on a concealed tape recorder, and I, sitting on the tricycle, would open a little door and listen to their confessions. I handed out a flyer that said: "The Church must go where the sinners are . . . Religion on the move, for people on the go."

To cover my butt, I had sent away to California to become a lifetime member of the Universal Life Church; it cost $36. I wore a full Catholic cassock and looked the part.

The tricycle was beautifully custom-made by the only remaining bicycle manufacturing company in America, out on Long Island. When I ordered the tricycle, the company wanted to know what it was for, because they make delivery bikes for businesses like pizza parlors and grocery stores. I said, "I'm an artist, and I want a bike that can haul a sculpture weighing 500 pounds." I ordered the bike painted all black to match the beautifully constructed confessional booth, which looked authentically Catholic. I had solid rubber tires so I wouldn't get a flat, custom shocks and special gearing. It was July and hotter

than hell.

All kinds of people approached me. For example, a large group of pro-abortion protestors attacked me, believing I was a clergyman. They had stickers that said, "I fuck to cum, not to conceive" and they slapped them on me and on the confessional booth. For the first time in my life, the police came to my rescue! Clothes do make the man, and the police fell for it.

"Portofess" made the front page of the *Philadelphia Inquirer* and was on CBS national television, CNN, FOX—you name it. It went global.

♦ **V:** *Tell us about another media prank.*

♦ **JS:** Dog Meat Soup. I wrote a letter [see box below] that I mailed out to 1,500 dog shelters—a lot of time, energy and money goes into acquiring information like that. The letter was written in really bad "Charlie Chan" English—it was a totally racist letter in desperate need of grammatical correction (intentionally).

♦ **V:** *What did you use as a return address?*

♦ **JS:** I had a PO Box at the MacDougal Street Copy Shop, those poor guys! They're good friends of mine. The owner at the time, and his assistant were African of East Indian ancestry. They always would say, "Hey Joey, we want to be in a hoax!" I had been coming in and photocopying newspaper and magazine articles there for years, and gotten to know them well.

When this "Dog Meat Soup" hoax happened, police, private investigators and news media stormed the copy shop looking for a Korean guy, Kim Yung Soo—which was my alias. Abe and Raoul (the owner and his assistant) shivered in their shoes but never gave me up. They told everyone that the Korean came in once a week to pick up his mail.

On my answering machine I had a message both in Korean and English, spoken by a Korean woman friend, with dogs barking in the background sounding like they were about to be thrown into a soup pot. I never answered the phone, but recorded all the voice messages, most of which were very hostile and racist, as well as the offers to buy or sell dogs. I believe the offers were attempts at entrapment.

People went ballistic. They went fucking ballistic! They apparently found out my home address through the phone company, and assumed I was the dog broker for the Korean company. I had a garden apartment in a brownstone on Waverly Place by Washington Square Park. I had to sneak out the backyard, hop the fence and go through my neighbor's place to buy groceries. There were people staked outside, around the clock, waiting for me to surface. These people had

traced me to that address, thinking I had dogs in the back yard. There were investigators on the roofs nearby, trying to see if I had any hidden kennels. People slid cards underneath my door saying, "Open up, we know you're in there." They were banging on the windows. The phone was constantly ringing. I never answered that particular line.

Sitting in the darkness, I recorded all the

incoming messages, keeping a log. I spoke daily with my rep at my clipping service, letting him listen to the incoming calls and the banging on the windows and door. He read me some of the clippings they were collecting; there were journalists claiming they had spoken with the Koreans and had made appointments to sell them dogs. There were animal lovers and activists, telling everybody this was really real—they were lying, for their own cause.

♦ **V:** *What an amazing prank. How do you come up with these ideas?*

♦ **JS:** I always say that *my imagination is my biggest muscle.* I believe that one can learn to think in ways that help a creative process. There are approaches like *juxtaposition: ironic reversal.* Taking it and flipping it. You take a subject and say, "How can I make a comment about this that will interest people? What can I associate it with? What can I put next to it?" Those are techniques

one can use to help come to a workable way of producing a satire. Again, there are so many elements involved in doing it, you know. You need the time and the patience and some financing, of course. I pay for all of this myself.

♦ **V:** *Tell us about your "Hair Today, Ltd." Prank—*

♦ **JS:** This was the time I decided to do two hoaxes simultaneously. In my studio I had a number of actors playing secretaries. I installed two auxiliary phone lines, one for "Comacocoon," where anaesthetized patients could take computerized dream vacations, and one for "Hair Today," which offered a perma-

nent cure for baldness." My apartment had a large living room so I could have two fake offices operating simultaneously. Normally, I put in an auxiliary phone line dedicated to the hoax so that when the hoax is over, I can get rid of it.

To do two pranks simultaneously, I needed two different P.O. boxes with two different addresses. In "Hair Today" I posed as a Native American surgeon offering scalp transplants from cadavers. I produced a brochure advertising the concept and seeking scalp donors: men and women with beautiful heads of hair who were in high-risk professions such as deep-sea divers, undercover narcotics detectives, or whatever. We would give you money in exchange for your scalp upon your untimely demise. How much we gave depended on the condition of your scalp, i.e., if you had scars or moles, etc.

Then we supposedly had bald people lined up who would pay thousands of dollars to receive a healthy head of hair. However, they would forever be on immuno-suppressant drugs.

A Native American doctor doing scalp transplants? How totally over the top can you get? To produce the brochure, I bought three different wigs which friends wore posing for "before and after" photographs. In the "before" photo they would be frowning, and in the "after" photo they would look really happy with this silly wig stuck on their heads.

I mailed the brochure and a fake ad, soliciting donors, to news organizations. I did the same

Dear Executive Director,

Excuse my English, please. Thank you. First, congratulation on all your good work with animal. We support. We would like to help your company make money. So we like to offer help so you make money. Dog shelter kill million of dog, cost money. Dog shelter cremate dog cost money. Dog shelter need money to operate. Where it get money? Hard to get money.

Many people like to eat dog. People need to eat dog. Where do they get dog? Some people they raise dog to eat. Some steal dog, make some people angry, hurt some people. That not right.

We like make proposal to your dog shelter to sell us dog. You save money, you make money. We buy all dog regardless of size or color. We prefer big, young, strong dog but we take all dog from your shelter. We cook dog in America. We can dog in America and sell in Asian marketplace.

Lot people in America eat dog. Most dog we ship oversea. Lot people eat dog. Many country eat dog. Korea, China eat dog, Philippines, Japan, Thailand, Cambodia eat dog. Dog is healthy for you. This way your cost of business is less. You make more money, more people happy. You get cleaner air. No burn up dog. No waste dog. People pet no disappear. Everybody happy.

Cause we understand some people no like idea to eat dog. But they make trouble for people who like eat dog. Those people called two-faced. Those people eat cow, rabbit and mice, squirrel and frog and everything else, but still give us trouble.

But dog is good food. Dog is good medicine, make sick people strong, make old people young, make penis hard, make sex good again.

Our business getting very big. Need more dog. We are prepared to offer you 10 cents per pound per dog. We pick up dog everyday, so you also save on feeding dog. We like very much to speak with you and make deal. Please tell us how many dog are available in your business. We have deal already to do the same with dog shelter in New Jersey, Connecticut and Massachusetts. We hope to be eventually in big city cross America.

You can join us now, save money and continue doing your good job. We do big business together. We have big business already with many dog breeder and many dog hospital. Dog no suffer. We have quick death for dog.

Looking to hear from you soon.

Thank you,

Kim Yung Soo, President

thing for "Comacocoon". The brochure for that one promoted the various dream vacations you could take (the Rip Van Winkle, the Sleeping Beauty, the Gulliver's Travels) for a time period ranging from a weekend to two weeks. During your "dream vacation" you could get a tan, have your teeth cleaned, give up smoking and learn a foreign language, or you could create your own fantasy. The hoax got coverage all over the country and around the world.

I got busted for the "Comacocoon" prank—-something like 17 charges were brought against me. I had used the name Dr. Schlafer, which is Yiddish and German for sleep. Dr. Sleep!—come on, obvious clue. One journalist who worked for a national tabloid became very suspicious because whenever he called, my secretaries would not put Dr. Schlafer on the phone—-he was always busy or out of the office. The journalist, who must have understood German, thought the whole thing was a front for drug dealing, so he called the police and other government agencies and told them I was a drug dealer.

The police went to the P.O. box address on LaGuardia Place and the woman who owned the business, probably terrified, told them my street address, which was 107 Waverly Place. Somehow, accidentally, the 7 was left off and they thought the address was 10 Waverly Place. So the police raided the wrong building. Eventually they got to the right address, but by then they were *really* pissed off. At the time I didn't know about any of this. I had no clue.

So, we're all busy doing "hoax central" when suddenly I hear all this banging on the door: "Open up! This is the police! Do you want to do this the hard way or the easy way?" I peeked through the peephole and saw a detective holding up his gold shield. I opened the door. I had four actors in the apartment, the phones are ringing off the hook, and the cops come in saying: "What's going on?" And I say, "What do you mean?" One detective says, "We're here to bust you." So I tell the actors they can leave, and the detective says, "Sit down, no one's going anywhere!" From the looks on their faces, these poor women are thinking, "What have I gotten myself into? I don't know anything!"

One detective sees my baseball bat by the door and picks it up, "You play ball." I answer, "I used to." He says, "Where?" I say, "Brooklyn, when I was a kid." He then asks, "Okay, where did you go to college?" I tell him, "New York." But that's too vague for him. He asks, "Riker's?" That's

when I realize he was using street slang—"going to college" to him meant, "Where did you serve time in prison?" I tell him, "Wait a minute. I do hoaxes." "You do what?" "I'm doing hoaxes. Let me show you some stuff." I pull out some press for the Cat House for Dogs and other pranks and after what seems like an eternity, they finally get it. They let on that a journalist tipped them off, but appreciating what I'm doing, and realizing I'm not breaking the law, they agree not to reveal the truth to him. But now they ask if I would be willing to work teaching cops about scamming. I'm going, "Yeah, right!"

Political figures provide a goldmine of opportunities for satire. The challenge is to construct something that hits the nail on the head in a funny, offbeat way. In 1992, the Dinkins Administration's ineptness at governing New York was the perfect target. The city was going broke and the infrastructure was crumbling. They were grasping at straws for solutions. I faked an interoffice memo from Mayor David Dinkins to his staff (I had a mole on the inside provide me with a copy of his signature), and then I leaked it to the press. It proposed that the City use a lottery to sell the Brooklyn Bridge. They could raise the millions they needed to fix the bridge and some lucky person would win a million dollars plus have the bridge named after him or her for five years. When the media flooded the Mayor's office, they swore they had no plans to sell the Brooklyn Bridge. But, in the world of politics, no one knew what to believe. An Italian newspaper journalist thought it was a great idea and suggested it might even work for the dilapidated Ponte Vecchio in Florence.

♦ *V: Did 9/11 affect the ability to do pranks?*

♦ **JS:** After 9/11, New York Senator, Charles Schumer, tried to make hoaxing illegal. After 9/11, doing hoaxes got to be a scary proposition.

In 1998, I did a hoax where I created a new weapon. The history of humanity boils down to the evolution of weaponry. Basically it goes like this: I'm a caveman, you're a caveman. You don't like me so you hit me with a rock. I sharpen the rock and I stick it in your ribs. You put a stick on the sharpened rock and you stick me back. I make a bow and arrow. You make a gun. I make a bigger gun . . . If we look at our history, that's what it is about: the progressive invention of weaponry. Now we fear anthrax, dirty bombs, suitcase bombs, terrorists getting hold of a nuclear weapon. I decided to take weaponry to another level, so I created the "Stop BioPeep" hoax.

I gave a lecture at the University of Tennessee. Afterward, a dark haired, bearded man with a deep voice and his suit jacket draped European style over his shoulders said to me, "Eye vant to be in hoax." I said, "Great!" It turned out that he was a mathematician at the J. Stefan Institute in Ljubljana. This is a very prestigious scientific facility.

A number of months later, I went to Australia to speak at the University of Queensland in Brisbane, and met some brilliant students who were working on their doctorates in genetics, psychology and mathematics. We went out afterwards, and, as frequently happens, these students also asked if they could help do a prank.

So, with all this help from different parts of the world, I was able to put together "Stop BioPeep," an international hoax that took almost two years to pull off. In the hoax, I claimed that a multinational corporation was developing **genes of addiction** to further their global marketing domination, selling products for human consumption. But the U.S. government and some of its allies found out about it and, realizing the new weapon potential, co-opted it.

They believed that through DNA identification they would be able to target specific races. There are 1.3 billion Chinese people who are going to take over and pollute the world. There are over a billion Indians. There are millions of poor starving Africans. There are just too many people. How can we get rid of these racial groups without some kind of retaliatory strike? Perhaps one could feed them all a cola (or something else they've become addicted to) containing a deadly virus that is time-coded through genetic modification to activate at a pre-determined time, while

making a profit. Then all the targeted people would die within minutes of each other, melting from the inside out. Something worse than Ebola. They wouldn't know what hit them!

In essence, the hoax consisted of a fake exposé of this hideous plot. I created the persona of a famous Australian humanitarian (played by me) who had been informed by a defector about the BioPeep plot and made it his mission to alert the world about this heinous research.

I staged demonstrations in Brisbane, Australia and in New York at the United Nations. I had made T-shirts of a two-headed chicken that my actors wore at the protests (chickens were being used as guinea pigs to identify the genes of addiction). I sent press releases to the news media all over the world attempting to expose the government's involvement and their intent with this weapon.

Because of this, journalists in Slovenia descended on the J. Stefan Institute. The director, knowing nothing about this, appeared on TV denying everything. I got a call from my Slovene co-conspirator who was really freaked out: "The media are here; they're after my boss who doesn't know anything about this and I'm probably going to get fired." (We'd used his real name, phone number and mailing address to give the hoax credibility). I told him, "I don't want to get you fired. Just tell the truth. Tell them it is a hoax orchestrated by me."

Then there was a Slovene shit storm. Some people were angry, but some were very pleased. And they invited me back to Slovenia to discuss the issues raised by the Stop BioPeep prank. I returned there and discussed the hoax and its issues and the media covered it extensively. That is the kind of coverage you want, because it is talking about the real issues.

♦ **V:** *The follow-up coverage—*

♦ **JS:** Yes. Usually the follow-up coverage is minuscule, because the media does not like to dwell on the fact that they were "had." But the after-the-fact coverage that discusses the ramifications and the intent is far more important than the coverage one gets for just launching a hoax.

After this happened and died down, I was invited to Rio de Janiero and Sao Paulo, Brazil, to give presentations at a couple of universities. By a strange coincidence, a Slovene student made an announcement that he had won first prize in a world competition in computer programming that took place in Rio. He was hailed as a national hero by the Slovene media and the president of the country (he had received the equivalent of $60,000 US from the government to prepare for

this contest.) However, it turned out that the kid had lied and had taken the money to Rio and had a good time with it. Upon closer examination, no one could find the organization that supposedly hosted the contest. Because I had just pulled the "Stop BioPeep" prank partially in Slovenia, the media there made a connection, alleging that *I* was the mastermind behind this kid's fraudulent winning of the contest!

I, in my impish way, decided to accept responsibility for this just to see what would happen. So, when the media called, I said "Congratulations! You've done a good job! You got me!" I, of course, was putting them on again. The media became frenzied with accusations and assumptions, none of which could be substantiated. It was a riot. The news reports even went so far as to suggest that I had committed a crime and should be thrown in a Slovene jail. This is all on my website under the name "Scandal in Slovenia."

♦ **V:** *How did you get out of that?*

♦ **JS:** I went back to Slovenia, explained the real story of what had happened, and even got to meet the President of Slovenia. He liked what I was doing to the media, and became a fan. So I am famous in Slovenia—they even featured me in their Slovene *Playboy.*

Slovenia borders Austria, Italy, Croatia and Hungary. You can be in Venice in two hours; Graz, Austria is only an hour-and-a-half away. Slovenia is a wonderful country that very few people actually know about. The landscape is beautiful; the people are great. They all speak five languages; the food and wine are wonderful. Every time I crossed the border and showed a passport, they gleefully shouted, "Joey Skaggs! Joey Skaggs!" They recognized me because I was such a controversial figure in their media for so long over this giant scandal. So now I'm thinking of retiring to Slovenia!

♦ **V:** *You must have a fairly huge archive of the pranks you've done—*

♦ **JS:** I have accumulated over forty years of archival material. Over the years I've laminated the front page of the publication whether I'm on it or not, and also the page that I'm actually on. It's always a funny contrast between the headline news with its serious or scary stories, and whatever absurd story I've created. I like the juxtaposition of that.

I have literally thousands of articles, and now I'm in the process of trying to figure out how to preserve them. I have to either digitally photograph them or scan them and put them on CDs and DVDs. I still have to hang on to the originals. If I don't laminate them, they turn yellow or brown and fall apart.

♦ **V:** *You have to keep them away from both light and moisture. I still have original issues of* Search and Destroy *for sale. I stored them in black plastic garbage bags inside cardboard boxes.*

♦ **JS:** Well, you hope that the mice and the bugs don't get to them. But archiving stuff is a real problem. I've been digitizing the TV shows I've been on. There are a couple hundred hours of video; I've been appearing on shows for many years. It's fun to look at, if you don't mind watching yourself get old. [laughs] But at least I have the historical documentation of the work. If I didn't have this stuff, and I was just telling stories, nobody would believe me.

♦ **V:** *All of us probably hope that after we die, our work can continue to have some inspirational value. I can see a version of ourselves living on forever on the Internet. Unless of course, the coming worldwide electrical storms wipe out everything computerized—*

♦ **JS:** We'll have back-ups, though.

♦ **V:** *The Internet has turned out to house everyone's resumé: "If you want to see my work, go to my website." In fact, you can't trust anyone who doesn't have a website. They have no provenance.*

♦ **JS:** If you can trust the website.

♦ **V:** *That's true; you can hardly trust anything, period. You can construct any number of phony identities on the Internet.*

♦ **JS:** At least the Internet is an excellent tool for reaching people around the world. I was just in China and had to show some people something on my website, in the hotel business center. And there it was. I could explain my work to them while showing them everything.

♦ **V:** *That's amazing, because you no longer have to carry around a huge portfolio. So you travel around*

the world giving lectures under the rubric of "Media Studies"?

♦ **JS:** I still lecture at art schools, for festivals, journalism organizations, colleges and universities all over the world, often under the heading of "Media Activism," "Media Communications," or "Media Literacy." It's important that people know how the media works and how it affects them.

♦ *V: Many of your hoaxes have been made possible by journalists not verifying basic information—*

♦ **JS:** And on one level I thank them for that. Because I'm able to use their inadequacies to illustrate other issues.

♦ *V: There's a lot on your website; who put it up?*

♦ **JS:** Friends. My website and my pranks are made possible by all the people who volunteer to perform in my work. Without their participation, I don't think I could do the work on such a large scale. Some of my hoaxes have involved scores of people.

♦ *V: Now, pranks are on mainstream television (in programs like* Punk'd *and* Jackass)— *mostly the kind that victimize people who are already victims. What's your take on this?*

♦ **JS:** What has happened in all the media, from television to Shock Jock radio, is that the bar has been lowered for substance and raised for the amount of sensationalism. It seems like you have to have more "effects" and more outrageous behavior in order to get attention and higher ratings. It's the same way with hoaxes.

♦ *V: Do you have anything more to say about* Pranks *after 9/11?*

♦ **JS:** Well, after 9/11, everyone started receiving white powder in envelopes! That was a popular hoax that shut down Post Offices . . . they called it a hoax but it was actually a crime. I wrote about it in a piece called "This Isn't Funny." It had the effect of law-makers wanting to outlaw pranks and hoaxes; it was very chilling. First of all, I don't condone mailing out white powder. It's really a hostile attack intended to inspire just one emotion—fear.

There are definitely attempts to remove *rights*, certainly the right to dissent, and that's what we do. We're creative dissenters, and when those rights are removed, then what do you do? How do you influence people to think about things in a different way? One of my aims is to get people to re-examine issues and to possibly have another opinion about something, to come to a different conclusion. But, you know, if I had done my "Stop BioPeep" hoax after 9/11, where I was accusing the United States of creating a new weapon designed to attack genetic types, I would probably be arrested!

♦ *V: Fortunately, you weren't.*

♦ **JS:** We are all stuck with, "How am I going to be effective? What am I going to do or say that's going to influence people?" What we are talking about are artists using information as a weapon of mass communication for the intent of making people realize that the direction they are going is not a good idea.

We use certain liberties to communicate: free speech, the Internet, snail-mail, telephone and FAX machines, theater in a public place—as tools to access the media. If these liberties are limited by law, then artists will have to come up with a different way of communicating, or, break the law. If you have such conviction and passion that you *must* do and say what is on your mind, then you will end up doing it whether it's legal or not. But if you break the law, you risk ending up in a legal loop or in jail . . . and you will no longer be either a working artist or a threat.

I have always taken great pains to be *legal*, because I do not want to be incarcerated.

♦ *V: Even though you're a godfather-status prankster, you may also be a real artist. You got flown to Spain to do an art installation called "Art Attack." Tell us about that.*

♦ **JS:** "Art Attack" came about because I was invited to do an installation—the kind of thing I don't usually do—at a museum, the Espai D'Art Contemporani (EACC) in Castellon, Spain, which is north of Valencia and south of

Barcelona. It's an affluent part of Spain where Spanish tile is made, with very low unemployment. The city built a beautiful new museum with a marble facade and they are very proud of it. I said I was interested in doing something about terrorism. Soon after our first conversations, 9/11 occurred. They said, "We've thought about this and we don't think we can do it." I replied, "No, this is the time when you *must* do it. Now it's more important than ever, because of 9/11."

They invited me over to talk to them and have a look at the facility. I noticed that the museum's marble facade was already being vandalized, and that vandals were also destroying the art that was outside. So I decided to adapt my concept to fit the situation.

My installation included a surveillance camera scrutinizing the side of the building. The city provided police barricades that I put six feet in front of the museum and along the entire length of the building. Then I drew chalk outlines of dead bodies inside and outside of the barrier.

Inside the museum, I had a video arcade game painted in a military camouflage pattern. On it I mounted a fake .45 caliber pistol. A video cartoon of Uncle Sam and American soldiers played on a loop, and there was a place where you could enter your initials to keep your score. It was a typical arcade shoot 'em up game. When you pushed the start button, the game went from the animation loop to the real footage from the surveillance camera outside, showing you real life in real time. You aimed the pistol at the actual people walking around outside of the museum. When you pulled the trigger and shot at them, you would hear gunshots going off through speakers both inside and outside the museum. Then there would be cartoon bullet holes on the screen showing where you shot the people.

♦ **V:** *This was breaking down the barriers between virtual experience and "real" experience—*

♦ **JS:** Yes. If you were shooting at real people and hearing the sound effects, there was an element of "terrorist" reality here that was scary. We posted warnings outside: "You are entering an Art Attack Zone." And I had a loud speaker outside the museum, announcing in several languages that vandals of this museum and its art would be shot. Survivors would be prosecuted to the full extent of the law.

Interestingly, the installation was vandalized. Some people broke in, smashed the game and stole the gun and the projector that broadcast the image from the surveillance camera. The piece was down for a week before the museum staff could get it rebuilt.

This piece received media coverage in Europe because it was so provocative. Again, it was a rare occurrence for me to get this kind of art world attention. I was very pleased that this museum in Spain had the courage to host the installation.

♦ **V:** *Tell us about another prank.*

♦ **JS:** Let me tell you about "Save the Geoduck." I was invited to appear on a talk show in Seattle. While there I went to the Pike Place Market, where they have these fish stalls. On ice was a giant clam called a "geoduck" (pronounced "gooey"). It is indigenous to Puget Sound, can live 160 years and attain a weight of up to fifteen pounds. The geoduck has what looks like the penis of a horse protruding from the shell. It's used to ingest food and move around in the sand.

At this time, the American media were focusing on Japan-bashing. The news media were showing blue-collar workers smashing Toyotas and Sony TVs and blaming the trade imbalance and their loss of jobs on the Japanese. I saw the geoduck as an opportunity to make a very thinly veiled anti-Japanese penis joke and expose the existence of prejudice and bias.

Now when doing a prank, I try to always use some facsimile of my name, like "Jo Jo the Gypsy," or "J.J." windsurfing from Hawaii to California, or "Joe Bones." So I was "Dr. Richard J. Long." As Dr. Dick Long, I was a marine biologist and environmental activist leading a campaign to stop the Japanese from eating the geoduck.

I sent out a press release with an 8"x10" glossy photo of me in a suit on the docks of Seattle holding a geoduck. I said that the

Chernobyl nuclear disaster had more far-reaching effects than originally detected. Lapland reindeer and their antlers had become radioactive because of the contaminated lichen they were eating. They were no longer suitable for the Japanese, who I claimed had been eating the ground-up antlers as an aphrodisiac. So they turned to the geoduck. I asserted that we shouldn't be allowing our natural resources to be eaten into extinction by foreigners using it as an aphrodisiac.

Claiming to be very offended, I sent out this press kit to news outlets around the country. People in the Pacific Northwest knew what the geoduck was, so they immediately jumped on the story. People on the East Coast thought, "Wait a minute, this can't be real." But as soon as they realized that the geoduck actually existed, they no longer questioned the premise.

On weekdays it can be difficult to get a large crowd to do a hoax, but I managed to get a few diehard faithful friends to stage a demonstration outside the Japan Society Building in Manhattan. Since I was out of town, I faxed information to them, telling them to say that Dr. Long was in Seattle taking care of some legal matters and couldn't make it, so the demonstration was going to be called off until he could fly to New York City. Then they would stage a bigger demonstration.

But the news media interviewed the demonstrators anyway, giving them the opportunity to explain the plight of the geoduck. In the NBC broadcast story, the correspondent said he had called the Museum of Natural History, and was told they hadn't heard of the geoduck. But he and his news crew went to Chinatown, where they found some. The report that ensued showed the reporter holding one up, saying, "And you wonder why they think it's an aphrodisiac?!" pointing to this giant schlong hanging out of the clamshell. All the newscasters in the studio could not contain their laughter at this obvious penis joke. But they ran it as news anyway.

I was able to access the news media with a penis joke that was anti-Japanese. Announcers, newscasters and even the weatherman made jokes about it all week long. I have all these clips. One of the necessary elements of documenting the work is hiring a press clipping service for both print and electronic coverage. This is how I'm able to keep tabs on how these stories circulate through the media. This is the only way I have been able to maintain an accurate archive. You can't just rely on friends and word-of-mouth, because things slip by.

Here are the necessary tools for perpetrating a

hoax: not only having a provocative idea with some plausibility and some sort of sensationalism built into it, but a good press release, the promise of good visuals, a location, a phone number and now, of course, an Internet presence—-all for the appearance of validity. Plus you need some sort of post office box address, a phone line dedicated just to the hoax, and the ability to follow up and keep it alive.

So for any future media satirist or prankster wondering (because they don't teach this in schools, of course) what is necessary to perpetrate and follow through, I have written a recipe on "How to Catch and Cook a Journalist." It's on my website, and has only ever been published in Slovenia, because nobody else would touch the piece.

♦ **V:** *That sounds truly educational . . . Can you think of another prank?*

♦ **JS:** When I was teaching at the School of Visual Arts in New York, Channel Four from England called. They asked if I had ever fooled the British news media, and could they challenge me to do it? I told them I already had. For example, the BBC had fallen for the "Fat Squad" [described in the RE/Search *Pranks* book]

The producer said they wanted to follow me around while I executed a hoax in London. I said, "Sure!" The story I made up was that my parents had been missionaries living with the Masai who were killed by lions when I was a child. I had overcome a painful childhood and had realized my calling in life was to help other disenfranchised kids with emotional and substance abuse problems. I based my work on the premise that, yes, we have a reptilian brain but we also have a mammalian brain, and I wanted to heal the wounded animal within us. I was concocting this based on a mix of philosophies, including an interesting book I'd read years ago by Elias Canetti, called *Crowds and Power,* and lots of other popular psychobabble.

Mimicking Canetti, I said that the lion is the "King of the Jungle" because he is an arrogant creature. He roars before the kill, and that is a command to flee. If you don't flee, the penalty is death. As humans, we are forced to obey commands but we are damaged by the resentment created by having to execute those commands. Some of us can escape the "stings" of this domination, while others turn in on themselves and consequently on others.

I created a manifesto based on this philosophy, combined with popular mumbo jumbo presenting something absurd but plausible. Friends in fringe news media helped me to fabricate a couple of

"published" articles in the U.S. and Canada. My persona was "Baba Wa Simba" (Swahili for the lion king), a therapist who would heal the "inner animal." The therapy was to reenact life in a lion's den. My patients were my "pride," and would do therapy on the floor: roaring to find their inner animal, crawling on all fours and taking group naps.

All this bullshit was then sent to the British news media with an announcement that Baba Wa Simba the therapist was coming to England to visit his pride of lions, the disenfranchised kids of East London. I checked into a hotel courtesy of Channel Four, and added the name "Baba Wa Simba" to my hotel registration so that if anyone called for Baba, they would ring my room. Kids in an acting school were recruited and I rehearsed them for a couple of days. We rented a parish hall, made a bunch of banner signs welcoming Baba Wa Simba to London.

The news media started calling, wanting to attend one of these "roaring sessions." So I got fifty hamburgers and had all my actors on their hands and knees eating off the floor . . . not very British. They would start with a low guttural growl, which would slowly develop into a full, throat-wrenching roar. Pretty soon all the kids were hoarse. Without exception, every member of the news media got down on their hands and knees and roared along with these kids who were playing their part to the hilt. They reported things like, "Feels good, actually!" and "It *is* therapeutic!"

♦ **V:** *Yeah, like Primal Screaming.*

♦ **JS:** Of course. So Channel Four ran this exposé about my visit to London, fooling the Morning Show, the Noon Show, Sky News, etc. They focused on the British news media that fell for the hoax. But while I was in England, a famous Brazilian news host from TV Globo who was visiting London, requested to tape a segment for broadcast in Brazil and Portugal . . . and he too got down on his hands and knees and roared.

Years later, when I was invited to speak at Catholic University in Sao Paolo and Federal University in Rio de Janeiro in Brazil, I got a call from *Veja*, a very popular Brazilian news magazine, wanting to do an advance profile on me. They asked if I had ever fooled the Brazilian news media, and I told them what had happened in London.

The *Lion King* movie had recently come out, and it was perfect timing—everybody had Disney on his or her minds. Here I was acting like the Lion King, and I work with disenfranchised youth. So this journalist says that this is very interesting and he wants to check into this, and can he please call me back? He calls back saying that he talked to TV Globo and they claim I am lying. I tell him I have a news clip of the guy doing it. He says, "You have a clip?" I tell him I have clips of everything I've ever done, and I'll bring it down to Brazil. He says, "Okay."

So I fly down to Brazil and in the auditorium it's standing room only. I'm showing video clips

of my work, and when I get to the Baba Wa Simba piece, the journalist who wrote the article stands up. He tells the audience that TV Globo denied they had fallen for my prank. So I say, "I have a gift for the audience." I play the tape, which starts out with the TV Globo news host talking off camera while footage of real African lions is shown. The audience starts screaming and applauding, because they recognize this guy's voice—that's how famous he is; he's like Walter Cronkite—and there he is on his hands and knees, roaring.

After the presentation, these guys whisk me off to the *Veja* editorial office where I show the video again. The next issue has a follow-up story with a photo of the TV Globo guy on his hands and knees roaring . . . It was a "Fuck you" to TV Globo: "You said I was lying but here's the proof."

♦ **V:** *It's so important you had that tape—*

♦ **JS:** Without the tape no one would have believed me.

♦ **V:** *What about your "Sex Tapes Save Marriage" hoax?*

♦ **JS:** Some pranks are opportunistic—-they just get dropped in your lap. Faith Daniels was looking for people to talk about "How Sex Tapes Saved Our Marriage." So I enlisted a fake "Mr. and Mrs. Joey Skaggs" to go on her show: a Caucasian Joey and a fiery dark-skinned Cuban Mrs. Skaggs. (You gotta juice it up, y'know.) She was a *babe*, too. The guy playing me was this skinny bald actor—it was really wonderful.

So they sent the limo and I had the fake couple waiting at my studio to be picked up. They had showed up early in the morning to do some preliminary preparation, and then went to the interview. They talked about how even on pizza you need to have different toppings; if the pizza's always the same, it gets boring. It was stupid, but that was the format of the show.

After the show aired, I sent out an announcement that Faith Daniels had been hoaxed. When journalists called her for a comment, her producers said it wasn't true. They claimed that this Joey Skaggs guy and his wife had *crashed* the show, and that they were not invited guests. Yes that is what lengths they will go to: they will lie, Lie, LIE! The public doesn't have a clue as to what lengths these people will go to to "construct" the news, to construct these shows, and how much they are willing to lie.

♦ **V:** *Did the show actually air?*

♦ **JS:** Of course it aired. I've got the clips. When I did the "Cat House for Dogs," one publication,

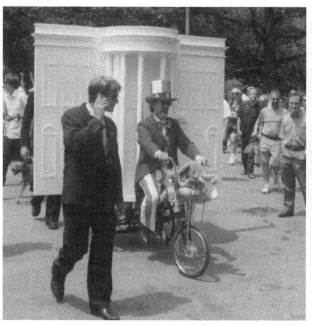

having fallen for the hoax, did a second article claiming they knew it was a hoax, but they were just going along with it to test the intelligence of their audience. Anything to save face!

♦ **V:** *Can you tell us about the Bush Fourth of July [2004] prank?*

♦ **JS:** A carpenter friend and I spent months building an 8' by 8' model of the White House. I had shown him the back side of a twenty dollar bill and asked him, "Can you make this?" He jokingly replied, "How many do you want?" I said, "No, not the bill, the White House on the bill!" I mounted it on the tricycle that I had used for the Portofess. I recruited friends and improv actors to play "Bushette" cheerleaders, a choir, the Saudi royal family, Bush's cabinet, a marching band and Bush supporters.

We printed up fake money to fill an attaché case, and had "Bush/Cheney for President" signs, a giant "Bush!" banner, American flags and red-white-and-blue balloons. A block-long parade of people gathered at Waverly Place at noon. Led by drummers, we marched into Washington Square Park in Greenwich Village. The public perceived the parade to be a pro-Bush parade because on the surface it was a pro-Bush parade. People were screaming and jeering, *"Why?!"* and "What the fuck are you doing?!" and "Get the fuck out of here! Are you crazy?!"

I was dressed as Uncle Sam pedaling this giant White House. We got to the arch in Washington Square Park, which was full of people—-mostly tourists, since it was a holiday. The performers made a giant semi-circle around the "White House." We were flanked by my Secret Service

people in black suits wearing American flag pins on their lapels with commando-type earpieces they were talking into. Yellow police tape was stretched out to create an aisle for the ever-growing crowd to come up to the White House to pay their respects to the "President."

I made a brief speech through a megaphone and then opened the door to the White House, revealing it to be an outhouse! Inside was a mannequin with a mask of President Bush dressed in a kid's cowboy outfit: hat, chaps and six-shooters. His pants were pulled down, exposing his Sponge Bob underwear and a chimpanzee t-shirt. He was taking a shit and wiping his ass with toilet paper made of hundred dollar bills. I had little shelves inside the White House on which I placed toy American soldiers, and little oil barrels.

There were also toy Abrams tanks and Humvees on the floor, which was covered with sand. A translucent skylight with the face of President Bush on a crescent moon lit the White House. Behind the Bush mannequin's head was a picture of Jesus praying. There were pictures of Saddam Hussein, Osama bin Laden and John Kerry framed as NRA targets on the walls. The inside of the door had the Constitution and Bill of Rights. Bush had changed key words with a grease pencil.

The crowd's jeers turned to cheers once they realized what was going on inside! This was an enormous project: building the White House and getting all the people and props together. I had originally planned to take this piece to the Republican Convention which was happening soon, but I realized that I probably could never get there pedaling through the streets with an eight foot wide, eight foot tall sculpture on a tricycle with a hundred people in tow. We'd be stopped blocks from the convention center and the piece would likely have been searched and possibly destroyed.

♦ **V:** *Right, it would have been confiscated before anyone could see it—*

♦ **JS:** After I had spent months and thousands of dollars on preparation, plus the effort of all my friends, I didn't want to take the risk. Of course, there was the chance that we would have been stopped at Washington Square Park as well and arrested but I was prepared for that. It would have made a hell of a story . . . well, that's enough! Go to my website to find other pranks I've done. ♦♦♦

DEATH GOT YOU DOWN?
AT LAST AN ALTERNATIVE!!!
© joeyskaggs2000
www.finalcurtain.com

SRL

Since 1978, Survival Research Laboratories (SRL), a controversial San Francisco coalition of maverick artists and intelligentsia, has been testing the boundaries of publicly acceptable performance with their thunderous, fiery spectacles utilizing one-of-a-kind machines to articulate philosophical and socially-critical metaphors. In earlier days, founder Mark Pauline engineered billboard "improvements" and transformed the streets of San Francisco into a gallery for his poster art dissemination. Here SRL cohorts John Law, Karen Marcelo and Babalou describe an outdoor performance prank done Halloween, October 31, 1996, at the Roxie Theater.

The SRL Show that Mark Pauline Missed

♦ **BABALOU:** A new gallery, 111 Minna Street, was opening up and they offered SRL a show in the alley outside. It was gonna be a busy night, Halloween, when there are a lot of people out on the street.

♦ **KAREN MARCELO:** This was the first show I helped on. We had the running machine and the inchworm—not many machines, because the alley was small. Plus we had some props: a coffin, and a box with a head coming out of it—we reused that for the Austin show.

♦ **JOHN LAW:** By coincidence, a documentary, *Pandemonium,* featuring SRL and other performance artists, was premiering at the Roxie Theater. Mark Pauline decided it would be fun to drive the V-1, which looks like a huge rusty cannon, and park it in front. The idea was to turn the thing on, run it a minute, and then get the hell out of there before the cops show up.

♦ **B:** Mark thought it would be great if the audience watching SRL on the screen would suddenly hear one of the *real* machines outside. It would be kind of a special event just for them. When Mark pulled up at the Roxie, it was Halloween night and the streets were just *jammed* and teeming with people—some in costume, others not.

♦ **JL:** About fifteen of us went along to block traffic and prevent cars from being hit by an eighty-foot flame. Mark pulls up, we block the street, he turns the fucking thing on, and it makes this enormous *insane* noise—windows are vibrating ten blocks away, cars are screeching to a halt, and people on the sidewalk are stopped in their tracks in amazement.

♦ **B:** Everyone on the street just froze and stared.

♦ **JL:** Unfortunately, there was a police drug stakeout a block away, and when the cops heard this huge sound, they dropped what they were doing and showed up within a *minute.* Before Mark could turn the engine off, we were surrounded by cops. Immediately we tried to explain that this was just "art."

♦ **B:** They asked for a permit, and Mark pulled out a V-1 bomber permit he had made, and they looked at it and went, "Hmmm."

♦ **JL:** By this time, the audience was pouring out of the Roxie.

♦ **B:** A huge crowd assembled immediately. Many of the people were Latinos from the neighborhood. Everyone started chanting, "Let him go! Let him go!" and a bunch of Latinos jumped on the flatbed and were chanting [accent], "Let heem go! Let heem go!"

♦ **JL:** The cops didn't know what to do. They looked at the crowd, and then they told Mark to haul the V-1 to the police station just around the corner. He drove there followed by the cops, and parked with the tail end of the V1 pointing right into the intersection of Valencia and 17th Streets.

The station lieutenant came out to see what was happening. Immediately, Mark begins explaining the technical minutiae of the V-1 which the cops are puzzled by, wondering what it is. He goes into great detail, and the cops love it, because they want to understand what this apparatus is. The lieutenant's looking at this huge piece of machinery, and he finally asks, "Well, what does it DO?" Mark goes, "Well, I could turn it on." And the lieutenant goes, "Yeah, go ahead and turn it on!"

So the rest of us, shaking our heads in amazement, go to the intersection and block it, because if a car drives through the flame it might be incinerated. We wait. The V-1 makes this huge, whirring, monstrous noise and we could see (but not hear) the lieutenant jumping up and down, waving his arms and screaming, "Shut it off! Shut it off!" It was a mime.

Mark turns the V-1 off, and the lieutenant is shaken to the core. He realizes that he doesn't want to file a report on this; he doesn't want anybody to know that he had anything to do with

this event. He says, "Look, get in your truck, take this thing out of my precinct and don't ever come back here, ever again! Just get the fuck out of here!" Mark got in his truck and drove off.

The lieutenant didn't want to do any paperwork on this; he didn't want anyone to know this had happened in his precinct, because then he would have to explain it. "Now let me understand this, Lieutenant Jones. You instructed this artist to turn on his V-1 rocket engine which spit out eighty-foot flames into the middle of Valencia Street—you instructed him to turn this machine on? Is that correct?" It could have ruined his career. That's the beauty of this. And there's no evil intent here; Mark's just having fun doing his art. And no one was hurt.

The thing about cops is: they're working class guys and they don't want to get into any trouble. They don't want to rock the boat (but the younger, gung-ho cops are more dangerous). You never want to lie to them, because they're trained to know when you're lying. You don't offer information. And when you answer questions, you couch your answers in the best possible light. Every cop, regardless of how intelligent or stupid he is, has been trained to know when people lie to them. If you're lying, they *know* you're lying—they can tell. So don't ever lie to them.

If what you're doing isn't overtly destructive or criminal (theft, or assaulting someone), if they look at the situation and go, "Nobody's really hurt by this. And there's thirty people here dressed up as clowns—if I arrest these guys, I gotta do the *paperwork*. And it's a bullshit charge that's gonna get thrown out." So if your group of a hundred people is polite to the police, doesn't give 'em a hard time, and doesn't lie to them, the cops will probably let you go. So don't piss them off by saying, "Fuck the pigs!" or make them feel small or stupid.

The other thing about cops: they sense fear. If you're afraid of them, they know it. They're trained to sense fear, and they're trained to know if you're lying. So don't be afraid of them, don't lie to them, and you'll have a much better interchange with them. These aren't the guys running the world, they're just getting a paycheck, and their job is to protect rich people's property, because that's what they get paid to do.

So, be real friendly, helpful, forthcoming. Describe in minute detail all the art, history, and literary and filmic connections that inspire you—do it until they're pulling their hair out, wishing you'd shut up. You tell the truth! Mark can talk for hours about the mechanical, technical and computer aspects of his machines, and it's bril-

liant. And the cops know it's true, and often they get really into it. They're interested in learning things, just like anyone, and they know he's telling the truth . . .

♦ **KM:** This was the first time I'd helped out in an SRL performance, and this was also the first time that Mark Pauline missed his own show (at the Minna Street Gallery). The show itself lasted about twenty minutes, and the police never came, because they were all at the Roxie Theater dealing with that. There are some pretty funny photos on the *www.srl.org* website.

♦ **B:** Meanwhile, when Mark started dealing with the police at the Roxie, a bunch of us had to return to Minna Street to facilitate the main SRL show there. Michael Dingle was managing things, and at 6 PM (when the parking meters expire) he had a bunch of us grab all the parking spots on the alley (thus clearing it for the show) and put up the police barricades he had rented—the barricades made it look "official."

After awhile we were set up and ready to go with the walking machine, and Eric Paulos was busy trying to fix the remote controls for another machine. Then the police showed up at Minna Street and asked if we had permits. We pointed to the barricades and hemmed and hawed: "Yeah, I *think* we have permits!" It was Halloween, and they probably had a lot of other things to do, so they said, "Well, just make sure you have this street *completely cleared* by 11 PM." Meanwhile, Mark was at the Roxie dealing with the police, who ultimately cut the wires to the V-1's distributor cap and told him to take his machine and never come back. He had to drive the V-1 on the flatbed back to the shop, and that's why he missed the SRL show.

♦♦♦

m ONOCHROM

of Vienna, Austria (they eschew the capital "M"), visited San Francisco in July, 2005, and did several performances sponsored by the Rx Gallery. Members of the audience were "buried alive" in a coffin, and the art group constructed a medieval catapult which attempted to set a world record for hurling outdated cell-phones. Monochrom founder Johannes Grenzfurthner was interviewed by V. Vale for the Counter Culture Hour. Here are some highlights of the interview.

♦ **JOHANNES GRENZFURTHN-ER:** Since 1993, monochrome is an art group focusing on technology, politics, and art. We are Context Hackers. Anytime you do anything, you have to think about the context in which it's placed.

♦ *VALE: You represented Austria at the 2002 São Paulo Biennale, the world's third largest art fair—*

♦ **JG:** We tried to formulate a big statement about art, politics and representation. Instead of sending monochrom, we decided to send a different artist named Georg Paul Thomann. He was born in 1945 and did a *lot of stuff.* He was the father of Austrian avant-garde art. He was part of the Viennese Actionists. He was part of the Punk movement in San Francisco and had a couple exhibitions here and then went to Germany. He was part of every big art movement and pop culture movement. He was even doing machine art projects before Mark Pauline and Survival Research Labs. He wrote the first German cyberpunk story.

["Thomann's biography includes his wunderkind childhood, references to and parodies of the Vienna post-war avant-garde, anecdotes of his irascible distrust of Austrian authority, his involvement with Communist politics, his sexual adventures, and his departure from Vienna for impossible international travels where he intersects with avant-garde and political activities country by country. Thomann was constructed as a fantasy-induced father of contemporary Austrian art."—Seamus Kelly, *Unterspiel* catalog for an exhibition featuring work by monochrom and others]

But he doesn't exist, because we invented him! We created Georg Paul Thomann as a kind of art avatar. Because he was fictitious, we could write his biography and control his life. So about twenty-five of us collaborated in designing the life and art of Georg Paul Thomann, publishing a 600-page book. This was an interesting way of dealing with the arts and pop history of the last forty years. About fifty percent of the people he allegedly met are fakes, too, so we have a lot of fakes and sub-fakes.

We created Georg Paul Thomann and sent him to the Biennale. Of course, he never showed up at the Biennale; he was always sitting in his hotel room and watching the porn channel, and *we* had to do all his work. So basically, we were his technical support and build-up team. People would ask, "So where is Georg Paul Thomann? I'd like to meet him again; I think I met him twenty years ago at an art fair in Dusseldorf" or whatever. We would reply, "He's just sitting in his hotel room. We're rather happy that he doesn't show up, because he's quite an asshole."

The Biennale is huge, with a hundred countries represented. Most of the artists sit in their small white cubes. They were like small bees sitting in this huge art complex. At the Biennale there's a hierarchy. There's the board, and the head curator, and the sub-head curators, and the national curators; the important artists, the not-so-important artists, the technical team, and the guides who show you around and explain to you the contexts and all the stuff.

So the first day we arrived there, we immediately explained to the technical people and the guides everything about the project: it's a fake. Interestingly, the administration and the top curators never knew anything. But the guides were walking around saying, "We have some really interesting artwork at the Austrian cube." Of course, many, many newspaper articles were published about Georg Paul Thomann . . . a big rumor pump. It was a way for us to actually deal with how the art system works. We could play with the system.

Georg Paul Thomann is quite old now. He'll die, and we're preparing his funeral. We'll go to Tyrol, because he's from the western part of Austria, and a lot of people working on the project will go to the funeral, and that will finish the project. We already have a really beautiful tombstone, with big letters that say, "I want to believe. Georg Paul Thomann, March, 1945 to July, 2005." So that will be the end of the Georg Paul Thomann project.

◆ **V:** *Didn't you get "real" journalists to write critical articles about Georg Paul Thomann?*

◆ **JG:** That's correct. We at monochrom try to build antibodies against being totally assimilated by "the sys-tem." That sounds like a leftist cliché, but most of our research and projects deal with this possibility or non-possibility of being assimilated. With Georg Paul Thomann, it's not the first time a fake artist was created; there have been fake artists since the Renaissance, or even before. The interesting thing about our project is: it's the first time a fake artist represented a whole country and went to a giant art fair. The very day that many people are joining together to create an entity like Georg Paul Thomann, that day he really exists, because reality is a construction itself; there is no "real" reality.

Art is a big system. It's a big autocratic system of many, many players, and it's really complex. Art is not only about people sitting in rooms of paintings, it's about the distribution of art, it's about the selling of art. There's a whole system of curators, there's a whole system of museums, there's a whole system of articles in magazines about art. So art is not only art. Art is a big, big system of intersecting systems . . . it's definitely an ecosystem that's part of the capitalistic system, of course. ◆◆◆

Who Shot Immanence?

On The Dynamics Of Appropriation And Intervention In The Work Of Georg Paul Thomann

Editors:
Thomas Edlinger
Johannes Grenzfurthner
Fritz Ostermayer

edition selene

YDIA LUNCH
MONTE CAZAZZA

Shortly after the RE/Search Pranks Festival in San Francisco (2003), Lydia Lunch, Monte Cazazza and his roommate Marzy Quayzar visited with V. Vale, Marian Wallace and their daughter, Valentine.

♦ **VALE:** *Lydia, we recently had a Pranks Festival and this woman asked, "How come there aren't more pranks by women?"*

♦ **MONTE CAZAZZA:** How hard did you look, Vale?

♦ **V:** *We asked around—that's all we can do! Word of mouth. At least we put Karen Finley in the original* Pranks *book—*

♦ **LYDIA LUNCH:** Well, maybe women just aren't that fuckin' silly. They're so busy trying to be taken seriously that they think a prank is more ridiculous. I don't know. But don't ask me about what other women do because I can't talk about other women. My whole career has been a prank.

♦ **MC:** There you go.

♦ **V:** *I agree. Well, give the definition for your special case—*

♦ **LL:** I'm one of those "special" people. I've got special needs.

♦ **MC:** Ten million dollars in untraceable banknotes is the kind of special need I have!

♦ **LL:** It's kind of a prank to get up there and tell people the most horrible details you can possibly reveal and then expect them to pay ten dollars to hear about them, just so they feel worse when they leave. I mean, how much more prankish can you get?

♦ **V:** *Actually, don't they feel better?*

♦ **LL:** They do feel better, I know. So they *think*. But they've been polluted, with the details of my disease. So I mean, that's kinda prankish, but . . .

♦ **V:** *Well, I do think it's prankish to pass yourself off as an "artist"—*

♦ **LL:** I don't use that term, *you* do. You're the one sitting there calling people artists.

♦ **MC:** I never use that term.

♦ **LL:** I call myself a confrontationalist, I never use the word artist. I don't do art.

♦ **V:** *But you do!*

♦ **LL:** That's what *you* call it!

♦ **MC:** I'm a cultural mortician.

♦ **V:** *I've never heard that before.*

♦ **LL:** I mean, I don't know who you're dealing with here. The mortician, the politician?

♦ **V:** *Actually, morticians are often politicians. I thought of a new word: the "poli-mortician."*

♦ **LL:** Yeah, well I'm a crankster, not a prankster. I'm very cranky, and I get paid for it. I give verbal emetics!

♦ **V:** *We put Monte in the* Pranks *book years ago, but we should have also included you.*

♦ **LL:** But you didn't realize at the time, because I was still pulling the wool over your eyes, that my whole career has been a prank. Why should I admit it in a book called *Pranks?* That would "out" me. Why should I out *myself?*

♦ **V:** *Because you do* out *yourself in your performances—*

♦ **LL:** But I'm not telling *your* deep, dark, dirty secrets; there are some things to still be thankful for! I talk mostly about myself. Well, and a few intimate others. What else could I say? Am I suddenly gonna be hit by a truck and only have nice, complimentary, lovey speeches; am I gonna turn into a guru of kindness? Forget it.

♦ **V:** *Monte, I've always wanted to ask if something was true that I printed—*

♦ **MC:** You printed it and now you're going to ask me if it's true?! The only thing I'm going to say is: I'm not guilty of it, whatever it is. My lawyer always says to not plead guilty.

♦ **V:** *I heard that when you were at CCAC [California College of Arts and Crafts] in Oakland, you poured a sack of cement down a set of stairs and called it "Fountain." [laughs] I thought that was really funny.*

♦ **MC:** Well, when there's nothing to do on the weekend, you just start—

♦ **LL:** You start *creating.*

♦ **V:** *That was like Duchamp, you realize. You were like the second Duchamp—*

♦ **LL:** "Étant donnés," my favorite piece of art.

♦ **MC:** If I only had his money.

♦ **V:** *He didn't get any; it was the collectors who did—*

♦ **MC:** It was his work.

♦ **V:** *He was always supported by the Arensbergs and others. But the big money went to the collectors who exchange his work after he's dead.*

♦ **MC:** The big money only comes after you're dead.

♦ **LL:** Can you wait? I can't.

♦ **MC:** I'm trying to get the big money while I'm alive, but it doesn't work that way.

♦ **LL:** I'm sorry.

♦ **MARZY QUAYZAR:** I like the story that when you were at CCAC, you wrote "DADA" on bricks and then dropped them on people's feet! [she applauds]

♦ **LL:** See, now *that's* high art. "DADA"! [laugh-ing]

♦ **V:** *That's a Zen slap, all right—it* is *a DADA gesture, truly. We hope these people were wearing steel-toed boots and didn't have to get rushed to the hospital—*

♦ **MQ:** They were like the CEOs, or the Deans, or something like that.

♦ **MC:** That was not the place for me!

♦ **V:** *Did you get a scholarship there? Did you at least get to live for awhile?*

♦ **MC:** Not that much money.

♦ **MQ:** After you dropped bricks on their feet?

♦ **MC:** No, before.

♦ **LL:** Why don't they ever pay you to *not* create? That's the moment I'm waiting for. I wish someone would come along and say, "If you'd just *stop,* we'll give you some money." And I'd be very happy. I'd rather get money for something I *didn't* do than money for something I did do.

♦ **V:** *Hmm; that's kind of a new concept for me—*

♦ **LL:** I think that's very post-DADA. "I'm stopping all creation, so please pay me. Or I'll threaten to do something *again!*" You know how there used to be the "foot-stomper" in New York [who would stomp on people's feet in the subway station and then run off]? I could be the "ear-shouter," and while I'm screaming in their ear I could pick-pocket them and they would never know they were ripped-off. [laughs] I like that idea: kind of a *surprise tactic.* Well, if I wasn't making enough money to live off, then blackmail would be my first call of duty.

♦ **MC:** Blackmail is very good—

♦ **LL:** But *pickpocketing* is very close to my heart. I love it; I fetishize about that. You have to train by hanging bells on a "victim's" coat—

♦ **MQ:** You knew somebody who did? Or you were suggesting that *we* should do it? You were trying to get me to do it.

♦ **LL:** Oh, I'll train you to do it! To just get out there and deceive someone and get paid for something I don't do: this is not a new thought to me.

♦ **MC:** She'll hook 'em and *you* pickpocket them—

♦ **LL:** Exactly, I'll scream in their ear and she'll grab their wallets. "Watch out!"

♦ **MC:** You don't even need to scream in their ear. You can get one of those little you know, when you're on a boat, they have those little horns?

♦ **LL:** Those shriek alarms?

♦ **MC:** The compressed-air ones, like a little fog horn. Then you can blast them and then run away with their wallets.

♦ **LL:** Yeah, yeah.

♦ **MC:** I don't think I could run very fast.

♦ **V:** *I read in the paper about someone in San Rafael who stole this Vargas painting, one of the "playmate" paintings from the fifties commissioned for Playboy magazine. The thief picked a gallerist who was crippled and couldn't run, and ran like three blocks down a major street with a painting and got away.*

♦ **LL:** Perfect, I love it. But I say: if you really want to be a crank or prankster: first you cripple the gallerist, then you rob them. That only makes sense to me. Why wait for one that might be crippled, when you could just, like, take their knee out? Again, getting paid for something you didn't do.

♦ **MC:** Or you could have a really nice lunch delivered, with a bunch of sleeping pills in it, and then just take everything.

♦ **V:** *Brilliant. Sleeping pills are underrated. I never thought of that.*

♦ **MQ:** Roofies, Ropinals.

♦ **MC:** Prostitutes first started using 'em—

♦ **LL:** On tricks. To knock tricks out.

♦ **V:** *So they don't have to do the deed?*

♦ **LL:** Again, getting paid for what you don't do!

♦ **V:** *Saves wear and tear.*

♦ **MC:** Get paid for not doing anything.

♦ **LL:** Now, it's the date rape drug, Ropinal. Frat boys use it at parties. It's widespread; it's rampant across campuses.

[topic of burglary:]

♦ **MC:** You have to be a lot more careful now. There are a lot more alarms and a lot more cameras and a lot more stuff everywhere. Cameras are the worst part, now. You could be three blocks away, walk by, someone has a tape, and whoever investigates just watches everyone that walked by.

You have to wear disguises and everything now. Or you have to figure out where everything is. Some cameras are really hard to find. A clock or a smoke alarm could have a camera in it—that's very common.

You have to assume that there is a camera somewhere, so what are you going to do about it? There are so many cameras everywhere now that you never really know. In London, they have 'em everywhere now. Like every block.

♦ **V:** *That's what J.G. Ballard said. I read in the New York Times that there's one on every city block in New York City, looking down. I wonder if, now, the police catch everybody who pulls stick-ups?*

♦ **MC:** They probably don't really *want* to.

♦ **V:** *Why not?*

♦ **MC:** Because they would spend all their time

doing that, so they have to prioritize what they're going to do. Only if something really bad happens, or if someone does something that's really lucrative—then they might go all out.

♦ **V:** *Years ago, I read there are satellites that can survey every square inch of the planet and read a license plate. But they can't catch Osama Bin Laden—*

♦ **MC:** You have to conclude that they don't *want* to catch him.

♦ **MARIAN WALLACE:** You can only read a license plate if you know where to look.

♦ **MC:** Yeah, you have to know where to look.

♦ **MW:** You can't go over every square inch of the earth—

♦ **MC:** And even if you *could* go over every square inch of the earth, you have to spend the time doing it. They only have so many people looking, and they don't save everything forever. But you never know when or where, so that's the problem—you have to scope things out really well.

♦ **V:** *This is like a new obstacle for wannabe pranksters: increased surveillance.*

♦ **MC:** Or for wannabe burglars—that's what I call "lucrative pranking"! You assume there could be a camera there, but there could be someone watching, or there could be no one watching. They could save their tapes or they could toss them; they could break 'em or they don't put two and two together. Or they do put two and two together and they start looking at every camera they can find. For instance, if you stole something fairly expensive and they knew *when*, they might go to every place around there if they really want to investigate.

♦ **V:** *You don't read about that much in the paper.*

♦ **MC:** Of course not!

♦ **V:** *I did read an article in the New York Times*

that at Macy's flagship store in New York City, there are like six hundred cameras placed throughout it. This was such a huge number that I thought it was a misprint; maybe it should have said sixty. They printed a photo of a little room with three people watching wall-to-wall monitors.

♦ **MC:** Have you ever been to Las Vegas? There are thousands of cameras in any of those casinos. They're always watching them.

♦ *V: Of course.*

♦ **MC:** You can still get away with stuff, but it ain't as easy as it used to be—

♦ **LL:** To be a prankster.

♦ *V: But pranksters, or rather, criminals, have gotten away with millions over the Internet, by stealing credit cards and stuff. That happened to me. I bought something at a downtown Italian clothing store that I later realized might be Mafia-connected. Shortly afterwards, I was up north in this small town and bought gas and some groceries. When I got back, someone from the credit card company called and asked, "Were you just in Tokyo?" [laughter] And I said, "No!" And they said, "Well, we didn't think so, because we have records of you buying gas and being in this store up north. At the same time, someone with your card number just spent six thousand dollars on camera equipment in Tokyo."*

♦ **MC:** I bet they did!

♦ *V: We found out later that it's the* store *that suffers; the credit company never loses. The store in Tokyo was out six thousand dollars.*

♦ **LL:** On TV I saw a documentary special about fake ATMs. The filmmakers contacted a guy who used to be a high grift fraud con-man. He found some Middle-Eastern guys selling ATMs (they look like a slot machine)—no background check or anything; they'd just sell 'em to anyone.

And this is what they did to prove how stupid people are. At an ATM, they had "Clean your card" pop up on the screen. Like, you need to *clean* your fucking ATM card? And people would swipe it, and that's how they could get all your information. *Anyone* can own an ATM, and there's a lot of fraud going on from that.

♦ **MC:** It just reads all your information and then says, "Temporarily out of money."

♦ **LL:** I think *I* should have my own ATM. See again, money for something you didn't do. That I can respect.

♦ **MC:** Now they have all those little ATMs that you see everywhere. Now is the perfect time to get your ATM, because you can move it around everywhere.

♦ **LL:** I could be like the little drummer boy with an ATM strapped to my chest. I could just be like a walking cash dispenser which steals everyone's

cards.

♦ *V: And apparently it must be easy to make a fake Visa card with someone's number on it.*

♦ **LL:** A lot of times, you can just call in numbers and order stuff over the phone.

♦ **MC:** The credit card companies have never made any attempt to make them secure, because they know they'd make *less profit* if credit card crime were wiped out! They've probably made millions just off criminal transactions, and they probably know that and don't want to lose that future income.

♦ *V: That's for sure. Hey Lydia, on the theme of*

pranks, there are three kinds: pranks you've done, pranks that other people have done; and prank ideas. There's always—

♦ **LL:** Room for more pranks.

♦ *V: Exactly, and there are always new ideas suggesting themselves—partly forged by new technology, like the Internet. Hey, you guys, can you sign my guestbook?*

♦ **MC:** I'm not signing anything.

♦ *V: Well, Marzy, you sign Monte's name so that we know he was here—*

♦ **LL:** Monte, just sign it with a fingerprint.

♦ **MC:** No, no. *That's* what they're going to start doing to people next. When they just want to get rid of you, they duplicate your fingerprints and then you're at the scene of every crime.

♦ **LL:** Of course, I'm there anyway—they just don't know it yet.

♦ **MC:** Like that car thief who leaves Elvis's prints all over everything. He made a copy of Elvis's fingerprints and would steal cars and leave Elvis's fingerprints on 'em.

♦ **LL:** I like it!

♦ **V:** *Lydia, are you sure you haven't done any pranks?*

♦ **LL:** Well, I attended the World Police and Firemen Games in Barcelona: ten thousand cops and fire-fighters competing in Olympic-style events, in sixty different sports disciplines. I went there to do a documentary. Cops love me, because I've been photographing police for years when I'm on tour. I always get them in compromising positions and photograph them.

Jerry Stahl will testify to this—he's seen me in action. They think I'm so innocent; they see me and think I'm the one they're supposed "to protect and serve." I guess this is kind of a prank, right? I'm sure I must've told you this story where Jerry and I are in a rented car in Florida doing our Spoken Word tour and we get pulled over for—not speeding, but because we look "too cool," by this big bull.

♦ **V:** *You mean you look suspicious—*

♦ **LL:** No, he said, "You guys just look cool, so I pulled you over. What are doing?" I said, "We're in a rented car and we're doing poetry readings," because that's the safe word. I said, "I do readings about power and submission. Why don't you come tonight, Officer?" He's like, "Ha ha ha. Well, I'm working. You weren't speeding; everything's cool. I was just checking."

He's walking back to his car and I'm like, "Jerry, watch!" He's like, "Oh, you're sick." So I wait 'til the cop's right back to his car, a good five yards away, and then jump out of the car and I'm like, "Excuse me, Officer?" making him walk back to me because it's part of the game. He goes, "Oh, yes?" I said, "Do you mind if I take your picture? Because I take pictures of people that help other people." Of course, in the picture he's flexing his arm—I caught him with bulging muscles.

Anyway, I've been taking pictures of cops on tour for years! So my partner Mark says, "You gotta come to Spain immediately!" I'm like, "Why?" He goes, "For The World Police and Firemen Games. I got a press pass for us; we can shoot some documentary footage." I'm all over it. So it's karate, motorcycle racing, etc. This is the best: the firemen had to run up a 35-step flight of stairs with all their equipment on their back. We're positioned at the top of the stairs, thirty-five flights of stairs up, and they arrive almost puking—in fact, some of them *were* puking. I've got photos and video.

I love the police, you see, because they're so easy to fuckin' manipulate. And they love me; they have no clue.

♦ **V:** *What do you mean? How are they easy for you to manipulate?*

♦ **LL:** Because *I'm* the one they *should* be protecting and serving. I went to this event with dual intentions, of course. I went, not only because I love being around the police, but *especially* if I'm flying on MDMA, which I was when I got my pass on the first day. High as a kite, flirting with the police!

I was just in glory talking to all these cops. This was my question: Does a thing like the world police and firemen games, which are a version of the Olympics for police . . . does it temper the testosterone inherent in that kind of a job? Like any martial arts or sports discipline, if you have a place to *put* your aggression and your passion, then you're not frying on high-wire the whole time.

Or, does this "Police Olympics" encourage a super-aggrandizing *machismo* that turns 'em all into fucking assholes? But it seemed to me that any of the cops involved in these games were so cool. You could tell in their eyes they weren't full of shit, they *did* want to help people, and there were a lot of women cops and women fire-fighters, too, which was great.

I was talking to cops from all over the planet. The thing is, these kinds of sports make them train all year, in disciplines like karate, weight-lifting, bowling. It gave them a *place* to put their aggression, it gave them discipline, it gave them something to aim toward, and made them not only better officers but better human beings because they had some place to focus that nonsense.

And they were all amazing, and not just "puttin' it on" for me because I'm a cute face. I'm looking into their fucking eyes; I can tell what's going on here. Anyway, we're bouncing around from place to place, so finally it's the last day, and the only thing left is bowling. And we're like, "Who wants to go to the *bowling?*" We've just been attending karate, weight-lifting . . . The bowlers have *got* to be a bunch of old farts; grandpas polishing their balls.

We go to the bowling alley, and this reminded me of the *Simpsons* (which I've never seen a full episode of, by the way) . . . they're drinking beer with Redbull, an energy drink, in it. So they're all screaming and hollering and whooping it up and they're all British. I go in there and they're all, like, "Have a drink! She's like Ruby Wax—look at her!" (Ruby Wax is an American interviewer who's in London; she's kind of an outrageous interviewer.)

So I'm flirting around with them. I'm looking over at one guy, thinking, "What is he wearing?" He had a cop shirt on, and the patch was from the

cop on the *Simpsons. I* don't recognize it because I don't watch the *Simpsons,* but the people I'm with tell me that's what it is. I'm culturally ignorant about this, so I go over to the *Simpsons* shirt-wearing officer and I'm like, "What's up with the shirt?" And he's loaded. I'm like, "I'm Lydia Lunch," and he goes, "I'm Pinky!" Six-foot-two, two hundred and fifty pounds.

So I'm talking with Pinky, and people are cracking up, and Pinky goes, "You gotta talk to Greengrass over there. He's the Gold Medal winner for the bowling league." So I'm looking at John Greengrass; he's got a scar on his forearm, and I ask, "Is that a bowling injury?" And he says, "It *is,* kind of."

I'm like, "Wait a second, what do you mean it's a bowling injury?" He's starts telling this story. He was coming back from the last World Police and Firemen Games, which happen every two years. Two years ago it was in Indianapolis; this year it was in Barcelona. He's coming back; he's at Heathrow Airport with his partner, they're leaving the airport in a car, going back home, and they get caught in a car chase.

Somebody has a stolen car, and there's a cop chasing. He's telling his partner, "We gotta do something!" His partner's like, "Do something? We're not armed, we're not in our uniforms, what are we gonna do?" Suddenly there's a spin-out and the stolen car is coming right at him. So he jumps out of the car and all he had is two bowling balls in the backseat. He gets out like Rocky, right?, and lifts the balls over his head, throws them at the windshield, stopping the car, which skids and takes his forearm with it. Out of the car gets a thirteen-year-old boy.

So my obvious question was, "Did you show him the *what-for* after that? Did you give him the old *one-two?*" And he goes, "No no no; wouldn't want to admit to that. The kid was only thirteen." I go, "If he was thirteen and was being disobedient, then I would give him a goddamn spanking, that's for sure." He goes, "Well, it's best to leave the punishment in the hands of the law enforcement officers, I guess, in this case." I loved it.

♦ **V:** *But how did his arm get injured?*

♦ **LL:** He threw the bowling ball at the car and the car skids out of control but kinda grazes him, so he's got this amazing scar. Which I photographed, of course. The bowlers turned out to be the wildest. They were British bobbies, drunk, having a good time. *I* had a grand time; I just loved it.

♦ **V:** *See, life is not so facilely eclipsed into these little categories. Like, if you're "counterculture," you automatically despise cops—*

♦ **LL:** No. Because I stalk the police—I stalk them with my camera all the time—I've got dozens of photos of all kinds of cops. They always let me take their picture; always. Because they have no clue.

♦ **MW:** They probably don't have many people ask them.

♦ **V:** *Most people don't have the guts to ask 'em.*

♦ **LL:** Some of them are pretty hot! One time I was coming out of Kennedy Airport to have a cigarette, and there's a big fat cop ass loaded down with all the gear—the cop's bending down to talk to the driver of a cop car. I come out and say, "Assume the position!" The driver starts laughing. I'm like, "Excuse me, officer, can you just stay where you are? I need a photo of this." And he's like shaking his head, and the driver cop is saying, "Let her take it, let her take it!" There it is, wide as the Mississippi, loaded with equipment.

♦ **V:** *The cop belt is very heavy; it actually weighs twenty or twenty-five pounds. I know a cop. He used to be the doorman at the Mabuhay. He went to the police academy and passed the exams. And he refuses to get a promotion; he wants to be a beat cop, on the street.*

♦ **LL:** Because he wants to help people. Every cop I have ever asked has said this. What's weird is, the media are never going to talk about any good deeds done by anybody, because that's not what the news is about; the news is about *disaster.* Not just in a story only about police, but *everything.* The slant is on that.

So for every person beaten by police—well, we'll see the tapes; they show it and they have 'em. They will *not* tell you about the life risk, the high divorce rate, the alcoholism, the suicide rate (which is four times higher than the average), etc. They feel the stress of the job; they are outnumbered, overworked, underpaid, and then they have to deal with the reputation of a few rogue assholes, which are in every fucking profession. So I have a very dualistic position on cops—

♦ **V:** *Whereas CEOs are one hundred percent rogue assholes. Well, most of 'em.*

♦ **LL:** I have a very dualistic love/hate affair with the police. But I have many of their cards, so every state I'm in, I can get out of jail free! ♦♦♦

QUOTES

I have this terrible desire to fake things at this level; to fake institutional things. I think that everything to do with institutions should be faked.—Slavoj Zizek, *Conversations with Zizek*

Not one shred of evidence supports the notion that life is serious.—John Milton

To speak is not to see, so all speech to some extent is blind.—Jacques Derrida

More than once Einstein wryly observed how convenient it seems that reality plays by rules invented by human scientists.—Diane Ackerman, *Alchemy of Mind*

Any representation of reality after all is an agreement that reality is a certain way.—Paige Schilt

Film: here we are (in reality) creating a virtual reality we hope explains reality.—Mindy Bagdon

My own suspicion is that the universe is not only queerer than we suppose, but queerer than we *can* suppose.—J.B.S. Haldane

We will first understand how simple the universe is when we recognize how strange it is.—John Archibald Wheeler

Something unknown is doing we don't know what.—Sir Arthur Eddington

The hallucinogen drugs shift the scanning pattern of "reality" so that we see a different "reality" ... there *is* no true or real "reality" ... "Reality" is simply a more or less constant scanning pattern.—W.S. Burroughs, *Nova Express*

Our knowledge limits our vision.—unknown

In 1969, Lyle Stuart published *Naked Came the Stranger,* a sex novel whose dust jacket said it was written by a Long Island housewife. In fact, the book was the work of more than two dozen reporters at Newsday ...The novel was a best-seller both before and after the hoax was exposed—*S.F. Examiner,* 6-28-06

Corporate media in, garbage out.—unknown

Sade only committed his crimes in his imagination, as a way to free himself of criminal desires. The imagination can permit all liberties. It is quite another thing for you to commit the act. The imagination is free, but man is not.—Luis Bunuel

The marvelous is the eruption of contradiction within the real.—Louis Aragon, *Paris Peasant*

Madness is the predominance of the abstract and the general over the concrete, over poetry.—Louis Aragon, *Paris Peasant*

The madman is not the man who has lost his reason. The madman is the man who has lost everything except his reason.—Chesterton

Man has delegated his activity to machines. To them he has forfeited even his faculty of thought ... Machines are responsible for working such unimaginable effects on people under the influence of speed as to alienate them from their slow selves.—Louis Aragon, *Night Walker*

Men pass their lives in the midst of magic precipices without even opening their eyes. They manipulate grim symbols innocently, their ignorant lips unwittingly mouth terrible incantations.—Louis Aragon, *Paris Peasant*

We were going to destroy boredom. A miraculous hunt opened up before us, a field of experiment where it was unthinkable that we should not receive countless surprises and who knows? a great revelation that might transform life and destiny.—Louis Aragon, *Paris Peasant*

Myth is the path of the conscious mind, its magic carpet—Louis Aragon, *Night Walker*

Among natural forces one power, acknowledged from time immemorial, remains as mysterious to man as ever, and an integral part of his existence: night.—Louis Aragon, *Night Walker*

The things you acquire become you, and you become them.—unknown

If God is all-powerful, why doesn't he kill the Devil?—Marquis de Sade

Only he who knows can see.—unknown

SITUATIONIST GRAFFITI

--It is necessary to systematically explore chance.

The dream *is* reality.

The walls have ears. Your ears have walls.

To exaggerate, is to begin to invent.

Liberty is not a "property" that we possess. It is a property that others prevent us from acquiring by the aid of laws, rules, regulations, ignorance, etc.

There are two kinds of people: those who create, and those who profit by them.

Take a trip every day of your life!

Invent new sexual perversions!

The forest precedes man, the desert follows him.

Don't change bosses, change your life!

Freedoms are never given to us; we have to take them.

The restraints imposed on pleasure excite the pleasure of living without restraints.

Neither robot nor slave.

The emancipation of humans will be total or it will not be.

Death to the lukewarm.

A cop sleeps inside each of us; it's necessary to kill it.

He who talks about love, destroys love.

I am a Marxist of the Groucho tendency.

It is not man, but the world who has become abnormal.—Antonin Artaud

Be realistic: demand the impossible!

Everything is Dada.

No liberty for the enemies of liberty!

The duty of all revolutionaries is to make the revolution!

Creativity. Spontaneity. Life.

To lack imagination, is to not imagine the lack.

Death is necessarily a counter-revolution.

To construct a revolution is to also break all interior chains.

Talk to your neighbors.

Only the truth is revolutionary.

My desires ARE reality.

To desire reality is good! To realize these desires is better!

The more I make love, the more I want to make the Revolution,

The more I make the Revolution, the more I want to make love.

Those who take their desires for realities are those who believe in the reality of their desires.

Long live direct democracy!

Our "modernism" is only the modernization of the police.

It's not a revolution, Sir, it's a mutation.

Liberty begins with one interdiction: Do not harm the liberty of others.

Car = Gadget.

The prospect of play tomorrow will never console me for the boredom of today.

People who work are bored when they're not working. People who don't work are never bored.

Our clean, tidy, hygienic repression.

Shame is counter-revolutionary.

Liberty is the conscience of necessity.

Real life is elsewhere.

 N D E X